P9-BZQ-135

On Display

Margaret Hall

On Display

A Design Grammar for Museum Exhibitions

Lund Humphries London

AM
151
H24
1987

c. 1

#16893524

12-21-87

Copyright © 1987 Margaret Hall

First edition 1987
Published by
Lund Humphries Publishers Ltd
16 Pembridge Road London W11

ISBN 0 85331 455 1

British Library Cataloguing in Publication Data
Hall, Margaret
 On display : a design grammar for museum
 exhibitions.
 1. Exhibitions 2. Museum techniques
 I. Title
 069.5'3 AM151

Designed by Herbert & Mafalda Spencer
Typesetting and film by
Tradespools Ltd Frome
Printed by Lund Humphries Ltd Bradford
Bound by Hunter & Foulis Ltd Edinburgh

PHOTOGRAPHS
The illustrations on the following pages were supplied by or are reproduced by courtesy of:
Academy of Natural Sciences, Philadelphia 13; American Museum of Natural History, New York 101, 179, 214; Antikvarisk-topograpfiska arkivet, Stockholm 151; Architectural Press Ltd, London 19 (top), 64 (top), 88 (bottom), 89 (top); Arts Council, London 26 (bottom), 38, 40, 62, 172, 193, 206 (top), 218; Australian War Memorial, Canberra 230; Bauhaus Archive, Berlin 16 (bottom), 95 (bottom); The Board of Trustees of The Royal Armouries, London 137 (× 2), 138; The Board of Trustees of The Victoria and Albert Museum, London 15 (bottom), 16 (top), 62, 129, 130, 163, 201, 225; British Museum, (Natural History), London 166 (× 2); The Conran Foundation: The Boilerhouse Project, London 128, 224, 238; Crafts Council, London 74, 147; Design Council, London 17, 18, 98, 174; James Gardner 17; Guildhall Library, London 15 (top); Hirshorn Museum, Washington 202; Historisch Museum, Amsterdam, 238; Jorvik Viking Centre, York 217; Light Fantastic Ltd, London 123; Metropolitan Museum of Art, New York 74; Musée d'histoire naturelle de Genève 180; Museum für Völkerkunde Staatliche Museen Preußischer Kulturbesitz, Berlin 65, 288; Museum of Costume, Bath 153; Museum of Fine Arts, Houston 160; Museum of Modern Art, New York 51; Music Museum, Stockholm 28; National Air and Space Museum, Washington 240; National Gallery of Art, Washington 51, 52, 62, 82, 105, 145, 149, 186, 196, 200, 207; National Motor Museum, Beaulieu 240; Pilkington Glass Museum, St Helens 170; Riksutställningar, Stockholm 72, 139, 161; Royal Treasury, Stockholm 37, 65, 154; Science Museum, London 233; Statens Historiska Museet, Stockholm 77, 128, 214; Swiss National Museum, Zürich 137; Tate Gallery, London 140; The Trustees of the British Museum, London 14, 19, 28, 38, 53, 57 (× 2), 64 (× 2), 72, 77, 83 (× 2), 95, 97, 130, 131 (× 2), 133, 140, 143, 147, 151, 153 (× 2), 160, 169, 173, 174, 197, 206, 222, 227 (× 2), 242 (top right, bottom); The Trustees, The National Gallery, London 183; University Museum of Zoology, Zürich 180

The photographs used on the cover/jacket were supplied, taken or reproduced by courtesy of:
Alan Irvine; The Trustees of the British Museum, London; Chorley, Hyman and Rose; Cuming Associates; National Gallery of Art, Washington; Edward Walton.

PHOTOGRAPHERS
Brecht, Enzig Ltd 129 (bottom), 132 (top left), 172; Martin Charles 36, 63 (bottom), 88 (bottom), 89 (top), 148, 197 (bottom), 201 (b), 217 (bottom), 218 (top left), 223, 231 (top); Chorley, Hyman and Rose 17, 18 (top), 19 (bottom), 27 (top left), 37 (bottom), 41, 53 (right), 72 (bottom right), 83 (left), 87 (right), 89 (bottom right), 93, 100 (right), 104, 130 (top), 133 (top), 140 (left), 141, 149 (top and left), 163 (bottom left), 169 (top left and bottom), 173 (top), 177, 183 (top left and right), 186 (top), 190 (top), 201 (d,e), 233 (top left); George Cserna 51 (bottom right); Cuming Associates Ltd 63 (top), 89 (bottom left); G. Dajoz 180 (top right); Ian Dobbie 74 (left), 147 (top left); Mike Duffy 217 (top); Mark Edwards 193; Rolf Hintze 88 (top right and left), 137 (top right), 220; Evelyn Hoffer 74 (right); Phil Sayer 174 (right); Bill Toomey 64 (top); Edward Walton 35, 39, 61, 77 (right), 95 (left), 97 (left), 98 (bottom), 100 (left), 126 (top and bottom), 128 (top and middle), 129 (top), 132 (bottom), 143 (bottom left and right), 153 (centre) 156 (top, centre and bottom left), 160 (bottom left), 178 (centre, bottom left and right), 180 (centre and bottom right), 183 (bottom left) 190 (bottom), 203, 207 (centre left), 214 (top and bottom right), 222 (top), 233 (top right), 237 (right and left), 240 (top right), 241, 242 (top right); John Webb 26 (bottom), 38, 62.

The following designers have kindly lent photographs of their work:

Gordon Bowyer and Partners 37, 53 (bottom), 83 (left), 233 (top left); Clason & Sörling 88, 137 (top right), 220; Paul Dillon 234; The Office of Charles and Ray Eames 27, 110, 231; Barry Gasson 132, 172; Piers Gough 218 (bottom right); Ivor Heal 130; Alan Irvine 18 (bottom), 27 (top left), 28, 41, 63 (top), 72 (right), 87 (right), 89 (bottom right and left), 93, 94, 100 (right) 104, 130 (top), 133 (top), 141, 149 (top), 163 (bottom left), 169 (bottom), 173, 177, 183 (top left and right), 186 (top), 190 (top), 201 (d and e); Colin Milnes Associates 236; Paul Williams 160, 164, 201(c), 225; Robin Wade Design Associates 36, 129, 148, 197 (bottom), 201(b), 214 (bottom left), 217 (bottom), 223, 231 (top).

The remainder of the photographs were taken by the author, who also provided the drawings.

I am indebted to the Design Council for permission to reproduce a passage from their files on the *Britain Can Make It* exhibition (1946), (page 17) and to the Museums Association for permission to use material on page 59 from the *Manual of Curatorship*.
MH

Contents

Foreword

The prime purpose of a museum is the collection and conservation of materials for posterity. To most people, however, museums are either an entertainment or a spectacle and the museum has an urgent duty to display and explain the collections in its keeping. In relation to this, security is of paramount importance: not only security against theft and vandalisation, but also against damage from environmental factors – heat, cold, damp and dryness. Thus an object must often be protected by glass and the light and atmosphere controlled under advice from conservators. To inform the visitor information must be made immediately available, but the object or picture must be allowed to speak for itself without clutter or over-elaboration.

At one time objects could be arranged in regimented rows in mahogany show-cases and information provided in handwritten labels, often terse to the point of obscurity. The designer was then admitted to the museum. At first it seemed that the designer had taken over: the visitor had to read hundreds of words, look at working models and reconstructions before being allowed a view of an actual object. This was – and remains – particularly true of natural history galleries, where it is now almost impossible to see a real fish, but where magnificent models show the reproductive system, the spawning process and migratory habits in the greatest detail. The aim of this book is to point the way to a balance between designer and curator.

Designers were admitted to the museum as beauticians; but although they may still have a cosmetic function they are now part of a team of communicators. Designers work with curators, editors, security men, conservation officers and administrators to produce a rounded vision of a museum's collections. Their skill lies in presenting this material tactfully. Indeed, tact is essential, for not only must they immolate their wildest flights of fancy, but they must also curb the wildest flights of fancy of the academic who may want, for instance, to write a 500-word information panel when space for 150 words is all that is available and, probably, necessary.

At the same time museums must arrange special exhibitions to highlight parts of their collections or bring new material before an eager public. They must reach out into the community, taking exhibitions to a wider audience, making their collections as available as possible. At all stages of museum display from 'blockbuster' exhibition to the re-arrangement of a single case, the work of the designer is crucial.

Margaret Hall, the author of this book, is one of the world's leading museum designers: she designed the first 'blockbuster' exhibition *Treasures of Tutankhamun*, in 1972 and is in charge of the permanent and temporary exhibitions of the British Museum. She is a Royal Designer for Industry. Her experience of more than twenty years' work in the museum world is distilled in this book which will become essential reading for all who work in museums – whether they be curators, designers or administrators.

David M Wilson *May 1986*

Acknowledgements

While writing this book I have been able to rely on help from many people. My thanks are due, first and foremost, to John Taylor and Herbert Spencer, Directors of Lund Humphries Publishers Ltd for their support and help in the shaping of it.

My director at the British Museum, Sir David Wilson, has given a great deal of support and encouragement to design in museums, and has been kind enough to contribute a generous foreword to the book, for which I am very grateful.

I am also indebted to: Jean Rankine, the Deputy Director of the Museum, for reading the manuscript and helping with constructive comments; to my colleagues in the Department of Conservation for their advice; and to my colleagues in the British Museum Design Office. Without their enthusiasm, hard work, and knowledge of the subject it would have been hard to illustrate the book fully, let alone complete it.

I have had the privilege of working for both Sir Hugh Casson and Sir John Pope-Hennessy and have benefited from their interest in museum design; I quote from them, as would anyone writing on this subject.

My thanks are due to many people who have helped in the preparation of this book and also to all those who have contributed to the development of the subject. I am particularly indebted to: Gordon Bowyer, Denis Brennan, Michael Brawne, James Gardner, Ivor Heal, Colin Milnes, Robin Wade, Paul Williams, Wim Crouwel of Delft University and Eric Sörling of Stockholm. All have found time from their busy practices to help me. Most of all I have to thank Alan Irvine.

Subject specialists have helped greatly. Brian Coe of Kodak Museum, William Stobbs on transport, Madelaine Ginsberg of the Victoria and Albert Museum, A.V.B. Norman of the Royal Armouries, Tower of London, Chris Hill of the Natural History Museum, London, Ralph Turner of the Crafts Council, and Bengt Skoog of the Riksutställningar, Stockholm. They have all reminded me of the realities of their particular subject, to my great benefit.

I have been able to turn, too, to the designers in museums: Michael Preston of the Science Museum, Giles Velarde of the Geological Museum, Ruth Rattenbury of the Tate Gallery, George Gardner of the American Museum of Natural History, New York, Gaillard Ravenel of the National Gallery of Art, Washington, Paul Dillon of the Museum of Victoria, Melbourne, and Tom Hewitt of the National War Memorial, Canberra. Their advice, and that of the museum designers whose work is only credited through their departments, has been particularly valuable. We are all indebted to Michael Belcher, for his part in creating the Group of Designers and Interpreters in Museums, a forum, in Britain, for these topics.

The material in this book comes from many sources, the errors are mine, and I hope for the understanding of my colleagues and readers.

Finally, I have to thank my family and friends for their patience while I finished the book, for the care and precision of Carla Andrewes who kept it in order, and Edward Walton for his 'action' photography at many exhibitions, and for advice and assistance throughout.

Margaret Hall *August 1986*

1 Introduction to the Grammar

The exhibition boom

The last two decades have seen an enormous increase in the number of visitors to museums, and, in particular, to those that stage special, temporary exhibitions. Partly this is connected with sponsorship: newspapers with a large readership have put massive propaganda at the disposal of the museums. There is, however, more to it than that. The volume of publicity for exhibitions has increased enormously, and so has the amount of time devoted to them and their subject matter by television. There has also been a great expansion of colour printing. With the introduction of newspaper colour magazine supplements and part-work publications images in colour which achieve a technical standard that thirty years ago was only available to the scholar and the connoisseur can now be placed before the public. In spite of, or perhaps because of, the ready availability of articles and programmes about exhibitions, the tide of visitors to inspect the objects themselves has also increased. People still come to see for themselves though the exhibition itself can now be regarded as a single, if major, component in a multi-media presentation.

'Permanent' and 'temporary' exhibitions

Museums, art galleries, commercial and educational bodies mount temporary exhibitions, and they also mount more permanent displays, and there is no absolute division between the two. Many short-life exhibitions have been extended for a considerable time and many permanent displays have been altered much sooner than the originators planned; the techniques of display are, in practice, common to both.

There is, however, a fundamental difference in aims, in strategy between the two. Sir John Pope-Hennessy, then Director of the British Museum, explained it in a lecture about museum design given to the Royal Society of Arts in 1975. He defined the temporary exhibition as lasting for a short time, and aimed at the non-recurring visitor, and the permanent display as being absorbed through repeated visits.

The visiting patterns for temporary and permanent displays may differ, but the organisation procedures and design processes are much the same and they are dealt with as one in this book. For both, the curator and museum designer will be bringing together objects and information in a defined place for a defined purpose and for a stated period.

Subject and setting

The range of museum objects is infinite, and this book can only touch on a few of them and their many combinations. The objects can be of great historic interest, beauty or value and made of any material, and they can range in size from a coin to a battleship. The accompanying information can include the traditional labels, maps and diagrams but also facsimiles, film, and computer terminals.

The settings can vary as much, ranging from a building six centuries old or a museum or gallery built in any style at any time in the last two

centuries to modern inflatable tents. The aim can be education, information, celebration, recreation, commerce or any combination of these.

Temporary exhibitions in a museum play a number of important roles. They can be used to amplify and extend the permanent collections, and also provide an opportunity to display material which is more usually kept in storage collections. They can mark the culmination of a piece of academic work, or an anniversary. But above all, in each of these roles, the temporary exhibition and its attendant publicity will bring regular visitors into the museum more often, and attract many who have not been there before.

Professional designers have to find a formula for handling this material. This book considers the responses of designers to the task of finding a harmonious arrangement of things, facts, ideas, site and purpose; and then getting the audience into and round the exhibition.

International

The interest in cultural exhibitions as major social events is not, of course, restricted to Britain. Important collections have toured the principal cities of the world. Many exhibitions have attracted attendances of well over a million people in a few months, after planning, design and construction that took several years and involved immense cost. The responsibilities of the designers have increased to match.

This book

The current interest in the contents of museums needs to be viewed against a background in which the public has become used to a high standard of presentation in other media. It is not just that museum directors and staff have decided to try to do better; they are now in competition with other means of communicating with the public. Museums today are widely used and successful cultural instruments. But, as Sir Hugh Casson observes, the Museum 'serves its five functions – to collect, store, conserve, research and present – much better than it did, but not so well as it might'.

Who is to make the improvements? It is not enough to put objects in cases, to keep them safe. The visitor will want to know what he is looking at, why it was collected, how it was made, what it has to do with the other objects nearby, and to be given enough information 'to make sense' of it. And to bring this about in a museum, as in the media generally, is the job of a large team with overlapping skills. The designer is part of this team, if only recently accepted on the scene. This book examines the designer's role within the team, and follows the exhibition from first brief through the phases of design, construction and maintenance. Sometimes the problems arise from the particular properties of the objects to be shown, and sometimes from the story that the objects are to 'tell'. But the nature of a museum is a problem in itself; how to make things clear in quite an unusual setting.

The reader may not always agree with the vocabulary used in this book. There is as yet little literature on exhibition design. Some terms come from museology, some from North American usage, and some are inventions by the author as the need arose. The author and reader alike will spend the next few years groping towards a bigger and better terminology.

Although this book is about the grammar of exhibition design it cannot be used as a design bible, but rather as a manual. The illustrations are included to make points; some depict the finest design solutions and some do not. Those from large museums may be the result of deploying a large budget, and those from small museums with limited budgets are often the product of hard thinking and ingenuity. Both are included because they suggest possible solutions to certain problems. Some of the design

examples are as much as twenty years old. The capital outlay is often such as to dictate a long life; and the solutions may still be the most satisfactory today.

This book does not attempt to cover the subject of museum architecture, except to suggest where and how the exhibition designer may have to come to terms with it. A building, even one designed today, has an expected life many times that of the longest-running exhibition. Fashions change, in collecting, exhibiting, and academic explanation, and objects travel around the world, often requiring local explanation. What persists is the designer's job of displaying, on the site provided, in a style appropriate to the visitors, certain material and ideas. This process has been called, 'the simultaneous integration of a host of considerations'.

An artificial setting

It is worth quoting Sir John Pope-Hennessy on the museum dilemma: '... the whole museum situation is inherently an artificial one. The works exhibited were intended for a vast variety of purposes ... the only purpose for which we can be confident they were not designed was to be shown in a museum ... they have been wrested from their setting and alienated from whatever role they were originally intended to perform. This is the Museum dilemma ...'

This dilemma demands more from the designer than mere cosmetic skill, the creation of pleasant arrangements. To tell the story of the material to the visitors the designer must be prepared to move the visitors around in three dimensions so that they receive a sequence of impressions that will form a proper exposition of the subject (meanwhile protecting the exhibits themselves). The curators make an academic 'sense' of a collection, but the designer has to translate this into visual 'sense'. The design of the arrangement is always subordinate to the objects themselves. 'A great design is one of which it could be said that there was no designer' (Ivan Chermayeff *Communication Arts*). The designer may use banners in the wind outside or a magnificent eye-catching entrance, but these are to attract attention and introduce the subject. The mechanics of design should never be obvious, the designer being no more noticeable than the good pianist accompanying the soloist.

The reader

Designers are hampered by the uneven way in which exhibitions are covered in the press. Whereas the objects, if they can be made newsworthy, are often described and pictured at length in the newspapers and popular magazines; the coverage of museum and exhibition design in the professional design magazines is slight and infrequent. Many articles have appeared in museological publications, but these are not generally read by designers – even those in museums.

The increased prosperity of the last decade experienced by Western countries may not be maintained. Museum exhibitions are an expensive part of the information explosion. Small museums may never command satisfactory budgets for their running costs, much less for setting up spectaculars. And so the book attempts to look at the logic by which good designs have been achieved, rather than the scale or cost of their realisation.

How the book is organised

After a brief look at the background from which today's exhibitions have developed, the book examines the steps in the organisation, planning, design, maintenance and evaluation of museum exhibitions.

The second section of the book, a designer's notebook, identifies some of the design idioms used in exhibitions, and examines the display problems posed by the treatment of a variety of objects and materials, and different kinds of thematic subjects. Additional material is available in appendices,

11

on, for example, the design of special exhibitions for the disabled, and a number of check lists are included, appropriate to the different stages of creating an exhibition.

The book has been designed for use as an *aide-mémoire*. For ease of reference, certain questions are treated under more than one heading.

2　The background

Formative and first impressions

Inside each of us there is stored a first recognition of every subject in which we have any considerable interest. These discoveries provide us with a starting point. For some readers their starting point will have been the *Britain Can Make It* exhibition in 1946, and some will have started some thirty years later with the exhibitions for the *World of Islam Festival*. We can group both these experiences, and those between, as 'post war'.

Today's young designer should realise how little of what he sees at present is entirely original. The long history of museums and exhibitions is fascinating (though space precludes all but a cursory glance), and it is worth taking a look at just some of the antecedent museums and exhibitions, the work of a number of the most distinguished designers between the wars, and a few of the best offerings from industry. Present museum exhibitions owe much to the development of commercial exhibitions, boosted by world fairs.

Conquerors to connoisseurs

The earliest museums of which we have any record, and early trade fairs, both affected the present organisation and design of exhibitions. The most famous museum in the Greek and Roman world was founded in the third century BC, though it was more an academy of scholars with a collection of related objects than the modern concept of a museum. The ancient world possessed many collections of valuable objects on display to the public. The temples of Greece housed precious objects used as votive

A collector's collection. The private collector of natural history specimens and curiosities, with display and storage based on classification.
Ole Worm's Museum, Copenhagen, 1655

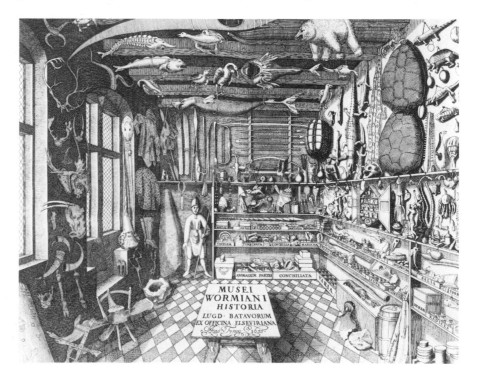

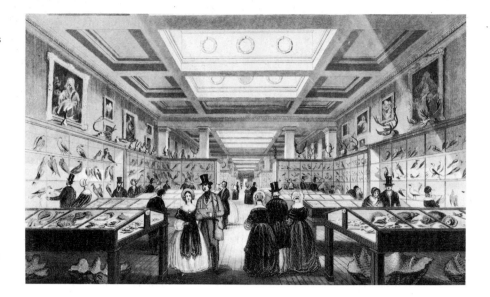

Taxonomy. The nineteenth-century Zoological Gallery at the British Museum. The room is crowded with cases and exhibits, with only the central aisle clear. No labelling is visible, although some visitors carry a 'synopsis'.

offerings, statues, and paintings. In the forum and at the baths the Romans displayed the treasures they had looted during their conquests.

In Europe, in the Middle Ages, it was the church that hoarded religious relics, mounting them with precious metals and jewels. To these treasuries were added art treasures brought back from foreign travel and the crusades. The long sixteenth-century Italian *galleria* became exhibition areas for painting and sculpture, while other rooms, *gabinetti* in Italy, *Schatzkammern* in Germany, housed curiosities and botanical specimens. What we would term 'the general public' was not admitted, but these special display rooms were to form the architectural models for the seventeenth- and eighteenth-century art galleries. Late in the seventeenth century a few museums began to open their doors to a select public, among the first being the Tower of London, the University Museum at Basel and the Ashmolean at Oxford. In the middle of the eighteenth century the Vatican established a number of museums; the British Museum was founded in 1753, and the Louvre in Paris in 1793.

Once even a 'minority public' had been admitted, our predecessors in museums began to experience the problems with which we wrestle today, securing the exhibits and controlling the sometimes unruly crowds.

During the nineteenth century the function of exhibitions began to change as the 'common man' no longer found museum buildings quite so intimidating. Industrial philanthropists started to provide money to build museums and also aimed to display the products of national skill for the edification of the public.

Many of these museums were organised on rigid plans, the daylit galleries set out as symmetrical corridors, with a wide central aisle for 'the promenade' and the cases were ranged strictly on the grid plan, by taxonomy. The cases themselves, fine pieces of craftsmanship, have proved more lasting than the ideas they housed. Designers today are confronted by the dilemma of whether to retain the fine Victorian cases, and something of the grid system, or sacrifice them to the present fashionable free 'interpretative' display.

Further complications are posed for the designer today. The nineteenth-century architect built his museum as a temple in praise of science and the arts. The Natural History Museum at South Kensington by Waterhouse is a fine example, adorned inside and out with works of art and symbolic decoration, which today are seen by some people as competing with the collections.

The early collections were organised to appeal to the connoisseur, collector or scholar, and the displays were either arranged 'aesthetically' or by classification or chronology. Both designer and curator today are very much within a tradition and they must recognise how hard it is to find completely new forms of display.

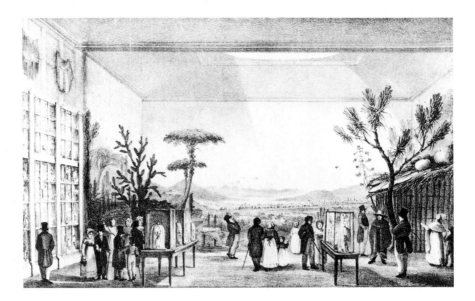

Simulation: *Ancient and Modern Mexico* brought to London in 1824 by Bullock. Traditionally-cased objects contrast with panoramic views and a facsimile Mexican cottage. Today, security and illusion still compete and conflict.

Fairs and 'curiosities'

In parallel with the development of the museums themselves other forms of display developed whose techniques have now been incorporated in the museum repertoire. Mediaeval fairs were organised on a strict grid of separate streets and pitches, and often incorporated tableaux and waxworks.

By the nineteenth century a host of diverse entertainments and exhibitions had arrived, often verging on the theatre proper, but providing a sort of 'moral alternative'. By then it was reasonable to expect that one could inform, educate and entertain all at the same time.

In 1812 William Bullock began to display curiosities from other countries in his Egyptian Hall in London. Up to then there had been little attempt to organise exhibitions in a systematic way, but Bullock displayed his material from other cultures with great imagination. By the 1840s Madame Tussauds waxworks was creating realistic 'atmospheric' presentations, and these were extremely popular with the general public who had not yet secured a ready entrance to museums and art galleries.

1851

The *Great Exhibition* of 1851, from which many London museums were to spring, was a milestone in the cultural and industrial life of Britain. This first great international exhibition established a style of display and an organisation of the floor plan, and it ushered in a tradition of World Fairs that have been vehicles for experiment in architecture and design ever

Grid plan. Cast-iron system (developed from Paxton's 1851 design for the *Great Exhibition*). The structure gives equal bays for displays and wide aisles for circulation.
International Exhibition, London, 1862

15

Order through symmetry. This is a religious display but early exhibitions often incorporated centred, altar-like arrangements for a variety of products. *International Exhibition*, London, 1862.

since. The *Great Exhibition* saw the earliest use of pre-fabricated standardised parts and this technique was reflected in the grid pattern of the interior stands. The grid continued to dominate the plan in the 1862 exhibition in London, and adapted to an oval form in the 1867 Paris Exhibition.

The symmetry of the plan was taken into the design of the individual stands. Much of the display material was arranged in the form of altars, or monuments, with the products of industry in a subordinate role, providing the components for elaborate patchwork-like patterns. The delights of display had overwhelmed the significance of the objects displayed.

The 1851 Exhibition may also be seen as a milestone marking much greater ease of access by the general public to the arts and sciences. During the latter half of the nineteenth century all the principal cities of Europe provided museums for a truly 'general' public. At last all the factors that influence the modern concept of the museum had come together. To the original loot had been added the organisation of the fair, the entrepreneurial skill of the showman, the simulation of the waxwork tableaux, and the right of the general public to access.

The start of storytelling

Soon exhibition organisers were to want displays to 'tell a story'. Orderly 'grid plan' arrangements and 'corridor museum' layouts do not facilitate thematic treatments. These demand fluid use of a whole area, with sub-areas devoted to aspects of the topic. The origins of this more fluid style are as follows:

In the 1920s in Germany a new kind of analysis of the problems of presentation emerged from the Bauhaus. The whole use of space was changing. A new architecture was being created throughout Europe, and this, together with new styles of graphic design, opened up completely new possibilities for designers of exhibitions. The 1925 Paris *Exposition des Arts Décoratifs* employed an exposed, structural framework supporting exhibits and text panels, a forerunner of our contemporary universal exhibition systems. At the *Pressa* exhibition in Cologne in 1928 El Lissitzky applied the new constructivist ideas, and we see, probably for the first time, photo-montage forming a key part of an exhibition.

The designer was becoming increasingly free to 'sketch' throughout the available space. In the *Deutscher Werkbund* exhibition in Paris in 1930 Walter Gropius and Herbert Bayer placed exhibits in a definite sequence to express an organic flow. The sensation of fluidity was increased by the use of curved walls and Bayer began to look into the possibility of extending the visitors' field of vision. The capacity to change levels as a form of punctuation between areas and to see one area from another were all important elements in telling an exhibition story. Again, in 1938, Bayer

Extended vision. Photographs on many planes, wall texts and spotlight 'tracks'. Herbert Bayer's architecture/furniture display poses the question, have we progressed in fifty years? *Deutscher Werkbund* exhibition, Paris, 1930.

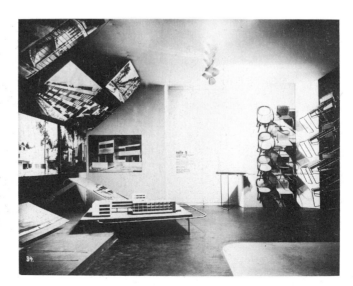

was experimenting with the language of exhibitions. In *The Bauhaus 1919–1928* exhibition held in the Museum of Modern Art, New York, shapes and footprints on the floor were used to direct the walking visitors; a technique that has been in use, on and off for the last 40 years!

The new look

During the Second World War commercial and art exhibitions virtually ceased, trade being constrained and national treasures dispersed for safekeeping. Exhibition techniques were diverted instead to government-sponsored propaganda. Ironically as a result, a number of lessons were learnt. Wartime messages had to be presented clearly, without frills, and much valuable experience was gained that was put to good effect in post-war exhibitions, such as *Britain Can Make It* held at the Victoria and Albert Museum in 1946. There were many displays surveying British industrial design, packaging, textiles, and sports goods, and among these there emerged a semi-theatrical reconstruction technique in the *War to Peace* section.

The archive photos of the exhibition show us an exemplary display on the *Anatomy of Design*. Logic had been added to decoration in the designers' work, and this had now to be explained to the new post-war audience. Here were simple and direct signs and copywriting integrated with three-dimensional design. But not welcomed by everyone. A letter of complaint received at the time by the Central Office of Information reads: 'the sordid, semi-underground half clean effect of the surroundings one might have been on a bombed site . . . rather than a majestic, finely proportioned building. The lighting made it very difficult to consult the catalogue . . . I hope any future shows will not be on these lines . . .' But the shows continued to use such stylistic devices, and the letters continue to this day.

In 1951 there was to be another exhibition which would affect all those to follow, much as did the *Great Exhibition* of 1851. For many years the *Festival of Britain* was to provide models for trade and cultural exhibitions, and parts of the technique and aspects of the style were to find their way into museum exhibitions of science, archaeology and decorative art.

The Italian influences

Museums design in the 1950s and 1960s was dominated by Italian architects: Franco Albini, Carlo Scarpa, and the BBPR Studio Architetti (Banfi, Belgiojoso, Peresutti, and Rogers). All had remarkable material to work with. In the immediate post-war period there were buildings of great beauty and interest to be reconstructed or converted. The settings were

Succinct copy and clean forms. Pointing hands direct the visitor. A designer expresses design. *Anatomy of Design* designed by Misha Black.
Britain Can Make It, Victoria and Albert Museum, London, 1946.

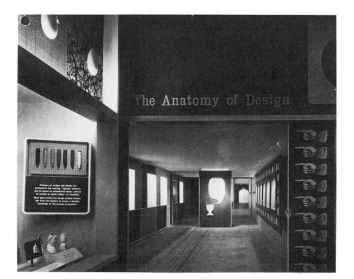

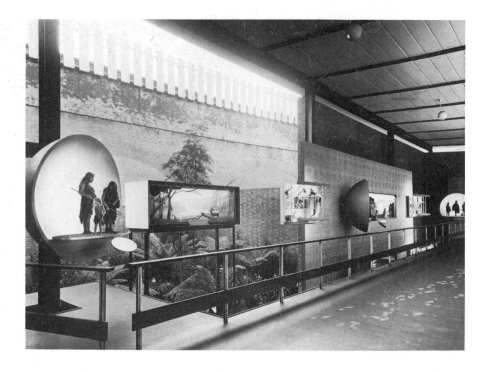

Mixed methods: cases of models, individually lit, dioramas and artefacts. Substantial barriers distance the crowds from displays. James Gardner's display for *The Peoples of Britain*, Festival of Britain, London, 1951

works of art, and in them the works to be displayed were placed with extreme artistry, each piece carefully arranged against the interior and its fellow exhibits, on mounts or supports that were beautifully detailed, and executed by master craftsmen. The objects were there to enjoy, rather than to teach, as few of them as possible, with the minimum amount of information, the objects speaking for themselves. This style was reflected in the exhibitions in other countries. In 1961 the Royal Academy in London presented *The Book of Kells*, the objects isolated by their presentation, and revered. This exhibition was to lead directly into the era of the 'blockbuster' exhibition.

The exhibition as theatre

After the *Festival of Britain* in 1951 another distinct stream of exhibition design came alive, that deriving from theatre, tableaux, and waxworks. In 1954 there appeared Richard Buckle's *Diaghileff* exhibition, to be followed by the *Shakespeare* (1964) exhibition at Stratford.

Continuous panels. These display enlarged manuscripts, alternating with Irish landscapes, which surround cases, containing the bound manuscripts. The cases are externally lit.
Book of Kells: Treasures of Trinity College Dublin, Royal Academy of Arts, London, 1961
Designer: Alan Irvine

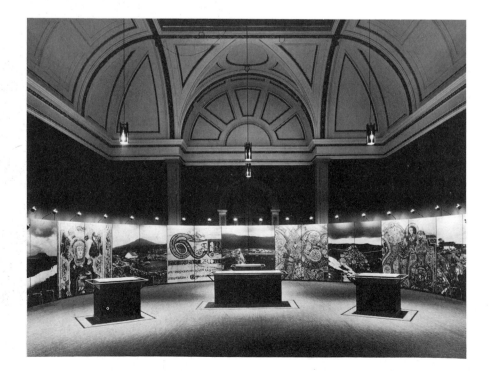

Carlo Scarpa's best known work, the
transformation of a bombed barracks to
provide an aesthetic setting for works
of art.
Castelvecchio, Verona, 1964

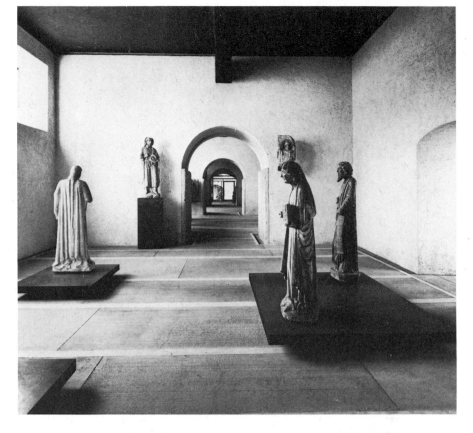

Designed for crowds: all objects are
labelled twice: once inside the linked
perspex cases and again on the light
boxes, to be visible over the heads of
visitors.
Treasures of Tutankhamun, British
Museum, London, 1972

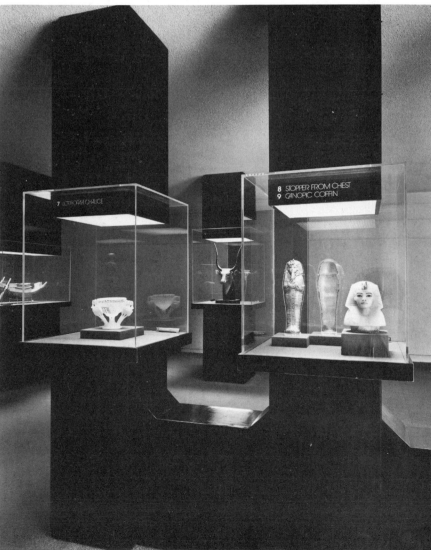

This 'evocative' style was reflected in museums. In 1970 the National Portrait Gallery put on *Samuel Pepys Esquire* and in 1974 the Victoria and Albert Museum presented *Byron: the 150th anniversary of his death*. In all four of these exhibitions a distinct genre was being established, separate from the pure aestheticism of the Italians, but also far from the didactic presentations of the mainstream of museum curators.

The 'blockbusters'

Organisers of exhibitions in this country tend to think of a new era starting in the 1970s: *Tutankhamun* in 1972 at the British Museum, followed by *The Genius of China* in 1973, *Pompeii*, *El Dorado* in 1976 and 1978 and the *Great Japan Exhibition* and *The Vikings* in 1980. In retrospect these have been regarded (not always affectionately) as 'blockbusters', comparable with giant movies such as *Caesar and Cleopatra*. It is worth considering what had happened, whether anything fundamental had been changed.

All these exhibitions used money in a new way. All charged admission, all were accompanied by catalogues that would stand up as books in their own right after the exhibition ended, and all were publicised with the sort of budgets that usually announce a new car. The exhibitions were being subjected to the technique of not proceeding until resources of overwhelming size have been organised to guarantee success. In other words, resources were made available, on a scale that was previously inconceivable.

Such exhibitions continue, albeit on a smaller scale. They do not have such impressive publicity, perhaps, and they may not take as much money at the turnstiles. The important point is that this generation of blockbuster exhibitions affected the whole practice of museum exhibition design, and the approach of curators, designers and text writers today, regardless of whether in fact they can count on substantial resources, support and publicity.

3 The exhibition makers

The team to meet the task

The roles within the museum exhibition team, the allocation of functions concerned with the conception, design, production and management of an exhibition must be clearly defined. So must the boundaries between the different roles. The size of the team will, of course, depend on the organisation mounting the exhibition. The number of participants might range from one- or two-man operations in a local museum to a large inter-disciplinary team in a national museum, or a team of specialists brought together under a commercial sponsor.

Whatever the scale of the project or the size of the team, the various stages and roles in the planning and production are likely to be similar, but in smaller projects a member of the team is likely to play several roles in turn.

Starting points

All projects start with a notion, a concept; this may range from a 'gleam in the eye' to a ten-page proposal, but there is always a point which the team will later recognise as 'the start'. It may well have come from outside the project team. Often the museum director or the head of department will have recognised a need or discerned the merits of an idea, or Government departments prompted perhaps by subject experts or potential sponsors, or entrepreneurs will have fed in the idea from outside.

Message and means

Whereas in the nineteenth century museum curators and academic specialists were the collectors, cataloguers and keepers of rare objects, in recent years they have perceived new possibilities within their subject fields. Originally, their theories about their subject were propagated to fellow academics through the learned societies and journals. The public, admitted to the collections on sufferance, probably had to work quite hard to assimilate information from the labels and other information which the curators chose to give them.

The public today, on the other hand, expects to be addressed by the specialist, and the specialists now expect to address, excite, amuse and educate the public, but intention alone is not enough. Sir John Pope-Hennessy suggested that 'museum specialists know their own collections too well'. What is more, there is much competitive communication going on outside the museum. To reach the new and wider audience curators call on designers, and those with editorial and allied skills for help in presenting and explaining their material in a simpler way. And to do this the designers and editors must try to see matters through the eyes of the visitor.

Design as order

Design is an umbrella word. It can cover every level of decision-making about the final form of an exhibition. Sometimes it refers to the

preliminary idea, or first sketch, sometimes to the overall detailed plan. It can proceed down the line as far as the nuts and bolts of the construction of the exhibition, even to the type on an object label and its positioning in a case.

Whatever the nuances, and there are many, one must remember that 'design' can be carried out by more than one section of staff in a museum. In the case of an exhibition, for example, the principal movers are likely to be the curators or academics who have the objects to display and know all about them. A key part of the 'grand design' will be the decision by the museum's administration as to which section of the public will have the story addressed to them, and what resources can be made available for the purpose.

The professional designer works among these groups or individuals, taking their basic ideas and expanding them to create a formula that will meet the needs of them all. The professional designer is not only exercising skill in the visual arts, but is also acting as a broker between the other interests behind the project.

Exhibition teams – for planning and organising – can vary in size from a single person in a small museum to a multi-disciplinary team in a national museum.

Co-ordination within a small team, or in the early stages of a large project within the core team, is easy, involving few people in close contact.

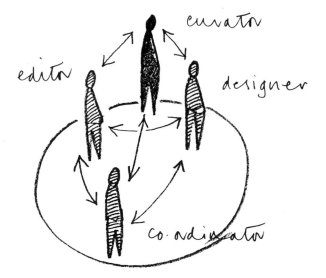

By the time an exhibition has been built and opened, many people have been involved. The exchange of information becomes a major task.
1 curator
2 designer
3 editor
4 co-ordinator
5 graphic designer
6 lighting designer
7 production manager
8 joiners
9 painters
10 electricians
11 security adviser
12 warders
13 conservator
14 lecturer
15 publisher
16 photographer
17 printers
18 sales people
19 'preparator'

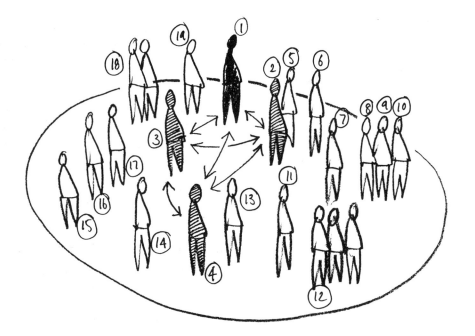

22

The composition of the team

There will probably be need for additional expertise in the team. The objects displayed do not tell their own story, and the verbal descriptions by academics may well be too scholarly for the public concerned. A skilled editor or scriptwriter, fresh to the subject, can make the information succinct and the story clear. Others may join the team for a large project; experts on conservation, security, education, evaluation, publicity, and technical advisers on the more specialised aspects of the lighting, use of computers and audio-visual presentation.

Many museums, either because their funds are limited or because they are particularly fortunate in their staff, prefer to build exhibitions 'in-house', rather than placing work with outside specialist exhibition contractors. A large museum's project team will contain carpenters, painters, electricians, photographers and printers.

Co-ordination

The size of a project will dictate whether the team can manage themselves or whether a co-ordinator is required; in a large scheme someone is needed to manage the whole project, to monitor costs, check schedules, and ensure that the members of the team remember to communicate with one another!

In some instances it is essential or desirable to borrow material from other museums and private collections. If the exhibition is to contain loan material the co-ordinator will have the critical role of organising loan permissions from a number of sources as well as being responsible for transport, security and insurance.

Running the show

The running and maintenance of a small exhibition can probably be carried out as part of museum routine, but a large exhibition will demand its own staffing. Good attendances may be satisfying, but they may bring the problems of litter and chewing-gum with them! Admission charges, although they sometimes make an expensive project possible, also demand 'front of house' management to handle tickets, money, and finally balancing the books.

The designer's responsibilities

The designer's role within the framework of the team involves responsibility for the physical arrangement and appearance of the exhibition. 'To assist the visitor in understanding the language of the objects themselves,' say Hebditch and Cameron, 'not to originate the exhibition'. However much of the designer's style appears in the final design, he is the mouthpiece of someone else's ideas, and an agent to see that the setting is appropriate and the objects secure. If his design is successful the designer may help to make the visitor's experience memorable.

Many design problems are practical and technical. On a large project three-dimensional structural design will be carried out by one person, and two-dimensional graphic design, text and illustrations, by others. In large teams extra effort is required to see that the graphic items are properly tied in with the structure itself. In a small museum both design skills may be deployed by one all-round designer. This may well give an advantage to the small museum, producing a unity of design for which the larger teams struggle!

Designers: in-house and freelance

The exhibition designer is sometimes a full-time 'in-house' member of the museum staff, and sometimes employed as a 'freelance' consultant. A number of writers have commented, with varying degrees of understanding and sympathy, on how their roles and their merits differ.

One way of evaluating the options is to consider when the museum wants its reward. An outside designer has a greater chance of delivering an immediate impact than his staff equivalent. He does not have to care about, perhaps does not know about, past conflicts or present protocol in the museum. Not being a permanent member of the museum's staff, he has not been subjected to covert, family-like, pressures in the past, and he will not have to live ever after with any offence he may cause. As a temporary member of the team he may have full partner status from the outset.

The museum probably scores in the long term by employing a staff designer. An overall policy can be established, perhaps with discreet trial and error, so that the museum develops a complete house style, and one that relates each project to others. In addition, the design service is always 'on tap'. There are many occasions when a single display case for new acquisitions or a single notice of a new display is required. Such a design 'laundry service', although often unnoticed, can make for smooth and stylish management of a museum. The house designer is also better able to function in the museum team of curators, conservators, and security staff, to consider their needs as a matter of routine. The designer receiving guidance from them on one project will bear it in mind in the future.

The risks attendant on the two options differ, as one might expect. A museum relying entirely on freelance design services may end up looking patchy and unfinished, whereas exhibitions in a museum entirely designed by staff may look polished but lack surprise. The freelance designer will tend to risk every sort of insecurity, and the house designer will risk being trusted, more as a servant rather than a partner.

The curator and the designer in tandem

Whether a designer is a freelance or staff member is less important than his relationship with the subject specialist with whom he is to work. The relationship is intimate and sometimes fraught. The academic specialist is going to speak through the designer and this demands mutual trust and understanding of both objectives and style. The balance between the two 'partners' will change throughout the project, each leading developments in turn, but both finally will have contributed equally. (The reader may be able to recall disastrous exhibitions illustrating both kinds of imbalance, caused on the one hand by academic supremacy and on the other by designer's folly!)

Group responsibility

Whatever its composition, the exhibition team has to develop trust between its members. The trust is of two sorts. First, each member must be acknowledged as competent in his own field of responsibility. Second, there must be a realisation that the aims of the team have been so brought together that any member can contribute ideas outside his own field, what are sometimes called 'unauthorised initiatives'. After all, as Sir John Pope-Hennessy observed, 'In the long run it is the talent and expertise of the individuals concerned which make the exhibit brilliant or banal!'

4 Classifying exhibitions

'An exhibition is a collection of objects which can be described as a series of connected displays, the duration of which is implicit in the arrangement and style. Exhibitions are only the *most* satisfactory means for sales, education, or propaganda when they are concerned with actual physical objects or demonstrations, when being able to see something in the round is more impressive than any two-dimensional representation.' (Misha Black *Exhibition Design* 1950)

Site and material

Before embarking on the time-consuming and expensive business of mounting an exhibition, the originators must know what kind of product they are aiming for, even if in gestation it may alter direction and type. In many instances the material to be exhibited will, of course, dictate the type of exhibition.

A particular locale will also to a certain extent, dictate the type and standard of exhibition to be mounted to accord with public expectation. Exhibitions referred to in this book have been sited in national museums and art galleries, city or local museums and art galleries, site museums, 'concept' museums and commercial museums.

Life of the exhibition

An exhibition having been chosen as the vehicle of communication, the next decision concerns whether the exhibition is to be permanent, or temporary. A third possibility is a travelling exhibition, which could mean either that the objects alone are moved from location to location, with different installations for each, or that the total installation travels together with objects. A further possibility would be that the travelling exhibition is, in itself, mobile, being set in a bus, trailer or train. Whether an exhibition is permanent, temporary, or travelling, two main alternative strategies exist for the organisation and subsequent design of the exhibition material.

Strategies

The first strategy is termed 'taxonometric'. Material is displayed by classification alone: one could be said to be providing an opportunity for visitors merely to discriminate between objects, probably drawing their own conclusions. The strategy assumes an informed public.

The second strategy is termed 'thematic'. This involves, as the name suggests, telling a story, and the visitor is guided to make connections and to follow the development of the thesis as it evolves in the exhibition. This development can entail a simple linear approach (nicknamed 'the tunnel show' – in one end and out of the other), e.g. the life-history of a statesman or the life-cycle of a butterfly. There can, of course, be a 'branching' within the linear type of exhibition, and in the exhibition of the life of the statesman there might be a sub-theme on, say, town life in the eighteenth century.

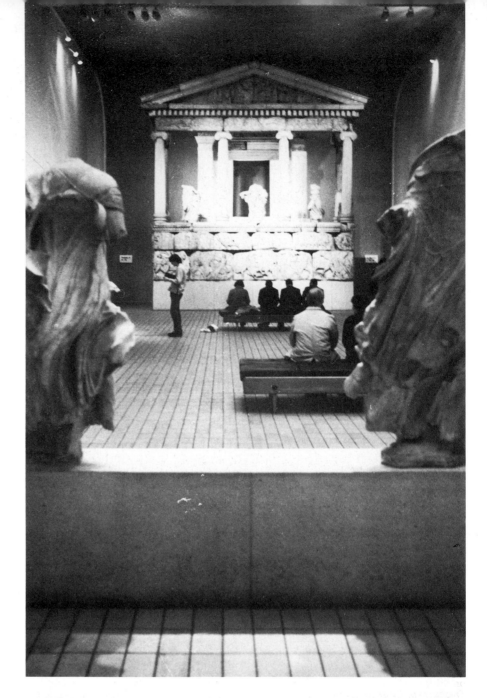

Permanence. The weight of the
monument and other sculptures, and the
expense of moving them, 'freezes' the
layout for at least a lifetime.
Nereid Room, British Museum, London
Design: Russell and Goodden

Temporary exhibition recaptures
propaganda impact. Generous space
available, short-life materials used.
Based on El Lissitzky's 1929 *Pressa*
exhibition.
Art in Revolution, Hayward Gallery,
London
Design: Michael Brawne & Associates

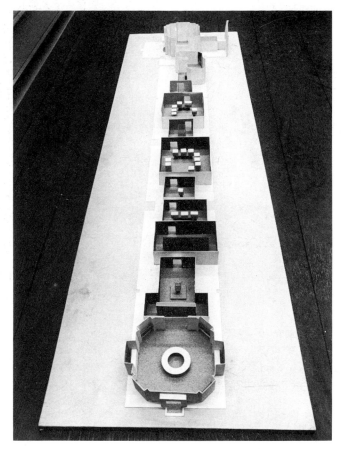

An alternative mode for the thematic strategy is the 'mosaic' type of presentation. Within a broad theme there are many separate displays offering random information from which the visitor can piece together his own selection of information on the main theme, pursuing his own route and following no particular order.

Degree of interaction

The intended visitors' reaction to the possible strategies, the degree of involvement with the 'machinery of communication', gives us two further classifications: the interactive and the passive forms. These descriptions can apply equally to the taxonometric and to the thematic linear or mosaic type of exhibition.

Above:
A travelling exhibition for economic transport and easy assembly. Pack flat – a large 'card' house, no carcase, just five panels slotting into one another.
British Architecture for Arts and Leisure
Designer: Alan Irvine

Above right:
Blockbuster 'tunnel show'. Narrow gallery imposes a linear design. The mass audience entails one-way flow (the service corridor, at one side, is not shown on this model).
Treasures of Tutankhamun, British Museum, London

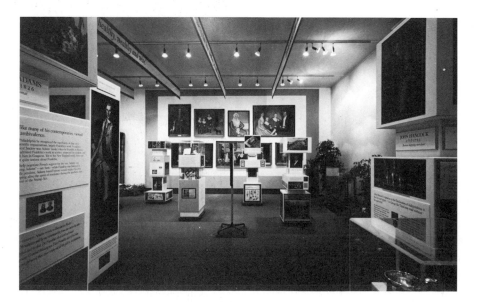

Mosaic treatment. Planned attractions everywhere, four-sided displays on freestanding units. Visitors wander, sample, study and piece together the exhibition story.
The World of Franklin and Jefferson,
British Museum, London
Design: Charles and Ray Eames

Evocative, transporting the visitor to the *suq* in Sana, North Yemen. Facsimile, built with imported props. Authentic spicy smells and market sounds added. *Nomad and City*, Museum of Mankind, London

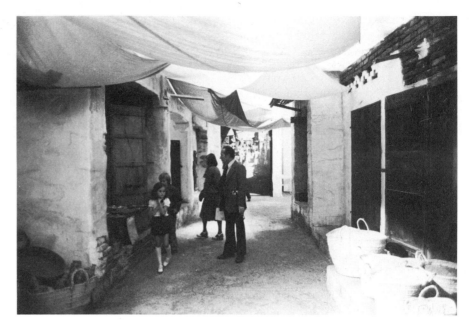

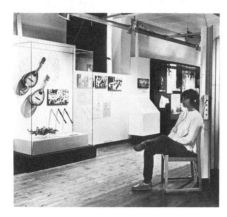

Interactive options. The visitors see instruments displayed, and can sit and hear the sound they make. Finally they are encouraged to try to play them. Music Museum, Stockholm

An interactive exhibition is one where a degree of involvement is necessary for the material and message to be appreciated. The involvement may be minimal, for example simple visitor participation in an exhibition of pub games in the Bass Museum, or extensive, for example the use of more complex teaching machines at the Natural History Museum which houses individually operated, push-button machines, in which specially programmed material can be exposed to the visitor.·

These types of exhibition are discussed later in 'Information:the look of the message', and 'The final score' on pages 91 and 116.

One must always remember that all these devices are an extension of the traditional static, object-oriented, museum display where the material is largely left to speak for itself, and the visitor paces himself through the theme that the curator is expounding.

Style

To some extent the strategy chosen for the exhibition will suggest the use of one 'style' more than another but a strategy and a style are not tied together inextricably.

Aesthetic display. Accompanying information is minimal. The objects are securely cased, well lit, precisely positioned with little distraction from mounts. They are 'left to speak for themselves'. Aichi Ceramic Museum, Japan Designer: Takashi Kono

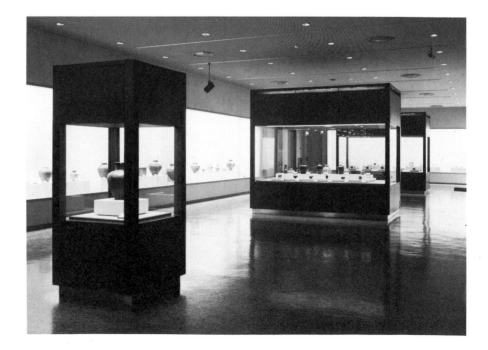

Exhibitions can be presented in different 'styles'. In an 'evocative' exhibition an atmosphere of an era, a country, a particular art style, or a scene is created in a theatrical way. This scene-setting aids understanding by evocation and association, and not necessarily by the display of informative texts.

In an 'aesthetic' exhibition each object 'speaks for itself'. Supporting texts and display mechanisms complement but are subordinate to the aesthetic and visual experience.

The 'didactic' type of exhibition has often been likened to 'a book on the walls'. The intent and appearance are primarily to impart information (though if interactive displays are incorporated this will not necessarily be in the form of printed texts or panels).

Permutations of strategy and style

While most exhibitions incorporate binary strategic approaches – taxonometric/aesthetic, thematic/evocative, thematic/didactic – there are many different combinations and permutations which are possible. Readers may find these pairings and the use of such terminology rather academic but increasing emphasis is being given to this approach in museum training. A greater appreciation of the strategy behind an exhibition should lead to a sharpening of vocabulary and this in turn should lead to the development of a critique of exhibition presentation on a par with that applied to the film or the novel.

5 Planning for design and production

The team and the timetable

The planning of the design, production, installation and running of an exhibition can be a complex operation. The total time needed for the design and production can vary from as little as a few months to several years. For example, thousands of man-hours were expended between the first idea of celebrating the bicentenary of Cook's death and the opening ceremony of the exhibition *Captain Cook in the South Seas*. One of the management tools used throughout any exhibition project is the timetable or schedule. This is an essential planning document which keeps all personnel involved together as a team and in sight of the overall goal. If the exhibition is to be run on a commercial basis time must be costed and the project must remain on budget and on schedule.

Stages

Many members of the team will be unaware of the stages involved in the design and production of an exhibition. Before planning begins in detail it is worth taking time to discuss the 'checklist' of items on which all have to agree. There are seven main stages in design and production to be worked through before an exhibition is complete. And all the items within these sections must have time set aside in which they can be discussed, approval secured, and action initiated. They are:

1 Inception – preliminary consideration of the project
a Idea
 Subject proposed and reason for an exhibition (such as a centenary) usually presented in a formal proposal
b Medium
 Suitability of the subject to presentation as an exhibition
c Audience
 At whom the exhibition will be aimed
d Aims
 Effect on the audience which it is hoped to achieve
e Location
 Site or gallery in which it may be staged
f Resources
 Money and staff which can be made available

2 Feasibility – examination of the assumptions in the proposal
a Team
 Identifying those who will work on the project
b Concept
 Further development and examination
c Objects
 Preliminary selection of exhibition material
d Storyline
 Preliminary draft of the story or themes of the exhibition, perhaps accompanied by sketches to form a 'storyboard'

e Cost
 Outline estimates of the expenditure/funding involved
f Site
 Examination of and decision about the area to be made available
g Timetable
 First estimate of the time to be allowed for the whole project, and the various stages within it
h Conservation
 Monitoring existing conditions, preliminary consideration of any special conservation provision
j Security
 Preliminary consideration of the level of security required, and the staffing, construction and equipment necessary
k Brief
 Findings incorporated into brief with which design team can start work

3 *First design ideas*
a Site survey + statutory and technical details obtained, e.g. air conditioning, fire regulations, electrical loading, means of escape
b Conservation and security requirements
c Preparation of sketch scheme, layout, disposition of objects, colour scheme. Graphic treatment of story-sketched out
d Presentation of scheme to those who need to give approval
e Approvals from 'client', fire officer, security officer, etc
f Confirmation of funding and budget

4 *Finalising the design*
 by this stage:
a Selection of objects finalised, all loans agreements concluded
b Script finalised
c Detailed working drawings of structure, cases, case-interiors. Details of electrical work, special effects (ready for tender if external firms used)
d Specification of finishes to appear in the exhibition
e Detailed layouts of texts and labels
f Prototypes constructed and tested
g Competitive estimates obtained, adjustments made to design
h Budget checks

5 *Production*
 Funds committed – all work in hand requiring supervision from the designer
a Building off and on site, case installation
b Electrical work, lighting
c Decoration
d Typesetting/artwork/photography/silkscreen printing and mounting all graphic work
e Object mounts
f Conservation completed: preparation of objects for display
g Testing: conservation conditions in gallery, security systems
h Dressing the exhibition
j Adjusting lighting, av effects etc
k Minor adjustments

6 *'Open to the public'*
a Previews for the press, private views, organisation of associated events, guided tours, lectures, etc
b Maintenance
c Observation/evaluation
d Photographic records

7 *Recording and dismantling*
a Pay invoices, final accounts
b Collect and process information, attendance figures, visitor surveys, press cuttings

c Hold post mortem with project team
d Complete records of the project
e Dismantle displays and restore exhibition site to original condition

Several other activities which may not involve the principal designer but which may involve other staff and other designers will run in parallel with these seven stages. These include the writing and production of the exhibition catalogue or souvenir publication, the production of postcards and the design and production of publicity material, ordering press photographs, the production of audio-visual programmes and arrangements for commissioning merchandise. The time-table for even a small, simply constructed exhibition might well need to incorporate these 'parallel' essential activities.

Sequence and timing

With the main stages established the next task is to list the numerous detailed activities to be carried out by each of the various team members in a logical sequence:

1 Check list of academic/curatorial staff activities
a Research into subject matter
b Draft exhibition 'synopsis' for discussion
c Selection of objects for display
d Locating suitable loan material
e Selection of objects for conservation
f Research into background information
g Compiling design brief
h Preparing script for editor
i Writing manuscript for catalogue text and captions
j Writing manuscript for object labels
k Selection of photographs for both catalogue and exhibition
l Writing manuscript for captions to photographs
m Proof reading catalogue
n Proof reading exhibition information copy
o Supervision of installation of exhibits
p Writing articles for learned/professional journals
q Compilation of academic records

2 The three-dimensional designer's activities
a Attend briefing meetings
b Compile the brief with the curator
c Background reading
d Site survey
e Examine objects and photos, assist in selection
f Draw objects to scale
g Draw preliminary sketch of layout for discussion
h Build model and test samples
i Check security and conservation
j Present scheme
k Prepare working drawings and write specification
l Build prototypes
m Organise tendering
n Agree and organise contract
o Monitor work on site

Check lists of other activities should be drawn up for other members of the team. After discussion all these activities can be given a time value:

e.g. photography for catalogue 10 days
 proof reading object-label copy 2 days
 preparation of working drawings 20 days

It is also essential to establish the details of other commitments and holiday plans of all the team members. The freelance designer may well

have other projects in hand and the subject specialist plans to join an archaeological dig on the other side of the world!

Priorities

The activities listed above, and many others, will all have different time scales, depending on the nature and complexity of a particular project. From these time scales will emerge an order of priority. The longest schedule must start first if the whole scheme is to be brought to a satisfactory conclusion. This is so obvious as to be easily ignored, and yet this interlocking of timing and priorities is at the very heart of the plan needed to create any exhibition.

Every aspect of the exhibition will have its own character and place in the scheme of things. Some contributions can be carried out independently without reference to others, and some (for example the way in which the various building trades have to follow one another on site) are highly dependent on the correct execution of what comes before and after. It is crucial that all this information be co-ordinated in a form which all the members of the team can understand.

The 'critical path'

System and procedure techniques borrowed from industry, such as CPA (Critical Path Analysis) and PERT (Programme Evaluation and Review Technique), can be useful management tools in the design and production of an exhibition where it is necessary to plan and schedule a series of inter-related, simultaneous and sequential events and provide simple visual documentation for all in the project team to follow. Properly employed, these techniques should result in the project being run efficiently, economically and effectively, without major crises!

While these techniques can be most complex and time-consuming (involving the use of computers if the project is to get Concorde off the ground or a motorway built) the basic principles can be applied to the work of an exhibition. Both systems use the concept of a network drawn to identify the individual activities involved in the project and showing how each activity depends on others. The network diagram shows the sequence of activities as well as those activities which are inter-related. The pattern will depend in each case on the tasks, resources and personnel involved.

The network diagram is intended, basically, to express processes in terms of time and it relates those processes which have different time scales. It may be possible to print a label overnight, but this helps not at all if the partition on which it is to be stuck takes four weeks to build. The various processes have to be threaded together into a number of sequences or 'paths'. A simple design sequence, in which none of the stages needs to overlap significantly with the others, could read:

suggestion–discussion–briefing–sketch design–
approval–final design–costing–authorisation–build

and in an ideal world each of these stages would be complete before the start of the next. From this it follows that the time taken for the whole operation can be discovered by adding together the time taken for each of the parts. This path is a straight line.

But more than one path has to be considered at the same time. For instance, the work of the three-dimensional designer may be separate from that of the graphic designer whose physical work may take more or less time, but who has to await copy to complete his designs. Nevertheless, the two- and three-dimensional paths have to be brought together so that information panels are available in the exhibition when there is a partition on which to hang them. The times on the paths will be recorded in days or weeks, depending upon the project, but one of the paths is 'the critical path' and that is the path where the various units of time added together produce the biggest total. If the length of this path is the one on

which the duration of the project is based, any delay in progress along this path can jeopardise the timetable for the whole project.

Progress checking

The success of this type of critical path planning depends on regular reviews of the progress of the project, the information on the network, and the time values put upon it; many 'critical path' planning diagrams fail because they do not take in a wide enough sweep of information, and therefore things that are not treated as central to the original plan appear to wreck it later. For example, if the case layout for an exhibition dictates the exhibit numbers in the printed catalogue, the time taken to print becomes of great interest, even to the three-dimensional designer!

6 Sites for exhibitions

The realities of the site

When student designers tackle exhibition subjects it is, reasonably
enough, made easier for them. Their college tutors will often provide the
ideal site for a hypothetical exhibition and the project is then 'tilted'
towards success. In reality the site for an exhibition is rarely helpful to the
professional designer, and on occasions verges on the impossible.

Most of our museum premises were built in the nineteenth century, a
few in the eighteenth, and even fewer in our own. Often they were created
for quite different purposes, and the interiors are likely to express a taste
and reflect ideas of society quite different from our own. The exhibition
and the building in which it is housed often have little or nothing in
common, yet the designer must somehow reconcile the two.

The architectural solution

The ideal setting for any exhibition must surely be in a building
specifically created for it. This permits an exact detailed arrangement of
the exhibition, the interior of the building and the siting of the building
itself, all complementing and expressing a specific collection. The last
decade has seen some notable new museum buildings. It has also
witnessed new extensions to existing buildings, and the conversion into
museums of buildings originally made for another purpose. Present
financial restrictions will make all of these less likely, especially new
buildings.

However permanent an exhibition may appear at the outset, the display
will change many times during the life of the building. Changes will occur
as collections grow, as the display appears old-fashioned, and as curators
change their view of the subject.

The site as exhibition

There are many instances where the actual site and the exhibition are one.
In open-air museums, such as those at Colonial Williamsburg in Virginia,
Ironbridge and Fishbourne, the designer starts with the original site,
enhances it, and works hard to prevent the information centres and the
notices that will steer the public around it from interfering with the
overall and original 'idea'.

The object as exhibition

The scale of some objects is so great that a single object may form an
exhibition in itself, and the designer and architect then have to
manipulate the visitors through viewing areas to vantage points around
and even through the object. Accompanying information has to be
deployed to match the points being made, but the scale will produce
particular design problems. A label or information panel may need to be
almost the size of a hoarding in the open! Some large objects, such as the
aircraft at the outstation of the Imperial War Museum at Duxford,
Cambridge, and the SS *Great Britain*, back in the dock at Bristol, where it

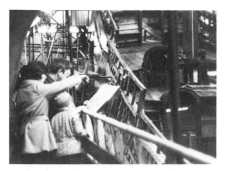

Giant exhibit as exhibition. Visitors view
the ship's structure, and continuing
conservation treatment, from several
levels. Information is placed at strategic
points, relics and artefacts are displayed
elsewhere.
The Wasa Museum, Stockholm

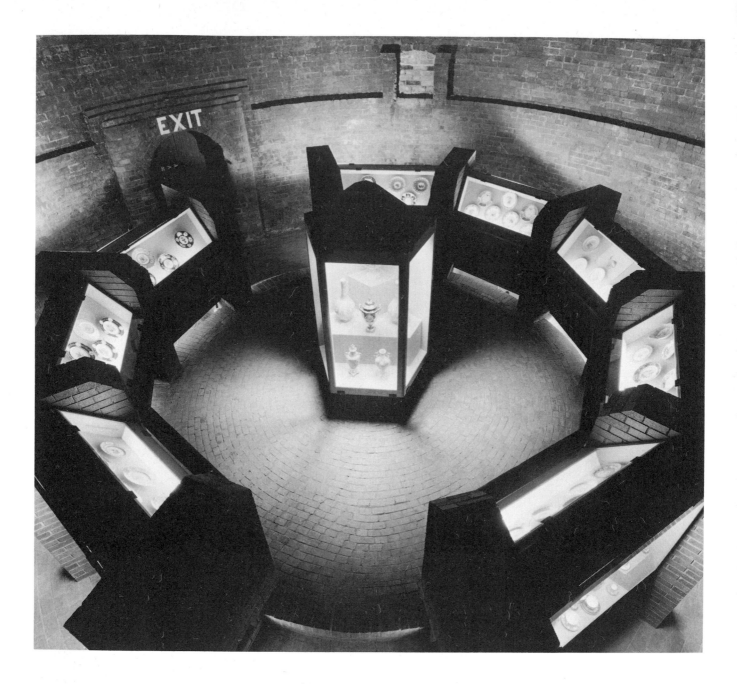

Significant site. The kiln shape is echoed in showcases of ceramics. Case divisions match the brick walls. The subject is both housed and symbolised.
Coalport China Works, Ironbridge Gorge Museum
Design: Robin Wade Design Associates

was built are without protective buildings. But both the *Wasa* in Stockholm and the *Mary Rose* at Portsmouth are confined within purpose-built structures, at first temporary then permanent. The problems of scale, however, remain and the designer is still concerned with organising the routes 'within the object'.

The setting helps

There may be strong cultural and historical reasons why the setting should be reflected in some way in the exhibition. In many fairly permanent and even temporary exhibitions the designer's brief may include the instruction that the architecture of the surrounding gallery must be retained at all costs. Where this architecture is in keeping with the material on display, either by date or style, the designers can find themselves positively advantaged. But the task will be quite sophisticated, since the architectural background and the exhibition have in such instances to be designed as a single entity.

The setting hinders

It is wise for designers to assume that on most occasions they will need to design their exhibitions to fit within unsuitable and unsympathetic

This site gives drama as well as security.
Set in dungeons, precious objects in
glass-topped cases are lit from a
'candelabra' of spotlights.
The Royal Treasury, Stockholm

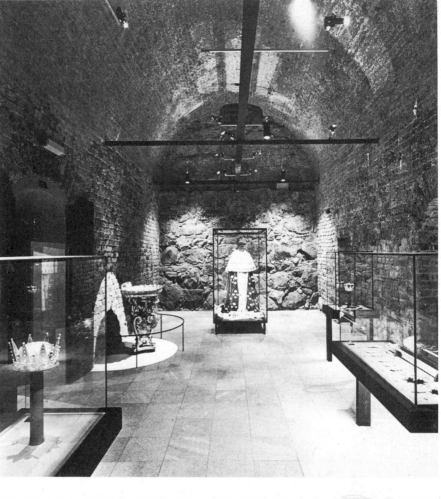

Actuality. The site as exhibition. Under
Whitehall, Churchill's wartime
headquarters: small rooms, narrow
corridors and original furnishings.
The Cabinet War Rooms, London
Design: Gordon Bowyer and Partners
(in association with Alan Irvine)

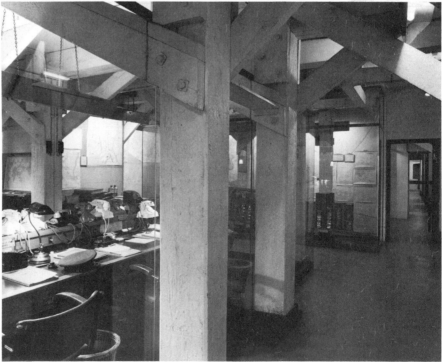

surroundings. In some cases, the surroundings may even actively distract
from the exhibition. Design skills alone may not solve the problem, and a
series of conjuring tricks will then be required.

One obvious solution, often employed, is that of screening the exhibition
totally from its surroundings so that the contents and the interior of the
building which houses them are never seen at the same time: the 'room-
within-a-room' treatment. But funds will not always permit this solution.

A 'shop window' for a museum. A bank lends a window, providing an unusual setting for ethnographical material, which publicises the museum nearby. Midland Bank, London

Organised distraction is another way of overcoming the conflict, in situations where the components of the exhibition are so strongly formed, coloured, or illuminated that attention is virtually removed from the shell of the gallery.

Unlikely settings

One method of attracting new visitors to the museum or art gallery is to mount a display of museum objects at an unusual venue: a bank, a railway station or an airport lounge. The designer has to turn the unusual 'atmosphere' in which the display is laid out to advantage.

The outstation exhibition is to act as an 'appetiser' or 'trailer' to that in the museum itself, and the contrast with the surroundings will attract initial attention. Such displays give rise to a particular information problem. It is no use urging people to find their way to the 'parent' exhibition from the temporary outstation display if they are not told how it can be done!

The temporary exhibition gallery

Many museums have found it practical to set aside special rooms to house their temporary exhibitions. Sometimes these consist of a single gallery, with no merit for this particular purpose other than that it can be made empty at the right time. Sometimes the temporary exhibition gallery will be quite sophisticated, designed and equipped to provide infinite flexibility. The designers of the exhibition may have at their disposal exhibition display systems, a coordinated system of partitions, modular cases, lights and a ceiling grid to support them.

The temporary exhibition gallery: what is needed

It is perhaps useful at this point to list the ideal requirements for a gallery specifically intended to house temporary exhibitions differing widely in all respects. Sometimes the designer will be fortunate enough to take part in the creation of such a new space.

Siting and public access
The temporary exhibition gallery should be positioned as close as possible to the main entrance of the museum, for a long journey through other galleries displaying other cultures may weaken visitors' appetite for a

Settings can compete – the hall by Inigo Jones. Drawings and prints could have been overpowered, so a tented 'room within a room' contains the display. *The King's Arcadia*, The Banqueting House, London
Design: Michael Brawne & Associates

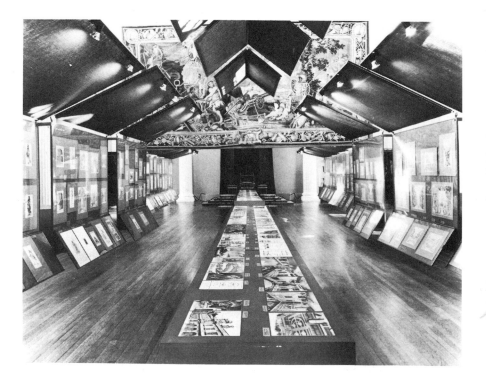

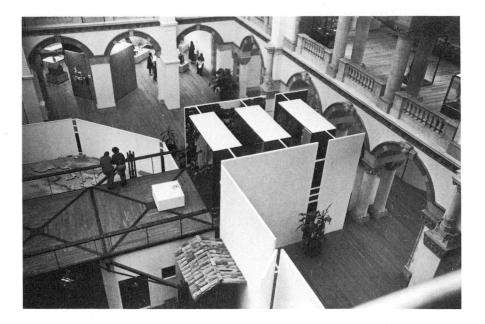

Levels. A choice of viewing angles from surrounding galleries. Sections of the centre-well temporary exhibition area can be 'winched' up or down.
Museum of the Tropics, Amsterdam.

special exhibition. Extended public viewing and functions outside normal hours will be made easier by a separate street entrance, security permitting.

Cloakrooms and lavatories
These should be within close proximity to the exhibition gallery.

Ticket and catalogue sales-points
These must be sited to service the entrance to the exhibition, with storage space for an adequate supply of catalogues. A sales area in the exhibition is desirable; alternatively the gallery should be within easy access of an existing museum shop.

Receptions, opening ceremonies
Such events may best be held in an anteroom if available.

The disabled
Lifts or ramps should be provided instead of steps.

Office space
This should be adjacent to the site for staff manning an exhibition which has an admission charge.

Workshop access
Those building, servicing and dressing the exhibition must have clear, wide access to the gallery. There must also be provision for deliveries of construction materials and loan material in large crates from the street.

The gallery
This should be as large as possible, free of columns, and in the case of displays of mosaics, carpets and tiles with sufficient height to allow for a balcony. The architecture should be as anonymous and colourless as possible, the style and colour coming from the exhibition itself. But this sentiment often does not appeal to architects!

The floor loading
Capacity must be as high as is feasible. The exhibitions may include very heavy items, and with luck there will also be the weight of large numbers of visitors.

Environmental conditions
It must be possible to exclude daylight from the gallery to permit the display of material extremely sensitive to light. Some material will be on loan, some of it vulnerable, and stringent conditions may be imposed for its conservation. Full air-conditioning and control of humidity are required for organic material, excavated metals, etc.

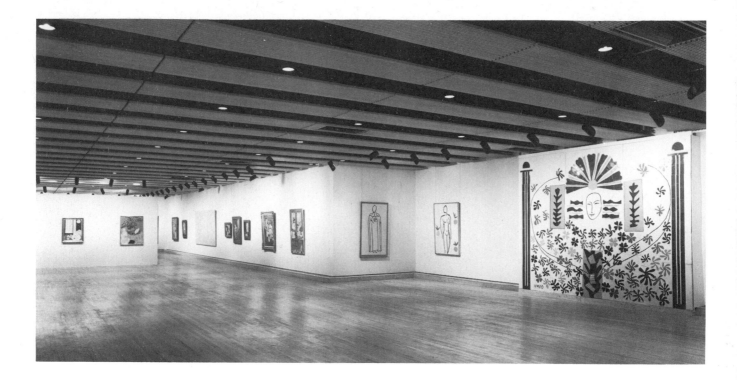

A 'black box'. Dark ceiling and movable screens give designers complete control of lighting effects for temporary exhibitions: in this instance, downlighting and spotlights from ceiling tracks.
Matisse, Hayward Gallery, London

The lighting and electrical system

This must, for conservation reasons, be completely and accurately controlled. There should be at least three independent systems installed in any exhibition gallery (1) working lights for use during installation, cleaning, maintenance, dismantling, and security patrols after opening hours; (2) emergency lighting to enable visitors to leave safely in case of failure of the main lighting supply, and (3) the display lighting system which should be fitted wherever possible with dimming devices.

The designer will wish to be able to deploy his light throughout the whole volume of the gallery and most temporary exhibition galleries are now fitted with a universal track system into which a variety of fittings can be attached. A grid of power sockets around the walls and floor will be required for lighting display cases, for power tools during construction and for cleaning equipment.

Security

An alarm system is essential for all windows, rooflights and doors. This system should be suitable for incorporation into the grid for electrical sockets in the walls and floors.

TV Monitors

Electrical channels should always be planned generously to take extra circuits in the future. Those carrying the wiring to power points, lighting and alarm systems should also be wired (or should allow for wiring) for co-axial cables for security TV cameras and monitors. Such cables can be used also for TV displays as a feature of the exhibition.

Public address system

Very desirable in the special exhibition gallery, where possible this should be linked with a public address system used in the rest of the building.

Fire detection warning devices

Smoke and heat detectors (sprinklers are quite unsuitable as water can cause far more damage than fire!), public alarms and fire fighting equipment will be needed in the gallery. Fire exits will be mandatory.

Floor, wall and ceiling fixing points

These are desirable, so that cases and even objects themselves, can be attached without any need for repair or redecoration between exhibitions.

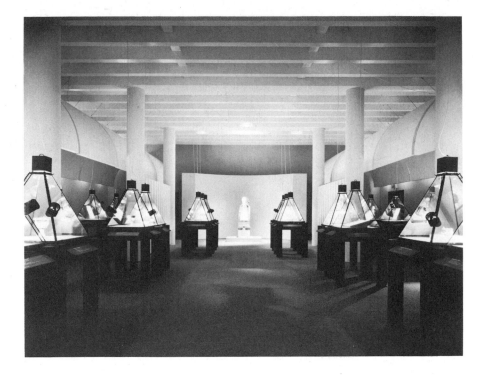

Adaptability. Temporary exhibition gallery, in which there are fixing points for suspended ceilings, and electrical tracks feeding showcase lighting (this symmetrical exhibition balances structural columns, left, with false, right). *Treasury of San Marco*, British Museum, London
Installation Design: Alan Irvine; Cases: Mario Bellini

This arrangement will dictate a module for spacing the fixing points, and the ceiling attachment points will also, of course, have to be on the same, (or a compatible) modular grid.

Finishes

On the walls and floor, finishes should be as hardwearing, as easily cleaned, and as neutral as possible, and be able to support cladding or take different coverings. Even a semi-permanent finish can be varied by using cladding on certain areas of the walls, and various sheet material, including carpet tiles, on the floor. The maintenance budget must include provision for periodic redecoration.

Users' Manuals

If prepared for a particular exhibition gallery, manuals will save a lot of time and expense. Museum staff, outside consultants and designers, change from time to time, and museums sometimes lend or let a gallery to an outside body. Incomers should be able to utilise the premises fully without taking up staff time with queries. Detailed particulars of the gallery, such as dimensions, floorloading, lighting systems and switching procedures should be included in the users' service manual, together with names and phone numbers of key staff, suppliers, and external services in regular use.

7 The design brief

From discussion to guidelines

A brief for an exhibition is a starting-point for the design process. It is the culmination of the first stage of work on an exhibition, the outcome of the dialogue between the curator and the designer, of the consideration, discussion and agreement between all the parties involved. The brief is best incorporated in a position paper which sets out what the initiators have in mind. It must take the form of a written document which can be referred to throughout the project; indeed, subsequent action and developments should be checked against the original document to ensure there is no deviation from the original criteria or, if there is, that it is agreed to by all involved. The brief should make clear on what assumptions the initiator is making the propositions, since the avoidance of misunderstanding is essential.

It may well be necessary for the designer to assist in drawing up the brief or to formalise it after discussion. While the designer may be skilled in translating requirements into reality from a tight brief there is much that he can contribute to the actual brief itself. He needs a firm brief for his work, if only in self-defence.

Defining objectives

The brief should summarise the aim, state the theme, and describe the purpose and nature of the exhibition. It should make clear how the project in hand relates to other exhibitions and the overall strategy of presentation (if it exists) of the institution. For instance, it might be one of a series of exhibitions and should therefore be linked stylistically to earlier projects or be related to existing exhibitions in adjoining galleries.

The objectives, in terms of the intended visitor, should be defined and answers should be sought to the question, 'specifically what do you want whom to do, know or feel after seeing the exhibit that they could not do, know or feel before seeing the exhibit?' (H.H. Shettel, 1965)

The target audience should be identified as far as possible, for the design solutions for the academic specialist, the foreign tourist, the casual visitor, the disabled, the student, or the school child may differ. Information on the probable level of audience and the likely attendance, adjusted for seasonal variations will need to be assembled from data collected from earlier exhibitions.

If the proposed exhibition is to have a strong educational element very detailed information will be needed on the 'goals' the visitor should achieve, and the steps by which he or she attains these goals should be made clear to the designer in the briefing document.

Some museums, principally scientific institutions, have attempted to develop a system of precise evaluation of the behaviour of museum exhibition audiences, and of the planning and design implications of their findings (see also pages 116–118). Evaluation requires evidence and if the evaluator in the project team plans to use the exhibition as a vehicle for research, the designer will need to know the experiments to which the

finished exhibition is to be subjected, in order to make provision for
recording cameras, etc.

The substance of exhibitions

The designer will need detailed information on the proposed contents of
the exhibition. This could take the form of a draft script, a preliminary
story with ideas on how it could be illustrated by objects, photos, etc.
Alternatively, if the exhibition does not have a strongly stated story,
details of the contents might simply be listed in chronological order or
under broad headings by type or materials.

Precise details of each object must be made available early on. It may be
that the designer will not have ready access to the objects themselves, in
which instance photographs of each object, with dimensions, are essential.
Dimensions should be expressed in a uniform way; height times width
times depth, or diameter. Where objects might cause a floor- or shelf-
loading problem the weight should also be stated. Space is a problem in
most exhibitions, and at the start of a project there is often an unrealistic
view of how much material will fit in. It is therefore helpful to group
objects under three headings: essential objects, objects desirable but not
essential, and 'gap fillers'.

At the outset the designer will also need to know which of the objects
might pose special display problems connected with conservation, the
need for special lighting, or security.

Hard facts and figures

At the briefing stage details of the exhibition site and its services must be
available, or, in the case of travelling exhibitions, the various likely sites
with details of the space available. Problems of site access for large
exhibits, contractor's vans or disabled visitors must be known in advance.

Public safety and fire regulations governing the use of the exhibition
gallery must be included in the briefing document. The level of security
required by the museum must be understood by the designer. The opening
date and duration of the exhibition must be fixed since this will affect the
choice of materials, finishes and methods of construction the designer
employs. The designer will need to design a given life into the exhibition.

The future of the exhibition should also be established: perhaps the
construction can be adapted, and, with minor alterations, display a totally
different subject or perhaps it could be converted into a travelling
exhibition.

The time the average visitor is intended to stay in the exhibition should
be estimated. This can be crucial if the project is a commercial one and a
precise 'turnover' is required. In other instances, the exhibition may be
part of another activity such as a visitor centre where the aim is to induce
the visitor to move on to other attractions.

The designer needs to know the budget available for the exhibition and
exactly what items the organisers intend this to cover (see appendix 2). A
seemingly generous budget can quickly shrink if it transpires that the cost
of insurance, transport or publicity also comes out of what was thought to
be the installation and maintenance budget. (It would be wise to allow a
small percentage of each section of the budget to cover unforeseen
contingencies).

Extending the message

The designer also needs to know whether the organisers intend to charge
for admission, plan to sell catalogues, other publications, postcards or
souvenirs in or adjacent to the exhibition, and whether his remit includes
the design of the sales counters and ticket-dispensing points. The nature of
the catalogue sold at an exhibition entrance can affect the rate of flow of
visitors through the exhibition. If it is undesirable for visitors to pause to
read catalogue information – either because there is a target attendance to

be achieved, or because for conservation reasons lighting is too low for reading – a souvenir publication may be more desirable. The general budget for publicity should be known, and whether the design of posters forms part of the design brief.

In the event of a large publicity budget, the exhibition might attract more visitors than the space can comfortably accommodate. Similarly, plans for the opening and associated events should be outlined at this early stage. Either the layout of an exhibition must be capable of receiving large crowds for opening receptions, of school parties for lectures, or these events must be tailored to fit the space available.

Incorporating revisions

All involved need to know the rules of the game before the designer gets near the drawing-board. The brief enables all the members of the team, all their aims, goals and aspirations and all the constraints of the project to come together and be recognised. The importance of the brief, and the need for its subsequent refinement, means that some considerable time must be allowed within the overall schedule for the revision. The brief should be at the designer's side for the duration of the project, as his bible. Any minor modifications to the requirements must, of course, be noted and dated on the original brief, although every alteration to the brief after serious design has begun is dangerous, time-consuming, and often expensive. As the project progresses, members of the team would be well advised to turn back to their original brief from time to time to ensure that, if there have been deviations, these are all agreed and are to the benefit of the end product.

Major revisions sometimes cannot be avoided. Although the normal emphasis must be on sticking to the original brief, occasionally 'circumstances alter cases'. Any revisions that arise have to be as carefully agreed and recorded as the original decisions.

8 The shaping of communications

Inform, educate, and entertain

The aim of most 'cultural' exhibitions is to educate as well as to entertain. The selected objects will be accompanied by explanation, although this will not always be in the form of the printed word alone. But the total effect will be that of a thesis, a statement of some sort, much more than merely a collection of objects.

The curator is a 'presenter', comparable to the 'presenter' in a TV programme. The objects that he is exhibiting may have a number of aspects, but in an exhibition he is using them to make a series of points. The objects may be virtually eternal, but a particular person is saying a particular thing about them at a particular time.

The right medium?

The exhibition form is one of a number of 'mass media' possibilities and if certain merits are claimed for it, it also has certain limitations. Someone must be brave enough to ask of the subject 'Is it an exhibition at all?' Many exhibitions are unsuccessful because their audience, material and style call primarily for a television programme or a book. Why should one ask visitors to read a book which has been pinned on a gallery wall? 'The most experienced designers of exhibitions contribute by what they insist must be left out, or taken elsewhere', as James Gardiner observes.

The visitors: whom do we expect?

There must be an agreed set of assumptions about the audience that is being addressed. Moreover, to make the 'thesis' clear to the intended audience, the material must be manipulated, expanded, condensed, and highlighted; in a word edited.

The subject specialist may not have the ability, time or inclination for such carpentry of the text. It may be better to introduce an independent, impartial editor or scriptwriter, but whoever does the work it forms an essential part of an exhibition. No visual attractions will make the exhibition work if the elements are in the wrong place, or explained in the wrong language, or even in too much of the right language!

The editor: making sense of it

Irrespective of who performs the function of editor, what exactly must the editor do? He must be active in three areas of decision. First, in encapsulating the initial idea. Someone is going to be addressed on something at some length by some means at some time and in some place. This information, when decided and incorporated in the brief for the project, provides the framework within which the whole team is going to work. This is the exhibition proposal.

Second, the editor will help identify the objects chosen to tell the story, decide the order in which they can be made to tell it, and what chunks of information have to be interpolated or attached to make sense to the intended audience. The sequence is extremely important. The objects and

a

18th century

Cook's early life

Preparation for the voyage

Quest for knowledge

1st Voyage

Cape Horn

Society Islands

New Zealand

Australia

Return to London

b

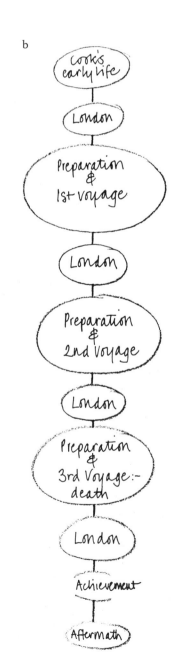

Cook's early life

London

Preparation & 1st voyage

London

Preparation & 2nd Voyage

London

Preparation & 3rd Voyage:- death

London

Achievement

Aftermath

c

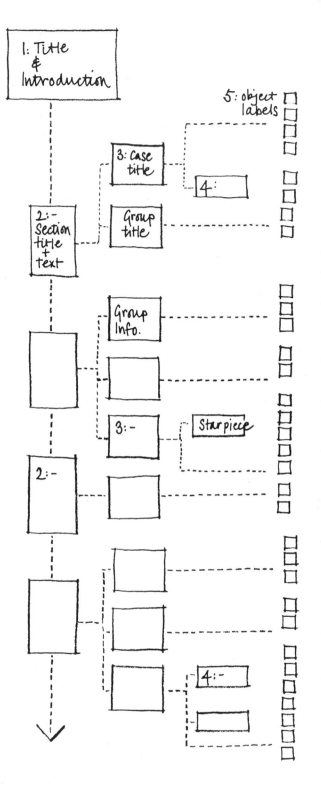

1: Title & Introduction

5: object labels

3: Case title

4:

2:- Section title + text

Group title

Group Info.

3:-

Starpiece

2:-

4:-

Structuring information:
a) Ideas 'mapped' for planning an exhibition on Captain Cook
b) The linear 'bead' treatment evolved for *Captain Cook in the South Seas*
c) A scheme for setting out information at appropriate levels on a five-point scale.

the items of information function as 'beads' in the story, and while the arrangement may be flexible and open, perhaps like a mosaic, the beads have to be assembled in a particular order, as an expression of the whole strategy adopted. And the strategy is, after all, one designed to move the visitors forward. Will they understand what to do at each section and each junction of the story? Will they find their way through the exhibition and out to the ancillary delights? At each stage the text will have to nudge the visitor forward.

The conclusion of this second editorial task, that of arriving at the strategy or structure of information, can best be incorporated in a diagram. The basic organisation of the exhibition now begins to resemble a plumbing diagram. The original notion for the exhibition has begun to turn into a machine.

The third stage will begin to involve language; the storyline of the exhibition will begin to use the very words which will finally appear on information panels and labels.

The exhibition script

When it takes the form of a script, the exhibition strategy borrows the techniques of the theatre, film or TV. But the dynamics are different. Instead of the material travelling past the onlooker at a set pace, in an exhibition the onlooker travels past or through the material at his own pace. Furthermore, whereas a TV programme is linear (the material arrives item by item in a fixed sequence, the only scope for the viewer to disrupt the sequence being inattention) the exhibition can offer alternatives at different levels, in different styles. To the linear technique of the TV programme has been added elements of the supermarket and department store.

'Levels' of information

Exhibitions frequently use a 'tiered' system of information to take account of many different levels of need. One visitor will need help in locating a continent while another seeks to identify an obscure tribal region. This reflects the technique of the newspaper, passing from headline through a brief summary to detailed information. And as in the case of the newspaper, the text of the exhibition can also be 'tiered' by its typographical style. Another analogy would be the three lanes of a motorway, which permit and encourage different speeds of travel, though the motorist is free to move from lane to lane, to overtake or even to stop on the hard shoulder.

Labelling the objects

The third editorial task is the writing and detailed editing of the case and object labels. The text has to be clear and minimal. The label-reader is not a captive, and the label-writer has to hold his reader's attention in the face of distractions from other exhibits and other visitors.

Deciding the content of the labels involves more than a matter of style; it stems from the basic strategy of the exhibition itself. Each object, left to itself, is an enigma. Somewhere, at some time, the viewer must be given information to fit the object into the 'story'. But is this information about the objects to be grouped together in a catalogue or handlist, or attached, as labels, to the objects themselves? Or is it to be divided, on some logical principle, between the two?

This decision will have to be made at an early stage in the project since it will dictate the role of the printed word in making the exhibition intelligible. It will also affect the designer's placing and grouping of every object. It might also need to form part of wider policy considerations, relating to the house style of the institution concerned.

The designer often has to explain certain typographical facts of life to the subject expert: to be legible the type used on the label must be set to an

optimum size; the more that has to be said on a label, the bigger that label must be; if it exceeds a certain size the label will run the risk of becoming an exhibit in itself, competing with others, disrupting the arrangement of cases, and turning the less scholarly visitor away altogether. In this area the role of the editor working with the designer is vital. Every word that can be deleted from a label, without making nonsense of it, edges the exhibition nearer to success.

The visitor to any exhibition arrives with certain expectations as to how he will be addressed. He reads newspapers, books, posters, charts, handbooks. All of these try to proceed by logical steps, with material sorted into levels of importance. All of them attempt a certain consistency of style. The visitor will transfer all these expectations to the museum exhibition. He wants to be told what to do to get the most out of his visit; he will learn the pattern of instruction, and will then expect it to be consistent.

Memory and the label: the load on the visitor

The planning of the relationship between an object and the text to which it relates is critically important. It depends upon the amount that the expected visitors can be expected to digest in a short time. The visitor has to use short-term memory taking things from one position to the next.

The object exhibited (or an illustration substituted for it) and the explanatory text about it may be in two different places. Even if the two are fairly close together they will seldom be taken in at a single glance. Thus the appearance of the object has to be memorised, the head turned to find and read the relevant text (or, of course, vice versa) and then the two have to be compared.

If this matching process is successfully accomplished the two elements of actuality and language are welded together in the mind of the viewer into a single unit of verified experience. This verified unit may then be further memorised and taken forward as the visitor proceeds to the next exhibit in the sequence to be 'understood'. The verified piece of memory has to be held, as it were, while the process is repeated again and again, as each exhibit and explanation are matched and welded together.

If matching does not take place, a single failure in an extended sequence is unlikely to deter the keen student. However, repeated difficulties are likely to cause the abandonment of the whole sequence, and the 'story' is lost. If this model is correct the first requirement (after making certain that the object can be fully seen and studied) is that the 'chunks' of text are of a clarity and length which makes them 'memorable' for the duration of the matching process.

The style of successful exhibitions would suggest that graphic designers and editors have found that between eighty and one hundred words of refined text appear to work well for general information but possibly less than that for explanation of an object. Controlled experiments might well yield something much more precise than such a rule of thumb. However, it is clear that text lengths which are substantially in excess of this figure are not fully read by the majority of visitors.

The labels themselves must be consistent internally. The visitor will move from a direct sight of the object to the opening words of the label. If he has seen a pot, he will look for a label about a pot, will then move forward to consider the information it contains – what the object is made of, by whom, and where. All this is the proper business of the label. But what of interpretation? Is the label the right place to compare a specific object with others elsewhere? Is it proper for the label to consider the 'meaning' of the object in a wider context? These are questions which each exhibition team has to decide for itself.

Time: the designer's fourth dimension

Many exhibitions have failed by ignoring, at the planning stage, the viewing and reading time that they will require. The time that visitors spend will depend on a variety of factors: their interest in the subject, their capacity for study, and the intervals between the buses taking them home. But whether they progress through the exhibition in the slow, medium or fast lane, they will decide individually how long they spend there. The material that the museum wishes to expose cannot dictate their pace, although the designer can motivate them to a certain extent by introducing techniques of pacing. As the text is being prepared, it is worth considering the time factor; if visitors were to read every word on every label, how long would it take them? And if this seems an inordinate time, which facts and words are redundant?

The text may well have to serve a number of routes. If the exhibition has more than one entrance it must still make sense when entered from any one of these. This may be in conflict with the editorial principle already stated but there are times when texts have to be duplicated and overlapped.

In the exhibition context, editing can never be separated from design. As the text and underlying strategy change so will the appearance; designer and editor have to learn to think as one. The editor is there to help the designer handle the vital fourth dimension: time.

9 Exhibition security

Priceless objects

The contents of museum exhibitions are not only extremely valuable but the objects are usually unique and virtually irreplaceable. They must be protected from theft, wilful and accidental damage by the public, and from fire. The exhibition designer must be aware of security problems at all stages of the project, from the brief until the exhibition is safely dismantled.

The experts' requirements

Advice and guidance must be sought from both the organisation's security adviser and fire officer when the design brief is being prepared. The responsibility for the overall security of the building in which the exhibition is held should rest with the security officer or adviser, and he will scrutinise any additions or alterations to the building suggested by the designer which might affect the outer security perimeter, e.g. doors and windows.The proposed exhibition layout and the construction details of cases must be approved before work begins and formal inspection of the exhibition installation should take place before the opening, so that any minor modifications can be made before the public are admitted. All materials used in the construction of the exhibition must be fireproofed.

Security starts in the office

Administration of the design project should also reflect the need for security. Complete lists of all the objects, together with the identifying photos, must be kept at all stages, and amendments to the content of the exhibition carefully noted. The designer should also be aware of the dangers of including descriptive detailed information about security systems in correspondence or on drawings which might be freely circulated. Each museum will have its own security procedures concerning access to the exhibition site by contractors and sub-contractors, and the designer and/or organiser must include these conditions as part of the contract for the construction of the exhibition.

Preventing theft and damage

Within the building, the public will probably be confronted by regulations which will affect their conduct during their visit to the exhibition. They should be told what they can or cannot do by signs and notices which must be compiled and designed so as to be clearly visible and comprehensible. These 'instructions for use' will be backed up by further smaller signs within an exhibition, reminding and emphasising, for instance, that free-standing objects must neither be touched nor sat upon. While these are management requirements the designer will still be involved in their implementation.

Regulations for the public

Visitors should not be allowed to take bulky coats or mackintoshes into a crowded exhibition. They will tire more quickly, take up more room, and there is the risk of camouflaging attempted pilfering or accidentally damaging objects on open display. The signs and notices should direct visitors to a cloakroom where coats and cases can be left.

The warders' part

The plan of the exhibition must be drawn up with security requirements to the fore. The warders, or guards, in an exhibition are probably the most effective deterrent to unruly behaviour. They will need to patrol the exhibition from strategic points, and the number of warders available and desirable will have to be agreed with the security adviser in the early stages. The actual method of display, whether the objects can be on open display or in cases, can on occasion be dictated solely by the availability of warders. It is important to remember that the keenest warder cannot see through solid objects, nor be in two places at once.

A good exhibition plan must be 'wardable'. The physical arrangement of cases, screens and solid divisions in an exhibition must be considered in relation to the value and nature of the collection and the supervision of the warders. Display treatments which provide a low level of illumination, intimate alcoves, or deep shadows could conceal the activities of those who might damage the objects or deface the exhibition structure.

Untouchable. A glass sheet, held by spacer bolts, protects ceramic panel suspended over table cases (keeping the visitor from the exhibit without the expense of a showcase).
Fernand Léger Museum, Bîot, France

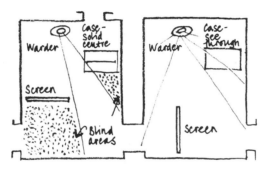

Room planning: areas of poor visibility, 'masked' to a warder in a fixed position, are contrasted with an improved arrangement in which most areas of the room are visible.

Below left:
See-through gaps provide clear views for warders. Visitors can appreciate extent of exhibition and compare distant objects with closer ones.
In Praise of America, National Gallery of Art, Washington

Below right:
Gangway. Textiles hang freely, out of reach, on either side, the public being allowed only in a central 'walkway'.
African Textiles and Decorative Arts, Museum of Modern Art, New York

Barriers

In one type of exhibition, termed a simulation, if the objects do not present a conservation problem, the designer and curator might well want to avoid any barriers between the public and the exhibit. With adequate invigilation, it might be possible to allow visitors to walk through an open display. It should be borne in mind, however, that the appearance of uniformed warders in the middle of the reconstruction of, say, a Bedouin camp can be incongruous, destroying the atmosphere so carefully created.

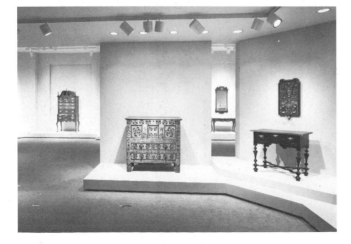

Barriers to distance the public from
exhibits – at waist height and shin or
thigh height.

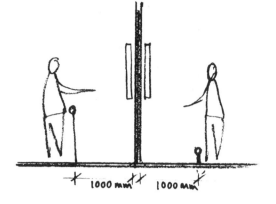

Another type of deterrent for use in open displays is primarily a
psychological barrier, designed to be unobtrusive, and which should
preferably be in keeping with the subject matter. The purpose is to
indicate to the visitors a 'no-go' or 'do not touch' area, and trust them to
respect the limitation.

This can be a simple rope or bar between uprights; or an area of pebbles
or gravel which will 'scrunch' if the notional barrier is violated.
Alternatively, objects can be set back on a plinth where they cannot be
accidentally kicked. Higher than the visitor, they will be more easily
visible, and, in a reconstruction, the plinth can be 'realistically' treated as
part of the whole scene.

Substantial barriers can be designed with more than one function. If a
barrier rail is at a suitable height it can also be leant upon by tired
visitors, or the rail can be mounted lower to act as a support for
information panels or for a number of dispensers of information leaflets
and maps. Thus treated, the prime security requirement will not be so
obvious to the visitor.

Expendable objects

Many museums cater for large numbers of children who are always eager
to touch as well as to see. The designer may well cater for this by
allocating a few objects or replicas which can be touched or even climbed
upon. These 'sacrificial objects' may be enough to exhaust high spirits,
discourage vandalism elsewhere, and this will certainly encourage
participation by the audience. But the articles must be hardy and well-
anchored.

Below left:
Uncertain foothold. Most plinths deter,
but add loose chippings and visitors are
more reluctant to set foot for fear of
detection.
The Splendors of Dresden, National
Gallery of Art, Washington

Below right:
Symbolic barrier ignored. Controlling the
very young is difficult. Here the exhibit is
tempting, the slope gentle and the barrier
rail inviting!
Origin of the Species, Natural History
Museum, London

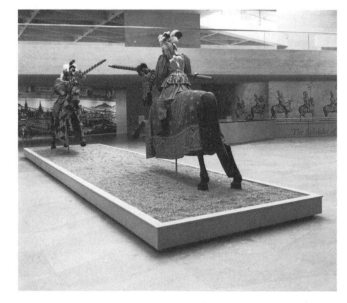

Overt security devices

An effective psychological deterrent to bad behaviour is to display the security devices prominently, as part of the design. To enter an exhibition of, say, valuable jewellery through what amounts to a strong-room door enhances the preciousness of the exhibits, and the privilege of seeing them. The security is not a reproach to the visitor, rather an enhancement of the occasion.

Of course open displays with barriers should be 'warded' as well, particularly if valuable material is included.

Mechanical and electrical devices

In most instances the curator and security adviser are likely to require that most of the objects be displayed in cases. Although a certain degree of security can be provided in temporary exhibitions, by screwing up cases after the objects have been arranged in them, there are good reasons for using the same traditional methods for temporary exhibitions as those employed for permanent displays, that is to say strong materials and high quality locks. It must be remembered that conservation staff may need regular access to check on the state of the objects, and speedy access will certainly be required for removal in the event of fire.

Sadly, vandalism has always to be taken into account, and shatterproof glass and Perspex should always be considered for casing objects of great value and those of a politically sensitive nature.

Covert protection. Visitors can be unaware of barriers. The solid, angled information panels (structured from workshops materials to fit the museum) protect exhibits unobtrusively. Coalbrookdale, Ironbridge Gorge Museum

Expendable props. The raised stone step indicates a 'no-go' area in this reconstructed *suq*, but the baskets and their contents are replaceable. *Nomad and City*, Museum of Mankind, London

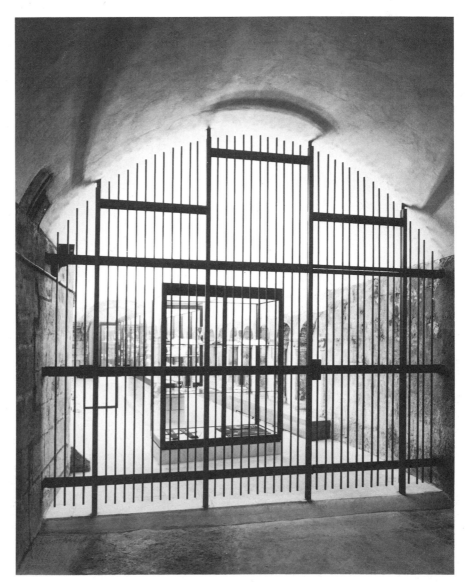

Functional symbol. During opening hours the specially designed grille provides overt security increasing anticipation, and signalling the importance of the collection. At night it protects it. The Treasury, Gloucester Cathedral Design: Gordon Bowyer and Partners

In such situations security can well be increased by mechanical and electrical devices. The designer should be briefed by the security adviser, backed up by the specialist firms, and provision for these devices must be made in the layout of the exhibition.

Ideally, electronic security equipment should be planned into any new museum building or gallery in such a way that the whole installation is virtually invisible. At the heart of such a basic installation, and its extension to each gallery, exhibition and case, there would be a clear security policy for the individual institution. The designer cannot be responsible for prescribing from the enormous number of sophisticated mechanical and electronic devices available. What he must do is to see that each layout and case specification meets the level of security demanded by the organisation that he serves, and this means close liaison with the security specialists, whose prime responsibility it is.

10 Conservation in the exhibition

Risks

Everything, from the moment of its birth or construction, deteriorates; particularly organic materials, though even metal and stone deteriorate. One of the main functions of a museum is to conserve its collections, so that works of art, artefacts and natural history specimens will last indefinitely. Stored undisturbed in controlled conditions there is every possibility of such indefinite preservation. However, two other functions of a museum are to study and display collections and this is to expose objects to the risk of deterioration.

Objects displayed to the public are exposed to many dangerous elements which might not be immediately obvious: light, heat and humidity, pollution in the atmosphere, attacks by insects and bacteria, the chemical effects of adjacent materials, theft, wilful damage and accidental damage by fire and flooding. There are additional risks when objects form a travelling exhibition or are loaned to exhibitions in other places.

The conservators' responsibilities

In order that the public may enjoy the delights of an exhibition without detriment to the objects on display, the exhibition must be designed for conservation. This is one of the areas where the designer will rely on expert advice from an essential member of the exhibition team, the conservator, who has to find a point of balance between the desired maximum exposure on exhibition and the minimum risk of deterioration for the object.

Two points of view are in potential conflict here; the wish to preserve the objects for ever, and the wish to show them as fully as possible to as many people as possible. The conservator has the unenviable task of advising on the best course to take.

While the designer should be aware of the general criteria for conservation of various types of material while on display, he must rely initially on the curator and conservator to identify specific objects in a list of proposed exhibits which will require special, stringent conditions for display. The conservator should specify at the briefing stage, in detailed physical terms, the characteristics of an acceptable environment; and he should provide the designer with information, if it is available, on existing conditions at the proposed exhibition site. At the preliminary design stage he may be able to forecast the expected conditions in the exhibition, with the installation proposed and the anticipated level of visitors, and he should then recommend the conditions required so that specialist engineers can specify suitable equipment, if it is necessary, to modify the predicted conditions to result in an acceptable environment. The conservator may also be responsible for testing and maintaining equipment throughout the duration of the exhibition.

Controlling light

The designer must be able to control the lighting in an exhibition to meet the conservator's criteria, even though on occasions it might appear far

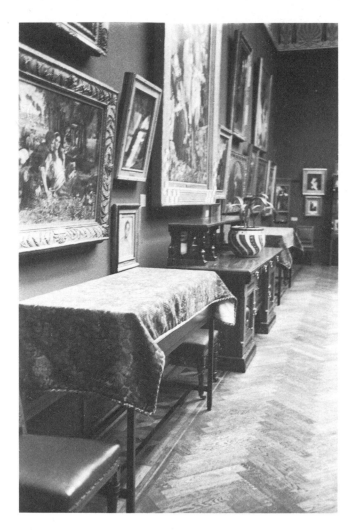

Above left:
Vernacular protection. If objects –
watercolours, manuscripts, textiles – are
sensitive to light, it is natural to cover
them with a cloth. Quite traditional and
appropriate here.
City Art Gallery, Manchester

Above right:
Daylight reduced. Here prints are
displayed in table cases against a
window, threatened by Mediterranean
sunlight. The heavy net curtains reduce it
substantially.
Fernand Léger Museum, Bîot, France

darker than either the designer or public will readily accept. The
illumination of objects sensitive to light is a particular problem. Light can
cause fading and deterioration to organic materials and to surface colours
on any 'base' material. The rate of deterioration depends on the strength of
lighting at the object (the illumination level) in relation to the length of
exposure and also the spectral composition of the light.

The level of illumination can be checked with a photo-electric light
meter which will show the strength of the light measured in *lux*. (While
this is the generally accepted term, the designer may find references to
measurements in lumens. In Britain and the USA a unit about ten times as
large as one *lux* is called 'lumens per square foot' or Foot candle. So that
1 *lumen* sq ft will be the equivalent of about 10 *lux*.)

Maxima

Maximum levels of illumination for different materials are recommended
by conservators. (These are to be found in the designer's notebook section
under material and object.) As a general rule, the damage received by an
object exposed to light is in proportion to the illumination value
multiplied by the exposure time. Thus, if two lamps are allowed to light an
object instead of one, the same amount of damage is likely to occur in half
the time. This means that the conservator will need to know the intended
life of the exhibition when very sensitive material is being considered. If
an exhibition is extended it is possible that some objects may have to be
taken off display as their 'safe' exposure time expires. At the *Great Japan*
exhibition in 1980–81 many of the sensitive scroll paintings were
exchanged for alternatives halfway through the exhibition. Such
considerations must be taken into account by the designer.

Conservators measure the length of exposure in lux hours (illumination
value times exposure in hours) or million lux hours (mlxh). One possible

way to reduce illumination time which the designer may wish to consider involves push-button visitor-control lighting for cases, the covering of objects by curtains, even though the visual appearance of covered cases may not appeal to the designer.

Ultra-violet light

In addition to reducing the illumination levels to minimise damage to light-sensitive objects, it is also necessary to eliminate ultra-violet (uv) radiation from the spectrum of light falling on the object. This is achieved by introducing between the light source and the object a filter, usually of a clear plastic film, which contains a uv absorbent chemical. The conservator is able to measure the proportion of uv radiation with a uv monitor and advise the designer on the degree of filtering necessary. While it is not necessary to filter the small quantity of uv light emitted by tungsten incandescent lamps and by Philips 37 and 27 fluorescent tubes all other fluorescent lamps will require uv absorbing filters. These take the form of sleeves to fit on the tubes, or sheet acrylic between the tubes and the objects.

Daylight through rooflights and windows will present both the conservator and designer with problems, and for a temporary exhibition the easiest and possibly the cheapest solution may well be to black out the natural light and concentrate on providing an artificial lighting system, which can be controlled more easily. If daylight is permissible the level of illumination will probably have to be reduced, by the use of blinds or net curtains. A uv absorbing filter will also be necessary. Varnishing the windows with a plastic film or double glazing with an acrylic sheet containing a uv absorbing filter are the usual methods adopted.

Controlling heat and humidity

Heat can cause problems in exhibitions. Sunlight and light from spotlamps create heat, in addition to the heat given off by radiators and the visitors themselves. The temperature in an exhibition area affects the humidity, for with increasing temperature the ability of the air to hold water vapour increases. The level of moisture in the air is important as it can affect the stability of organic museum objects, such as: wood, bone, leather, paper, etc. And it can also affect metals. The conservator will measure the level of moisture with a hygrometer whose readings will be expressed as percentages of *relative humidity* RH (that is, the ratio of the amount of water in the air to the amount it could hold if fully saturated).

Low values of humidity registered on the hygrometer indicate dry conditions and high values indicate dampness. But what is the implication for the designer? If the conditions in the gallery have to be adjusted and the installation of full permanent air-conditioning is out of the question, the designer will be expected to accommodate portable humidifiers or dehumidifiers. Hopefully the need for these functional pieces of equipment can be determined at an early stage in the design, so that they can be incorporated into the layout and, if their appearance is inappropriate to the style of the exhibition, masked in some way.

Monitoring equipment

Where conservators have to keep a close watch on the environment of an individual case containing objects of a very sensitive nature they will expect a hygrometer and thermometer to be on view, near the vulnerable objects in the case. Unfortunately, these look obtrusive and there is little that can be done but accept them, except perhaps to request that instead of two instruments a combined thermometer/hygrometer might be used. Where humidity alone must be monitored, small, printed card humidity indicators are less obtrusive, if banked among the object labels. The designer may be asked to provide cases with accessible bases or voids behind, or to the side, in which humidifying or dehumidifying equipment can be housed. If the exhibition budget allows, this can be the automatic

Anticipation. When schedules prevent the checking of conservation conditions on site, predictions can be made by test-running a prototype showcase, lit, using a recording thermo-hygrograph.
British Museum, London

First Aid. The hygrometer in this case showed the RH was too low for this wooden gaming board. The conservator inserted a glass dish of water on the ledge above the exhibit.
The Vikings, British Museum, London

mechanical equipment mentioned on page 57, but the conservators can on occasion achieve the desired environment by cheaper chemical means involving desiccants (such as conditioned silica-gel), to regulate the RH. To hold this soda-like substance, the designer will need to detail suitable trays to be constructed as part of the case. For both mechanical and chemical methods, he will need to provide for free circulation of the conditioned air within the case, by means of gaps between the display area and the area containing conservation equipment. If the case construction precludes space in the base, silica-gel can be contained in display bases for individual objects.

Controlling dust

The conservator will also be concerned with the danger of sensitive objects being damaged by dust which contains atmospheric pollutants. Sulphur dioxide and hydrogen sulphide are the commonest substances likely to cause damage to the surface of objects. The conservator may well recommend an air filtration system for the whole exhibition site and prohibit open display of objects. If the exhibition is on for a long time the designer will be expected to detail dustproof cases. The extent of dustproofing depends on how airtight a case is. A dustproofing construction detail may be more successful on a small case than the same detail on a large case, since the larger the case the less effective the dust-proofing measures become. This is because a large volume of external air is drawn into a big case when the temperature falls and the air pressure inside the case contracts, and air and dust particles are drawn in from outside. On larger cases, therefore, it may be necessary to double the dust-proofing measures, introduce air-filtration systems, or mechanically pressurise the air inside the case so that it is pushed out, taking dust with it.

Hidden hazards in materials

Many of the materials which the designer may wish to specify for use in the construction of showcases – timber, proprietary boards, adhesives, paint and fabrics as a background for displays – could be a conservation hazard. Certain materials give off volatile substances which can damage some metal antiquities. There is no way in which the designer alone can predict whether the materials he wants to use will be safe. This can be confirmed only by the conservator who will carry out tests on the proposed materials in a conservation laboratory. Time must be allowed in the exhibition schedule for the sometimes lengthy testing of materials. If a fabric or paint passes the test for use in one exhibition, it will still be necessary to carry out further tests on fresh samples if the same material is specified, say a year, later for another exhibition. This is because manufacturers may change the composition of dyes and other ingredients which might fail the suitability tests even though the appearance of the product has not altered.

Exhibitions that are designed in an 'evocative' style will demand the use of many 'real' materials, such as thatch and plants. These can harbour pests, which will be liable to attack the objects on display, such as original furniture and fabrics. Again, the advice of the conservator should be sought; he may well insist that all such materials shall be professionally fumigated. But he may welcome the use of live plants to increase the humidity in a dry atmosphere.

Conservation check list

The designer must work with the conservator on each exhibition to ensure that:

a Levels of illumination are appropriate to the type of objects displayed and the uv radiation is eliminated
b Correct conditions of relative humidity and temperature are achieved and maintained
c Heat from light sources in showcases is kept to a minimum
d Design of cases is such as to exclude dust
e Materials used in the confined and enclosed space of the cases are tested to check that they will not cause damage to the objects

Each exhibition will contain objects made from a variety of materials, some of which can have quite different criteria for conservation and display, and it may well be that objects made from certain materials cannot be displayed with others made from different and incompatible materials.

	Material	Illuminance (lux)
Recommended levels of illuminance which should not be exceeded*,†	Easel paintings Animal and plant materials where surface colour is important (including undyed leather, wood, bone, ivory)	200
	Works of art on paper (including water-colours, drawings, prints, stamps, wallpaper, historical documents, photographs) Textiles (including tapestries, costumes, upholstered furniture, carpets) Miniatures and manuscripts Dyed leather Natural history exhibits	50

* Materials that are not light-sensitive may be lit at higher levels but is unwise to increase the levels to above 300 lux in a museum where there are also light-sensitive exhibits because of problems with adaptation as the visitor moves from room to room.
† For photography, light levels may be increased to 1000 lux for short periods provided there is no significant heating caused by the lights.

	Materials	Relative humidity
Recommended levels of relative humidity*	Mixed collections in humid tropics (Air circulation important to discourage mould growth). Too high for metals	65%
	Mixed collections in Europe and North America (May cause frosting and condensation problems in museums where winter temperatures are low)	55%
	Compromise for mixed collections in museums where winter temperatures are low. Textile collections	45–50%
	Metal-only collections Local material exhibited in museums in arid regions	40–45%

*Ideally all levels should be maintained to within 65 per cent but at any rate the danger limits of 65 per cent and 45 per cent should not be exceeded.

11 Sight and light

Introduction to the lighting task

Lighting is one of the most critical elements of an exhibition. It sets the atmosphere of the exhibition and can control how things are seen and therefore the visitors' reaction to them. Light is an integral part of the concept of the exhibition and of the form that it is going to take. It is not something to be added after the arrangement of cases and objects has been finalised, as custard is poured over prunes!

Illuminating an exhibition, whether by daylight or artificial light, is a complex task, involving an understanding of the basic physics of light, geometry, ergonomics, perceptual psychology, a knowledge of technical equipment and conservation. Ideally, the exhibition designer should have the support of a qualified lighting engineer. Few do. The designer must therefore set about remedying any gaps in his scientific education, if he is to light his exhibition properly.

Museums are short of funds not only to hire additional professional skills, but, usually, also for the purchase of an adequate range of light fittings (luminaires) and lamps. A designer, particularly at the start of his career, will wonder how to proceed. Luckily, a great deal of technical information is there for the reading. Most lighting equipment manufacturers offer demonstrations of lamps and fittings that they produce and give technical advice as well. Time spent on such investigations will give the designer an idea of what is available and how to use it. Before choosing a method of illumination the designer should decide what is essential and desirable in the exhibition. This entails a check procedure for each project:

The task: what general message has to be conveyed by the lighting? What are the visitors to do?
Style: what appearance will convey the right atmosphere?
Equipment: what is available?
Constraints and tolerances: what power supply is available? What limits will the conservators set?
Ergonomics and physics of light: check the size, behaviour and perceptual characteristics of the anticipated visitors.
Maintenance: how can the planned system be kept going? If heat is produced by the lighting can the ventilation system cope?

The eye of the beholder

In planning lighting, designers are catering for the vision of the visitors. It is worth reminding ourselves of how this works. The retina is a small screen at the back of the eye on which the eyeball (a jelly lens) projects an image. There are devices in the retinal screen which respond to small areas of this image. Some respond to white light and others to certain colours alone. The eye moves in the head, and the head moves on the body, and so we can bring the sensitive machinery of the eye to bear upon what is around us. To get an image into the visitors brain the designer must arrange to reflect light from the objects in the exhibition. A minimum of

Daylight. A standard method of top-lighting used in picture galleries to illuminate paintings (This can also be adapted to artificial lighting).
Kettles Yard, Cambridge

light is required to work the sensory system, but a maximum limit has also to be observed. The eye is very adaptable, but it can be confused by too great a contrast, and even damaged by excess light. The adjustment is simple; the pupil of the eye opens and closes (like the aperture of a camera) and such adjustments are made all the time by visitors to enable them to enjoy material illuminated at quite different levels.

Readers may wonder why such matters are being recapitulated here. I advise them to pay a visit to the nearest exhibition! If each object, and its accompanying label is checked for illumination a number will be found to be underlit in terms of reading or seeing details of craftsmanship; many will be casting awkward and distracting shadows; and often the light cast by the fitting will be in the wrong place, the fixing having 'drifted'. Moreover, the general light level of the gallery may simply be too low.

The eye is also sensitive to the colour of light. It has a different sensitivity to light of a lower colour temperature than to light of a higher colour temperature. Low colour temperature light, such as light from incandescent sources, may make a room appear bright at low levels of illumination, while fluorescent lamps, which have a higher colour temperature, need a higher level of illumination to make the same room seem equally bright.

Using daylight

Both natural daylight and artificial lighting pose problems, but daylight is particularly suitable for the lighting of stone sculpture, which is not subject to damage from the ultra violet component in natural light. The intensity of daylight, even its variability, may enhance the exhibits.

Daylight may not always be chosen by the designers, but thrust upon them. The sites of exhibitions are often the galleries of museums built in the last century, where the illumination is solely by daylight from rooflights or clerestory windows. Even assuming that the strength of the light is adequate for the proposed exhibition, the designer will have to check the positioning of glazed surfaces in the display for distracting reflections. (For the purposes of description and of calculation 'daylight' is taken to be the level of natural light under overcast sky conditions.)

The contents of the exhibition must be carefully checked from a conservation point of view. Some materials, such as the sculpture already mentioned, are unaffected by the ultra violet component of daylight, but most materials are. Normal glazing is no protection, and it must be replaced by laminated glass treated with an ultra violet filter in sheet or varnish form. The varnish form of filter is impermanent, and the designer (and the budget) should allow for repeated treatment to the rooflights and windows. Even if daylight from rooflights and windows is sufficient it often falls in the wrong place. The observer can easily be distracted if areas of the floor and walls are brighter than the exhibits. In general the light source should be diffused, and this also has the advantage of removing the direct views of the sky at the same time. In many galleries this has already been taken care of, a glazed velarium (a translucent screen or ceiling, sometimes of fabric) having been introduced below the roof lights. Where this has not been done, and provision is needed for a temporary exhibition, a fabric ceiling or velarium of fireproofed muslin or casement, can act as a diffuser, and defeat the superfluous reflections.

Controlling contrasts

Where there are extreme contrasts resulting from the limitations of the natural light source the designer can borrow from professional photographers, and introduce artificial 'filler' lights into some of the heavily shaded areas.

The handling of soft daylight is one thing, that of sunlight quite another. The effect of strong patches of light may be useful in an evocative setting, but in general these are very damaging to prints and drawings and to all

Velarium. The exhibition ceiling diffuses light from above (daylight or artificial lighting). Ceiling-level framework supports lighting track for accent lighting.
Artists of the Tudor Court, Victoria and Albert Museum, London
Designer: Paul Williams

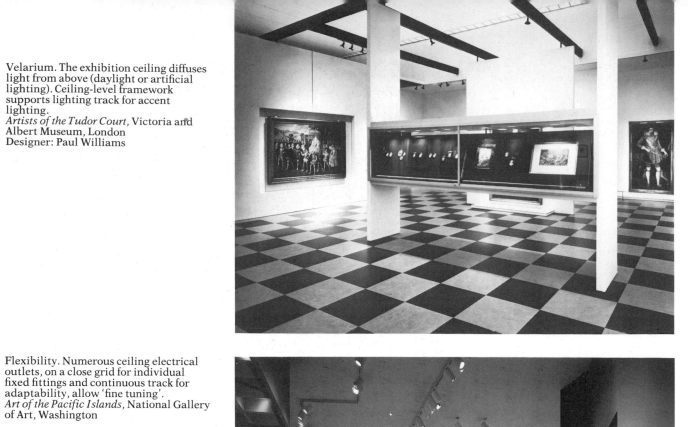

Flexibility. Numerous ceiling electrical outlets, on a close grid for individual fixed fittings and continuous track for adaptability, allow 'fine tuning'.
Art of the Pacific Islands, National Gallery of Art, Washington

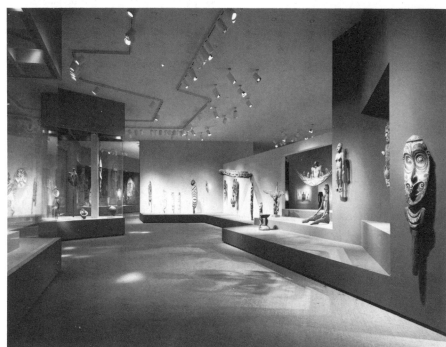

Combination. Fixed system of louvred panels incorporating air-conditioning outlets and providing diffused daylight (or fluorescent lighting). Flexibility provided by track between the louvred panels.
Bryan Wynter, Hayward Gallery, London

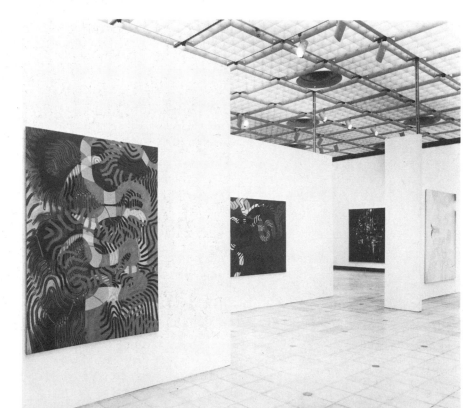

Drama from tungsten lighting. The route is illuminated by high-level downlighters; clear Perspex-topped cases are lit from spots on track at lower level.
Treasures of Ancient Nigeria, Royal Academy of Arts, London
Designer: Alan Irvine

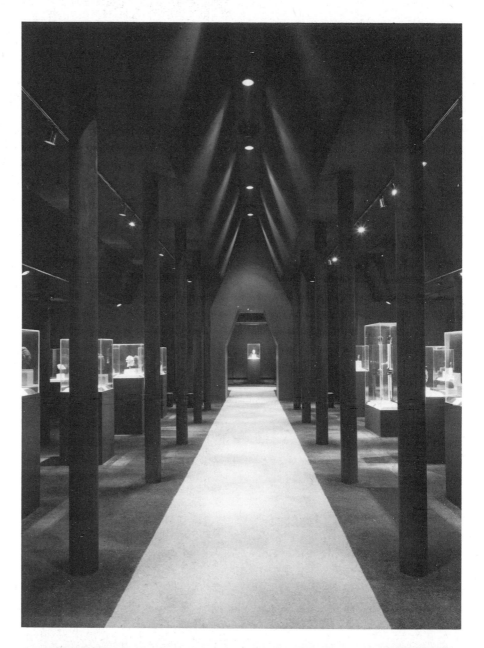

Light spill. The room is illuminated solely by the light generated from case light boxes (containing fluorescent tubes above specular louvres).
The Thirties, Hayward Gallery, London
Design: Neave Brown, Max Fordham Partnership

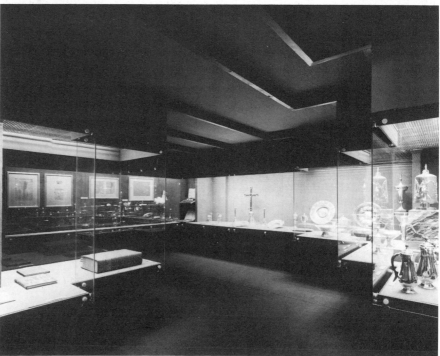

Baffled. The source of illumination for Michelangelo's *Tondo* is screened by an angled panel directing light onto the glazed sculpture.
Royal Academy of Arts, London
Design: Robin Wade Design Associates

Light without heat. Fibre optics introduced into this table case, providing local illumination of a sensitive object – highlighting with safe, miniature spots.
Man before Metals, British Museum, London

other organic objects. The designer must secure control through opaque or translucent louvres and blinds. Moreover, the solar heat will have to be controlled, and the conservator will probably ask for diffusing glass to be fitted.

Since light and heat are so closely interconnected careful balancing of both should take place at the design stage, and monitoring maintained during the run of the exhibition. It is safer to assume that both these energy sources are out of control, rather than the reverse, and the team should check accordingly.

Daylight illuminated

Many museums wish to open their exhibitions in the evening, and others will want to make them enjoyable on dark winter afternoons. The designer who is using daylight as the main source will have to augment it with artificial light and balance the two together to provide a pleasing and constant effect that will last until closing time.

One possibility is to use artificial light to imitate that from the sky. By switching on overall fluorescent lamps, so placed as to repeat the effect of natural daylight, little change will be made in the appearance of the displays, particularly if the tubes are placed above a velarium. The switching can be affected by the attendants in the gallery, or if funds permit by photo-electric cell devices, which can 'read' the level of daylight and act accordingly by progressively switching on the artificial light.

Control of light

Frequently the designer may decide to exclude all daylight from the gallery, and illuminate it only by artificial light. This ensures total control; levels can be calculated from a conservation point of view – in particular ultra violet light can be eliminated – and the heat outputs can be calculated more precisely.

The control is not only technical. With proper switching and attention to maintenance, atmosphere, emphasis, contrast and colour can be supplied wherever needed, and sustained throughout the life of the exhibition. The designer is then in complete control.

It is worthwhile listing what, exactly, is to be lit. In planning the lighting of an exhibition there are several different requirements to be met. First, the public must be served. There must be general light, enough for visitors to see their way round the exhibition (and to be able to read the catalogues). Some of this light must be graded so that visitors can make an easy adaptation between the areas of approach to the exhibition, the gallery itself, and the areas where they exit from it. Then, the display itself will have to be lit; there must be lighting for the exhibits themselves, and sometimes 'effects' lighting to create or emphasise atmosphere. Graphics and charts will also need to be properly lit.

The gallery must also provide emergency lighting. If there is a power failure clear lighting will be needed to evacuate the visitors. This must be operated on a separate circuit, or by batteries, so that it is available in the event of failure or interference with the main circuit. It will have also to operate illuminated exit signs.

Service lighting is required when the public are not in the gallery. The exhibition will have to be patrolled for security, it will have to be cleaned, and repair and maintenance staff must also be catered for. Service lighting, both for emergencies and for staff, may require separate circuits from each other. The service lighting may be too strong for the conservation levels set for the exhibits, and the lighting of the exhibition may be too restricted and dim for cleaning and maintenance.

The effect of all or any of these systems must be agreed with the conservators. General light, designed to permit visitor circulation, will spill into the cases and on to the exhibits to some extent, in addition to the light specifically provided for them. Similarly, service lights for

Backlighting. This provides even
illumination for shadow puppet display
and ambient light in gallery. Centre
displays emphasised in 'light pools' from
fittings between ceiling louvres.
Museum of Ethnology, Dahlem, Berlin

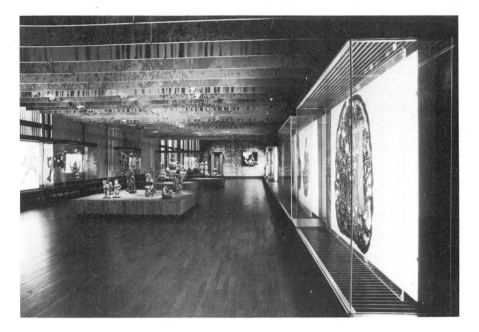

Reflection. The use of external lighting
for cased objects creates shadows.
With the careful use of mirrors reflected
light can illuminate the sides of objects.
The Royal Treasury, Stockholm

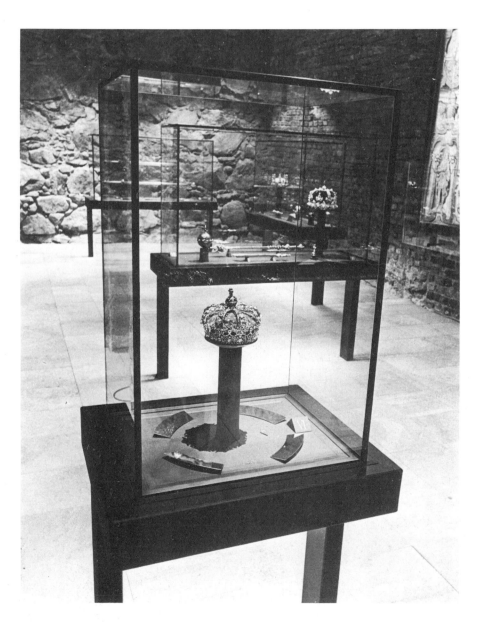

patrolling, maintenance and cleaning may also spill on to the objects, and it may be desirable to aim them in such a way as to avoid this, and also to agree time limits on their usage.

The very low light levels, dear to the conservator, are not always appreciated by visitors. Many complain of dark exhibitions, and a compromise may be necessary such as increasing illumination on the floor. If this is not possible, the designer can place a clear explanation of the reasons for low lighting levels at the entrance to the exhibition.

Light colour and intensity

In lighting the exhibition the designer must always be aware of the colour of the light employed. There may be obvious colour differences between the lights specified to secure the overall illumination, and the effect on the atmosphere of the exhibition can only be judged with the naked eye.

Not so immediately visible are the variations between light sources described by the term 'colour temperature'. Such slight variations, having little effect on floors, walls, signs and labels, can be critical when the lighting of individual exhibits is planned. In many exhibitions the correct 'colour rendering' of the exhibits must be the starting point of the complete lighting scheme.

The designer must remember that he can easily be deceived by the very adaptability of the human eye. When we have experienced a light for some time we tend, unless the colour is extreme, to regard it as white; the light available becomes the norm. This may serve us adequately in domestic life or in the office, but truly 'white' light is what we need for the proper colour rendering of works of art, and this is from light sources which emit waves from the whole of the visible spectrum. The tungsten filaments of incandescent lamps provide light across the whole spectrum, but with a bias towards the red end of it, and fluorescent lamps are generally biased towards the other end, green, blue and yellow.

The designer has to consider how precise is the control of colour temperature required for a particular project, and if it can be achieved through intuition and trial and error. The starting point, subject to the limits imposed by conservation, must be the story which the curator wishes the objects to tell, which may concern their craftsmanship, their art, or their setting.

Balance and unity

The light levels and the colours used must be made to agree with the work of the graphic designers, who may often wish to use colour codings in maps and diagrams. Care must be taken to see that the gallery lighting does not spoil the 'separation' of the coloured areas employed.

It is tempting to solve separately the lighting of the exhibits and the information about them, and this must be resisted. The keen visitor will be making constant reference from one to the other, and fatigue and irritation will be induced. Many of the design problems of an exhibition are solved at the drawing board. In lighting, by contrast, the designer has to step back and consider the exhibition as a whole.

The intention may sometimes be to use frankly theatrical effects to make a point. Strong coloured lights may be used to define areas of subject matter, or emphasise points of 'punctuation'. This can be achieved by the use of colour filters in front of the light sources. These can be effective where the light does not affect the colour character of exhibits, or create an atmosphere that is unnatural. Usually, however, the material is displayed under 'normal' lighting.

The 'normality' is, of course, related to the subject matter of the exhibition. The 'normal' lighting for an Arab tent is desert sunlight, for a seal the cold light of the Arctic, and for a Rembrandt warm candle light. Works of art represent a particularly difficult problem, and definite policy decisions have to be made. Is it more appropriate to display a Rembrandt or a church fresco in the light in which they were created, or in which they

would usually have been viewed at the time, or in the strongest light which they will now stand for us to see the detail within them?

Lighting equipment

There are many different lighting requirements within any one exhibition, and it will take a variety of equipment, sources and fittings to satisfy them. The exhibition designer has a great deal at his disposal. While it is true that most of the lamps and fittings (luminaires – the devices which apply and direct the light produced by the lamp) have been developed for commercial and domestic use, manufacturers are becoming increasingly aware of the specific lighting needs of the museums and art galleries.

Light fittings (or luminaires)

While it may seem that there are a large number of different lamps or light sources they are relatively standardised, and those from different manufacturers are interchangeable. The same cannot be said for the light fittings, or luminaires, in which they are housed. The number of fittings available is enormous, and although it is possible to make some adaptations, the designer should never assume that a fitting from one manufacturer will work in the system developed by another.

Although it has not yet been manufactured, one can conceive of an ideal museum light fitting! It would protect the light soure, control the light from the tube or lamp while making the most of its potential, not overheat, be simple to install, and, when installed, would not drift from the position and angle assigned to it. Last, but not least, it would have a pleasing appearance without drawing attention to itself, and be capable of being completely neutral when in an exposed position in an exhibition gallery. In short, the fitting would display something else, not itself.

When selecting a fitting the designer has to bear all these points in mind, and only select or specify a fitting that will deliver exactly the amount, colour and shape of light that he needs. The light fittings, therefore, may take up a substantial part of the total budget for the exhibition.

The life of the lamps used in the fittings should be calculated and a check made on the availability of replacements. It may be safer to buy in a stock of spares at the outset, and a generous contingency margin should be allowed in the overall budget for this item.

Greater control of lighting

The designer has the same responsibility for the control of lighting in an exhibition as for the control of form, texture and colour, yet this responsibility sometimes eludes him. Often, in an otherwise sophisticated and tightly organised exhibition the lights appear to have been allowed to develop a life of their own; strange pools and streaks of light appear on the floor while other vital areas remain unlit. Untidy lighting is more than irritating, it can be dangerous. On occasion visitors can be seen stumbling towards their next target object, temporarily blinded by a light originally intended for quite another purpose. For the partly-sighted visitor such things are even more serious.

It is worth examining how this design anarchy occurs. The principal cause is the nature of the buildings in which many of our exhibitions have to be mounted and the nature of the equipment that we use to light them. Many galleries were built before artificial light became feasible, and fittings are therefore introduced which were developed in quite another context. Whether in the adaptation of older galleries or in special temporary exhibitions a track lighting system, incorporating a range of easily available and economical adjustable fittings, offers flexibility. The track itself however, becomes a feature of the design, and has to be disguised or harmonised with the rest of the setting or display.

The light fittings at the disposal of the exhibition designer originate in domestic use, or in commercial displays. In kitchens and living rooms the

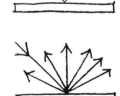

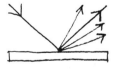

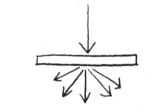

Reflection of light:
a) Light reflected from polished surface at the same angle at which it strikes it
b) Light reflected from matt surface in all directions
c) Semi-matt surface scatters some light and reflects some light directionally
d) Light which passes through diffused material is scattered.

Sight and light angles:
a) & b) Field of vision
c) Zone where lights should not distract
d) & e) Greater limitations on lighting
imposed by visitors wearing glasses.

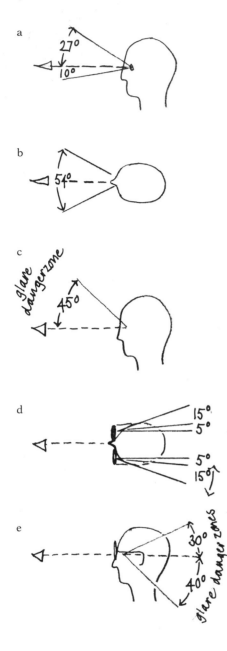

circulation of the users is very restricted, and there is little difficulty in keeping the light out of their eyes and on the subject to be lit.

Another form of circulation control obtains in shops, where many of the displays are organised in windows, or in internal bays. Both have the character of proscenium theatres, the bodies and eyes of the viewers being firmly screened from the exhibits. Where an exhibition is organised on such a proscenium basis the control of the lights to avoid spillage and the glare that goes with it is relatively simple.

Today many exhibitions are organised to give a free flow of visitors between the cases and objects, looking around them in all directions. What has happened is that the exhibition has progressed from proscenium theatre to theatre-in-the-round, without the range of fittings being available for the provision of comfortable lighting, and perhaps with the designers failing to appreciate the complexity of the task with which they are now faced.

Geometry of the lights and the visitors

Some parts of the design of an exhibition can be carried out by intuition and sudden flashes of inspiration. Lighting is not one of these. The geometry that governs the eye lines of the visitors and the light cast by the luminaires, and the shadows and levels and reflections involved have to be resolved by a most disciplined procedure. Just as a chair and its back and arms are the result of an ergonomic coming together of production materials and human dimensions so the lighting scheme involves matching the eyes of the visitors in all possible locations and directions with the output, target areas and directions of the fittings.

So familiar are we with sight and light that is quite hard to view them as though they were part of a new invention, to be set out on a drawing board. Yet, in the critical setting of an exhibition gallery, this is exactly what must be done. Each fitting will emit a cone of light, or a shape roughly similar to this, and the visitors carry around other cones comprising the visual fields formed by their eyes. The designer has to ensure that these two cones overlap where there are exhibition objects, or information, or parts of the gallery required for perambulation. What is *not* required is that the eyes of the visitor are within the cones of light from the fittings, and yet this is what happens all too often, with blinding results.

There is only one way to make certain that the arrangements are satisfactory (short of endless trial and error in the gallery) and that is to project the visual field of the visitors and the provisions of the lamps on the drawings, both in plan and section. Only thus can one be certain that the 'equation' – of eyes, objects and light – has been solved.

The cone of vision of the individual, that portion which is used for detailed viewing, is surprisingly small. It is in fact an angle from the eye of only one degree. (This can be understood by looking at one's thumbnail at arm's length. When one considers objects of different sizes in this way one

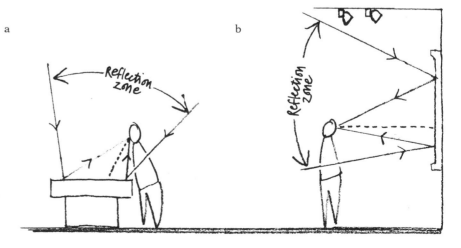

Reflection zones: lights in these areas may introduce unwanted images within the display
a) Table-case
b) Glazed wall display

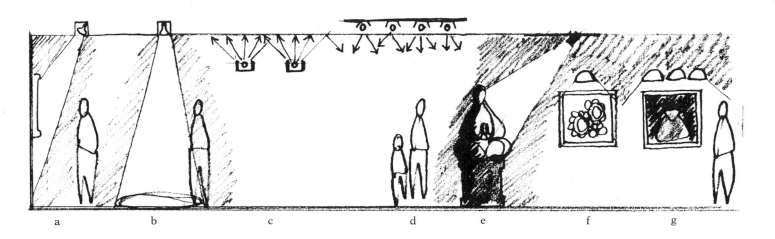

Basic lighting methods:
a) Wall-washing
b) Downlighting
c) Uplighting
d) Diffused
e) Directional spot (accent)
f) Lighting of pale objects
g) Increased illumination for dark
objects

develops a completely new view of the distances at which they might best
be displayed.)

This cone is, of course, only the visual area for detailed perception.
Around it is a much larger cone where movements of tone and colour can
always be perceived, but without gaining enough information to make any
analysis of what these movements represent. Of course, a viewer deals
with the narrowness of his visual cone by turning the eyeballs in his head
and his head on its shoulders, and he can thus aquire information from a
much larger area. In this operation one area of study is relinquished to
attend to another, and the total range of information is assembled by
scanning the visual field until all relevant portions have yielded enough
data.

There is a further complication, since viewers can range from two to six
and a half feet in height! To organise the total visual expectation in his
drawings, the designer has therefore to develop a stack of cones, one above
the other, all of which must meet the requirements of the display and the
light available to it.

Some exhibitions are designed as 'tunnel shows': the path of visitors and
their relationship to the exhibits are firmly restricted, and here the
lighting equation can be fairly easily achieved. In a more loose form of
exhibition plan the designer must first map out the visual cones on the
basis of what he wants the visitors to do, and then follow this with a
further map of what they are likely to do, by no means the same thing!

The information in this section cannot claim to be exhaustive; however,
if the reader applies these techniques to one or two projects they will
prove revealing. Chance has played a part in exhibition lighting which
would never have been tolerated in other areas of design.

Switching lights

The designer must ensure that switching arrangements for the lighting
installation are clearly set out in the specification to the electrical
contractor. Switching arrangements are not only a part of the design but
have to meet the needs of the exhibition management. Display lighting
must either be switched together or in separate banks according to type of
fitting. Perhaps it will be best to have the case lighting on one circuit and
the general lighting on another. Independent circuits for servicing and
emergency lights have also to be agreed.

The designer may have worked out an effective lighting arrangement,
and the contractor built it and arranged effective switching, but the users
have to be able to operate it. It may be the duty of warders and others
unfamiliar with lighting to switch the system from the service mode, used
when the museum is closed to the public, to the display mode required
when the public is admitted to the gallery. This can only be carried out if
the switching instructions are clearly set out and the individual switches
carefully identified.

12 Heating and ventilating

Heat from light

With a few exceptions, devices that produce light also produce heat. In fact, lighting, heating, and ventilation should always be regarded by the designer as inseparable. The light fittings will become hot, and the cheaper ones may themselves deteriorate. The heat emitted from the lamp may discolour or even scorch the surrounding materials if they are too close. Before a designer specifies a light fitting a sample should be obtained and tested systematically for some hours, for short tests will give no idea about its characteristics over many hours in a display.

The lights must always be calculated as part of the heating system of the gallery, as must the visitors! While the heat generated by the lights and the heating system together may be acceptable in an empty gallery, calculation should also be made of the temperatures when the exhibition is well attended. It must be borne in mind that each visitor will contribute heat comparable with that from a one hundred watt bulb.

Heat from light sources outside the case can be a problem when light shines through the glass of a case, which greatly increases the temperature, producing a 'greenhouse effect' inside the case.

Heating and ventilation

The design of heating and ventilation systems is beyond the scope of this book. However, the designer should be aware of the problems that could be encountered when designing temporary exhibitions within an existing system, and also the liaison necessary with heating and ventilating engineers in the design of more permanent exhibitions.

While the maintenance of correct temperature and humidity for reasons of conservation is a primary consideration, the comfort of the visitors and staff is also important.

Existing systems

In the initial survey of the exhibition site the permanent method of heating will have to be noted; the type and position of radiators, the input and extract characteristics of heating and ventilation grilles. The exhibition design must then take these into account so that the effect of the introduction of screens, solid partitions, wall cases, false ceilings, lighting, etc. can be calculated by and agreed with the engineers and maintenance staff. Some designs will involve the forming of 'rooms-within-rooms' and these will interfere with the normal flow of air.

It is possible that not only could conditions in the gallery become intolerable, but also the plant itself could become overworked and damaged. The area of 'screening' in relation to the volume of the gallery may have to be considered, and in addition, care must be taken to see that none of the grilles or vents, for intake and extraction, are blocked.

There are times when some partitioning has to be constructed in front of existing grilles as part of the whole display scheme. In such circumstances it may be possible to introduce a second, corresponding grille in the new

partition, but to ensure the free flow of air between the two the free area of the new one may have to be as much as double that of the original.

Access must also be maintained to the hot water radiators or convector heaters that are often found in older buildings. Such access space should be sufficient to service the equipment if this should prove necessary, but as a precaution the designer should press for the overhaul, checking and servicing of all integrated systems before the exhibition is built.

New installations

In general, the designer should try to influence the positioning of any new heating elements in any gallery being built or converted, since an ill-considered installation will limit and restrict any future positioning of objects and cases.

13 Showcases

Travelling case. Mounted inside will be objects, with more in the drawers below. When open, the doors, with hinged extension panels, will be used for display. Riksutställningar, Stockholm

Below left:
Modular system, 1970 (basis of many exhibitions since). Uprights, panels, light-boxes, glazed frames. Storage space and maintenance essential to keep operational. *Costumes of Palestine*, Museum of Mankind, London

Below right:
Storage wall cases. Manuscripts and scrolls behind sliding glass panels. Underneath are unobtrusive cupboards. The Heralds' Museum, Tower of London
Designer: Alan Irvine

Introduction: the case for showcases

A case is a recognition of limitations! If our visitors were infinitely honest and careful, and our climate pure, temperate and stable there would hardly be a need for display cases. But the world is not perfect, the objects in the museums are in our care, and we have, as far as possible, to keep them in their present state. Only when that is accomplished are we entitled to put them on show with accompanying information.

It is true that some objects can be made visible *and* inaccessible by being displayed at a certain height or defended by staff or barriers. But most material must be cased, be it freestanding furniture, or in wall alcoves. It makes little difference whether these cases come from stock, are made on site, or arrive fresh from a manufacturer; they will, in many instances, dictate the form of the exhibition.

The ideal 'all-purpose' showcase has probably not yet been designed. The perfect case would combine complete security and ease of access, stability, and at the same time meet requirements for conservation, flexible lighting, and an infinite range of display facilities, while being a thing of beauty without detracting from the exhibits themselves. However, there do exist a number of reasonably satisfactory, if not perfect, solutions.

Categories of showcases

The designer may have at his disposal when designing an exhibition one or more categories of showcase:

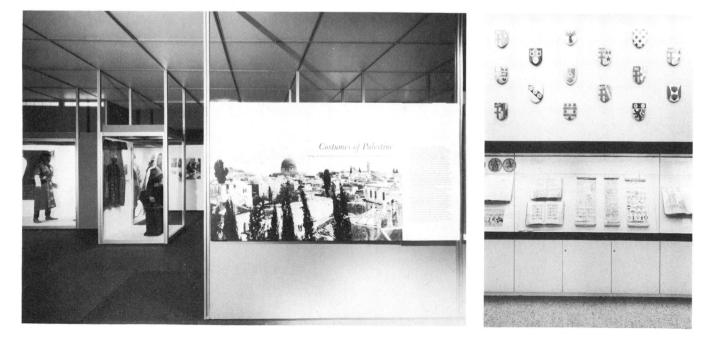

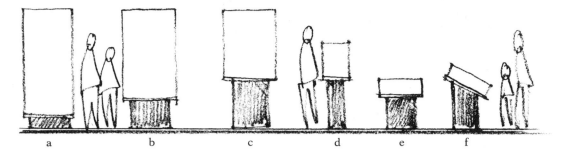

a b c d e f

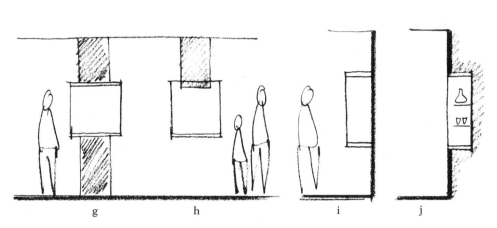

g h i j

Types of cases:
Freestanding: cases that visitors can walk round to view objects from all sides:
a) Full height
b) Three-quarter height
c) Half height
d) 'Shade' case
e) Table-case
f) Lectern or desk case
g) Braced between floor and ceiling
h) Suspended from ceiling only

Wall cases:
i) Against the wall
j) Set into wall.
As with freestanding cases, full-height, half-height or three-quarter height are in common use.

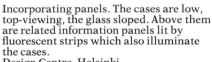

Incorporating panels. The cases are low, top-viewing, the glass sloped. Above them are related information panels lit by fluorescent strips which also illuminate the cases.
Design Centre, Helsinki

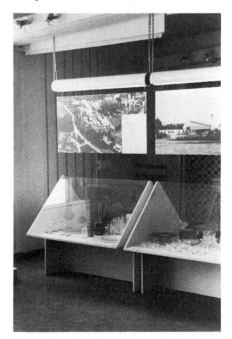

Existing cases
These may have to be pressed into use although originally designed for use in permanent displays (designed and constructed to a high standard and therefore costly).

Standard components
There may be a system of standard components, a permanent exhibition kit which, like Meccano, can be erected to form cases of different types.

Travelling cases
The cases might be part of a travelling exhibition and would probably be of fairly light construction, easily assembled.

Specially constructed cases
The cases might be specially constructed for a particular exhibition and be of a temporary nature. This might mean that the cases are built into the structure of an exhibition or are designed and built to simple construction standards from inexpensive materials. They might have a relatively short life, but could possibly be re-used for another exhibition.

Combined storage and display
Where space is at a premium, many cases will have to carry out a dual function, being both display areas and storage space.

Many museum designers have faced the very awkward problem of having to produce a unified design for an exhibition using a variety of cases from all these categories.

Types of cases

Showcases come in all shapes and sizes, simple and complicated, with and without integral lighting, but the basic types are:

Vertical
Upright cases, comprising wall cases, inset cases, freestanding cases.

Horizontal
Flat or sloped, called table or desk cases.

Ease of access to dress the case is all-important. For each type of case there are several means of access, each with advantages and disadvantages. But

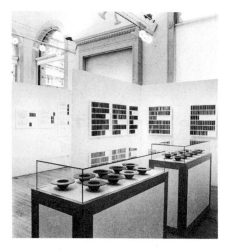

Table cases. Tops in the form of glass boxes (glass panels simply cemented together) which lift off for access. Lighting external, from spots from ceiling track.
Colouring Metals, Crafts Council, London
Designer: Ivor Heal

Full-height cases (or glass rooms). Uninterrupted glazing from floor to top. Common flooring through case interior and public circulation area maintains unity.
Metropolitan Museum of Art, New York

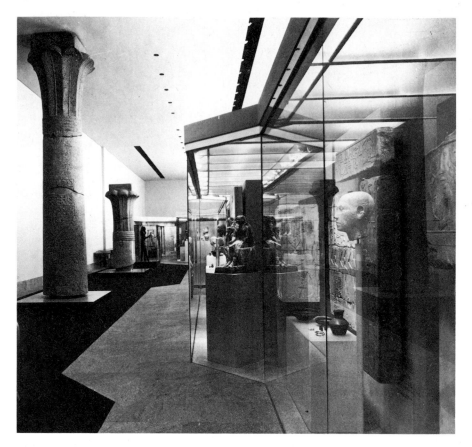

an object must never be put at risk when putting it in a case. In a permanent exhibition, where frequent access to the objects may be necessary for study purposes, access should be quick and simple for the curatorial staff. However, in a temporary show a more complicated method of access may be accepted by the Security Officer; for instance, it is considerably cheaper to have screw-fixed panels rather than sophisticated locks.

Public use of cases

Before designing new cases, observation of the public in an exhibition is useful. This will reveal that visitors require much more from a showcase than merely the services of a container. Visitors like to lean on the case for support (and balance wine glasses on it at receptions) and if it contains detailed drawings or manuscripts children will use it as a support for drawing or writing notes.

Visitors come in all sizes, and for a case to provide for their 'sight lines', its dimensions, both inside and out, have to be considered very carefully.

A brief for a case

If cases are being specifically designed for a particular exhibition the intended contents will determine the size and type. The method of access chosen will depend upon the nature of the contents, frequency of access, and the position in the gallery. As well as being a container, the case can also function as a screen, baffle, and room divider. (It can also become an oven! What permits sight can also admit light and heat.)

The conservator's requirements must always be considered carefully in the design of the case. Access may be required to the base of the case to house humidification equipment and other devices. The conservator will need to monitor the case once it is equipped, often wishing to check the conditions within the case without opening it, and so provision must be made for a small opening to give access for testing probes.

Access to freestanding and wall cases:

a) Hinged-side access. Provides good visibility. Case dimensions should relate to arm's length for dressing. If cases are placed together, fitting lining panels is difficult unless divided into convenient sections

b) Hinged-front access. Permits easy dressing. Large cases may require a transom for stability; these will limit sizes of lining panels and inserted display blocks

c) Top-hinged. Can be dangerous! Strong stays are required to keep open.

d) Sliding front. Provides good visibility, easy to dress. A single sliding panel may need support when fully opened. Lining panels may need to be in sections to pass through the opening.

e) Two sliding panels, used where space is limited on both sides of the case. Glass 'overlaps' when closed, and, sealed with dust-excluding strip, may be distracting (some patent sliding systems provide a butt junction).

f) Sliding upwards. Weight of glass can present problems and be dangerous when in open position, strong 'stops' and supports are required.

g) Sliding downwards.

h) Lift-off front. Provides maximum access for lining panels, display blocks and placing objects, but the weight of glass may require two people to open the case.

i) Demountable case system. Useful for temporary and travelling exhibitions. Even when construction is simple a team may be needed for erection.

j) Rear access. Useful for large 'walk in' cases, but access corridor reduces gallery space. Difficult to see the effect when dressing the case and to make adjustment at front, once dressed.

k) Lift-off 'shade' or 'hood' case. Good visibility if constructed with edge-to-edge glass or perspex. Covers too heavy to be manageable in larger sizes without risk to the object displayed.

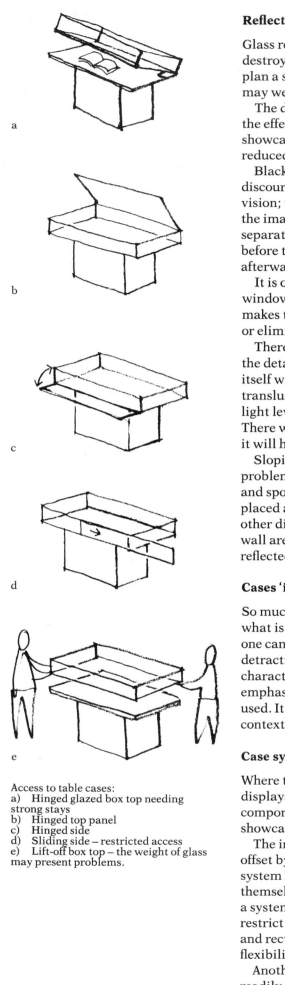

a

b

c

d

e

Access to table cases:
a) Hinged glazed box top needing strong stays
b) Hinged top panel
c) Hinged side
d) Sliding side – restricted access
e) Lift-off box top – the weight of glass may present problems.

Reflections and the positioning of cases

Glass reflects. Most of our museums contain cases where reflections destroy the view of the contents. Draughtsmanship is partly to blame. On plan a sheet of glass shows up little if at all, and yet its effect in the gallery may well prove disastrous.

The designer can, if he is able to consider the problem in time, minimise the effect of reflections in the gallery by planning the positioning of the showcases. A certain amount of reflection may be inevitable, but it can be reduced by study at the design stage.

Black and white photographs of an installation can, however, be unduly discouraging. Most of us have two eyes, and with them the power of stereo vision; we can use this to separate the objects seen at, say, five feet from the images of objects some twenty feet away. This faculty of visual separation is there as a reserve; the designer should remove the reflections before they start, rather than requiring the visitor to filter them out afterwards.

It is obvious that a vertical case placed opposite another, or opposite a window, will reflect them, and sometimes the geometry of the gallery makes this unavoidable. In such instances the reflections can be reduced or eliminated by sloping the glass of the case inwards.

There are other ways of dealing with reflections from windows. First, the detail of bars and sashes can be removed by screening the window itself with opaque material, such as plain blinds, gauze curtains, or other transluscent screens, and then, if conservation permits, increasing the light level within the case concerned, and providing a light background. There will still be some interference from the reflection of the window, but it will have been reduced to bearable proportions.

Sloping cases, whether at table or floor level, represent another problem. They are liable to pick up reflections from windows, rooflights, and spotlight systems in the ceiling. Such sloping cases may have to be placed against a wall devoted to them alone, away from the windows and other distractions. There is a price to be paid for such an arrangement. The wall area concerned cannot be used for display, unless that, too, is to be reflected.

Cases 'in character'

So much for the negative 'problem-solving' aspect of the showcase, but what is its positive contribution to the display? In a permanent collection one can argue that the cases should ideally be anonymous to avoid detracting from the objects exhibited. In a temporary exhibition the character of the exhibits and the nature of the topic can be extended and emphasised by the choice of materials and by the style of case detailing used. It may be possible to provide a substantial echo of the original context within which the material was made and used.

Case systems and systems for cases

Where there is a regular demand for cases to take a variety of changing displays, modular exhibition systems, constructed from standard components, have been developed to provide a variety of sizes in showcases.

The initial capital cost will be considerable, but in the long run will be offset by savings on the cost of mounting subsequent exhibitions. Such a system is ideal where the museum staff can change an exhibition themselves, but it is somewhat restricting for designers. The basis for such a system are the external aluminium posts which, if square in section, will restrict the shape of the cases and of the whole exhibition to the square and rectangular. Hexagonal or octagonal post systems give infinitely more flexibility.

Another interesting development involves the use of standard and readily available systems, such as slotted angle and industrial scaffolding.

Vernacular. Portholes 'glaze' these unusual wall cases – a compulsive feature. Where sailors once looked out visitors now peer in!
National Maritime Museum, Stockholm

Right:
Scaffolding poles are clamped together as on a building site. Large glass panels form case fronts and tops, spotlights are hung above. *Sutton Hoo* exhibition, Statens Historiska Museet, Stockholm

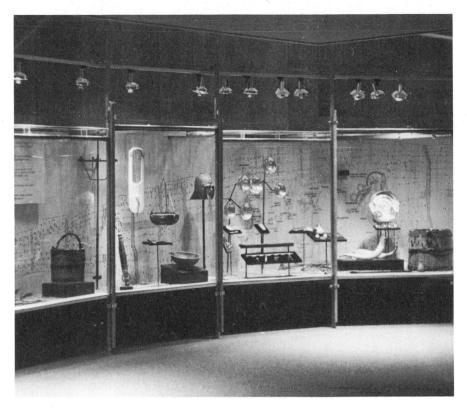

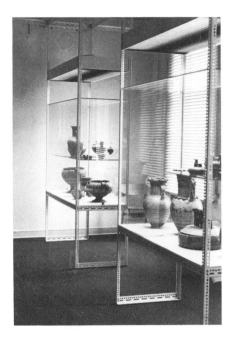

Slotted angle. Readily available metal components are used to form the supports and structural members of these unusual cases. Parts reusable and economical.
Antikenmuseum, Berlin

Building components, such as moulded Perspex roof lights, have often been used to advantage in temporary shows of bold exhibits, although defects and distortion make their use unwise for more permanent displays.

Exterior cases

Some exhibitions are mounted out-of-doors or can be seen from outside through the windows of the museum. In addition many museums use external cases for the display of posters. The specification for such cases has to deal with the extra risks involved. Weatherproofing has to be incorporated into the basic structure and detailing of the case design, and steps taken to prevent condensation.

Case lighting

The lighting of the cases must be planned on the same principles as the lighting of the whole exhibition, each case forming a miniature exhibition in itself, and also being made a harmonious part of the whole scheme.

The same elements must be considered at the two different scales: what point is being made, what style will express it, what are the limits imposed by conservation, maintenance and budget, and what geometry governs the whole scheme, bringing together the angling of the lights and the sight lines of the visitors.

In the gallery itself the designer has more elbow room for his arrangements, but within the case space is restricted, and it is tempting to light the interior from outside. Within the case fluorescent lamps are generally preferred, both for reasons of conservation and also evenness of light cast. However, many of the objects within the case will need special emphasis, or their detail must be brought out, and here low voltage incandescent lights can be used on their own or to supplement general fluorescent lighting of the case.

The maintenance of light fittings and the replacing of lamps and tubes must always be allowed for in the exhibition layout, but this is, of course, particularly critical within the restricted space in a case full of exhibition objects. It is desirable for re-lamping to be carried out without opening the display area of the case at all, which always carries with it some element of risk.

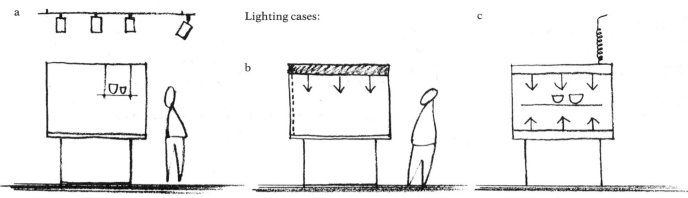

Lighting cases:

a) External lighting: through glass top, but 'greenhouse' conditions may result unless 'cool' light sources used. Objects can cast shadows when lit by slanting light.

b) Integral lighting: light box separated from case interior by diffusing glass or louvres (with clear glass panel preventing dust). Fluorescent for even, well distributed light, or tungsten, for highlighting, can be accommodated.

c) Lighting from below (as well as from upper light box) to reduce effect of shadows and to light undersides of objects. Light source must be masked, usually by louvres.

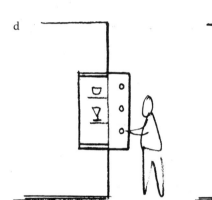
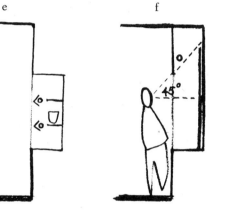

d) Backlighting: fluorescent tubes behind diffusing material, usually opal perspex. Tubes must be evenly spaced, at some distance from diffuser. Ideally, fitted with dimmers to control brightness.

e) Strip lights (fluorescent or tungsten) attached to shelf ends inside the case, illuminating both above and below a shelf. Can only be used when objects do not present conservation risks.

f) Fluorescent lighting: behind case fascia panel (without diffusing panel separating light from case interior). Angles of vision must be calculated to avoid glare from light source.

g) and h) Vertical lighting (plan views): slim fluorescent tubes set in case corners, forming light columns. Suitable for wall cases with solid sides, but can cause glare used in freestanding cases.

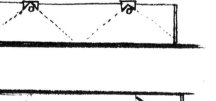

i) Fluorescent column (plan view): set behind case uprights. A possible solution for lighting in old wall cases.

j) Side lighting (plan view): louvres essential to mask fluorescent tubes. Accurate calculations of light spread is needed to ensure even illumination on case back panel.

k) External lighting for shade cases. Problems of glare from light source and possible heat build-up within the case.

l) Internal case lighting: slim lightbox for miniature fluorescent or incandescent lamps. Brightness at eye level should be carefully controlled. Wiring to the lightbox, housed in case corner, may be distracting.

Lighting table cases:
a) Fluorescent light source causing glare
b) and c) Source hidden by a central division or by placing case against a wall
d) and e) Overhead lighting can cause discomfort from reflections in case tops
f) Lamp sources screened; light can be reflected back into case centre by angled mirror.

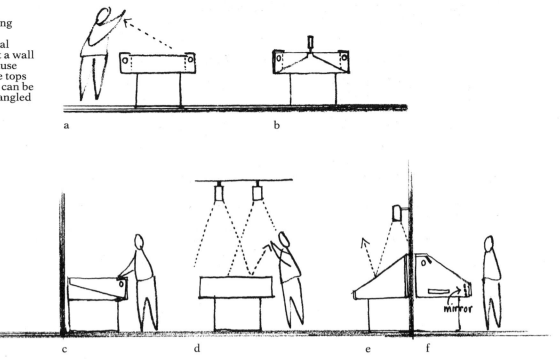

a b

c d e f

As the word implies, the background should remain at the back and appear recessive in relation to the object. This does not exclude the use of a strongly coloured background, provided that its illumination is sufficiently less than that of the exhibit for the latter to appear sharper and brighter than the background. If the display arrangements make it difficult to achieve this difference in illumination, then a weaker background colour should be used.

14 Case interiors

Introduction

Because of the cost, the designer may not always be able to have specially designed and built cases for the objects in a particular exhibition. Standard cases, designed at an earlier time, will often have to be utilised. The objects may be quite out of scale with the cases, and special care will have to be taken to harmonise the two. It may be necessary to take as much trouble with the design for the arrangements within the cases as for the whole of the rest of the exhibition.

The main task in designing case interiors is to ensure that individual objects are presented at an appropriate viewing level, and in suitable light. However, the effect of one case interior must be considered, to some extent, on that of the others in the exhibition.

The objects themselves tell a story within the case, by their grouping, and the emphasis given to them. On occasion it may be necessary to achieve emphasis for a particular object which is neither conspicuously large nor small, and does not possess a very attractive surface. There are no specific guidelines for arranging material in cases. Case dressing is a considerable skill, but in the last resort, it comes down to a compromise between the views of the curator and the designer.

Density

Curators are guardians of a great deal of material. They would like to include as much as possible, and would like the information about it dealt with as generously as possible in the labels. The designer wishes to make the case arrangement immediately attractive, even when seen from the other end of the exhibition, and the material given enough space for each object to be fully enjoyed. Fashions in density of display change. It is worth looking at photographs of arrangements from the past and noting the rich clutter which was seen to be appropriate in, say, the 1890s, and the sparse treatments of the 1960s.

The arrangement of objects in exhibition cases can only be partially determined on the drawing board. Ideally, time should be set aside for 'mock-ups', fitting in the accompanying information with the objects. Sometimes, particularly in loan exhibitions, the objects are not available at this early stage of the project, and the designer may have to work with accurately scaled drawings, or scale models.

The right level

Presented with a few pieces of small jewellery for display in a large empty case, it is immediately obvious that the objects have to be supported to bring them up to eye level, and also that the case must be filled in some way to prevent the exhibits being entirely lost. In fact, this is an extreme example, but any object must be visible, both in outline and detail, and must be given a visual context.

Methods of displaying objects in cases:
a) Glass shelves suspended from underside of lightbox
b) Shelving supported in grooves in back panel
c) Glass shelving supported on proprietary system of brackets slotted into uprights fixed to case back
d) Display table formed from Perspex
e) Table of glass (or Perspex sheet) on either bent Perspex or on cemented glass right-angle supports
f) Glass or Perspex sheet supported on solid blocks
g) Vertical display panels at varying distances from face of glass
h) Panels projecting from back of case for the display of small objects
i) Front block sloped for display of labels, with additional back panel for information or for objects of special emphasis
j) and k) Display blocks: square, rectangular and circular
l) Sloped panels to catch top lighting for displaying small objects

a

g

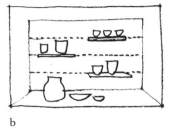

b

h

c

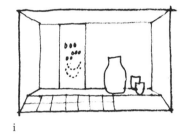

i

d

j

e

k

f

l

'Blocking up': varying levels of square blocks bring objects to visitors' attention. Label text is silk-screened on sloping case edge.
European Terracotta, National Gallery of Art, Washington

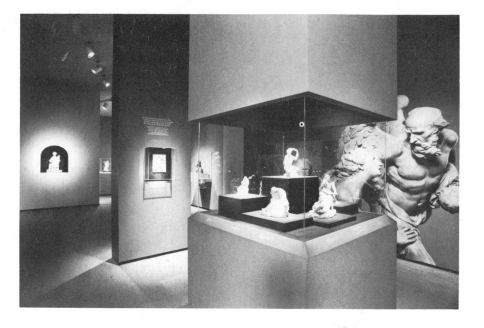

Case blocks

One method of meeting these two requirements has been widely adopted by museums. It uses a series of 'building blocks', usually painted or covered in fabric. With these the designer and curator can raise the exhibits to the optimum height for viewing. This simple solution is attractive because the museum staff can play with the bricks, like a children's game, until an arrangement is settled upon, and the blocks provide a stable support for the exhibits. The disadvantage is that the facets and angles of the blocks are likely to provide visual distractions throughout the case, and further experiment is needed to remove these distractions. Time must be allowed for this stage of trial and error.

The covering of blocks with fabric is easier to specify than to achieve! Frayed edges and untidy corners are most distracting, and the designer may prefer to have the blocks painted and repainted, or made of solid timber with a permanent finish, or of Perspex.

Perspex is a most tempting display material, since it can be used to reduce the effect of density of the case interior; the blocks or supports can either be made from the solid or constructed from sheet material. However, it is not trouble-free. Views can be distorted, reflections can crop up in awkward places, and the electrostatic nature of the material attracts dust, and therefore poses servicing problems.

There are many variations possible in the use of blocks, thin ones being used to form 'tables' or shelves at various heights, and angled ones to provide slopes upon which flattish objects can be pinned, or supported by ledges.

With more time and money at the designer's disposal the blocks can be 'sculpted' to mount individual groups of objects, and here it may be advisable to divide the fitment into sections. It is, after all, one thing to design supports that will nicely fill a case, and quite another to get them in through the case opening!

Case shelves

Shelves, although reminiscent of the 'storage' type of display, have much to recommend them. Adjustable shelving systems can provide support for the objects at the right viewing level, which can be finely adjusted, and this can enable a much greater density of display than is possible with the use of blocks. It is true that any system of this sort may add strong visual lines to the display, but these can sometimes serve to unify disparate elements within it.

Discreet supports between heavy textured fabric-covered panels. The slim vertical channels hold brackets for glass shelves. Fluorescent light diffused through specular louvres.
African Pottery, Museum of Mankind, London

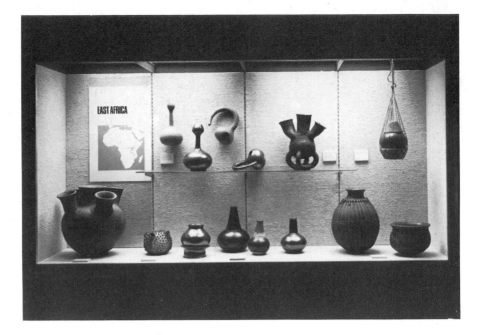

Monumental. Fine materials, simple form: stone base, glass shelves, metal uprights (nothing to tarnish the cathedral plate). The underside of the light box formed from diffusing glass.
The Treasury, Gloucester Cathedral

Related panels in shade and table cases. Both vertical and flat panels are fabric-covered. Labels are positioned to catch light from above.
Golden Age of Anglo-Saxon Art, British Museum, London

The vertical supports of many of the proprietary shelving systems can be fixed to the back of wall cases, and any distracting effect of vertical strips can be minimised by masking with the display panels backing the case. It is also possible to construct cases with columns at the corners, which provide an integral support system for shelving. Alternatively, the case may provide, or can be adapted to take, supports from the underside of the top of the case.

Panels in cases

Wall cases, whether fitted with vertical shelf supports or not, invariably have a back display panel which can support light objects pinned directly on to it. It can also be used to provide the means for fixing the support of heavier objects.

When new cases are being specified, or old ones adapted, it is worth considering fitting a double layer of one of the forms of pinboard on to a dense material, such as chipboard or block board. In such assemblies designers must be careful to check that the materials and adhesives are acceptable to the conservators.

The use of such vertical panels need not be limited to the back of the case. As in the use of 'flats' in traditional stage sets, panels can be brought forward to all points in the depth of the case.

Emphasis

When there are a number of objects in a case one often requires emphasis to provide the 'keynote' of the case. There are a number of techniques available to achieve this.

Part of the glass may be masked, so that the case interior is seen through one or more portholes or slots. The positioning of such openings and the arrangement of objects in the restricted viewing space that they permit can provide a high degree of emphasis.

Much can also be achieved through the careful positioning of the objects. An object at eye level and close to the viewer has considerable impact. If the subsidiary exhibits are some distance further away, the contrast can be quite dramatic.

Another type of emphasis can be achieved by adding a patch of stronger colour or texture to the panel behind or beneath the principal object. It may be possible to provide an individual spotlight for the key object. If it is possible to provide a number of such spotlights and an automatic method of switching them, the objects can be presented in sequence to make a technical or historic point to the display. Where the key object is particularly small it can be backed by an enlarged photograph of it to increase impact on the viewer.

Information and objects

No arrangement of a case can be finalised without full knowledge of the information that the curators feel must be presented close to the objects, and how this fits into the overall strategy for information. A 'heading' may be needed, summarising the contents of the case, perhaps some background information to the display, and individual descriptions and explanations of the exhibits. If the exhibits can be seen from two sides the labels will have to be duplicated.

The moment these decisions have been made the designer must recognise that he has acquired a second set of objects, notices of a given colour, size and shape, and that they too now have to be 'designed' into the whole case layout together with the exhibits originally listed. Each object has to be identified, and where the case is not crowded it may be possible to have a straight ratio of one exhibit to one label. In a display of high density, however, the information about a group of objects may have to be handled on one label (always remembering that if the public have to look too far for information they will give up). Often designers prefer to gather

all the labels on to a special slope, fitted at the front of the case. There they do not compete with the exhibits, and they can be well lit and angled for easy viewing.

Case linings

Backgrounds to objects displayed in cases are an important element in the whole exhibition, since while they are serving the objects in the case, enriching their character and colour, underlining their importance, they are also being viewed across the whole gallery. In the total design for the exhibition backgrounds are acting like wallpaper, their colour, texture, and graphic components all evoking the atmosphere and period of the exhibition. Where the cases are close together their backings will form a substantial proportion of the visual experience of the visitor.

The back, sides and baseboards of the cases are frequently constructed of a layer of medium hardboard, or of a denser board with a cork layer superimposed upon it. On these boards light objects can be pinned and supports for the heavier ones screw-fixed. The boards themselves can be painted or covered with fabrics, chosen so that pinning will not mark them. Fabrics must be chosen from those acceptable to the conservators, and then selected to give texture and weave that 'scale' comfortably with the objects. Hessian will serve for pottery, finely woven silks for jewellery, and so on. The same considerations apply to the use of other materials, acceptable for conservation and suitable in scale of texture and colour. Timber, stone, spray finishes and photographic enlargements may all be considered, but like the fabric finishes, they have to serve twin purposes, enhancing the objects in the case and the total ambience of the gallery.

15 Screens and seats

Introduction: the case for screens

Portable screens are widely used for the display of two-dimensional material and objects in shallow relief. They are also used extensively for graphic and text information. Their use substantially increases the display area, and provides great flexibility within an otherwise fixed area. They can encapsulate groups of exhibits, can emphasise divisions between topics, and can reduce the size of a room otherwise too large. They are also an invaluable tool for the management of exhibition areas, keeping the public out while construction and servicing are taking place.

There is, of course, no ideal all-purpose museum screen, just as there is no ideal all-purpose display case. Many are satisfactory for specific sites and functions, however, and are often used for travelling exhibitions, many proprietary screens being marketed for such purposes. In permanent displays, however, these will often be found to be too insubstantial for the display and fixing of actual objects, and are best restricted to graphic displays.

A brief for screens

The following characteristics are required in screens for museum use whether specially designed or proprietary. They must be stable, adjustable to uneven floors, and must provide firm fixings for brackets and take solid objects or framed material. They should have provision for floor fixing, but no projections to trip up visitors. They should have vertical concealed channels for electric wiring, and surfaces which can be renewed, as required, with paint or covering materials.

Travelling exhibitions need something different. The components should be light enough to be handled by a small team (ideally one person!) and the erection system and instructions should be clear and straightforward. The materials should be as strong as weight and cost permit, the screen detailed to obviate damage through rough handling. Any projections on a screen system may cause damage, be knocked off during transit, or dangerous to handlers. It is desirable, from the outset,

Types of screen:
a) Single leaf: standing on floor.
Projecting feet are necessary for stability but visitors may trip over them
b) Screens joined at right angles, either by clamps or connected to uprights
c) Suspended
d) Braced between upright posts fixed at floor ceiling points
e) Cantilevered or sliding screen

a b c d e

Open timber lattice screen provides
hanging space for architectural drawings
without reducing the gallery area,
already small. The 'see through' aids
security.
The Heinz Gallery, RIBA London
Designer: Alan Irvine

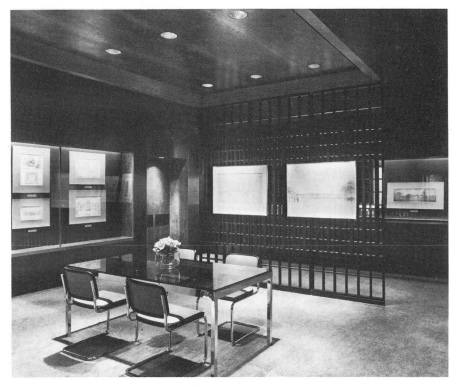

Joined by clamps. The panels are
rectangular, forming (with proprietary
clamps) a single effective information
screen which can be extended and all
parts reused.
Museum of the Tropics, Amsterdam

that racked storage for all components not in use is available as close as
possible to the gallery.

Any system must, of course, be considered in relation to the vehicles
likely to be available for their transportation.

Lighting screens

The benefits of screens can often be outweighed by the problems of
illuminating them satisfactorily.

There are three possibilities. Sometimes a generous provision of floor
outlet sockets is available which can match the geometric grid of the

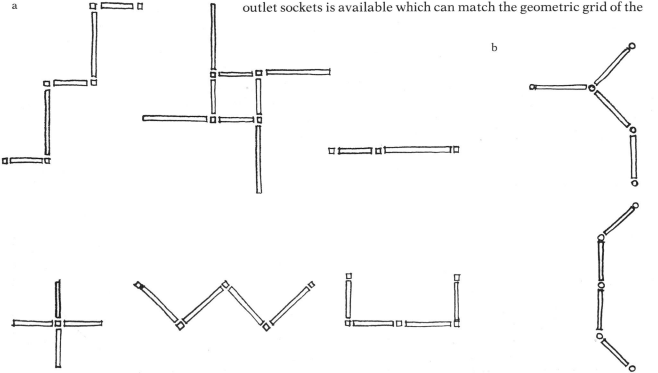

Screen layouts:
a) Plans of a variety of screens
connected to square posts or 90°
clamping mechanism

b) Octagonal posts, circular posts, or
connecting mechanism, provide greater
flexibility on plan: configurations at 45°
in addition to 90° angles

Giant lenticular. Staggered panels, joined at right angles. Below: One angle yields an integrated seascape. Right: Moving adds several other smaller views (all in reflected even light).
The Faroes, Stockholm
Design: Clason & Sörling

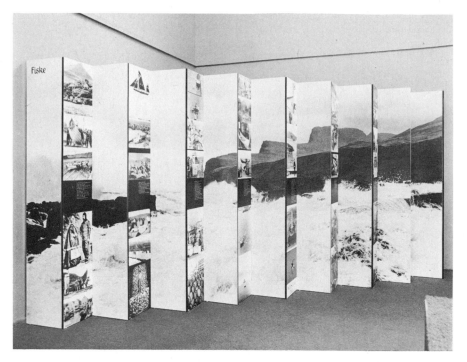

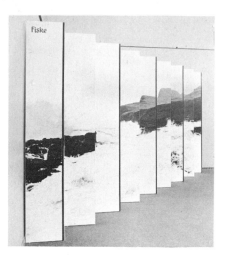

Fabric screens under tension at the entrance to the exhibition. Functioning like panels, silk screened with graphics and information text.
Centre Georges Pompidou, Paris

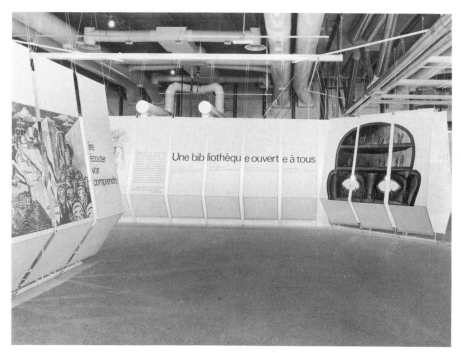

screen arrangement. If so, each screen can have the lighting fitment that it requires.

There may be a similarly flexible source in the ceiling, with a possible lighting track to take incandescent fittings which serve each screen, but in this instance glare must be avoided.

A general diffused lighting system may be the best compromise, using rooflights, laylights or velarium. The daylight from windows of the gallery will seldom, if ever, provide an adequate solution. It usually comes from windows on one side of the gallery, and most exhibitions need to use both sides of the screens for display.

Ceiling screens. Interesting exposed services might detract from exhibits. Suspended, stretched fabric on frames masks pipes, focusing attention on paintings mounted on free-standing screens.
Duchamp exhibition, Centre Georges Pompidou, Paris

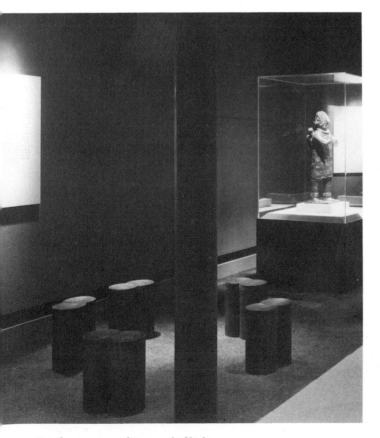

Stools are grouped in a pool of light so that visitors may sit to read catalogues.
Treasures of Ancient Nigeria, Royal Academy of Arts, London
Designer: Alan Irvine

Integration. Seating harmonises with the exhibition content. Stools for warders are formed from plywood, the visitors' simple benches are made of timber.
Great Japan Exhibition, Royal Academy of Arts, London
Designer: Alan Irvine

Seating

However skilfully the designer manages the display of the objects, provides an appropriate atmosphere, and 'paces' the public through the exhibition, some visitors will suffer fatigue. Unless seating is provided they will lean heavily against partitions, screens and cases, squat on the steps and plinths, drape themselves over barrier rails, and even utilise the chairs of the warders!

The seating should be part of the design of the exhibition, and if it cannot be created specifically for it, it should be selected with great care. Space may be at a premium, either because the available area is small, or admission is being charged and a maximum throughput of visitors is desirable and it may be necessary to create minimal seating with benches.

Seating should be provided, however, not only to cater for fatigued visitors but for positive reasons as well. If the overall lighting of the exhibition is low, seats in an area more strongly lit can enable visitors to consult their catalogues in comfort. If the whole exhibition style is strongly evocative, the seating design can play its part in this and reinforce it. The seating should never be allowed to conflict with the overall feeling of the displays. All too often the introduction of warders' chairs into a 'reconstruction' exhibition strike a most incongruous note.

Informal. The octagon shape does not relate to the walls, neither does it compete with exhibits. A suitable shape for a centre position.
Picasso Museum, Château d'Antibes, France

In character. The wooden chairs (and the lectern-like information stand) in this gallery seem to be in keeping with the early seventeenth-century paintings.
National Museum of Fine Arts, Stockholm

Contemporary. In this exhibition of modern art the canvas chairs seem appropriate but somewhat temporary.
Museum of Modern Art, Stockholm

16 Information: the look of the message

The transmission of communications and instructions is a vital part of exhibition design, and the designer is often the only decision maker on the form and methods to be adopted. No one else in the exhibition team is better qualified on matters of legibility and visual acuity, and the designer will therefore make a number of empirical decisions and will implement them.

The designer is, in doing this, functioning as an amateur psychologist in the perceptual and learning fields. Work on similar exhibitions projects in the past, coupled with comments from the users, will have given him a set of guide lines, enough at least to avoid the worst errors. Very few information systems in museums and galleries are disastrously bad, they are usually inefficient, and wasteful of the visitors' energy.

The designers and graphic designers may want to do better, and may then turn to the relevant psychological literature. Unless they have received an appropriate education in a related subject to degree standard (as well as their own basic design training) they will be shocked to find that the findings of the psychologists are not expressed in the designer's mother tongue. A whole vocabulary has to be mastered before the designers find out exactly what they do not understand.

There are few books that attempt to close the gap between the two communities, and this book certainly does not attempt to be one of them. The designers of today should attempt to familiarise themselves with the work of the psychologists, the designers of the next generation will have to.

Editing and the designer

The exhibition designer is not only handling broad principles, circulation routes, and the detailing of major components but is at the same time responsible for the visual appearance, the correct functioning and the appropriateness of the information. This is of the greatest importance, of course, when the exhibition is strongly didactic in nature.

Hopefully, all the information material will have been selected and prepared (with the designer's assistance) at the early stages of preparation for the exhibition. The designer, whether working on his own or with a specialist graphic designer, has to relate the objects and the setting to the means of conveying the information. The words of the editor and the images formed by the graphic designer are always part of the three-dimensional designer's responsibilities.

The graphic sweep

The exposure of a member of the public to the graphic design of a temporary exhibition, or new permanent exhibition, starts with the advertisement in the paper, or the poster on the notice boards of the colleges, schools and libraries. Here the first images and messages are being fed into the potential visitor.

London and the larger cities carry the poster in public transport, and the museums chivalrously advertise each other. Much more propaganda can be deployed, but against strenuous competition. In a metropolitan

Range of information to be designed for visitors before, during and after visiting an exhibition. All should be designed within the exhibition 'house style'. Not all exhibitions need every item.

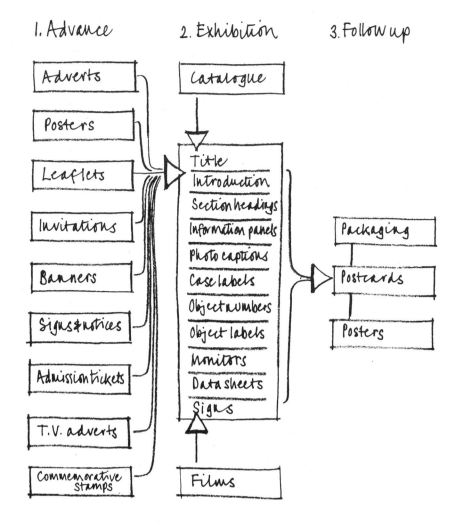

1. Advance

Adverts
Posters
Leaflets
Invitations
Banners
Signs & notices
Admission tickets
T.V. adverts
Commemorative stamps

2. Exhibition

Catalogue

Title
Introduction
Section headings
Information panels
Photo captions
Case labels
Object numbers
Object labels
Monitors
Data sheets
Signs

Films

3. Follow up

Packaging
Postcards
Posters

Duplicate display! A single poster often gets lost when displayed on its own. Grouped here as a pair they command attention even in competition with cast-iron railings.
British Museum, London

92

24 hour publicity. A giant sign on a hoarding on the front of the building, floodlit at night, announces the temporary exhibition.
Royal Academy of Arts, London
Designer: Alan Irvine

Competition and repetition. All print competes for attention and advertising most of all. Bold 'logo' titles like this also appear on the exhibition poster, leaflets, admission tickets, banner and title.

Geffert, Kynaston, Marsden Thomas, Pierre, Reilly, Rennert, Trotter, Wagler, Watts.
Full details and tickets (evenings £3.50, OAP and student £1.75, lunchtimes £1) available from Barbican Centre Box Office, Level 7, Barbican, London EC2. Tel 01-638 8891 or 01-628 8795. All credit cards accepted. Tickets also available at the church 30 mins before each performance.

Art Galleries

THE HIDDEN PEOPLES ▼▼▼ OF THE ▼▼▼ AMAZON
An impression of life and culture in the tropical rainforest
For recorded information telephone 01 580 1788
Admission free
MUSEUM OF MANKIND
The Ethnography Department of the British Museum
Burlington Gardens, London W1X 2EX

setting the poster has to attract the visitor who has seldom or never visited the museum before. Place, time and charges have to be made explicit, and enough information provided to steer the visitor to a territory perhaps seldom visited before, if ever.

Everyone working in a museum has had the wry experience of helping a lost visitor who is standing, still bemused, in front of the very entrance. The experienced designer will provide a clear message on the building, 'you are here'. Large hoardings and banners may be necessary to demonstrate the title and range of what is being exhibited, and to incorporate as much ancillary information as possible, without detracting from the central message.

Guidance by graphics

The feeding of messages to the visitor never ceases. Every panel of information, every label, is part of a 'continuum', with the style carrying on through items large and small. The skills of the editor and graphic designer act as a substitute for those of the museum guide as if there is an informed person always at the visitor's elbow, using the same vocabulary and assuming a constant level of understanding or ignorance on the part of those being guided.

It can be difficult for the design team to impose this continuity of style on material which may be supplied by subject specialists in fits and starts and out of sequence. It will often be of advantage if everyone has agreed and understood the styling for the presentation of information before the flow of text has started to arrive.

Signs and titles

Whereas in many object-orientated exhibitions typography is intended to be self-effacing, allowing the objects to 'speak for themselves', entrance signs have to attract attention, mark an event, and be memorable. They are within the style, but slightly above it. In many exhibitions a single unique exhibit is selected to be featured as a 'logo', for use graphically on printed publicity material and repeated on hoardings and banners at the entrance. Ideally, the symbol must arise naturally from the material.

Banners, provided there are no objections from the local planning authority (and there shouldn't be), attract attention admirably. They can

Identity. The title at the entrance is bold
and the 'logo' instantly recognisable to
visitors who have already seen the
posters and advertisements.
Royal Academy of Arts, London
Designer: Alan Irvine

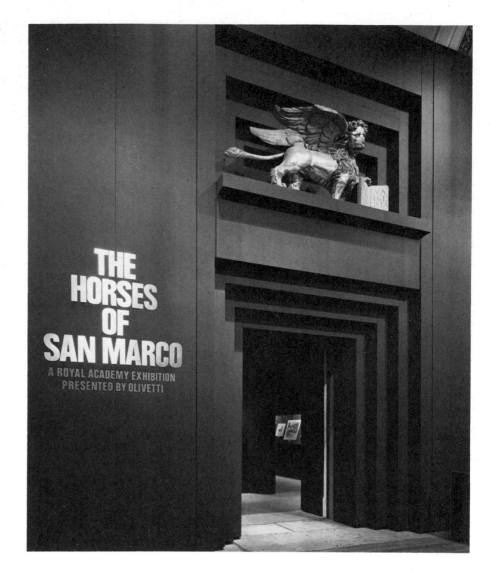

Solid advice. These square direction signs
display pointers to all the areas in the
museum. Repeated on all levels they
provide direct, discreet prompts to the
visitors.
Van Gogh Museum, Amsterdam

make an austere public building less forbidding, and show that it is truly
'open for business'.

The designer should never underrate the importance of the typeface
selected for his exhibition. It has to reflect the style (and even period) of
the exhibits or topic. The chosen face may be used in a number of 'media':
three-dimensional letters in differing finishes, signwritten, silkscreened,
printed, and photographically enlarged. The title, in the right typeface
and setting, introduces the visitor to a new environment. He is aware of
stepping into another culture and another time, and he knows that the
exhibition has really begun.

Introducing the subject

The opening sections of an exhibition make a number of assumptions
about the knowledge and interest of visitors. Will they know, for instance,
the date of Captain Cook's birth, or the whereabouts of Thebes? And even
more important, will they be able to enjoy the exhibition if they are not
given such information?

At this opening stage, just beyond the title, the organising team will
have had to make very important decisions about how they are going to
'orientate' the visitors to the subject matter, what information it is
necessary to introduce and assuming it is imparted by the printed word,
how it is to be positioned. Here the relationship of the information to the
whole structure and its integration into the main design is very important.

The visitor is being propelled into a new atmosphere, different from his
home, the street, his transport, and even the entrance hall of the museum.
The light levels may be different, and he has to adjust to these. The level

Orientation at the entrance. The visitor
'adjusts', needing time and space to
discover the exhibition's scope, the era it
covers and what objects will be on
display.
Museum of Mankind, London

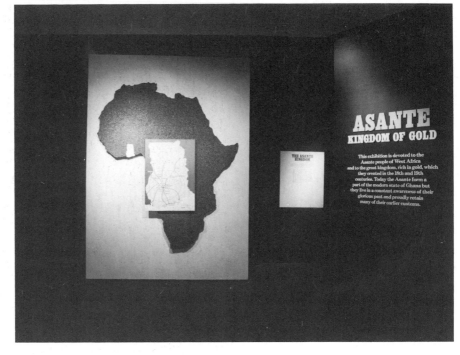

Seen from above. A life's work displayed
on the museum walls, but visitors first
study the painter's life on sloped
information panels near the entrance.
Van Gogh Museum, Amsterdam

and volume of text is critical. The visitor needs assurance and a clear idea
of what is ahead, and what to do to enjoy it; but even in a didactic
exhibition he cannot stand and read an essay. The balance has to be
studied carefully.

Graphics and the third dimension

Most of the information about the exhibition which is on show outside is
designed 'on the flat'. The graphic designer cannot necessarily control the
placing of advertisements in newspapers, nor the position of posters and
the competition to which they may be subject. However, inside the
building, the designer *can* exercise control, and the co-ordination of two-
dimensional and three-dimensional design is vital if the whole system is to
work.

Artwork is usually seen on a drawing-board under a good light. When
the result is viewed full size in an exhibition gallery under a light dimmed
for conservation reasons the balance of the design is quite altered. Size of

Positioning. This enables things to attract
the visitor's eye. This diagram, drawn by
Herbert Bayer in 1929, shows the many
planes that the exhibition designer
commands.
Werkbund exhibition catalogue

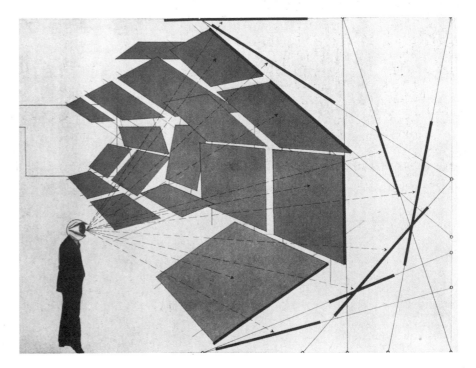

a

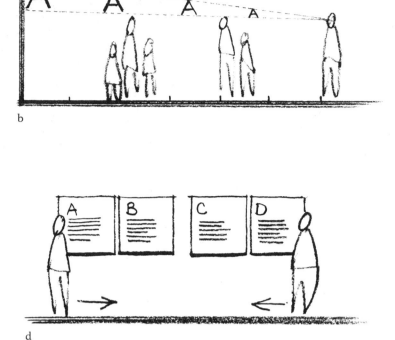

b

c

d

e

f

a) Viewing angles: for reading labels on shelves of different heights. (A small-scale version of Bayer's extended vision diagram.)

b) Lettering sizes for titles: these must relate to the intended first viewing distance. To be positioned at a height which can be seen over the heads of visitors in front

c) Type-size guide for information panels. Line length (at say 90 mm) in the hand-held catalogue needs enlarging to a width of 300–350 mm for a wall display

d) Matching text to the direction of travel here, easier to read left to right

e) 'Stacked' visitors reading text may cause 'bottle-necks'

f) Information 'layering': general information, in large type informs at a glance above the heads of visitors engaged in reading detailed information in smaller type

type assumes a new importance in relation to the spaces available and the vision of the visitors. The graphic designer must always cater for less than perfect sight.

The graphic design may be obscured by the visitors themselves. Sight lines for all main headings must be checked to make certain that they can be read above the heads of the crowd. It is also useful to identify the most essential and critical items of text. If they are placed badly, and then missed by the visitor, the whole of the thesis behind the exhibition can be missed; if they are placed badly on the plan a bottleneck will result.

Co-ordination between the three-dimensional designer and the graphic designer is also critical in securing the desired flow through the galleries. The information must not only be placed for easy reading, but also in such a way that the flow is encouraged (meeting a sentence for the first time at its end is most uncomfortable). Every notice will have implications for the flow and it is useful to check and indicate these 'implications' on the plan.

96

Information panels

There are certain points in an exhibition which require substantial text; the objects can be meaningless without the background of their origin and use being made clear. Large portions of text sit uncomfortably on the label of an actual object, and destroy the appearance of the case arrangement. Some other presentation is needed.

There are a number of ways of presenting substantial portions of text, but the commonest is that of the 'information panel', which corresponds to the enlarged page of a book. Often these panels include photographs and diagrams, sometimes even small objects are included by mounting them close to the related text (indeed, many exhibitions consist entirely of panels of text and illustrations). The materials and methods used to make these panels are related to the planned life of the exhibition. For many purposes, typeset information can be enlarged photographically and mounted on one of the proprietary boards and heat-sealed. For greater permanence the text can be silk-screened, or encapsulated in plastic laminates. The method of production of the information board governs its appearance and size. The very ease of production has made it widely used, and familiarity has reduced its impact for the designer is using what amounts to a visual cliché.

Before the information panel had been fully developed information was often put directly onto the backs of showcases and the gallery walls by a sign writer. Such a technique gives the designer greater flexibility, and there is a lot to commend it where the information is required to merge into the background, rather than to compete with the objects exhibited. However, the designer has to make certain that the signwriter knows exactly what is wanted. All the rules of typographical design apply, and signwriter and designer must together find the length of line, the design of lettering, and the size of letter that fits the job. The use of a craftsman in this way does permit some judicious testing and experiment before the whole text is put in hand.

Labelling the objects

The sequence in which information is set out on labels must be standardised to help the visitor. This has to be organised at an early planning stage of the exhibition. It is a complete waste of time to design labels for objects unless and until this has been done.

Left:
Choice overhead. When crowds obscure the view, how do visitors select a case to study? Displays are identified above, and below, between cases, more detailed information is displayed.
The Vikings, British Museum, London
Design: Robin Wade Design Associates

Below right:
Absorbing text. A visitor spends time digesting two-dimensional facts, but he, lighting and panel are all within three dimensional design.
Captain Cook in the South Seas, Museum of Mankind, London

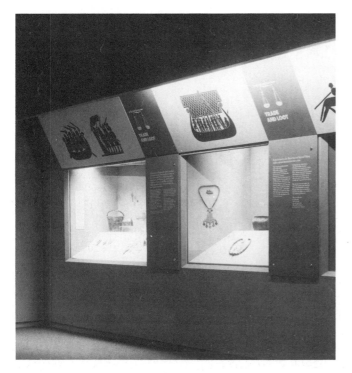

Facts in a case. Footwear is described on the information panel in general, on the object labels in particular (royal figures in background).
Asante: Kingdom of Gold, Museum of Mankind, London

Dichotomy. Lengthy texts often interfere with aesthetic experience if both are presented together. Here objects can be enjoyed without text: pull-out panels yield information if required (or even a secondary collection).
Museum of Far Eastern Antiquities, Stockholm

The considerations are:

The positioning of the label and its information in relation to the object
The label may be placed adjacent to an object or at some distance; in the latter case, some means of 'keying' the two together may be needed.

The overall appearance of the displayed objects and their accompanying labels
The overall appearance of a display is spoiled by labels that have been trimmed to different sizes. The labels should be of uniform size, edited and designed so as to accommodate the agreed maximum number of words and symbols. In an art exhibition the labels must not risk detracting from the exhibits. To prevent this it may be desirable to bank a number of labels together, below or to one side. The route for the visitor's eye between object and label must be checked to see that no undue effort is required.

'Keying' of labels
Where there is a danger of individual labels overwhelming small objects they can sometimes be banked together some distance away. This means that the object and its supporting information are no longer taken in by a single glance of the visitor, and the object will have to be keyed to its label by a number. To make recognition and identification easy the number near the object should be in the same colour and typeface as that on the label.

Recognition will be aided if the apparent size of the two numbers is the same from the expected viewing position. If the object number and the label number are roughly the same distance from the eyes of the visitors they should be of the same size. If the distances of the two numbers are noticably uneven, the further of the two numbers should be enlarged to compensate.

'Keying' of information
In a display where object labels would look totally inappropriate, such as in models or reconstructed scenes, an identification key should be used to

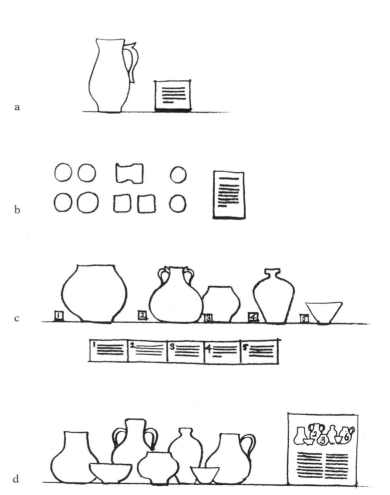

Labelling the objects:
a) The one-to-one relationship of label to object
b) Group label where information applies to several small objects
c) Keyed numbers relating to banked labels or to a group label
d) An identification key on a label

98

Portable information:
a) Labelling through the catalogue
b) The portable label, using key numbers
c) The portable audio-guide providing both identification and commentary

a

b

c

Options. Information can distract attention from objects. Add a translation and objects can be overwhelmed. These portable second-language cards free display space.
St Catherine's Convent National Museum, Utrecht

tie the label information to the point to which it applies. Numbers on a photograph or outline diagram can be used to locate the various pieces of information. The drawback is that this method requires keen interest and close attention from the visitor. The link will be more easily established if the drawing or photograph of the scene or model is taken from the position where the visitor reads the label.

Portable information

It may be clear at the planning stage of an exhibition that text in the galleries themselves must be kept to a minimum to allow concentration on the objects on display. It may then be necessary for alternative channels of information to be developed. A catalogue can be designed and produced for the visitor to take round the gallery (with the benefit of recalling the exhibition later at home). A free leaflet can be provided, or a portable label of 'paddle' type returnable at the end of the tour. What are the design criteria for these items?

First, all items must be designed in the same graphic and typographical style as the other information in the exhibition. Second, the use of all the devices must be catered for in the overall design of the exhibition. How

much light will the print receive in the gallery to make it readable? Does the amount of information suggest seating from which it can be read? Can the reader be certain of finding the exhibit in the gallery from the description?

Picking pictures

During the last few years techniques have been developed which will enlarge colour photographs to vast dimensions. It is true that neither these nor the simpler black and white enlargements are cheap, but they do put a range of possibilities at the designer's disposal, and also pose a number of design problems. Smaller photographs can easily be fitted by the graphic designer into the disciplined layout of the information panel or the back of a display case.

For the three-dimensional designer the risks posed by giant enlargements are much greater. However effective large enlargements may be, they possess a texture or grain which can be disturbing. As a background to a display, and at some distance from the viewer, they can be very effective, establishing a context for, and a landscape behind, the objects on display. If, however, they can also be viewed at close range as the visitor travels through the exhibition the texture can be distracting. Before planning these enlargements care must be taken to draw, on plan, the positions from which they can, and should not, be viewed.

The images within these giant enlargements can pose problems. For instance, if a number of landscape images which can be viewed together, are present in the same gallery, care must be taken with the scale of enlargement and the positioning on the walls or screens to make certain that the horizon lines of all the pictures are level. The need for this may well lead to the rejection of otherwise excellent pictures.

Where figures are involved a similar need for consistency arises. A key figure in each picture should be selected which can then be enlarged to a size constant throughout the display. Another factor involved in the enlargement of figures concerns size as this approaches that of the visitors to the gallery. Whereas on a small scale, when they form part of the illustration image they have no more effect on the whole design than other elements in the illustration, as they approach full size they have a positive relationship with the live figures in the gallery. It may be useful to enlarge them to life size, but it will be necessary to carry out a precise study on the design drawings to ascertain how the enlarged figures will actually appear in relation to the layout of the gallery as a whole and to the visitors in it.

Below left:
Multiplication. Display provides model, projected picture, map and text. Visitors are drawn by their preferred image to the story in the text. Roman Palace and Museum, Fishbourne, Chichester
Design: Robin Wade Design Associates

Below right:
Bird's eye view. The model introduces the exhibition subject. Mounted vertically on the wall, it saves space. Viewed in conjunction with giant photo enlargements of volcanic scenes.
Pompeii, Royal Academy of Arts, London
Designer: Alan Irvine

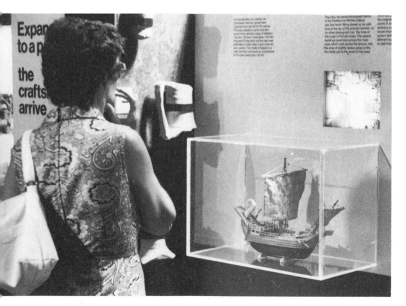

The model as information

Certain kinds of information can best be transmitted through a model. A scientific process or an historical scene, when miniaturised, can appeal greatly to the curiosity of visitors. The designer must bear in mind, however, that the medium of model-making is expensive of time and resources, though if enough information can be bunched together through using it a model may in reality be very economical. A whole series of models may sometimes be appropriate, if funds permit. They can, if necessary, be mixed with other methods of communication, such as information panels. It is necessary to standardise the scale and finish when more than one model is viewed at a time or within a sequence.

Audiovisual devices: the expectations of the visitor

Exhibition design has to contend with the blunt fact that as a medium it is one of the least stimulating channels of information that visitors are ever likely to experience. Colour TV, the high standard of colour printing, and microchip games and gadgets provide a level of stimulus in the home which may make the museum seem as quiet as a cloister. Though quiet may be what some visitors have come for, for others the placid face of the museum display will appear alien.

The inclusion of audiovisual devices is often seen by curators and designers, mistakenly, as a simple method of appearing up-to-date, as a recipe for instant success. Nevertheless, such gadgetry is an element to be deployed if and where appropriate; the expense will only be justified, however, if the devices are completely integrated within the overall design.

Audiovisual combinations

Devices can be extremely attractive to the visitor and designer alike. But to avoid confusion they must be deployed strictly according to the exact function that they fulfil in transmitting information.

The programmes, whether audio or visual or audiovisual, can be divided into those (like labels or information panels) that exist to supplement the objects exhibited, and those (like TV programmes, lectures or paperback books) that are a substitute for them.

The devices concerned, and the controls behind them, are also of two sorts. First, where the audience itself summons the material from the devices, by operating them involving what is currently called 'interactive programming'; second, where the audience is passive, in body if not in mind and the material is transmitted to them 'automatically', 'willy nilly'!

This division between the passive and the interactive is not a new one. An advertisement hoarding is passive, while a reader has actively, to turn the pages of a book. Technical complexity of the medium does not affect this division. The hoarding may be illuminated by lasers, and the book replaced by a computer-assisted display terminal but the division between passive and interactive remains.

The machines in these categories, and the means by which they are operated, are merely devices to deliver programmed materials. It is necessary to establish exactly what role a machine and its programme are being called on to perform. There are at least four discrete roles. First, as in a TV programme, the performance can be a complete substitute for the material of the exhibition, and the story being told about it. Second, the device and programme can be used to stimulate, for example the sound of an indigenous tribe and the flickering light in a jungle. Third, it can evoke, for example the playing of sea shanties behind a display of nets and ship models, and fourth, it can supplement information, providing a map behind an object display, or a commentary to a picture.

Talking points. The guide is an audio 'wand', so the showcase text can be reduced. Gallery plan must allow for users lingering without blocking circulation however.
Treasures of Cyprus, American Museum of Natural History, New York

Circumstances alter cases. All two-
dimensional notices need to be checked
with the three-dimensional design when
the exhibition is in use.
British Museum, London

Types of audiovisual presentation

Combined audiovisual techniques can be used to create a total
programme about the subject of an exhibition or can be used to
supplement the display. They can take various forms: multiscreen tape-
slide presentation, simple single screen, loop films with commentary or
video taped programmes. A visual display of slides alone, possible with
caption slides interpolated, is more often confined to the supplementary
role.

Sound in the exhibition can be worked into a total programme to
provide commentary; simulated background sound effects or music can be
a supplement in the whole display area, especially if this is designed in the
form of a reconstruction or is a total 'experience' such as the *Spotlight*
exhibition of ballet costumes at the Victoria and Albert museum in 1981.

There are problems in confining sound in a gallery in such a way as to
relate it to a single display alone. In such circumstances it is usually
supplied through directional speakers, headphones, fixed listening posts,
telephone handsets, wands or sound guides. These outlets will dictate the
organisation and treatment of the recording to be played through them. It
is, for example, inappropriate to receive a dramatic programme through
ones ear's when scrutinising details in a display case!

Siting audiovisual installations in the exhibition

The location of audiovisual presentation points will depend upon their
function within the total exhibition strategy. There are certain placings
where they could prove a positive impediment to the 'argument' being
advanced by the display. Some of the av material might be grouped

Immediate information. Presentation can
be triggered by proximity devices. This
monitor, pillar-mounted, heavy-based,
can present video film providing
background information encapsulated
amongst exhibits.
Museum of the Tropics, Amsterdam

together in an 'orientation' area at the start of the exhibition; in Colonial
Williamsburg this material is in a separate Visitor Centre, away from the
historic area. 'Cinema pods' can be designed into the display, bunching
the viewing audience together. Or, at the end of the exhibition, the
material can be located in a lecture theatre, acting as a 'follow up' to the
exhibition proper.

Wherever the av stations are located, they will attract groups from the
total audience, and these must be allowed for in calculating the
'throughput' of the design. If the individual stations are small there are
likely to be queues before them, which will interfere with the general
traffic through the circulation areas. The designer has to find an equation
to balance the capacity of each av station, the estimated rate of visitors,
and the duration and frequency of the programme. No calculation will
avoid a need for positive control of admission at peak periods, such as the
arrival of coach parties. The designer may not play any part in the content
and production of the programmes, but he must be aware of the duration
and intervals as a part of his control of the total flow through the
exhibition.

However good the programmes, visitors will not stop and view them in
discomfort, so each station must be carefully designed, like a mini-cinema.
The electrical supply must be at hand, clear access available for servicing
and maintenance, and great care taken to check the eyelines of the
audience. The control method used, proximity switching, control by the
visitor, and automatic repeats will all affect the design of the station. If the
demand upon it is very variable it may be necessary to provide space for
control of the equipment by the gallery attendants.

The designer also has the very difficult task of confining the sound to the
areas to which it relates. Moreover, the warding staff may have to suffer it
for many days on end. Unless the designer has had considerable acoustic
experience it is wise to allow considerable time for experiment and
adjustment to such sound stations well in advance of the opening of the
exhibition.

Avoiding or limiting audiovisual disasters

Many curators and designers have been frightened off using audiovisual
techniques because of the cost of the original installation and of the
creation of programmes of a high standard with appropriate treatment.

Continuous maintenance and supervision will be needed throughout the
life of the exhibition, which will make a demand on the museum staff.
Equipment breaks down, audiovisual equipment is no exception, and the
timing is always inconvenient! Ideally there should be standby equipment
close by so that any bit of hardware can be replaced with the minimum of
interruption. In the same way, the programme material, discs, tapes,
slides, films, etc must also be duplicated, in their entirety, and the
damaged programmes must be replaced or repaired immediately.

When failure does take place – the programme going 'on the blink', the
attendants must be able to switch off the whole installation without delay.
To cover the vacant space in the gallery (and the gap in the story) the
designer must have provided an alternative source of information which
can rapidly be brought into play. The av station must have its 'failsafe'
designed with it from the outset; substitute text and pictures should be
such as to be pulled across the vacant area with little or no effort or skill.

17 The take-away factor: the exhibition shop

Strengthening the message

The final (and in many ways, the most) interactive display in an exhibition is the sales area or museum shop; where the visitor can obtain further information on the subject of the exhibition from related books and can buy facsimiles of some of the objects seen in the exhibition.

The shape of the shop

As part of the design brief, the designer will have obtained the main requirements for the organisation of sales areas. The siting of these, either at the beginning or end of the exhibition, will, to some extent, depend on the overall merchandising policy of the organisation. Staffing restrictions may not allow for a special exhibition sales area apart from the main museum shop, in which event the relevant merchandise will be displayed at both ends of the exhibition with directions to the shop. The ticket sales point or admission desk may double as a catalogue sales point.

The layout of sales areas must take into account the estimated peak attendance numbers to the exhibition and cater for maximum crowds wanting to purchase the cheaper items, usually postcards. The sales of more expensive items, replicas (for which there will be security requirements) and books will need separate counters for browsing by the visitors. The designer must also make provision for the area to be warded effectively. Unless the layout of the exhibition can provide ample storage space, the designer could find his carefully detailed sales area resembling a small warehouse, with packages, piles of catalogues and books stacked in every corner!

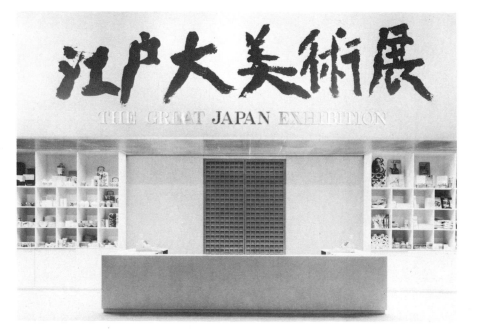

Designed commercialism. This looped routed exhibition brings entrance, exit and shop together prompting visitors, twice, to buy. Shop storage doors are decorated with Japanese lattice motif.
Royal Academy of Arts, London
Designer: Alan Irvine

The graphics of packaging

The souvenirs, posters and catalogues purchased at an exhibition should be seen as an extension of the publicity material and designed accordingly. Packaging, paper bags, and carrier bags, as 'walking publicity', are an ideal vehicle for the exhibition logo.

Specialisation. Posters need different display and handling to publications, replicas and cards. Here they are located in a separate self-service unit.
Treasures of Tutankhamun, National Gallery of Art, Washington

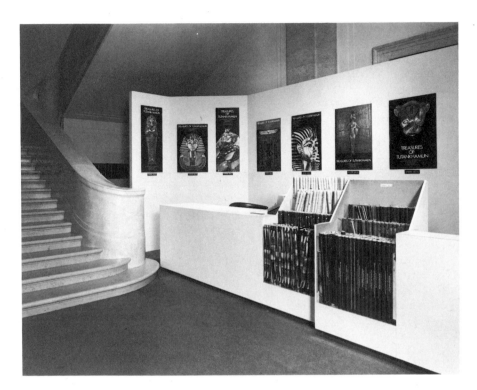

18 The designer communicates

The designer has his brief

There comes a time when the designer can be said to be sufficiently briefed for the actual 'design stage' to commence. Information will have been assimilated about the objects themselves, the site, the anticipated audience, the available budget, the expected life of the project, the conservation and security hazards, and possible containers for the objects. The designer cannot spend any more time in research but must actually sit at the drawing board and produce a design! The first design task is a mechanical one, to draw all the objects to be displayed to the same reduced scale. The curator will want to know if all the objects selected can be accommodated in the exhibition, and this checking of dimensions enables the designer to give a clear assessment at the outset.

Of all the activities in which the exhibition designer is engaged the actual creative design process occupies a comparatively short and concentrated period. The research, the administration of the project, and the site supervision take up a far greater proportion of the designer's time. Students tend to find this hard and painful to grasp.

The 'design process' is mysterious. It is difficult for the uninitiated to see where the successful designers have gained their ideas, and how they have arrived at a final solution. Often the designers themselves can only partially account for their train of thought.

Analysis and synthesis

If the design process is seen as a form of management the designer can simply follow a logical procedure step by step, and the 'answer' will come out in the end. Certainly the first stages of any design process are clear-cut and sequential. Through the brief the designer has acquired the client's requirements. The various restrictions which impose themselves on the project (limits of space, time, resources, funds) have reduced the number of solutions possible. 'Originality often follows in the course of an analytical working process. This logical approach represents no monopoly of the exhibition designer but is the basis of all good design.' (Herbert Bayer, *Curator*)

When all this material and information has been assimilated by the designer the synthesis of the design takes place. Treating the designer as a sort of computer, two kinds of factors are fed in; we can call them 'hard' and 'soft'. The hard are expressed in months, pounds or dollars, square metres. These are tangible, and can be quantified.

The 'soft' factors are not capable of such tight expression. This is the area of feeling, often described as 'intuition'. The designer will be using a visual language. His client must understand and share it. What is more, in the case of the client who is a museum curator, the public is the client's client, and they in turn must share or at least understand the designer's language. This language is made up of a number of idioms which he has acquired from training and experience, and even a few new idioms which he has generated to meet particular problems. (See 'The designer's idioms and devices' on page 127.)

Sequence and order

Hierarchy and structure for the various pieces of information evolve from discussion between curator, editor and designer. This will suggest the basis for the plan for the exhibition, but the realities of the site may make it necessary for the designer to extend or compress some of the sections of the subject matter, adjusting the density of the objects within a given space. It is here that the original grading of the objects into categories of essential, desirable, and optional will prove invaluable. This gives the designer room for manoeuvre without upsetting the plans of his curatorial colleagues in the team.

Style and imagery

But what will the exhibition look like? Important signals will be given to the visitors by the colouring and treatment of the different areas. Symbols and images often suggested by the objects themselves will indicate other areas, other places, even the passage of time itself. A critical trip through a well-designed museum exhibition will reveal all kinds of special images and idioms: the altar, the shop, the library, the terrace. In each case the designer is sending a special signal to the visitors, a form of covert message that he trusts will intensify the overt messages of the objects and texts that come from the curator.

Visitor expectation

The designer must take into account that the visitors will arrive with certain expectations. They will already have been conditioned by a range of design styles, materials and finishes such as are found in a number of public interiors: airports, coaches, restaurants, public houses, jewellers' shops, boutiques, travel agents, supermarkets.

The designer cannot hope to design for the whole of mankind. He will be working to a set of fairly fixed expectations, and he will have to decide if he will respect the conventions to which his public is accustomed. For instance, will he choose to display jewellery in small cases, backed by velvet and fine silks? Or is it necessary to make a positive point by displaying material in an unfamiliar way?

Fashion is changing the experience of the public all the time. So the public and the designer are both part of a moving system. Even the materials used in the exhibition (exposed, natural timber for instance) serve as a signal to the visitor. Are the materials familiar, echoing the appearance of the contemporary home? Or are they rare, signalling exotic novelty of some kind, another place, another age? Sometimes a gallery will signal one thing in its proportions and general style, and quite another in its details, materials and finishes.

Pacing

The designer may use various techniques within the gallery space to orientate the visitors and to organise their circulation. Attention must be attracted, directed, and deflected, and the pace of viewing must be controlled to emphasise the most important objects and the most significant points. What is more, the visitor must be encouraged to go further. The designer must always bear in mind that the visitor is a wasting asset, by reason of cumulative fatigue!

The various devices and idioms by which the designer achieves this control do not dictate the style of the exhibition, but they have to be derived from and deployed within it (see page 127).

Briefing the client and the exhibition team

Before the designer sits down at his drawing board he will need to check that the rest of the team have understood the techniques that the designer will be using to communicate with them. If the other team members are not design-trained they will not necessarily appreciate the type of craftsmen and contractors who will be involved in the building of the

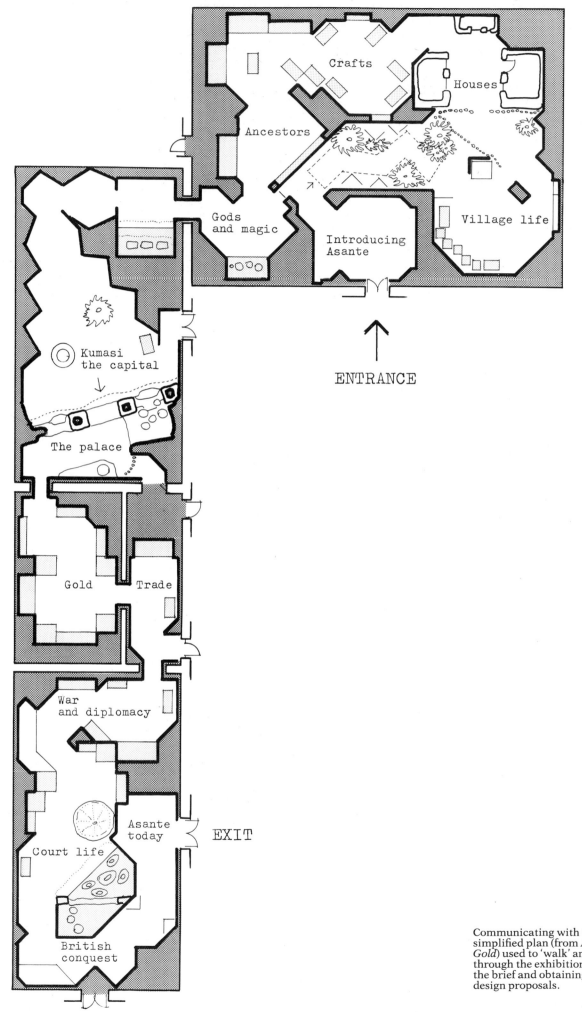

Crafts

Houses

Ancestors

Gods
and magic

Village life

Introducing
Asante

↑

ENTRANCE

Kumasi
the capital

The palace

Gold Trade

War
and diplomacy

Asante
today

EXIT

Court life

British
conquest

Communicating with the client: a
simplified plan (from *Asante: Kingdom of
Gold*) used to 'walk' and talk the client
through the exhibition making sense of
the brief and obtaining approval for the
design proposals.

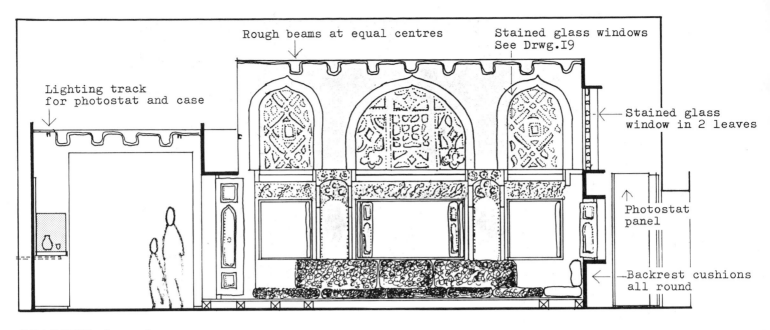

Rough beams at equal centres

Stained glass windows
See Drwg.19

Lighting track
for photostat and case

Stained glass
window in 2 leaves

Photostat
panel

Backrest cushions
all round

SECTION A - A

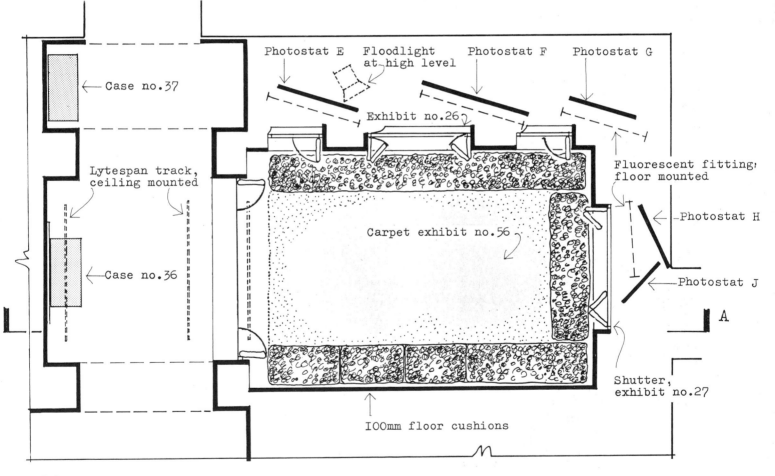

Case no.37

Lytespan track,
ceiling mounted

Case no.36

Photostat E Floodlight Photostat F Photostat G
at high level

Exhibit no.26

Fluorescent fitting,
floor mounted

Photostat H

Carpet exhibit no.56

Photostat J

Shutter,
exhibit no.27

100mm floor cushions

A

PLAN

Communicating with the contractor: the
designer's intentions made clear on plan
and elevation for a reconstructed *mafraj*.
(The completed display is seen on page
197).
Nomad and City, Museum of Mankind,
London

exhibition. If intentions and terminology are misunderstood later on, the designer is to blame.

In the course of design and production there will be a number of potential crises to be avoided or weathered. The designer must make certain that his role is understood, that possible causes of delay are pinpointed in advance, and the various stages at which the appearance of the exhibition will be presented to the team are programmed. Efficient presentations are not only good manners, they also prevent time- and money-consuming revisions of the scheme.

Every designer has a preferred method of presenting his needs. Sometimes an illustrated document or report seems to speak most clearly to the client, sometimes a conducted visit to a similar project or site is best. A well-organised and prepared tape-slide or video tape presentation has many advantages, if the resources are available. Such a 'canned' presentation provides an explanation of the project for the client and also makes available material by which the 'house rules' of the museum can be explained to new members of the design team and academic staff, and also to student visitors.

Communication within the design team

When more than one designer is involved in visualising and producing an exhibition communication difficulties can arise, even when the three-dimensional ('3D') designer and the two-dimensional graphic designer are able to work in the same office. There are an enormous number of separate parts in an exhibition. Each designer will have a slightly different network into which their tasks have to be fitted, and these networks will have to be connected to become effective. (This is the price to be paid for securing greater design expertise in each of the two areas.)

Ideally the two designers should be working in tandem from the very start of the project. The 3D designer will normally lead the team, having overall responsibility for determining the structure, meeting the construction deadlines, and controlling the major portion of the budget. The graphic designer will need to ensure that the main construction programme is not held up by late arrival of information to be displayed. To avoid financial penalties the two designers must work closely with each other, and with the curator whose ideas they are interpreting.

Presentation to the client

The main problem in communication for a designer is how to successfully transmit his ideas to his client and curator concerned. Detailed scale drawings of plan and elevation may be totally incomprehensible to the lay members of the team. Materials themselves can be misunderstood; small samples of timber, paint and fabrics to be used in the final scheme may well mislead the other members of the team, who may be unable to visualise the effect on a large scale.

Presentation. Rough hurried card models suffice 'in house'. Charles Eames, briefing teams overseas, worked accurately, modelling figures, scaling photos down (apparent here, his 'mosaic' exhibition plan).
The World of Franklin and Jefferson, British Museum, London

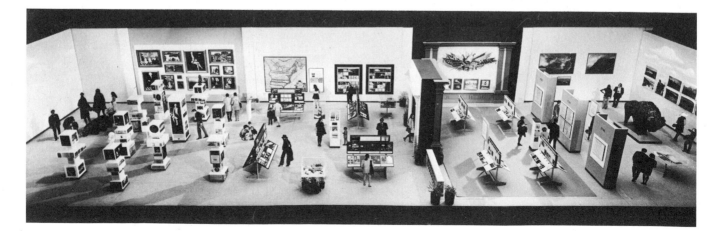

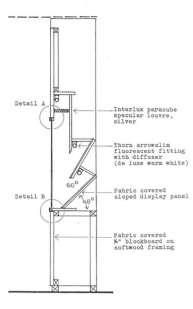

Detail A

Interlux paracube specular louvre, silver

Thorn arrowslim fluorescent fitting with diffuser (de luxe warm white)

60°

48°

Fabric covered sloped display panel

Detail B

Fabric covered ¾" blockboard on softwood framing

SECTION THROUGH TYPICAL CASE

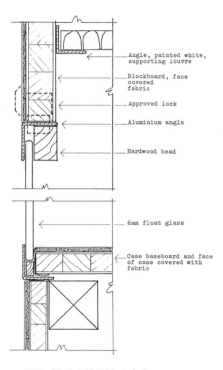

Angle, painted white, supporting louvre

Blockboard, face covered fabric

Approved lock

Aluminium angle

Hardwood bead

6mm float glass

Case baseboard and face of case covered with fabric

FULL SIZE DETAILS A & B

Communicating with the workshop: the designer's instructions to craftsmen presented by working drawings, setting out construction details and junctions of materials.
Case details from *The Medal: Mirror of History* (See page 149).

If timetable and budget permit, a small-scale model of the exhibition will often resolve matters of detail and policy; a wise investment in view of the additional understanding and agreement that can be achieved. Even on a table top, a curator can visualise the density of the proposed display, and the way in which the exhibits and text items are arranged along the circulation route. The security adviser, too, can check the position of warders in relation to the circulation of the public. The designers themelves will learn from their model, checking the interlock between 2D and 3D elements in the design. On some scales, even the objects themselves can be introduced into the model.

The scale model is, of course, no real substitute for actually trying things out in the gallery, for experimenting full size before finalising the scheme. Space, time, and money will probably limit such 'mock-up' arrangements to a few case loads of the objects to be exhibited, but something of the flavour of the exhibition will often emerge, even from such limited experiments.

Here the graphic designer has a considerable advantage. Full-size layouts of information panels, complete with samples of the proposed text and type-size are relatively simple to produce, and the whole team will be able to check the legibility of the chosen typeface from different angles and distances.

Communicating with the exhibition constructors, builders and contractors

The designer is responsible for communicating the design to those who are going to build it and put it on site. For this purpose the preliminary drawings, models, sketches, and full-size mock ups will be invaluable. It makes no difference whether the construction team is employed by the museum as part of a permanent workforce, or whether it consists of staff provided by the appointed contractor. The designer's visualisation has now to be transformed into hard fact. With the design proposals accepted the 3D designer has to provide detailed, scaled, working drawings for all the items that have to be built. The drawings have to show the types and positions of all electrical fittings. A written specification is required for all the materials, colours and finishes used in the construction, together with detailed instructions on access to the site, restrictions on the working period available, and, most important of all, the date by which completion is required.

The graphic design elements have also to be specified, either as elements within the main contract for construction, or as a series of smaller contracts with specialist firms. If any contractor has to provide services to any other, the nature of the services and the dates and stages when they are needed must be specified in both contracts.

Tenders and contracts

After this mass of detailed designs and requirements has been assembled it usually falls to the 3D designer (or in the case of a large team the production manager or co-ordinator) to seek competitive tenders from suitable contractors. It is advisable for several firms of a similar standing and experience in such work to be approached before all the working drawings and specifications have been completed to see if they will be in a position to quote for the work by the date, and also, if their tenders are accepted, whether they can undertake to carry out the work to the schedule specified. At this stage communications with the contractors must, of necessity, be formal. All those competing must be treated equally in every way to ensure fair tendering.

Once the contracts have been placed with selected firms, continuous and precise communication will take place, non-stop, between the designers and the foreman of the craftsmen actually carrying out the work. The latter will include carpenters, painters, electricians, carpet layers, typesetters, photographic firms, drymounting and silkscreen specialists,

and in the case of travelling exhibitions, firms concerned with packing, transport and the mounting of exhibits.

Amendments

As the exhibition opening date draws near communications will become less formal, if more urgent. Minor amendments will have to be made on site, to save time. With outside contractors even minor deviations from the original agreed contract can result in heavy additional charges. To control these, there must be a strict understanding between all parties as to who can communicate such variation orders to the contractor. The designer must note such variation orders as they are placed, and the original contract will bind the contractor to notify the designer in writing of any items that are considered as extra as and when they occur. Precision in such matters keeps the project within budget and disagreements to a minimum.

19 'Open to the public'

Opening time

The designer will have deployed objects to make up and illustrate his exhibition theme and in doing so will, consciously or not, have utilised various design idioms (see page 127).

Eventually construction of the installation will be finished, and only then, when the paintwork has dried, will it be considered safe for the objects to be brought onto the site so that the exhibition can be 'dressed', labels added, the display lighting finely 'tuned' and conditions for the correct environment of the objects checked. The exhibition is at last ready to be opened and this gives rise to a new set of tasks and challenges.

The exhibition in use

The opening day is usually reached with much relief but the designer's task is by no means at an end when the public walk in. Until that moment the design and the assumptions on which the designs are based have been hypothetical. It is impossible to predict exactly how the public will behave in a given space and how the flow of people will react to special objects and cause traffic jams.

The designer's role is unlikely to include the actual management of the exhibition during its run; others will take on this responsibility, but it is the designer's duty to brief the manager, warding staff and maintenance staff on his intentions as to how the exhibition should work. (Ideally these staff should be involved earlier on in the project so that by the time they take up their responsibilities they are personally involved.)

Private views

The official private view provides a major test for any exhibition. It is likely that it will provide the maximum number of visitors at any one time, testing thoroughly the circulation space and calculations on floor loading!

There are other tasks for the designer. As with press views, additional furniture may be brought into the gallery, chairs, tables for press notices and for refreshments. The strategic placing of these is essential; for entertaining the visitors must not obscure their view of the displays that the designer has been planning.

It is not unknown for these occasions to be marred by the failure of the lighting system and last-minute photographs peeling or falling from their fixings. First aid must be at hand. The wise designer and exhibition manager will have arranged for an electrician and other technicians to be nearby at private views, and the invitation of the contractors who installed the exhibition, is, on occasion, more than a mere courtesy!

With a very large temporary exhibition it might be advisable to try a 'dummy run' before the public are admitted. The whole system of ticket and catalogue purchase, queueing, and circulation through the exhibition should be tested for snags, by inviting staff and friends to a preview. The early attendances at the exhibition may pose additional design problems

of direction signing and crowd control and even during the life of an exhibition the public may force certain changes upon the management that have design implications; signs, barriers, lighting and the deployment of warding staff in crowd control may all have to be adjusted.

Good housekeeping and maintenance

An exhibition should be designed from the outset with maintenance in mind. Materials chosen should stand up to the expected wear and tear over the expected period. But once open to the public the exhibition must be maintained in a pristine condition throughout its duration. It is most discouraging for, and discourteous to, visitors if an exhibition is allowed to become dirty and worn. There must be a constant monitoring of all elements and aspects of the exhibition to ensure it is maintained with the same 'integrity and spirit' in which it was conceived. Money must be available in the overall project budget to cover maintenance, either by internal staff or the original contractor. A maintenance manual will greatly assist those managing the exhibition. Such a manual should give details of contacts who will rectify defects and wear in the structure, finishes, electrics and graphics. In particular, specifications for lamp changes, and for replacements of fluorescent tubes must be correct.

Failsafe measures

It is useful to be prepared for as many eventualities as possible during the run of an exhibition and in order to facilitate maintenance the following tips may be useful:

Ensure sufficient paint is retained for touching up, to match all colours used originally.

Extra fabric or other background materials should be kept in store.

All negatives of photos or information panels should be kept throughout the duration of the exhibition.

Art work should not be destroyed until the exhibition closes.

Spare parts and standby equipment are essential to maintain any audio-visual displays, plus sound effects or a standby alternative to cover breakdowns.

Duplicate copies of tapes and particularly of slides will probably be necessary; after about 500 fifteen-second projections of a slide there will be some noticeable fading of the dyes.

For the smooth running of audiovisual displays the designer and manager must make sure that only qualified and accredited personnel have any access to the equipment.

Although it may seem extravagant, it is wise to have two or more copies of each object label and spare numbers and spare letters for replacing captions.

Stocks of spare fluorescent tubes and spot lamps should be held, in accordance with the original specifications.

Additional seating units should be available if the visitors appear exhausted and are damaging the exhibition structure by resting against it.

Children may draw objects and copy from information panels in the exhibition. Unless they are issued with clipboards, to rest on, there is a danger that they will mark surfaces. (And anyway the issuing of clipboards can encourage their participation in the exhibition.)

Recording the project

An exhibition is an ephemeral event and institutions might well wish to keep evidence of staff time and funds expended, and on occasion to record a unique event for posterity. The curatorial staff might well need to record the exhibits in a particular sequence. Time spent on compiling records of the completed exhibition can be valuable. A useful criteria for record-keeping is that there should be sufficient information kept to enable an identical exhibition to be built.

The records to be kept fall under the following headings:

Contents
Catalogue or list of objects
Text of labels, headings, and information panels
Reference to illustrations and diagrams
Negatives or negative numbers of all photos used in the display

Appearance
Black and white photographs of the installation and case contents (the photos of display of all objects/exhibits will probably be a security requirement)
Colour photographs or transparencies
Specification of materials, finishes and colours
Drawings of the project 'as completed'
List of light fittings and lamps
Details of conservation equipment

Personnel
Contractors and suppliers names
Addresses and details of their performance
Details of the project team

Data
Date and duration of exhibition
Attendance figures
Total costs
Total revenue
Staff time

Publicity Records
Copies of printed publicity material
Press cuttings

Dismantling the exhibition

When the last visitor leaves the exhibition on its closing day the project team is then faced with the final stages of their task: to organise the dismantling of the exhibition. Here the rule is 'last in-first out'. The objects which were the last things to be placed in the exhibition just before it opened are naturally the first things to be removed at the close. Only when the last object has been removed can the dismantling begin; probably in the reverse order of its construction.

If the exhibition was built by specialist contractors and the whole exhibition structure is on hire, then that contractor will dismantle and clear the site as part of the original contract. But if the internal museum labour force was employed, construction materials can be salvaged and used again, providing they are economic to store and staff time is available.

20 The final score

How well have we done?

Only when an exhibition has opened to the public is there time to reflect, time to assess whether the initial objectives set out in the design brief have been reached, and to what extent. Judging from the attendance figures some exhibitions are a conspicuous success, but every designer has to recognise that some exhibitions fail, and even more painfully, that some of his own designing fail.

But what are the causes of these failures? How can the various levels of success or failure be first identified and then measured? Criticism in the press, on radio, and TV of the finished product is often personal and idiosyncratic. Can standards even be set for the functioning of an exhibition, let alone be measured?

'Evaluation' and evaluating

It is believed in some circles (particularly in North America), that an exhibition can be 'evaluated'. This belief is even stronger in the case of scientific and educational exhibitions. There is no harm in this belief if it makes those who hold it happier, more confident, and better able to practise their professions. But 'evaluation' in this sense seems to be primarily concerned with finding numerical expressions, and one must question the extent to which these techniques can be applied to exhibition design. Would the kind of evidence that such methods produce be of use to an aircraft designer, the engineer of a tall building, or a Public Health Department? Designers are of many kinds, and only some are qualified to translate numerical data into design decisions.

An essential element in any scientific method of obtaining evidence is 'the control', the setting up of an experimental situation in which only one factor has been varied from the one situation under study. However, there can be no 'control' for an exhibition. One cannot create two *Tutankhamun* exhibitions in identical situations. The exhibition as experiment is not available to the designer, however attractive it might be. However, it is always possible to make a 'mock up' of an individual exhibit for an exhibition. To some extent such a mock up can be tested, and improved before the final version is constructed.

It must be remembered that a single exhibit, isolated for the purpose of such testing, will not produce the same behaviour in the viewer as it will in the final ensemble in the gallery. For this reason the designer must remember that the mocked up version may be yielding quite misleading information. This is not to say that no useful evaluation is possible. Some is.

What can be done is to observe the variations of visitors behaviour within a single exhibition. Heads can be counted, and the variations noted in the number and composition of the visitors. Perhaps the most important aspect of this monitoring is to increase the appreciation of the design team about the variety of visitors for which they must cater. It is seldom feasible to carry out major alterations to improve a temporary exhibition during its life. If something is found to be lacking, the design of

the next exhibition can be improved in the light of the experience, and it will function better as a result.

Criteria for evaluation

Obviously the team who produced the exhibition will have their own criteria by which they will judge the completed work. Commonsense and observation of the exhibition 'in use' will provide answers to many questions, such as:

Does the theme of the exhibition seem obvious to the general visitor?

Are the objects displayed clearly and in a logical sequence?

Do theme, content and design form a homogeneous whole?

Is the style of the display and the methods used appropriate to the audience, objects, and the site of the exhibition?

Is the exhibition balanced between real objects, information and imagery?

Is it in any way original? How does it compare with other exhibitions?

Is there sufficient space for the visitors to circulate comfortably?

Is information supplied in the right places?

Is the content of the information displayed on panels and labels (for example) to the point, and functional? Does the style used make them clear?

There is also a very practical note, vital for future projects:

Are the display materials used in the construction of the exhibition standing up to the job, the wear and tear exerted by the daily attendance?

Observation will provide only the most general answers to many of these questions. The serious evaluator can refine these answers and obtain much finer data from the completed exhibition by means of visitor surveys, interviewing, conducting questionnaires, and by the use of video recording and time-lapse filming.

This study of attendances will be of interest to the exhibition organiser as well as to the design team. Is the exhibition reaching an adequate audience, and what time of day or part of the week do they favour? Admission charges will provide attendance figures, but surveys will be necessary to find visitors ages, educational and economic backgrounds, and how they were transported.

The designer learns

Designer and organiser have to learn all the time, and they cannot learn without information. Many designers have a sense of frustration through never learning 'how they have done'. Every aspect of visitors' behaviour will have some design implication. Through which form of publicity have they heard about the exhibition, did they come alone or in groups, and of what size? How long did they stay? Were they the audience for which the exhibition was planned? Or a wider one?

Observation of the audience is not only of this general kind. Each physical element in the exhibition is like a piece of furniture, subject to human use. Observation of visitors will show the time devoted to each activity, to each element. The designer will be able to see which displays, specific objects and passages of text hold their attention, and correspond with their interests. It has been suggested that 'interactive' displays enable the organiser to obtain precise details of visitor response. It is a large step from this to claim that one has measured their understanding of the exhibition's message, or the amount of material from the subject that they have 'learnt'.

The whole subject of evaluation is at an early stage of development. There is already a great deal of literature concerned with ways of extending the designer's own observations. Many of the techniques suggested will deliver useful detailed information which will improve the design of specific items within an exhibition. Often, however, too much is claimed for such 'scientific' numerical studies. Designer and organiser are working within an aesthetic climate, in which fashions and personal tastes are still of overwhelming importance. The success of the exhibition, however much attention is given to the nuts and bolts of the displays, will depend upon the extent to which the designer and organiser can understand and share the general culture of the visitor.

The exhibition team evaluates itself

If the designer is going to formalise his methods of evaluation, it is only reasonable to apply them, however painful, to the design team itself. Throughout the project, from briefing to opening, the design team have been 'performing'; the evaluation can conclude with an assessment of their strengths and weaknesses. A lot has been communicated between them, and the history of these communications may be most instructive for the next project.

21 Futures

The future: the link with the past

This book opened with a brief history of museum exhibitions, designed to show the framework in which designers had developed their work up to the last decade. It is reasonable, therefore, to conclude with some speculation about the future, both medium and long term. Such speculation must be accompanied by posing some awkward questions, and even casting doubt on the very words that have been used to describe, in this book, the practices at the time of writing.

Within the last twenty years there has been an enormous growth in the development of exhibitions in museums, and a matching increase in the interest of the public in the museums and their contents. This has been due very often to the excitement of temporary exhibitions (many of which are illustrated in the book), which have attracted attention from the press, not only for their content, but as news.

Many new techniques and technologies have been developed, exciting in themselves, which have been applied (particularly to science displays), attracting vast audiences.

In the art world public attention has been drawn to the record-breaking prices paid for paintings and rare objects in the salerooms, and the consequent appeals for funds to retain them in our museums. When the curators triumph, they naturally wish to exhibit their trophies, and a new public is drawn into the art galleries and museums.

In the developed countries 'leisure industries' have arisen to deal with the results of increased standards of living on the one hand, and shorter working hours resulting from technological change on the other. Leisure and tourism are both part of the terms of reference of a museum director, together with the maintenance of academic standards. There is no sign of the interest in museums and their exhibitions becoming less.

Forecasting

That is not to say that the museum will persist in exactly its present form into the next century. Will the designer, as we know him today, be a part of whatever form the museum takes in the twenty-first century? It is clear that if we can visualise the future role of the museum designer, it will begin to colour the practices of today.

Of course one has to be bold to forecast any kind of technical and social change. George Gardner, the American museum exhibition designer, deals with these changes in an article 'Where is museum exhibition going?' He points out that the film *The Shape of Things to Come* (based on a story by H.G. Wells and made in 1936) predicted a man on the moon in the year 2036, and that a man actually landed there in 1969. Since prediction is such a risky business, Gardner prefers to consider only the trends already apparent in exhibition design today.

One can rule out the changes that will take place in the more cosmetic aspects of gallery design, since too many aspects of fashion will affect them. There are other areas where some 'next guessing' is not only possible but essential. It is clear that policy will change considerably on

the use of funds, fuels and other forms of power. And with a new view of power we could tend to question how ready we are to move things about; we may balance the taking of an exhibition, suitably packed, from one country to another against the cost of bringing the visitors over to the exhibition. We may also take a different view of the costs of initiating and building temporary exhibitions, with their considerable academic and design input. To make them cost effective we may run them for much longer periods and transport different versions of one exhibition around the country to major centres. Increased audiences would make exhibitions more cost effective than at present. Giving exhibitions much longer lives will alter the way we construct them.

Savings

The present temporary exhibition is designed for a short life, and if it is to be adapted for wider use and maintained for a longer period the materials used and the design details will have to be re-examined. So will the life of materials. In a climate where waste will be discouraged it will be necessary to monitor the life of individual components. How a wooden plank travels from a tree to a bonfire, passing through an exhibition en route, will be increasingly of interest. One will no longer be able to design 'as if there was no tomorrow'! We may have to design so that we can recycle materials from one construction to another, and exhibition units so that they can be adapted to display subjects of widely differing character.

This will entail a completely new understanding of energy by the designers; every piece of construction material will embody a certain energy investment, and its adaptation will make further energy demands. When the designer of the future 'draws' instructions to the craftsman he will be making an 'investment' of energy, and he will be fully aware of it.

Standardisation

Many exhibitions today are the result of museums lending objects from their collections to complete the displays in other museums. Sometimes display units, models and information panels are similarly circulated. Such interchange is limited, of course, by the variation in dimensions, display systems, and light fittings between one museum and another. Sooner or later designers are going to have to work towards a greater compatibility, and this means a greater standardisation of display units and related components, and less 'one off' special designs. The building trades have been able to achieve a degree of standardisation without resulting monotony, and those in display will have to work along the same path.

New technology: information handling within the design office

In the 1960s and 1970s we started to look at the devices that were becoming available (if expensive) to store and transmit information, and to consider their application in design. Today almost anything can be done, and reasonably cheaply. There is enough equipment on the market to make it profitable to define the functions that we would like to transfer to such equipment.

Designers are very much in the information-handling business; information comes from the exhibition sites, the experts, the objects to be displayed. When the design solution has been arrived at it has to be transmitted to those who are to build the displays, and when the displays have done their job the designer will wish to acquire information about the number of visitors and the reactions of the public. Each of these areas of information-handling can probably be done better, faster, and cheaper than at present. The designer has to study what is involved, and make out a case based on the savings that will result.

120

Electronic drawing

The actual processes by which a design evolves and is recorded will change. Today a designer sits at a drawing board, digesting and storing information, isolating the core of each problem, and then, by manipulating the drawing, tries different solutions for fitness and size. The new computer terminals will give him finger-tip access to the data, and the ability to draw and redraw electronically.

Computers, after tackling company payrolls and getting man to and from the moon, are now set to take over the office and the drawing office. Certain possibilities appear already, if not the possibility of paying for the installations. But any designer, particularly any designer who teaches, is foolhardy if he does not prepare the claim he will want to stake in the new equipment.

Data storage

First, storage? The museum designer has to aquire and have access to a number of dimensions, the plans and elevations of the available rooms, the positions of services, the dimensions of furniture, cases, barriers and plinths. Major exhibits can be measured in outline on acquisition, and the designer can hold these dimensions at his finger tips. A great part of the exhibition design, before colour, light and texture are involved, is the manipulation of these elements.

The computer can already enable the designer to store in outline the various voids, or volumes, which he has to assemble, and gives him the capacity to recall them on a screen, and move them about with a pointer. Extra computer capacity and 'programming' can enable the voids to be raised and lowered, and rotated in space. And so the assembly of gallery, cases and objects can be viewed in outline from any viewer position, and the angle at which light is cast can be simulated, assessed and modified.

At the moment the cost of a computer installation to do this is probably equivalent to the salary for several 'designer years'. But designers should enquire how this cost is coming down.

The designer of the future may well be able to draft animations through his computer. Coupled with his 'pen' will be programmes that will permit him to people the plans and elevations of his exhibitions with mobile visitors, complete with their movements, circulation and pauses appropriate to their age and interests. He will have a microcomputer 'exhibition simulator'.

New technology: information handling within the exhibition

From the point of view of most designers, micro-electronics are not yet inside museum exhibitions. It is certain, however, that they are already at the door. And just as the designer deploys timber, metals, and paint to put across the message, so also will he have to deploy micro-electronics.

Certain parts of the message in an exhibition are still handled in a very clumsy way. For instance, the whole supply of supplementary information in an exhibition can both be extended and yet lightened at the same time. Audio guides, both from portable tape players and induction loops, are already in common use. The new technology makes the devices infinitely lighter, cheaper, perhaps even expendable. Visitors should be able to talk-back to the guide, indicating responses to the commentary, selecting sections of particular interest. It is now possible to visualise science exhibitions with a high level of electronically-based interaction with the visitors. The next generation of designers will have to keep a close watch on their micro-electronic colleagues, since the design will relate closely to what they can offer.

The transfer of information by micro-electronics will not, of course, be limited to supplementary information in the exhibition. At the moment, the objects are often little more than the tip of the museum iceberg, the greater part of the collection being permanently in store. It is true that access to it can be organised for the specialist visitor, but if the entire collection can be photographed (or holographed in three dimensions), or

stored on video discs, the entire collection can be immediately available to the gallery public. Any supplementary information can be coupled closely to the images, and the objects themselves can remain safely in store.

It is only one leap from this gallery access system to publishing. If the video discs are available on sale, the visitor can, in effect, take the collection home and view it there, and then, with the TV set, 'telephone' the museum computer for more 'encyclopaedic' information. By this point, the 'museum' will have taken on quite a new meaning.

New technology: the objects on call

If we look at the museum of the future we may not be able to see any objects in it; they will be conserved and studied in conditions of maximum security elsewhere. Their images will have been made available to all people, anywhere, called up by infinitely branching programmes, using not only manual but also voice commands. This will satisfy many, but not those who want to walk around the objects at their own pace, at an angle and distance of their own choice.

Fascimiles

Techniques already exist by which any object can be described and recorded in the greatest detail, having regard to dimensions as well as colour and texture. Such information, stored in digital form, will enable perfect facsimiles to be created, even at some distance from the original and the data store, and these facsimile replicas could be so perfect that only an expert eye, aided by scientific devices, will be able to detect copy from original.

This would, of course, effectively remove the sense of unique experience that the visitor to a gallery now enjoys. On the other hand it will give almost universal access to the objects for study and teaching, even treating them as expendable while the originals are perfectly conserved and studied under ideal storage conditions.

The traditionalist reader will feel some reserve about such a future, but must recognise that part of it is already here. The best museum shops already offer facsimiles of objects in a wide range of materials, giving great pleasure to even the most discriminating visitor. The museum of the future can also be anticipated by visiting the caves of Lascaux, where the archaeological and artistic wonders can only be seen facsimile; the original caves, for reasons of conservation, are no longer open to the public. It has been mooted that Stonehenge should similarly be copied.

While conservation may no longer be a problem when the galleries are full of facsimiles, the designer will still not be free from the constraints imposed by security. The price of facsimiles may still dictate that they are treated with some of the respect due to the originals.

It is unlikely that exhibitions will be completely of an 'open display' nature. Some originals will still be present in most of them, but academic studies will be aided considerably by an original piece being compared with others of a similar kind in other collections. At the moment this is done by photographs, but the use of facsimiles will enable much fuller comparison by the serious student and a gain in the development of theses for academic purposes.

At the moment holograms are a novelty. When this has worn off, and the standard of reproduction improved, they may well become a substitute for objects difficult to obtain, and may even constitute an entire exhibition. The technique does permit the showing of objects in their original setting, rather than against artificially-created backgrounds, and for certain subjects this consideration may well make them the sole 'objects' in an entire exhibition. Beyond this, however, lies the possibility, not far off, of three-dimensional television.

New technology: sophisticated display cases

Electronics are bound to alter the museum display case. The means of monitoring conditions within will aid conservation, and refinements of beam reading and tremblers will improve security. These devices will be improved until they work to very fine tolerances, and transmit suitable warnings to appropriate stations when need arises. The case will have been made to 'think for itself', becoming a pseudo-intelligent member of the museum staff, and even logging its own performance.

The greatest contribution of the thinking museum case will probably be in its capacity to interact with the visitors using it. Proximity devices will be capable of increasing light levels when a visitor is close by, and leaving them low for good conservation when the case is unattended. What is more, the labels near the exhibits can be made touch-sensitive, releasing projected diagrams, commentaries, etc when requested. The sophisticated case will not only work as a supplement for the conservator and the security officer, but also for the compiler of the catalogue and the guides and lecturers.

Conclusion

Long before the new electronics have been widely introduced into museums, scholars will feel threatened. Museums have served as temples of learning and scholarship, and a pasture or playground for the connoisseur. Already museums have been drawn into the orbit of the leisure industries, and this has entailed an enormous increase in the number of visitors. Users will expect more and more access to the objects and the information needed to understand them, and the devices in their supermarkets, public libraries, hospitals and homes will give them a high expectation of 'interaction'. A home where the children are playing chess (or *Star Wars*) through the family television set will find it increasingly hard to absorb information from collections presented in a traditional way.

It is likely that the staff of science museums will react quite differently to those concerned with collections for the arts. Science is devoted to the explanation of cause and effect, and the technologies that science makes possible, so it will be quite appropriate for the visitors to a science museum to use the latest technologies to relate to the material in it. The museums of art and history may respond differently. They will probably ask their designers to use gentler methods of persuasion on their visitors, allowing greater time for consideration and reflection. Nevertheless, many devices could be incorporated in a careful compromise between the new and the old traditions. This area is one that the designer will have to master sooner or later, but asking all the time, 'if both clever and sensible, is it at all lovable'?

Holography: images in London from objects in the USSR. Plates in wide-angled frames, covered in black velvet (light sources critical). Will curators exploit and designers deploy this technique further?
Holography – Treasures of the USSR, Trocadero, London, 1986

123

The designer's notebook

A joke alert. Inflated legs over a New York parapet, with high-heeled shoes. A three-dimensional banner marks the exhibition and enlivens a static façade.
The Great American Foot Exhibit, Museum of Contemporary Craft, New York

Exernal alert. Repetition of motif, message and sponsor. Banners convey a sense of occasion.
Whales, a permanent exhibition, Natural History Museum, London

The designer's idioms and devices

So far, this book has dealt with the background of museum exhibitions and the stages by which, today, they are designed and constructed. Various theories have been offered to explain what takes place. Case studies are needed to illustrate these theories: studies of actual objects exhibited, actual subjects treated and actual design idioms employed. To cover all of these would demand an encyclopaedia. No designer could write it and few would have the time to read it.

Practising designers carry in their head a store of visual items that have made an impression on them in the course of their work (some indeed use actual notebooks for this purpose). The following sections recall a typical sample of such items in the form of photos, sketches and notes intended to convey attempts at exhibition problem-solving. The displays must make objects and explanation clear to the audience, but they must also set about changing its ideas.

The visitor will arrive at an exhibition with a series of concepts of what it contains. For example, a 'concept' of an Egyptian mummy, its appearance, its age, and its container. Some of the visitor's ideas will be elaborate. They will embody multiple concepts, concerned with much more than objects alone, forming complete 'models' of how the objects relate to each other and within complex schemes involving space and time.

However, whether the ideas which the visitor has at the outset are simple or complex, and whether his knowledge of the subject is sketchy or profound, the task of the designer is the same. The attention of the visitors must be drawn to the objects and displays, to alert them to receive the scheme of, and the story behind, the exhibition.

Such attention-getting is easy if the objects themselves are arresting or attractive, unusual or paradoxical. Placing them in a meaningful sequence with sufficient accompanying information will then suffice. The story behind mundane objects is harder to put over, and putting over a story or ideas with few or no objects at all is even harder.

Manipulating the visitor

The museum visitor, intent on examining the objects in an exhibition or engrossed in the story being unfolded, will not be aware that he is being manipulated: being made to circulate, being in fact 'placed' by an unseen designer or manager. The visitor will move in certain directions, quicken his pace, stop and study, be encouraged when he tires. His movement will not only depend upon enthusiasm for the objects on exhibition, but he will be propelled by certain devices and features which the designer has incorporated into the layout, organisation, lighting and detailing of the display.

The designer is addressing the visitor through the design of the exhibition, utilising a series of design 'idioms'. These idioms are comparable with the 'non-

Idioms and devices employed in an exhibition. The stages by which visitors are manipulated through an exhibition.

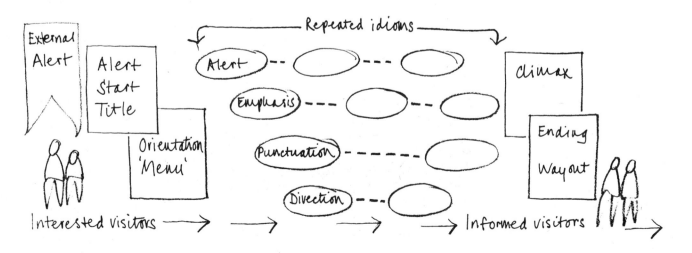

verbal communications' with which we enrich our speech: the shrug, the wink, the raising of an eyebrow, the bow, spreading gestures with the arms, the pointing hand. The exhibition has started from a message from the subject specialist, has been edited to organise and sectionalise the material, and the designer now has to find three-dimensional forms which will be readily understood by the visitor. Feelings and impulses must be transmitted to aid appreciation of the objects and understanding of the information which accompanies them. At all times the visitor has to be reminded of the general character of the material exhibited and the story being told, as well as the individual stories behind the individual exhibits. The visitor has also to be moved around! The idioms at work in an exhibition will be of two different types, atmosphere and action.

Atmosphere and action

The idioms of atmosphere are those which help to set the scene or convey the mood of the total exhibition. For example, they might express the geographical or historical context. The other idioms are those designed to prompt action, though the visitor may be quite unconscious of how he has been paced, propelled or deflected through the exhibition. Idioms of action will include 'alerts', the drawing of attention. There will also be idioms of emphasis, underlining the importance of a section of the exhibition. At times the exhibition will need punctuation, to 'sectionalise' the story. Finally, throughout the gallery, the visitor will have to be moved, by propulsion, direction, deflection and traction, as is most appropriate at the point in the story. The idioms will vary in importance and role, but they will all be capable of being expressed by means of devices in three dimensions, by colour, lighting, texture, and by graphic information. Above all, however, they must be capable of being read correctly by the visitors.

Alerts

Visitors' attention must be engaged, to make them see the exhibition building, to note that an exhibition is open, and to perceive its relevance and importance.

Top:
Alert indoors. Revolving, high up, this symbol signposts a section of the exhibition, *Perception*, from all parts of the building.
Evoluon Museum, Eindhoven

Above:
Alert by symbol. The prow of a Viking boat scaled to dominate the entrance corridor to the exhibition.
Sutton Hoo exhibition, Statens Historiska Museet, Stockholm

Left:
Opening alert. Roman 'T' contrasts with rough polystyrene 'E' over a dustbin. Shock title for an exhibition about values in design.
Taste, Boilerhouse Project, London
Design: Minale Tattersfield and Partners

Banners can supply this essential information in a mobile, three-dimensional way. A static building can be made to come to life and a dull one brightened. Banners carry a touch of the fairground, of the parade, and symbolise a happening.

The entrance to an exhibition must be clearly signalled. The visitor must know where the exhibition starts. A 'sock' opening, giving a sense of drama, or surprising the visitor, makes clear that what follows differs essentially from its surroundings. The reception area may need immensity or magnificence, but sometimes sharp humour can serve to 'open' the exhibition. Unusual or moving lights, or intriguing sounds, can alert visitors; so can a powerfully symbolic display, evoking the character of the material visitors are about to experience.

There are many competing distractions: the street, other galleries, the museums and other visitors. The 'alert' (whether serious or humorous) helps visitors to focus their attention on the displays.

Orientation and choice

A visit to an exhibition begins with disorientation. The visitor has been disconnected from the street, from other displays, and has to be connected firmly to a new experience.

A logo and colour scheme already embodied in publicity material can provide a linkage from the start. These features can be repeated, where suitable, throughout the displays, maintaining the link and giving a sense of continuity.

Both content and form can be shown clearly at the outset. Visitors can be given a 'menu', showing what is within, so that they can prepare themselves, and allow time for the sections with which they are most concerned. Experienced museum visitors know that they must allocate their time with care.

Most visitors, too, can read a simple plan. If this is shown at the entrance, and at any junction points, and is clearly labelled, the public feel in control of their visit. (The same simple plan should be on all leaflets and catalogues, recognisably in the same form.)

Top:
Orientation and choice. A plan and 'menu' at the entrance to the *Hall of Human Biology*. Visitors immediately see what is on display, and where.
Natural History Museum, London

Centre:
Atmosphere, style. Elaborate dried-flower arrangements in urns evoke the period. Plants can link, be barriers, or soften 'edges'.
Vienna in the Age of Schubert, the Biedemeier Interior, Victoria and Albert Museum, London
Designer: Paul Williams

Left:
Vernacular. Ceilings and pillars provide the context, culture and atmosphere. Down-lighters concentrate attention on the objects.
The Genius of China, Royal Academy of Arts, London
Design: Robin Wade Design Associates

129

Atmosphere

To be successful, an exhibition has to transmit a great deal of information, but it cannot do so without also indicating a 'feeling' about its subject. The designer provides details of style, both sophisticated and vernacular, to trigger off memories in the visitor. This is the theatrical side of an exhibition; overall lighting can give an objective view or pools of light in a dark gallery can stress importance or rarity. Symbolic or associated colours can indicate royalty, the sands of the desert, or the green of nature.

All sorts of coding devices must be given consideration in order to locate the exhibition within a particular culture, and the sections within a chronology. The designer can use materials (such as timber and fabrics) to suggest place of origin and indicate time in the treatment of illustrations (such as sepia-toned photographs for the nineteenth century). The smallest detail can help: floor levels, finish to the walls or even smell can all serve to establish the atmosphere of an exhibition.

Action and pacing

Just as a film editor organises images for a television programme, so an exhibition designer is responsible for arranging displays in a certain order, an order that will make sense of the whole. In an exhibition, however, the viewer is moved through the material, rather than the material being moved past the viewer. So editing in television becomes propulsion in exhibition design, and a number of design idioms are developed to achieve this.

The designer 'paces' the visitor at all times. This pacing is essential in any exhibition to prevent the visitor missing exhibits through fatigue. Pacing must be reasonably consistent throughout the exhibition, avoiding bunching in front of key exhibits. The design idioms differ little from those used in successful department stores or fast-food catering establishments; the difference is in the way that the exhibition designer has to check, at each station in the tour of the exhibition, what he is doing to the visitor. However attractive the design may look on the drawing-board, or initially on site, its true test comes when the visitor arrives and is teased, nudged, deflected, slowed or accelerated along the planned route. The design of an exhibition contains an implied choreography for visitors to perform.

The first piece in the designer's repertoire is attraction. For instance, an attractive vista can be laid out ahead, dramatic lights can provide a sense of anticipation, or text and display which are only partly visible through slits in the wall can draw visitors forward through curiosity. Some of these 'forward' items, partially concealed, can be kept deliberately ambiguous. Then there are more obvious hints, pathways of contrasting colours, a route marked with arrows, tyremarks or foot-prints, if these are appropriate to the exhibition's subject matter. Illustrative material can be arranged so that the images 'point' in the right direction. Apart from overt

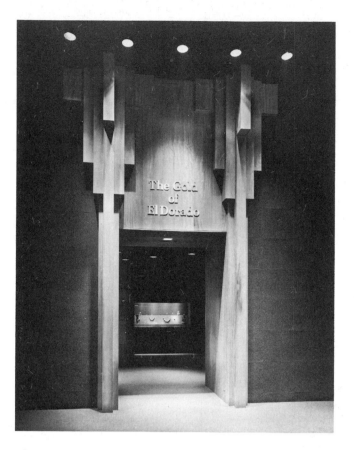

Top left:
Pacing by suction. Brightly illuminated doorway to darker area with low ceiling. The designer created a theatre proscenium with spotlit treasures beyond.
The Gold of El Dorado, Royal Academy of Arts, London
Designer: Alan Irvine

Centre left:
Tease. A hole in the screen gives visitors authentic atmosphere and a 'trailer' of more to come, while giving the warder a security 'peephole'.
The Floating World, Victoria and Albert Museum, London
Designer: Ivor Heal

Below left:
Direction. The caravan in the giant photographic enlargement points the visitor into the exhibition.
Nomad and City, Museum of Mankind, London

Below:
Enticement. The visitor must go forward to make sense of Howard Carter's famous exclamation on opening the tomb (other visitors push from behind).
Treasures of Tutankhamun,
British Museum, London

Right:
Manipulating and pacing the visitor by the arrangement of room plans:

a) Corridor display with fast and slow routes, the object of special importance providing a 'draw' at the end of the room
b) and c) The corridor divided into bays with emphasis points placed to 'pull' visitors through
d) The 'interlocking comb' device where visitors are forced to pass every part of the display and are pulled through by points of special emphasis
e) The 'comb' planning device, with the fast lane attracted only to the tips of the comb's 'teeth'
f) Providing a change of pace within a room, with two single points of emphasis leading to a meander through clusters of exhibits
g) A feature at the entrance with choice of route, right or left, leading to a vista with an object of special importance to draw visitors through the rest of the room
h) The island display, the main route round it, with no options

i) The linked 'archipelago', a cluster of objects on the main route with some points of emphasis
j) The 'archipelago' forming a mosaic of objects or information with a point of emphasis to draw visitors into the room
k) The arresting entry point pulling visitors into the room

l) Pulling visitors into the room in order to encourage them to view a chronological display or storyline in the desired order
m) The central reference point with associated material in surrounding bays
n) Featured objects draw visitors to related material in each section

a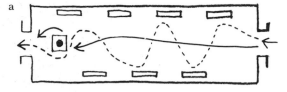
b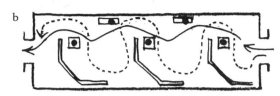
c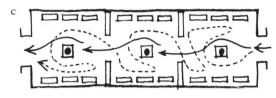
d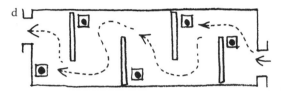
e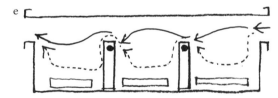
f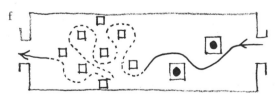
g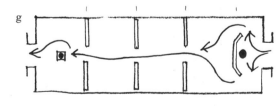

h
i
j
k
l
m
n

directions by signs and text panels the flow of visitors from behind can encourage those in front to descend a ramp. It is the designer who organises the strength of propulsion appropriate to each section of the exhibition. It may also be necessary to take steps to boost the flow of visitors if, after the exhibition opens, it is found that there are bottlenecks.

The designer has to decide and organise the amount of freedom that visitors are to be given. A tight corridor disposition may be easy to arrange but is only suitable for certain linear subject treatments. Other arrangements, although appearing to allow random access to displays, can still be tightly controlled. Bays can be organised in such a way that they indicate that some of the material is subsidiary to the main displays, and visiting it is optional. Even where island displays are placed in the middle of the gallery other displays and information panels can be used to 'bounce' the visitor forward. Each display says, obviously, what it contains; it also indicates, more discreetly, when to move on, and where to.

Punctuation

The exhibition designer is not only concerned with controlling visitors' pace by covert devices. Often the

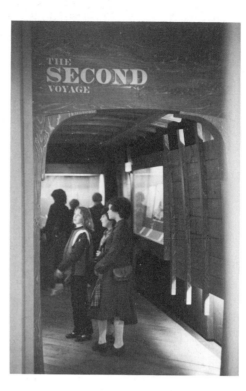

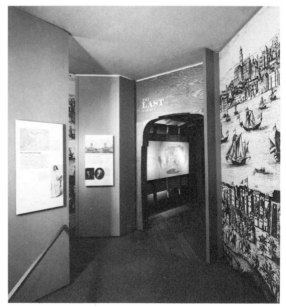

Above:
Chapter headings. Each voyage comprises a section of the story marked by an introductory corridor. Visitors pause to digest text and maps.
Captain Cook in the South Seas, Museum of Mankind, London

Top left:
Pause. A carved screen suggests and imposes a break, impedes the circulation. This is 'covert' punctuation, for the screen itself is one of the exhibits.
The Burrell Collection, Hayward Gallery, London
Designer: Barry Gasson

Left:
Full stop. This column is a landmark for visitors, drawing some on to stop and look, deflecting others into side galleries.
Metropolitan Museum of Art, New York

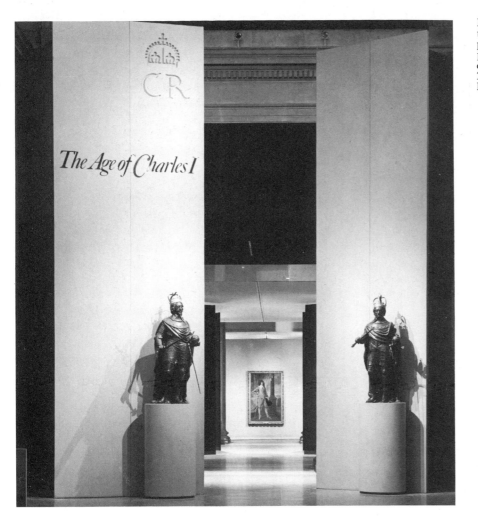

Emphasis by symmetry. Here, framing the entrance, the large figures suggest pomp and emphasise the vista ahead: the portrait of the royal subject of the exhibition.
The Age of Charles I, Tate Gallery, London
Designer: Alan Irvine

Joke ending. More a final directional exit sign than a climax, based on the subject matter of the exhibition.
The Ancient Olympic Games,
British Museum, London

material itself falls into sections, demanding a frank form of punctuation. As in written text, exhibition punctuation can be organised to give pause in a number of ways. An introductory section, perhaps in the form of a bay for audio-visuals, may correspond to the introduction to the subject of a book. A significant item at the end of a vista provides a full stop, a seating area may correspond to a chapter heading. (Many exhibitions depend on the use of a catalogue to tie them together, and the experienced museum visitor will use seating space to catch up on his reading, to match text and exhibits.)

Often the design will have to provide for a form of parentheses. Much of the material in an exhibition will be suitable for a wide range of visitors, but there will also be a proportion of specialist enthusiasts who will look closely at specimens that will not be of interest the general public, and who will read erudite explanations that that same public will skip. The designer can create bays or study areas outside the main flow of the exhibition for these specialist interests.

Emphasis

The designer needs a repertoire of idioms of emphasis, devices by which certain exhibits can be shown to have a key position in the story. Larger objects provide their own isolation, but smaller ones, isolated in their own cases, can be given significance.

Viewing angles can be utilised. Visitors who have experienced a number of objects at eye level will respond to other objects set in a well, or raised above them, or placed on altar-like plinths.

The designer can use symmetry: paired objects on either side of a proscenium opening can provide a signal for important things to come. This is particularly effective where the rest of the displays are fluid and asymmetrical in character.

Restriction, paradoxically, can also provide an indication of importance. If the visitor has to view an object by first going up or down a ramp, or by waiting for a turn at a small peephole, the designer has signalled that this is something not to be missed.

Positioning may be the most obvious method of emphasising objects, but lighting can also be effective. Key objects can be spotlit, theatrical fashion, or emphasised by the use of cutout stencils which shape the light being cast.

Climax and cultural differences

Finding the right ending for an exhibition involves a clear policy decision in the planning stage: what is the visitor expected to feel or do on leaving?

There are several choices available. It may be possible to build up to a positive climax, with increased contrast of lighting and colour, perhaps through the size or rarity of the exhibits. Some exhibitions provide an obvious, splendid object for the finale. But a dramatic ending may not always be desirable. The designer may need to introduce a quieter note, promoting reflection and further study, with a recapitulation of parts of the text from the exhibition itself, and introducing the visitor to the museum's bookshop.

A word of warning, perhaps to the designer. Some collections such as the *Treasures of Tutankhamun*, have been exhibited in a number of cities, each time mounted in a freshly designed exhibition. The differing solutions offered may have been the result of designers rising to a professional challenge or, perhaps unconsciously, they were trying to find design idioms and a style suited to their particular country. There are many apocryphal stories of the offence which human gestures can give if offered in the wrong country. The same applies to colours. For example, the significance of a given colour varies between one culture and another, black denoting mourning in the western world, white in India, yellow in China.

Even the relative positions of objects in a display will vary from culture to culture. In Europe, based perhaps on a reading pattern, there is a tendency to move from left to right along a gallery wall unless specifically obstructed, and the assumption is that the most significant object will be at the end of the series. In Japan, among other nations, the principal item may belong in the centre of the display, other material around it being subordinate. The designer should appreciate that visitors from another culture may not react as promptly as the indigenous population!

Climax. The gold mask isolated in the final room. Other treasures were quite densely displayed. Visitors paused to reflect before leaving. *Treasures of Tutankhamun*, British Museum, London

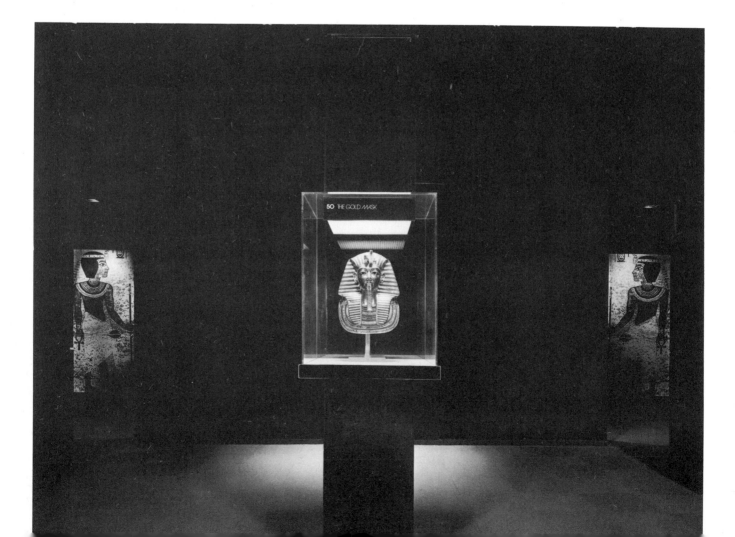

The museum object

The information given so far in this book has been concerned with the basic principles, the participants and their roles, the steps which they take, and the major hazards of exhibition design. But the basic ingredient, the reason for a particular exhibition or the display of a particular collection, has not yet been considered in detail. The objects in a museum exhibition are the very reason for its existence. It is the objects, or collection of objects, which will determine the style of the exhibition and will dictate the method and conditions of display and interpretation. The objects are the designers' starting point, the unique element in the exercise.

The sections which follow show examples from various exhibitions of different examples of methods of display for a range of different museum objects.

Before arriving at a finished display, the problems of providing the correct environment for the conservation of particular objects, the different demands on lighting, the effects of colours and background textures, and the problems of safely hanging, propping up and mounting particular objects must be considered. In parallel, ways of imparting information in a suitable medium at the right level to suit different kinds and sizes of objects have also to be taken into account.

The reader will find in this section that often there is reference as much to points of conservation as to points of design. This is quite deliberate, since the designer should never make a move without checking with the conservator the state of conservation (and the requirements of continuing conservation) of the object he is displaying.

The main considerations are set out with each category of object, often with precise tolerances. The author has had the advantage of advice from conservation colleagues, although any mistakes are, of course, hers alone.

There is one danger in providing information about one skilled speciality, such as conservation, to people working in another: in this case, design. The designers may feel that they now know enough to make judgements for themselves. This would be disastrous. I have set out the limits of material in this book to give the designer reader the measure of the complexities involved. They must at all time take problems and check proposed actions with the conservators. They alone are qualified to take this sort of responsibility.

This part of the book is intended as a manual which offers a quick form of reference for designers, curators, or private collectors to traditional, new and experimental display techniques for museum objects. It assembles reference material, which for the most part is at present scattered in various books and journals. Its aim is to record successful displays and ideas of presentation.

The 'collection' of display ideas is presented for easy reference in alphabetical order. The selection of examples demonstrates a bias towards fine art, antiquities, archaeology, and ethnography, being the areas more directly within the author's experience. Most illustrations are taken from museums and art galleries, although a few examples have been selected from commercial settings.

Armour

Introduction

Armour imposes quite specific strains upon a designer's ingenuity. It is large, it shines, and vital pieces may be missing. A piece of armour in a case, designed to make a historical or cultural point, can easily overpower all the other exhibits. A conscious effort has to be made to keep the exhibit within its context, and this is almost to deny its very nature.

We tend to view armour through a sort of romantic filter, and the craftsmanship and glitter make an impression far beyond the appreciation of structure and function. Moreover, an element of display was essential for the men who originally wore it, and this must be taken into account.

Armour itself is a kind of mould. The shapes and dimensions are those of men once living, and, like the casts of the victims at Pompeii, the warriors become instantly accessible through their suits. A suit of armour striding is a soldier striding, on horseback it becomes the rider. Historic ghosts become substance in front of the visitor. Until one comes to the head. What faces does one give to men who fought in great and decisive battles?

Does one look for a portrait reference to the man or the period or does one fill the armour with the neutral face of a dummy, or prop the visor open on the mount, and leave the features to the imagination of the visitor? Here we are in the area of taste, and cultural tact.

The structural side of armour is relatively easy to display. Components have to be opened up, angled, and lit to explain the mechanisms at work: simply an exposition of the engineering. Craftsmanship and decoration need the same.

Types of display

Depend on the type of armour and how much of it survives.

Storage display

In the style of old armouries – packed in, forming striking patterns, lit as a 'tableau'.

Realistic action groups

Re-creating battle positions, but must then have heads, hands and be fairly realistic or individually give the impression of being on a figure – possibly on an adjustable wooden figure (as at the Tower of London).

On stands

Traditional wooden stands, or more modern versions or tapered plinths. Important that pieces of armour should be seen at the height corresponding to original usage.

Odd pieces

Spare helmets – suits often had spare helmets – shown as 'objects' can be suspended or fixed on brackets to a back board. Chain mail (originally worn with surcoat over) would be more suitably shown on a stand without limbs or features or suspended on a pole. Single pieces can be fixed, in the appropriate place, on a 'cut out' figure or on an enlarged photo of an archive engraving.

Cases and security

For full-height suits of armour, treated realistically, cases must be sufficiently spacious to avoid a 'claustrophobic' effect. Full height access should be provided.

Where environmental conditions are satisfactory some armour may be suitable for display in the open, providing all pieces are securely fixed. However, it is advisable for all small items to be displayed in cases.

Conservation

There is a dual problem: steel armour will rust in a damp atmosphere and therefore low humidity is needed. But leather used to strap the armour to limbs presents a problem as the dry conditions to prevent rust on the armour can cause leather to disintegrate. Ideal conditions for mixed materials would be RH 50–55%, temperature 18°–20°C. Silver decoration on armour can tarnish and so materials used adjacent to the display should be tested (see pages 58–59). Dust settling on armour will dull the display and therefore cases containing armour must be as dustproof as possible. If shown in the open, the gallery should ideally be air-conditioned.

Lighting

If the armour is displayed in cases, as a study collection, where details of all parts of the exhibits must be clearly visible, overall fluorescent lighting is essential, with some spot lighting to highlight details, as an optional extra. For a full suit of armour the lighting must evenly illuminate the full length. In a dramatic, evocative setting the display would be enhanced by spotlighting – perhaps to suggest sunlight glinting on armour.

When the exhibits are free standing or wall mounted, general gallery lighting, either daylight or artificial, supplemented by spotlights is suitable.

Supports

Most suits of armour would be displayed, strapped and fixed as originally worn, on dummy figures of wood or covered wire. The stance of the figure may be such that combined with the weight of armour no additional support is necessary. Alternatively armour can be fixed to an adjustable metal or timber frame, padded out to provide support and protection, stability provided by an upright support fixed to the floor or the baseboard of the case. This form of support can detract from the armour and so it is best suited for use within a wall case where the back of the armour and its support is not visible.

For the display of helmet and cuirass alone, exposed metal or timber stands are commonly used, but lack the solidity of another conventional support, the tapered timber block. As with the display of costume (pages 152–7), any attempt at providing a complete

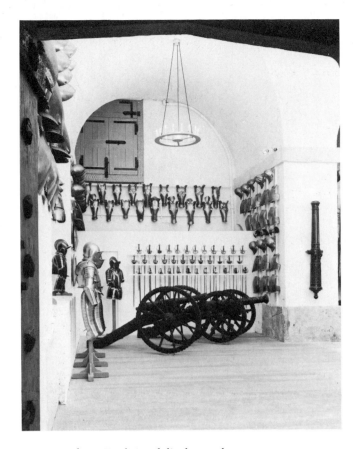

Pattern making. Traditional display, and storage of armour on wooden stands. The cannons form a barrier protecting the swords.
Cannon Room, White Tower, Tower of London

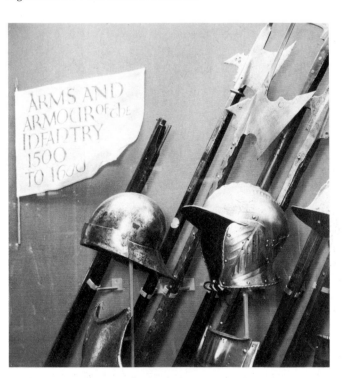

Armour on carefully modelled support dominates the room, set as sculpture in the scene depicted by photographic murals. Legend in large type on sloped label.
Sigismund Vasa exhibition, Stockholm

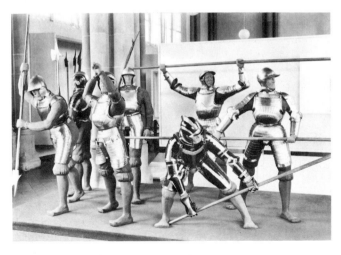

Realism and posture against a plain background. An actual battle reconstructed from a painting. Heads, hands, feet are stylised. A low plinth distances the visitors.
Swiss National Museum, Zürich

Evocation. Heading is lettered on a hessian banner, original stone wall is adjacent, helmets are on metal supports. Display, although cased, contains carefully planned movement.
Hunting Gallery, Tower of London

figure must solve the problem of the head and hands if these are to be visible. Moreover, the decision has to be taken as to whether a stylised abstract head without features or with realistic features are used. This will depend to a great extent on the setting and surrounding displays. Any attempt to display fragments of armour on parts of realistic figures should perhaps be avoided as the result of dismembered limbs and torsos smack more of the battlefield than the museum.

Backgrounds

The background to a display of suits of European armour might well be selected to evoke atmosphere; the natural setting of the rough-hewn stone of a castle, or the simulation of such a setting by the use of present-day building materials or textured finishes, or the photographic 'wallpaper' effect of stone walls or landscape. Individual pieces of armour, displayed almost as works of art, would be enhanced by the use of steel grey or blue finishes such as paint or fabric, while a natural hessian weave might well be suitable if the piece is not too small nor the decoration too fine.

Labelling

Full-length suits, like costumes, probably need a sloped floor label, but type size must be enlarged and adapted accordingly.

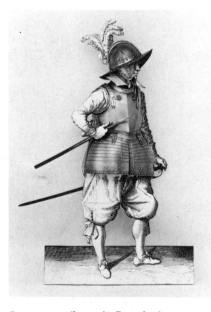

Support – a 'bas relief' method.
Contemporary print is enlarged, and holes are cut in the case back-panel to hold the armour (a costume technique applied to metal).
Tower of London

Books

Introduction

A successful display of books and their bindings will echo the normal conditions of reading: the type viewed at the correct distance, and the books held at a comfortable angle.

Displays of historic books are greatly enhanced by the possibility of the visitor being able to sit and read modern versions, and facsimiles of related works. Reading and study areas for these purposes will be well used if space permits their provision.

Types of display

Books are displayed in museums for a number of reasons:

For bindings, as art objects, examples of the bookbinder's craft.
For printing, demonstrating the development of print, examples of fine printing and the design of typefaces.
For content, text and illustrations
With other material, single books are often incorporated into the display of other materials such as manuscripts, drawings, memorabilia, instruments and room settings.

The method of display and the design of accompanying information should reflect the reason for display.

Cases and security

As they are portable and vulnerable all books will have to be contained within show cases. Ideally, books should be displayed on a flat surface, either horizontal, or on a slight slope not exceeding ten degrees from the horizontal. The so-called 'table cases' are ideal, preferably equipped with a leaning rail to permit lengthy study. The internal depth of the case must be so calculated as to take the thickness of all the exhibits in the display, and allowance should be made for the books being arranged both open and closed.

When an individual book is displayed with other material it may be useful to provide a block mount for it, or even to arrange its display in an individual case to enhance its importance.

Conservation

The materials used in books – paper, cloth made from plant fibres, and leather – are among the most sensitive with which the designer has to cope. It is imperative that light levels in the exhibition are kept at 50 lux in order to prevent the pigments from fading and the paper from becoming brittle. Humidity should be kept above 45% RH to avoid 'desiccation' and below 65% RH to avoid mildew, mould, and the reddish brown spots on paper known as 'foxing'. Lack of ventilation combined with high humidity will also encourage 'foxing'. Paper moreover is liable to attack by sulphuric acid from the sulphur dioxide present in the urban atmosphere. Leather is equally if not more sensitive to sulphur dioxide: it causes the condition known as 'red rot', a very common problem with book bindings.

All materials used in the display cases should be tested to make certain that they contain no substances which might produce a chemical change in the objects. Conservation may dictate that the openings of the volumes – the pages actually displayed – be altered from time to time, or the books may even be kept closed for a short period, such as one day a month. This means

Display stand on which children can turn over enlarged book illustrations. A jolly cut-out figure incorporating wire supports. *Swiss Picture Books for Children*, Museum of Applied Art, Zürich

Open books. Here individual cases hold books at reading angle, so they can be deployed with other graphic exhibits. City Museum and Art Gallery, Stoke-on-Trent

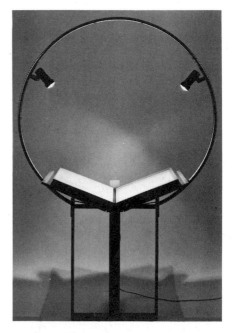

Travelling unit in the form of a book stand with integral lighting. Riksutställningar, Stockholm

Desk-case display. Information panel at glass level separates manuscripts bound as a book from 'window-mounted' papyri, each set in glass 'sandwiches' (taped edges masked by insert panel).
Dead Sea Scrolls, British Museum, London

Adjunct book. Essential to the story, but an interloper in a two-dimensional display. The case is an angled unobtrusive compromise.
Tate Gallery, London

that conservators may require access to the cases during the exhibition, and the designer should facilitate this.

Where mixed with other material, the conditions required for the conservation of the books may well dictate the conditions for the whole of the display.

Lighting

Lighting of books and their bindings must always be restricted. Fluorescent lamps will give a uniform illumination, but all fluorescent tubes should be fitted with ultra-violet filters. The positioning of the lighting in the case should avoid glare in the eyes of the viewer. Cases should be positioned against a wall or screen, or if double-sided cases are used, they must have a solid baffle between the two compartments to avoid glare from one case spoiling the view from the other.

Supports

Books displayed on a slope must be prevented from slipping. For a temporary display this can be done quite simply by placing mapping pins (1 cm in depth) as supports. However, a ledge will supply continuous support, and this is much to be preferred. Such a ledge should support a volume along the whole length of the bottom edge of its binding. Probably the least obtrusive method of support is by means of 'L'-shaped Perspex ledges, screw-fixed to the case baseboard under each volume.

When a volume is displayed open the leaves must be held in position by retaining straps. The material used must be approved and tested to make certain that it has no damaging chemical effect on pages or binding. If a transluscent material, a polyester film such as 'Melinex', the ICI product, is used the text can still be read through the strap. The straps are never fixed to the volume itself, but to the case baseboard. If this is not convenient, the strap can be formed into a loop round the volume, fixed to itself with 'magic tape'.

When the title page of a thick volume is displayed the left-hand cover may need support to prevent the strain on the spine of the book.

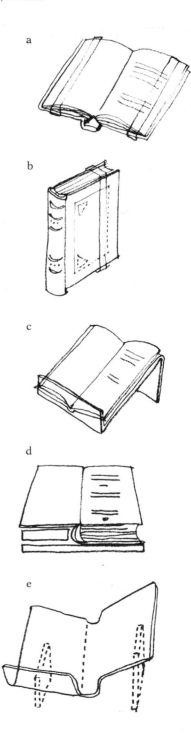

a

b

c

d

e

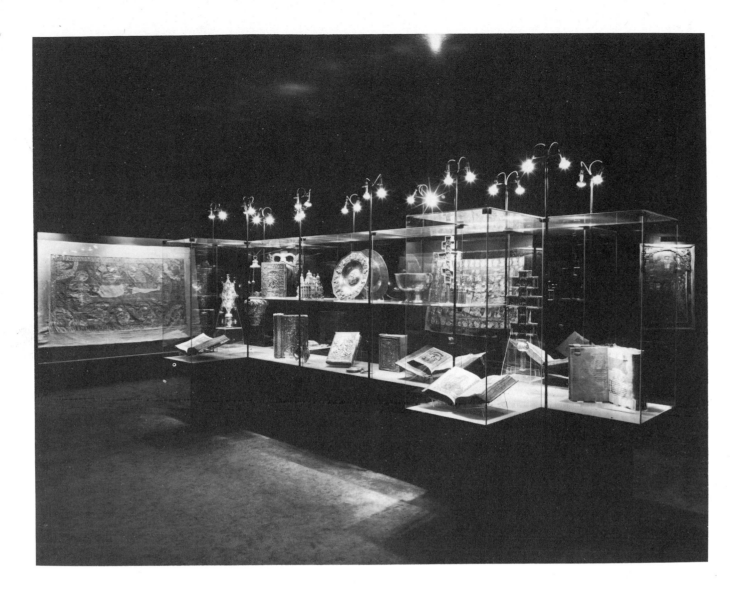

Temporary display. Bound illuminations, some closed showing bindings, on Perspex stands. Spotlights above cases. Other material also included. (N.B. if displayed on a long-term basis there could be conservation problems.)
Rumanian Art Treasures, Edinburgh Festival
Designer: Alan Irvine

Left:
Book supports:
a) and b) Melinex bands/strips round the leaves of an open book and binding
c) An angled Perspex stand to hold an open book
d) Support for the cover of a thick book to display the title page
e) A shaped Perspex stand to provide support for a book opening at a specific place without straining the spine

Backgrounds

Plain backgrounds, those with minimum texture, or very close woven fabrics, are preferable as they do not detract from the printed page. Where a volume exhibited has an elaborately tooled binding – and this is the point of the exhibition – fabrics may be used to create a suitable 'atmosphere'.

Labels and information

Labels should not be positioned so that they fall within the shadow cast by the books to which they refer. If the purpose of the display is to show the content of the book and the key extract runs beyond the page displayed, the subsequent pages can be shown as adjacent 'same-size' photographs to complete the information. If a particular passage on a page has special significance its importance can be emphasised in a number of ways:
 By marking the relevant lines in the book margin on the restraining Melinex strip in a bright colour.
 By the application of a transparent coloured overlay on a 'same-size' photograph of the pages concerned, placed near the exhibited volume.
 By the display of a photographic enlargement of the relevant passage.

Buildings

Introduction

Although many buildings have to be 'displayed' (if you can use the word about anything so big) on their original sites, a number of buildings are preserved by being taken carefully apart with the conserved parts being reassembled together on a new museum site. Often this results in the buildings being in open landscape, comparable with their original setting, and the direction-signing and service-planning open up a number of interesting possibilities for the designer.

However, in such projects the designer will be working with a much larger team than the one usually found in a traditional museum. Surveyors and landscape designers may well be included in the team of specialists, and it will be worthwhile becoming familiar with their fields of work.

Signing

Like other large objects, such as aircraft and liners, a building is an exhibit which is penetrated by the visitor, and this gives the planning of direction signs an added complexity. Where the buildings are complex the signs will not only have to direct the visitors to the exhibit, and into it, but also tie in with handheld guide-maps and plans. The whole exercise demands a much more sweeping approach than that called for in the confines of a gallery.

Labelling buildings: inside and outside

In travelling between buildings, and into and round them, visitors will be travelling much greater distances than when in a museum gallery. It is essential that they travel with a pilot! Plans of the site and the building are essential, and can be used to carry a great deal of supplementary information. Such plans must be matched with the identification of the building and its parts, regardless of whether the information is near or actually attached to the building itself.

All externally displayed signs, texts and diagrams must be weatherproof. They must be legible from a distance (let the designer visualise substituting a postman for the visitor and consider the consequences). The signs cannot be too sturdy. Traditional signwriting will be fine if suitably varnished or protected, laminated plastic signs must have the edges fully protected, and where the sign will have a long life, there are good arguments for using stove-enamelled signs such as have been tested over the years in our towns and cities.

Within the building the labels will function like those on any large object, but as far as possible, the spirit of the building must be reflected in the style of the label. It is also essential to check the direction from which the visitor will arrive at the label. An object labelled after you have left it is very frustrating. The rule should be, if in doubt, duplicate!

Props

It is not likely that the curator will want his building presented empty. To bring it alive it will have to be 'dressed' with appropriate furniture of the period and pictures that provide historical references. These will have to be protected with barriers that, while being effective, do not clash with the spirit of the structure itself.

The building may be an example of an unusual or historically important construction. Here it may be necessary to recreate part of the structure at an incomplete stage, or to leave exposed some parts of the structure which have been revealed during restoration. All this will call upon the skill of the designer, and also on the ingenuity of the craftsmen he will be working with.

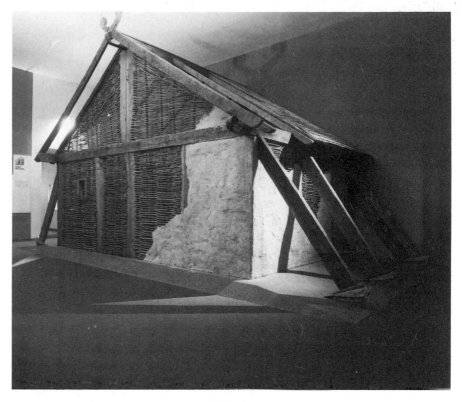

Label outdoors. A site label made to 'weather'. Text information encapsulated in laminated plastic, with sealed edges. Digges Burial Plot, James River, Virginia

Facsimile house. Visitors could study traditional construction externally and enter reconstructed interior. (N.B. Many original buildings are now transported and re-erected in museum displays.)
The Vikings, British Museum, London
Design: Robin Wade Design Associates

Planned relationship. Information panel is large enough to attract but does not distract. Building construction and explanation could not be closer together. Weald and Downland Open Air Museum, Singleton, Chichester

Traditional signwriting used to label an original stone cottage re-erected on an outdoor museum site. Weald and Downland Open Air Museum, Singleton, Chichester

Ceramics

Introduction

Clay, one of man's earliest resources, has been used to fashion vessels, figurines, images, and to provide building materials, in all cultures and throughout all ages. In spite of the friable nature of the material many earthenware objects have survived from the earliest times, to be exhibited in museums today.

The various temperatures at which the material is fired produce the different types of wares. These range from coarse, low-fired terracotta, earthenware, and stoneware to fine translucent porcelain fired at high temperatures.

The scale and finish of the various categories of earthenware will often dictate the style of the display.

Types of display

Examples of primitive techniques of production appear in archaeological and ethnographic exhibitions. More sophisticated pieces are exhibited as works of art, or to express, with other material, periods of history. The exhibition of the tools, craft and technology of production are featured in didactic displays, often enlivened by demonstrations.

The problems of display, peculiar to ceramics, apply whether the material is mixed with other exhibits to illustrate general points of history or geography, or isolated as 'aesthetic displays' or study collections of like objects for the use of scholars.

Vessels
Certain displays require particular handling. By virtue of its specific patterns, oriental material will require special settings and white 'blanc de Chine' porcelain will demand lighting to develop its transluscence, and backgrounds to strengthen its outline.

Tiles
The display of tiles demands arrangements quite different from those for ceramic vessels. Building tiles can sometimes be assembled to show their original constructional use. Large collections of tiles can be mounted to show the development of their pattern and colouring, but care has to be taken to avoid the impersonal and confused nature of bathroom manufacturers' showrooms. Flooring tiles can be set, functionally, in floors, where the public may be reluctant to walk on them, and in this position they are sometimes used as a means of labelling exhibits in the gallery. Tiles can be grouped together, and hung, framed, on the wall. Great care is needed to avoid the frame interfering with the tile design.

Shards
If the material is broken and incomplete, the curator may wish to assemble shards to show, as far as possible, the style and form of the broken object. Where there are sufficient pieces a complete reconstruction may be attempted, the spaces being filled by neutral material; the designer will then be able to treat the whole construct as a normal vessel. However, it may be more practical to display the shards on a flat surface.

Cases

Most ceramic pieces require all-round viewing. Many have decorations on the underside, and makers' marks and other information of interest to the specialist and collector. Where possible, free standing cases will make this degree of access to the exhibits easy and natural.

Where an existing room with a strong architectural character is available for display, cases may be constructed to echo the details of the room. This is particularly appropriate when the period of the room and the exhibits are the same. Even when this is not the situation, it may be desirable to unify room and case, leaving the exhibits to 'show themselves'. There are then only two design elements present, the total setting, and the arrangement of the objects. (Generally, in museum galleries, three elements are present, the objects, the cases and the total setting, all possibly different in chronology and style.)

Security

Porcelain, both because it is vulnerable and also portable, must always be displayed in cases, and the same applies to the smaller pottery exhibits. Stoneware and studio pottery, however, can sometimes be displayed in the open. This depends on assessment of the likely audience and also on the use of plinths and related barriers. It may be advisable to hold some pieces in position using soluble glues.

Stability
Many pieces of porcelain are both light and brittle, and may have a high centre of gravity. They have therefore to be regarded as unstable, and must be protected against vibration transmitted through the cases. In particular, the use of glass shelves may increase the risk of the objects 'walking'. Where site vibration is likely to be high, cases must be firmly anchored to the floor with specially designed mountings. The conservators may decide to use adhesives such as 'Blu-tack' to attach the pieces to their shelves.

Conservation

All porcelain must be regarded as extremely fragile. Large pottery, stoneware in particular, is less liable to breakage, but even so, the surface and its decoration may be vulnerable. Ceramics are not susceptible to the action of light, and are not affected much by heat and humidity, although the pigments in some surface decoration could be affected by light. It is desirable, however, that fluctuations are avoided, and relative humidity maintained between 50% and 55%.

Where broken specimens have been reconstructed in the past, using materials and techniques that would not be acceptable to conservators today, they may now be vulnerable. For example, old-fashioned adhesives may be affected by the atmosphere of the gallery, and

the object weakened or distorted. However strong in appearance, pottery is not impermeable. When objects have been buried in the ground they can absorb soluble mineral salts, and later in the open appear to have grown whiskers!

Lighting

Whatever the available lighting, considerable trial and error must be allowed for when cases are being dressed. If lighting from the top of the case is used and the display is set on glass shelves, care has to be taken to avoid the distracting shadows one object can cast upon another, especially if the case is crowded. Often these shadows can be eliminated by the balancing of top lighting with up-lighting from the floor of the case – in effect, using two light boxes. If top lighting only is

available, and decoration on the side of a bowl is likely to be in shadow, some light can be reflected by placing the object on a piece of mirror. However, to mirror the whole of a case base would be a distracting element.

Supports and mounts

Mounts should be as stable as possible, but also as invisible as possible! Some vessels, such as those made for use on the ground, do not stand up without help, and require their own individual mounts. Sometimes a simple cylinder of Perspex is suitable, often a wooden collar is less distracting, and, if the base of the case or shelf permits, small rubber stubs can be used to provide three-point bearings.

Plates and shallow bowls can be held on plate stands, such as the plastic covered wire or Perspex stands

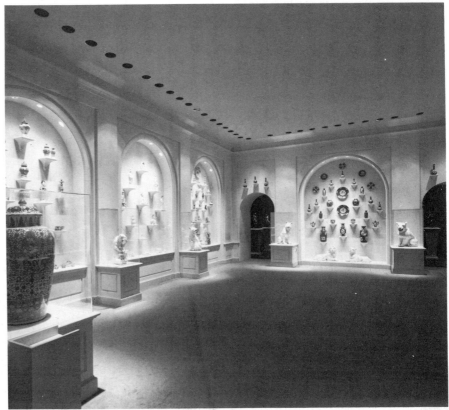

Shallow wall cases with adjacent information panels closely related to exhibits which show pottery makers' marks.
Coalport China Works, Ironbridge Gorge Museum

Above right:
Selected groups of objects are clustered in individual cases related to information panels. The curving gallery wall unifies the display. All light from above.
City Museum and Art Gallery, Stoke-on-Trent
Design: Colin Milnes Associates

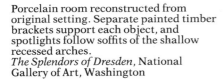

Porcelain room reconstructed from original setting. Separate painted timber brackets support each object, and spotlights follow soffits of the shallow recessed arches.
The Splendors of Dresden, National Gallery of Art, Washington

made for use with domestic ornaments. But special mounting is required when a plate is to be hung on the wall, and any such attachment must be approved by the conservators.

Where the exhibit has to be seen from many angles, it may be raised by the use of blocks. Where even greater visibility is called for slowly revolving turntables can be mounted within the blocks, which may require the exhibit to be held in place by 'temporary' adhesives.

Mirrors can be introduced into the display to show reverses and undersides, but the designer must bear in mind that mirrors are not selective, and may show parts of other exhibits and portions of case construction, and be very distracting.

Backgrounds

Apart from the usual fabric or other textured backgrounds it is sometimes helpful to use photographs of contemporary prints or paintings as background to give a flavour of the period. Pages from the pottery 'travellers' catalogues are sometimes available. On occasion, details of the ornament used on the exhibit may be used. With all these approaches caution is needed. The enlarged photographs provide a very powerful image and may easily drown the specimen objects to which they relate.

Props

In considering the display of more primitive objects it may be useful to supplement the vessels with some other domestic tools or garments so as to enable the visitor to understand the level of community in which the vessels were used.

A great deal of the more sophisticated porcelain and finer pottery have been created by techniques used within the memory of many still alive, and the processes and tools employed can be included in the display, reconstructed from existing craft collections and with material from the museums devoted to the early industrial potteries.

Again, the use and domestic context of the later ceramics can be shown by setting a 'dresser' arrangement of shelves within the display case, where a number of related objects, such as clocks and candlesticks, can be included.

Pottery and china play a large part in the reconstructions of rooms, such as 'a Victorian kitchen' or 'a miner's cottage'. In such contexts the related information has to be confined to remote labels or panels to avoid destroying the illusion.

Top:
All glass wall-cases in daylit gallery. Picasso's unique plates are angled to catch the light, with minimum distraction from the case components. Picasso Museum, Château d'Antibes, France

Centre:
Dresser display within a showcase. The traditional shelving suggests the original use of the exhibits. City Art Gallery, Manchester

Left:
Staggered display. This clearly indicates the grouping of material. Tiles are exhibited on the angled slope below, with related information, vertical, above. City Museum and Art Gallery, Stoke-on-Trent

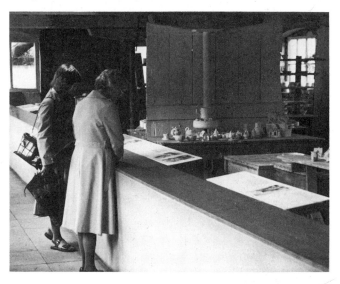

Open display. Modern pottery placed directly on glass table tops. The dish supports are stained timber, echoing the display table structure.
Making It, Crafts Council, London
Designer: Barry Mazur

Actuality. Workshops in their original building. Place, process and product shown together. Original workshop daylight plus spotlights directed onto information panels on the barrier.
Coalport China Works, Ironbridge Gorge Museum
Design: Robin Wade Design Associates

Labels and information

Since a single display or case may contain a large number of exhibits, ceramics impose a particular problem of labelling. Top lighting may create shadows round the objects which could obscure labels. To ensure a clear view of the contents, the individual labels can be brought outside the case onto a combined label, the texts positioned closely to the case arrangement. If there is insufficient space to have the label panel outside the case it can often be included on an interior slope at the front of the case, which still separates it visually from the exhibits.

Information panels and diagrams
The public visiting a collection of pottery and china will often possess only a slight idea of how, technically, it was produced. In a 'factory' museum, a technical museum, the visitor should be 'briefed' in advance on the processes that will be displayed, and on the technical innovations that made the various developments possible. Only then will he be able to appreciate fully the collection of examples.

Diagrams are useful in offering simple explanations of technical processes, such as kiln design, and the stages by which ornament has been transferred to pottery can also be made clear diagrammatically. In addition, when the form of a damaged pot has to be shown from shards, with many parts missing, the shards can be incorporated upon a diagram outline.

Audio-visual displays
Pottery and china have been developed over the centuries by refining manual skills to a high level. Film and video recordings of potters in action will be useful for conveying the 'dynamics' of pottery and can supplement live demonstrations where these might be available.

Scale models
Some museums are fortunate enough to have scale models, showing the craftsmen at work on the processes. Being in miniature, these can be effectively incorporated in a case display. Though time-consuming to produce, if the skills are available to the designer at reasonable cost, they are a vivid method of demonstrating processes to those unfamiliar with them.

Sherds pinned on a fabric-covered slope. Each piece numbered and keyed to the label below (Similar intact pots were displayed nearby).
Kiln Sites of Ancient China,
British Museum, London

Coins and medals

Introduction

Coins are among the most difficult objects to display well. They share certain characteristics with medals and medallions: they are small metal objects, usually round and double sided, with relief inscriptions and devices. A great deal is packed on to a small area!

Any of these three objects will demand similar display solutions, and these solutions may also be suitable for the display of engraved seals and their impressions.

Coins and medals differ in one particular, however. The relief decoration on coins is often worn and care must be taken to make the design on the coin visible by careful lighting. Being usually somewhat smaller, they will also be rather more difficult to fix in position in a display than medals.

It is easy to swamp these objects with supplementary information and they are, above all, made of precious metal, valuable and easily portable.

Their character can be seen (for usually we are blind to it) by looking at the loose change in our pockets. To see the detail, a coin has to be held within a few inches of our eyes; to get maximum information, such as the date, a worn specimen will have to be angled exactly to the light source.

All coins need magnification to yield the detail of the design, whether isolated or in a collection. The specialist audience will require to see both sides of the coin, and a lot of supplementary information with it. A number of coins displayed together will tend to bore the general public, while an isolated coin may make a significant addition to a general exhibition, provided that it does not get lost from sight.

Designed for study: a covered leaning rail in front of coin cases. Text panel at the back of the case, coin enlargements on case fascia.
Usher Gallery, Lincoln
Design: Robin Wade Design Associates

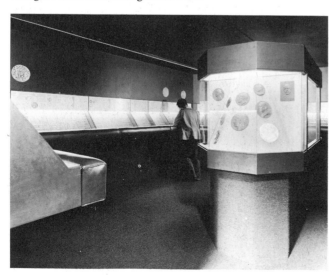

Fixing coins and medals:
a) With pins
b) On a ledge
c) In a circular depression on a sloped display board or set in a Perspex sandwich, both sides visible
d) Set on a shaped mount fixed to backboard with pins
e) Mounted on a triangular block, incorporating the label – a useful method when a single coin is included with other objects
f) Fixed onto the label together with a photo of the obverse of the coin
g) Shaped Perspex forming a stand for a medal

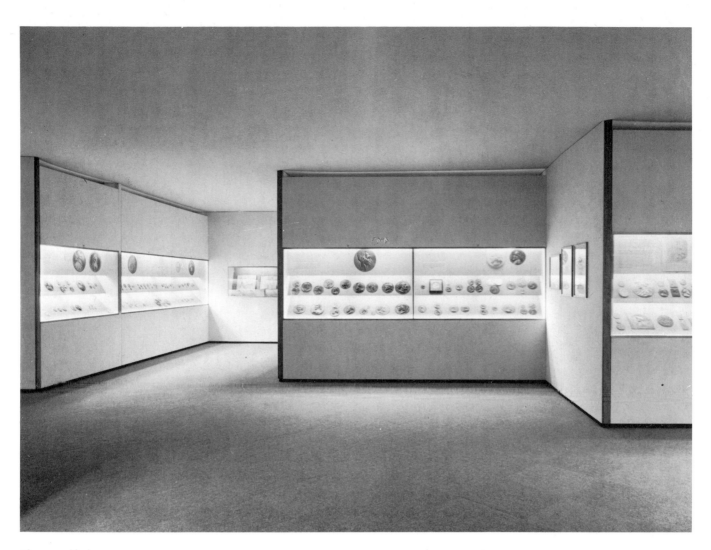

Above and below:
Photographic enlargements of medals displayed in wall cases. Sloped display panels below, lit with raked fluorescent light to enhance the relief on the medals.
The Medal: Mirror of History, British Museum, London Designer: Alan Irvine

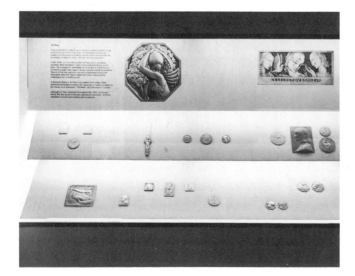

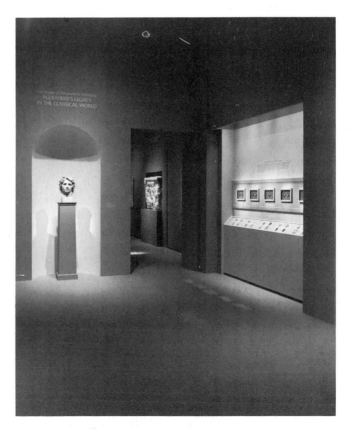

Right:
Portrait busts can be compared with coins grouped in spotlit frames inside a glazed recess. Text and enlargements are displayed below.
The Search for Alexander,
National Gallery of Art, Washington

Types of display

There is a place for specialist displays in museums of the everyday, durable currency of a number of countries. In such collections the arrangement will derive more from the experts than from the designer.

But these three kinds of display pose entirely different problems:

Isolated coins

Design problems arise when a coin or medal is used as an individual piece, in a display of mixed material, serving as a form of chronological punctuation. Here the presence of the coin has to be emphasised; it has to be 'boosted' to make it rank with the other objects on display. It can be featured on its own mounting, or set on an information panel or label.

Grouping

A large number of coins presented as a single unit will entail the display of a great deal of information to set the coins in their geographical, historical and social context, and the positioning of this information is all important. Before an individual coin and its information can be 'read' by the visitor, the assembly of information must make sense as a whole.

Hoards

In displays of archaeological material coins are often arranged much as they were discovered – within a container or in a heap – not to show individual details but the wealth of the find.

Cases

Cases for the display of coins are usually fairly shallow, to enable the exhibits to be placed near to the glass, and the visitor to be able to get close to the object itself. As the objects require detailed study, taking some time, a leaning rail is often a thoughtful inclusion by the designer. This can be applied to a vertical case, or formed from the edge of a table case.

Security

Because of their intrinsic value and small size, coins should always be given maximum security. The designer will often need to include alarm devices as specified by the security adviser. Additional precautions can include backing the glazed front of the case with a sheet of Perspex, which, if treated with anti-static solution and fixed close to the glass will not obscure the detail of the exhibit.

Conservation

In antiquity, coins and medals were struck in a variety of metals: gold, silver, lead, copper and bronze. In more recent times various alloys have been used. A mixture of these materials combined in a single display can raise problems for the conservators and the designer catering for them. And a single coin, of any material, displayed with completely different objects, possibly of organic materials, will pose particular conservation problems. Ideally, from a conservation point of view, coins should only be displayed together if they are of similar material.

Gold is virtually indestructable under normal conditions, being unaffected by heat, humidity or pollution. Silver coins are susceptible to tarnishing from minute amounts of sulphur compounds in the air or from materials used in the construction of showcases. Lead coins will corrode very quickly if any traces of organic acids are present, and these can be found in certain timbers; oak, in particular, must be avoided. Timber and many other materials have to be tested before use.

Bronze coins are susceptible to corrosion by sulphur dioxide. Relative humidity within the case must be maintained between 40–45%. In general, very dry conditions within cases and the exhibition area will protect objects made of other metals from corrosion. In addition, all materials used in case components must satisfy the conservators.

Medals with ribbons will need substantially reduced levels of illumination, and also ultra-violet filters fitted to the light sources to prevent fading of the dyes in the textiles. The RH should be higher than for coins, otherwise the silk of the ribbons could become brittle.

Lighting

An even, directional lighting, angled obliquely from one side, will accentuate the relief on the face of a coin. In most coin displays the source is usually fluorescent strip lighting at the top of a showcase, but it is essential to ensure that the light source itself is not visible when the visitor is studying the exhibit. Alternatively, strip lighting can be arranged from the front of the case, possibly shielded by a leaning rail. Side lighting is less satisfactory as the light level drops considerably towards the centre of a wide table case.

The angle of light must be related to the angle of the display board, but fine adjustments will be necessary. The thicknesses of the coins will vary considerably, and some will need to be tilted individually, by placing packing between the coin and its mount.

Mounts, supports and background

Even if they are displayed in flat or shallow sloping cases, each coin will have to be fixed into position. The most usual method is by three or four pins pushed into the case back board. For ease of fixing, this board should be of a fairly soft composition. The pins should be bronze or silver-plated to match the metal finish of the coin or medal.

Alternatively, specially made individual Perspex mounts can provide both a ledge and a fixing device to the back board. In a sloping case a series of ledges, on which the coins can rest, can be formed by the shallow stepping of the back board. Continuous ledges can also be provided by lengths of Perspex.

Where duplicate coins do not exist, or where medals are displayed, a method of ensuring that both faces can be displayed is to 'mount' the object in a Perspex sandwich and display it as a screen with access from both sides.

The backgrounds selected for cases containing coins and medals should be plain and – if fabric is used – close woven. A fabric with a heavy slub will detract from the object. The colour and texture of the background will need to be related to the predominant colour of the coins or medals being displayed, but a matt finish is essential in a painted background.

Labels and information

There is a danger that a large amount of detailed printed information in close proximity to an individual coin will overwhelm it. Such labels should perhaps be reserved for study collections or the information made available through a catalogue instead.

The 'keyed' method of imparting information is the most suitable, provided that the text is placed in such a way that the visitor does not have to move away from the object to read it.

Both the scholar and the schoolboy will want to see both sides of a coin. When the obverse of the coin is not available (which would call for two examples of the coin in question), an electrotype copy or a 'same-size' photograph of the obverse is often mounted adjacent to the coin.

The background information to a collection can be displayed as an integral part of the display with coins actually mounted upon the printed information (provided the paper is acceptable to the conservator). Another obvious method of imparting information about the appearance of a coin is by magnification. Photographic enlargements accompanying the coins, or the use by the visitor of 'Fresnel' lenses will enable the point to be made more effectively than the use of descriptive text alone. (A 'Fresnel' lens is made from thin-sheet clear translucent material, such as Perspex, with circular inclined planes engraved on or cast into it. Resembling a gramophone disc, it provides the light-bending properties of a traditional lens, but it is not only cheaper, lighter, and unbreakable, but also takes up very little space or depth in the arrangements for the display.)

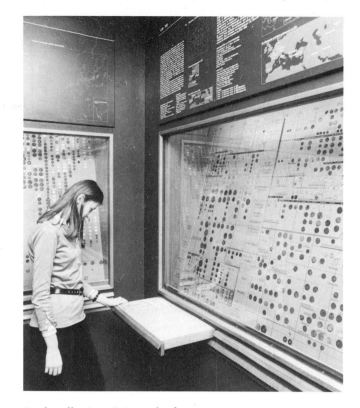

Study collection. Coins on leather-covered sloped panels. Grooves define sections of display. Information both above cases and on pull-out panels below. Royal Coin Cabinet, Museum of National Antiquities, Stockholm

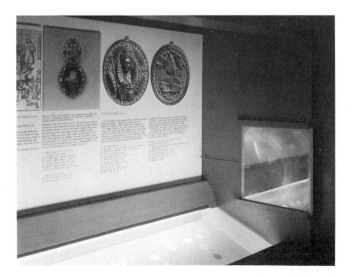

Magnification by counterweighted Fresnel lens which can be placed over individual coins. After use the lens draws back clear of the display.
2000 Years of British Coins,
British Museum, London

Costume

Introduction

The term 'shaped textiles' covers those textiles which are made up into clothing and which are generally known as Historical Costume. This title embraces regional and ethnographical costume, fashion, uniforms, and stage costume.

Displays of such material start with one positive advantage; they are easily understood and enjoyed. The visitors can visualise themselves wearing the costumes, and try to imagine the restrictions imposed by the garments compared with those of present-day dress. Displays of costume have an instant impact, even before other information has been attached to them.

While interpretation in a costume display can be minimal without reducing the total story, the problems of display which face the designer are considerable. The materials of which costumes are made, and have attached to them, entail the most stringent conservation measures. Many of the costume styles require large areas of space for their proper display. Many of the exhibits will be incomplete, without 'body, gesture, or ambiance'. Faced with this difficulty, the designer of the exhibition has to create the illusion of bodies wearing the costumes, and the illusion has to be created at reasonable cost, and in such a way that it does not conflict with the style of the garments. One of the most critical areas of exhibition design, both as regards taste and compatibility, is the facsimile reproduction or symbolic representation of heads: hair, facial features and expressions.

Types of display

Living models

Costume is always best seen on the human figure. If there were no risks attached, the designer would use live models to bring historical costumes to life. The use of a museum collection in this way is, however, out of the question. If the creation of this type of illusion is required, funds must be obtained, and the skills mustered to create accurate replica costumes, and live models, not only dressed in them but versed in their display.

The bar on wearing original antique costume, though frustrating, is inevitable. Not only have time and atmosphere made the original materials deteriorate, but the garments will already have been weakened by the stresses imposed by their original wearers.

Realistic figures

However, costumes displayed on realistic figure models and placed in realistic settings can be used to re-create the past. This method appears to be very popular with the general public, creating an actual event, a 'slice of history', or an interlude in domestic life of the past. Such settings may be effective but they are also expensive to produce. A total scene has to be created, rooms, furniture and the 'props' that reflect the times. To maintain the illusion, figures wearing the costumes will have to made to the highest standards: in England, those of Madame Tussauds.

Commercial figures

Presenting historic costumes on commercial display figures of the present day is also possible. They are available in a number of postures, styles, and finishes. A wide variety of heads and features and hands is available, but the degree of reality achieved varies widely, and the cost with it.

The major problem is that of reconciling the faces and postures of today with the clothes of the past. The faces of the past are known to us through portraits, and although these may be conventionalised renderings of the period, they help to form our ideas of the appearance of the epoch: the visitor may find it difficult to accept a period garment with the facial expression and body posture taken from the shop windows of the local department store.

Stylised figures

It is possible to display costumes on models with specially styled heads, hands and feet, where the hidden torso supporting the costume is built up in a variety of non-naturalistic ways. This method has the advantage that the costume can be made to dominate the stylised wearer.

Symbolic figures

It is also possible to show the design and construction of costumes on 'models' which are completely symbolic, no attempt being made to simulate the body, even in part. No heads or limbs are constructed; the costume is simply supported at the critical points in space, the suspension taking proper account of floor levels, etc.

Flat displays

Some costumes can be made fully visible when hung on flat hangers, cardboard cut-outs, etc, and this can be attempted when for reasons of conservation support in the round is not required.

Costumes can also be mounted as a bas-relief, each being mounted on a padded board which forms a shallow torso. The shaped boards can in turn be mounted on a vertical surface. As with the flat 'hanger' technique, the 'padded board' technique is only suitable where the costume is neither too bulky, nor too heavy, and where it can be tucked around the board without jeopardising the material or its construction.

Compromises

The designer does not have a completely free hand in deciding which form of display to adopt. The method used for mounting or supporting the costumes will dictate the type of display that is possible.

It has to be faced that some aspect of the display will appear unnatural. The aim is to reduce to a minimum the number of contradictions to which the visitor is subjected. For example, commercial display figures can be acceptable; the figures standing as symbols for the original wearers. If they appear against a neutral

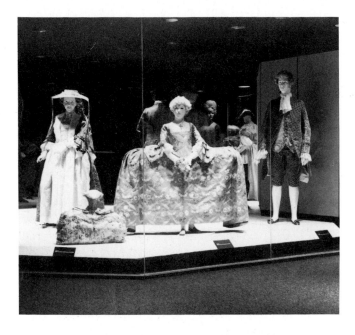

Edge-to-edge glass cases, full height. Lit from recessed ceiling fittings. The figures stand on a 'floating' base panel, its sloping edging housing the labels.
Museum of Costume, Bath

'Rag doll' models used in a shop display of boldly patterned dresses. This technique could be adapted for displays of folk costume.
Marimekko, Helsinki

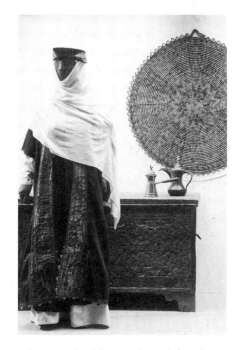

'Shop-window' figure adapted, fitted with stylised head and hands. A setting is suggested by including pieces of domestic furniture within the case.
Costumes of Palestine, Museum of Mankind

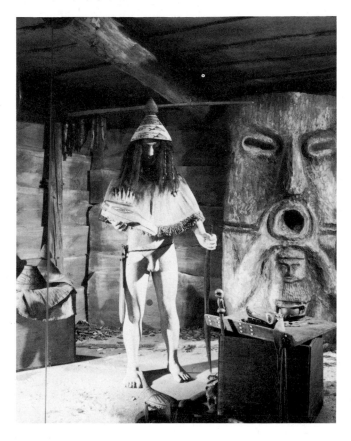

A Nootka chief in his reconstructed Vancouver Island house. As commercial figures unsuitable for displaying minimal costume, a sculptor was commissioned.
Captain Cook in the South Seas, Museum of Mankind, London

background, they will be accepted as a convenient convention. But place the same figures in realistic room settings, and the result may easily look like amateur theatricals at their worst! On the other hand, completely non-figurative 'models' will appear ghoulish if posed in such realistic settings.

The converse applies to the use of highly realistic models. Seen in open display, in a realistic room setting, the visitor will enjoy the illusion of being present at a real, live occasion. But place such figures rigidly in glass cases and they may appear as stuffed human 'game trophies'.

Minimal clothing presents a problem. It will dictate either a two dimensional display or specially designed, sculpted figures.

Security and cases

Any touching of an historic costume damages it and must be prevented. When costumes are on temporary, open display they must be distanced from the public by some barrier, physical or psychological. However, open display can be even more damaging to costumes – which are usually elaborate and could collect dust and harbour pests – than to flat textiles. Where costumes are being exhibited for longer periods they are usually made secure from vandalism and thoughtlessness by being shown in cases.

Whenever possible, cases should be designed specially for the display of costume, so that they not only contain the costume, but can display it fully extended. The construction of the case must be proof against dust, but the case must be fitted with ventilators which permit the free circulation of air around the garments. The ventilators should incorporate replaceable filters (such as cellulose wadding). Particles of dust will by this means be prevented from entering the case, but the filters must be so placed that they can easily and regularly be replaced.

Conservation

All the conservator's recommendations on a suitable and stable environment in the exhibition must be observed. Protection from excessive light, pollutants, and insect pests must be guarded against, as in all museum practice. It is unlikely that a costume display will be a permanent one. Certain specified levels of light and humidity must be maintained (see Textiles) but even if the designer is able to provide a relatively ideal environment, textiles will always deteriorate.

The major factor in the conservation of historic costume is that of stress. Costumes must not be erected on figures or supports by pinning or 'draping'. Display figures should always be adapted to fit the costumes and not the other way round! It is preferable to use models that are too small which can then be padded to provide support for the costume without imposing new stresses. Handling should always be left to the specialist.

Clothes mobile. Contemporary dresses on open display on hanger-type fittings suspended by nylon cords. Draughts make the dresses move and generate abstract patterns.
Museum of Applied Arts, Helsinki

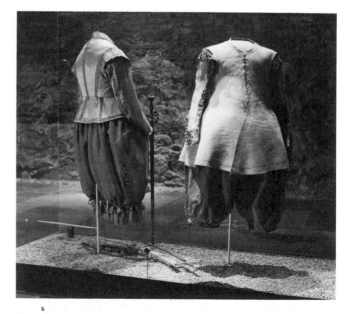

Historic garments of Gustav Adolf II. No heads or limbs attempted. Costumes on padded metal frames, rod supports to baseboard, fixings gravel-covered. External spotlighting.
Royal Armoury, Stockholm

Lighting

Illumination for all textiles must be kept at a very low level (maximum 50 lux, with provision for the elimination of ultra-violet radiation). Textiles made up as costumes are no exception. Fluorescent lamps fitted with u-v sleeves and controlled by dimmers can provide an even light at the correct level. However, the colour rendering provided by fluorescent lamps will have to be considered carefully. Some additional tungsten lighting may be needed to increase the modelling of the garments or to increase emphasis on a particular costume.

The light level in the display being low, the visitor must be given time to adjust to it on entering the exhibition. Introductory text panels may well provide a transition area for this purpose.

However low the light levels within cases may be, visitors have to circulate around the gallery. Additional lighting on floor and step areas will probably be necessary, but this should be kept as low as possible, and controlled carefully to avoid spillage on to the costumes themselves. Before the operating levels are fixed, before the exhibition is opened, levels should be carefully checked to see that the light on the exhibits has not built up, from a number of scattered sources, to an unacceptable level. And at the same time, the reflections in the cases should be checked to ensure that they are interfering as little as possible with the image of the exhibits. With care it may even be possible to balance the lighting throughout so as to eliminate reflected images altogether.

Costume accessories

The various accessories to costumes, fashions, and uniforms may well be displayed elsewhere in the museum, but hats, headdresses, footwear, gloves, jewellery, fans, suitcases, swords, umbrellas and walking sticks can all be recruited to enrich costume displays. Their use will be particularly important when the costumes are incomplete, and a consistent atmosphere has to be maintained throughout a large display.

If the skill and resources are available it may well be advisable to create facsimile garments or accessories to complete an outfit which is incomplete. Contemporary fabrics are unlikely to be available, as they would themselves constitute valuable exhibits. With care it may be possible to trace equivalent modern materials for the reconstructions.

Where certain items are missing, particularly in adjacent displays, it may be better if the missing portions are re-created in neutral and identical modern materials, making clear to the visitors that they are not part of the original costume but are present only to provide visual clues.

The curator of costume will undoubtedly have strong views on the correct way to proceed, and the designer must take these into account.

Supports for costumes

The choice of type of model figure to support the costume will not only depend on funds available, but also upon the shape and style of the garment which is to be exhibited. A simple formula reveals that the more ample the garment available, the less the supporting model will show. It may be possible to choose from a much wider range of models as a result.

Drastic surgery and ingenuity can enable discarded shop models to be converted to suit a museum display, particularly if hands, feet and heads that are more appropriate can be substituted for the existing ones.

All model figures will also require support. With full-length costumes there is no problem, the strongest of supports being hidden under the garments. Shorter garments make it necessary to design the support to be acceptable if not beautiful, no easy task. The stands supplied on many models are extremely distracting, particularly those from commercial sources. The square or circular bases can be hidden in a loose surface, under the case baseboard, or on top of a plinth. The best support for the model is through its feet. This precludes the use of original shoes as part of the display, specially made shoes being provided to incorporate the fixing of the supports.

Dressing the model

Whichever type of model is used, much adaptation will be needed to enable a costume to fit it successfully. In the display of fashion, undergarments made to the pattern of the original will help to display the garment. Additional padding can achieve the same effect in the

Head created by wire frame providing support for the hat at a realistic angle. Croxteth Hall, Liverpool

Wigless commercial model: clarity of line suited to the collection displayed. The figure is of now, assertive, and the gallery setting a gentle period one.
Jean Muir, Lotherton Hall, Leeds

Faces subdued. Carefully modelled heads with clear features, but with gentle colouring so that the costumes dominate. Authentic jewellery completes the display.
Costume Court, Victoria and Albert Museum, London

Spaced out: hats without heads. Each is supported on a clear Perspex rod, giving minimum visual interference.
Costume Court, Victoria and Albert Museum, London

Accessory. The static figure brought to life with an authentic fan, carefully positioned. This is not a prop but part of the costume.
Costume Court, Victoria and Albert Museum, London

An abstract display technique delivering realism: a touching family wedding group. Commercial models adapted, whitened, their hair 'sculpted' from tissue paper.
Croxteth Hall, Liverpool

Footnote. Typeset text is slipped into a sloped Perspex label holder. Plain and simple to reduce distraction and close for reference.
Costume Court, Victoria and Albert Museum, London

hands of a skilled conservator. This kind of adjustment to secure a natural effect will take considerable time, and the designer must allow for this when scheduling the project.

Selecting heads

The head (see also Armour) can pose problems to the designer. The visitor confronted by the face of a model immediately seeks the eyes, as in day-to-day social contact. If these are lifeless or in any way odd, the whole effect of the costume will be marred, and the illusion of the period shattered. Absolute realism is difficult to achieve, and calls for extremes of modelling skill and good taste, both backed by substantial funds.

Many curators and designers prefer to use simple, stylised, neutral, almost abstract, heads, with only a suggestion of facial features. These provide support for hats or headresses and can, if modelled in a disciplined way, enhance the costume. Many ingenious methods have been devised for such 'neutralising' of heads and even whole bodies – construction of papier mâché, painting the surface black or white, or texturing it to give homogeneity to a number of models.

Where the model is to 'wear' a hat, support has to be given to it corresponding to the hair style of the period, or it will not sit well on the head, nor will it correspond to the fashion of which it was a part. For realistic models, wigs of real hair can be purchased and styled carefully to the period. For more stylised heads, hair can be created from hemp, formed in papier mâché or other materials. Whatever the convention used for the model, the hair must follow it.

Extremities

Hands and feet, though important, can be made more easily and cheaply. They can be used to add character to do-it-yourself models, they can be cast from those of other models, or carved from inexpensive material such as polystyrene and coloured.

Backgrounds to costumes

In the confines of showcases, various background treatments can be used, not only to emphasise the costumes, but to set them in context and to provide continuity if the display covers different periods or geographical regions.

Enlarged photographs of appropriate contemporary scenes can be used to provide sympathetic backing for costumes, the effect being even more powerful if original contemporary negatives can be used for the purpose. Alternatively, if carefully scaled, a painted decoration of the scene can be used, or decorative costume details of the period set against the three-dimensional costumes. The curator may have at his disposal fashion plates of the period, and these can be unified throughout the display by having all the figures enlarged to the same size.

In open displays, or complete room settings, bolder techniques can be used. Selected pieces of furniture near the costumes will provide simple social and historical clues for the ordinary visitor, as will the discreet use of contemporary curtains, covers and wallpapers.

Reinforcements. Sometimes exhibits need substantial 'backing'. Here the foreground material is detailed, interesting. Where only supplementary information is required a photographic backing is effective.
Royal Army Museum, Stockholm

Information and the labelling of costumes

For a full length costume or standing figure, viewed at close quarters, the obvious place for a label is on the floor at its feet or on the plinth on which it is standing. If the figure is close to a wall the label can be mounted there. If the audience is some distance away from a figure, or group of figures, it may be best if the label identifies them with a number. Detailed information can then be grouped together on an information panel with the numbers keyed.

Where a chronology of costume design is displayed it may be sufficient to group costumes of a period together without providing detailed information on each garment. The date that identifies the group can then be incorporated in the background to the group, or on the glass of the show case concerned.

The lighting levels in a costume gallery are naturally concerned with the display of the costumes, and in such circumstances it is easy to overlook the labels so that they remain partly invisible. It may be necessary, therefore, to angle the labels individually so as to make maximum use of the light available.

Drawings and prints

Introduction

The ideal way to look at prints or drawings is to handle them individually from a portfolio, varying the viewing distance and the angle of the light oneself. Not only can one adjust for the detail and intricacy of each but also for the limit of one's own eyesight. There is the added pleasure of being able to turn a drawing over in order to study another on the verso.

Facilities such as these have, in a museum, to be restricted to supervised students' rooms. The facilities in the public gallery will be far from these ideal conditions. What is the best display that is practicable? Under certain conditions it may be desirable to take into account the style and execution of each print and drawing, creating the sort of settings that a connoisseur might arrange for his private collection. The practicalities of museum administration and costs, however, usually restrict the provision to 'neutral' settings, concentrating the attention of the visitor on the individual drawing itself, rather then suggesting its ambience.

The designer must ask, of course, what the reasons are for collecting and displaying prints and drawings together, rather than with other artefacts from the same country and period. Many exhibitions of furniture, history, architecture and biography are enriched by related prints and drawings. However, museum departments of prints and drawings revolve around the nature of the material involved: paper.

To the layman, paper seems a safe and relatively inert medium. To the curator, conservator and designer it is quite otherwise, and certain considerable problems have to be overcome. Early paper, made from rag, has a fairly long natural life, while modern papers, made from wood pulp, have a high acid content, and can quickly become discoloured and brittle. Paper is the material common to prints, drawings, books and manuscripts, and has its own parameters for conservation, although the display requirements of each may differ to some extent.

Window-mounting drawings and prints:
a) Hinged window mount
b) The drawing or print attached – stamp hinge method
c) The mounted drawing supported and fixed onto the backing board with 'L'-shaped Perspex pins

Types of display

Rotation

Museums and art galleries possess more prints and drawings than they can display at any one time. This calls for a frequent change of objects within a permanent setting, a rotation of the collection, making use of fixed and often standard frames. However, faced with the continuous task of framing individual prints or drawings for 'rotating' exhibitions, and bearing in mind that many drawings are already mounted for storage, a number of museums and art galleries install permanent 'frames' in the form of slim wall cases where the objects can be 'rotated' quickly and simply.

Travelling

Prints and drawings are ideal candidates for travelling exhibitions because of their size, and because of the possibility of standardising the size of mounts, frames, and packaging. This uniformity makes possible quite sizeable travelling exhibitions on relatively low budgets.

Mixed

A relevant print or drawing is often displayed as documentary evidence along with material from other collections, such as costumes, ceramics, or glass. Here conservation must be carefully considered. The care of the print or drawing may dictate conditions of lighting much more restricting than those for other objects within the display cases.

In room settings

Individual framed prints and drawings are often featured in 'room settings'. The designer will need to position individual pieces most carefully; the position chosen to enhance the overall design may not be suitable from a conservation point of view.

Cases

Cases for prints and drawings are, in fact, large frames containing more than one exhibit. They can vary from a single hinged glazed frame, fixed to the wall, to more elaborate cases containing integral lighting and sloped interior display space.

The designer has to consider the optimum angle of presentation to the visitor, and the optimum angle to secure even illumination from the light that can be provided. The study of this geometry and the compromises that it involves cannot be side-stepped; visitors come in many sizes, and reflections (of the wrong kind!) can easily be created.

Some prints and drawings will require lengthy study. This can be very tiring, and the designer should, wherever possible, provide leaning rails as part of the case design. Sometimes the case design will incorporate sloping glass, to reduce reflections, and the leaning rails can be used to prevent the visitor's head from hitting it.

The backboards in the case must be constructed in such a way as to be easily removable, to facilitate changes of colour and material. The material should also be soft enough to accept pins.

Security

The security of individual prints and drawings displayed within cases will be dependent on the general case security system. However, those individually framed will have to be well-secured to the walls or screens in a similar way to the method used for paintings. In the layout of the exhibition the designer would be well advised to position small individually framed exhibits within the warder's line of vision, if at all possible. Alternatively a group of small frames can be given greater security by 'framing' them with a sheet of glass or Perspex.

Conservation

Prints, drawings, and (especially) watercolours are among the most vulnerable of museum objects. The best way to preserve paper, and what is on it, is to keep it in the dark in specially made boxes in an air-conditioned store room; for any exposure to light causes discolouring, bleaching, and sometimes darkening. As a result, the balance of the original colour and tone values will change.

To display a print or drawing is always to shorten its life to some extent, so the conservator is likely to impose the most rigid criteria upon the designer for the display of any work of art on paper. The design 'brief' is likely to contain maxima for the light levels and duration of exposure. Daylight must be strictly

Framing:
a) Window mount set in timber frame (plan view and section)
b) For an exhibit which has to 'bleed off'
c) For a drawing with a deckled edge

controlled, and preferably eliminated. Artificial light will also have to be strictly controlled and rationed. The conservator is likely to insist on levels of 50 lux and for limited periods only. All fluorescent tubes, and glazing to any natural light, must be fitted with ultra-violet filters. To enable fine adjustment it is advisable to fit all artificial light sources with dimmers.

A temperature of 19°C ± 1° is usually acceptable, with a relative humidity of 55% ± 3%. If the atmosphere is too dry the paper will become brittle, if too damp, moulds such as 'foxing' will appear and distortion (cockling) of the paper will occur.

The actual paper on which the print or drawing has been executed may be its own source of 'contamination' since wood pulp paper has a high acidity content. All surrounding materials in the construction of cases, frames, mounts and backings must be completely acid free. And to make certain of this all materials used by the designer must have been professionally tested.

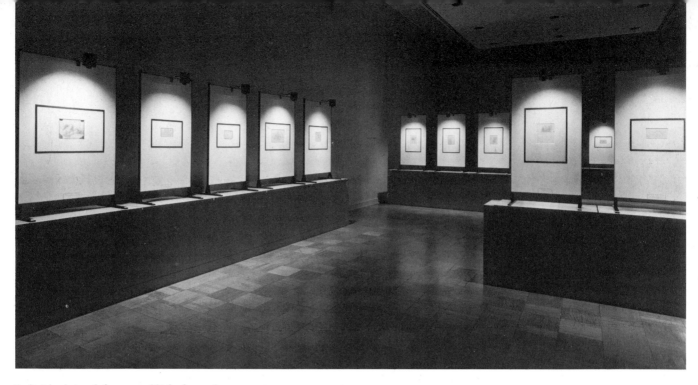

Individual stand, frame and light for each drawing. The plinths group them, and raise their centres to ideal viewing levels.
Leonardo da Vinci Nature Studies,
Museum of Fine Arts, Houston
Designer: Paul Williams

Visible labels. The prints are traditionally mounted in timber frames. Below each exhibit the labels are wall-mounted, angled upwards to catch the available light.
Boymans and van Beunigen Museum, Rotterdam

Grouped prints window-mounted. The fabric-covered panel sloped to catch the top fluorescent light evenly, with sloped labels catching spilled light.
Captain Cook in the South Seas, Museum of Mankind, London

An important warning: however tempted, the designer should never handle loose or unmounted drawings as dirt and grease from hands can cause irretrievable damage.

Many materials have to be kept well away from any display. Materials such as rubber-based adhesives, impact glues, and pressure-sensitive pads are very dangerous. The designers themselves can be dangerous too: they should always use pencils for taking notes near a collection, and never pen and ink, biros, or felt-tipped pens.

Lighting

The need to provide acceptable colour rendering of the exhibits must be paramount in the selection of fluorescent lighting for coloured drawings or prints. An even level of illumination over the surface of the exhibit is essential, obviously, but where a combination of fluorescent and tungsten filament lamps are being used care has to be taken to secure an even 'colour mix' over the whole surface.

Uniformity is necessary not only upon the single exhibit, but also throughout a complete display. If a long case lines a wall of the gallery fluorescent tubes of the same type and length must be used throughout to ensure uniformity of colour.

Where the illumination of framed objects is from a light source outside the case, the avoidance of reflections is important and should be solved by checking the geometry of the display, or by the use of glass with a 'bloomed' finish, a variety that does not

need to be in contact with the face of the exhibit. (Some types of non-reflecting glass are on the market, but are unsuitable from a conservation point of view because they require to be placed in contact with the exhibit.)

Mounting and framing

Mounting and framing is a specialist task, but the designer will want to control the final appearance of the mounted object, and so must become familiar with the techniques, materials and limitations. The mounts (or mats) and backings must always be made of 100% rag fibre or of purified pulp; they have to be completely acid free. Acid-free card is expensive, and only made in a limited range of colours.

It is important that a frame, however shallow, contains some atmosphere. Prints and drawings must always be separated from the glazing by the mount, as condensation can settle on the inside of the glass as the result of a change in room temperature, and this will have a damaging effect on paper and image. A card window mount behind glass in the frame will create an airspace adequate for conservation purposes. This makes non-reflecting glass unsuitable for this particular purpose, since it has to be mounted directly upon the image surface of the paper. Wood must never be used as the final backing to the frame as the resins and acids can migrate to the paper causing stains and discoloration.

Proprietary 'sandwich' frames are available, consisting of a sheet of glass and a board held together with clips. Unless an airspace can be provided, and the edges sealed against dust and other pollution, these frames are not recommended by conservators.

Perspex is an ideal 'glazing' for prints and drawings which are to form part of a travelling exhibition, both for lightness and resistance to impact. For pastel and charcoal drawings it is, however, quite unsuitable. Perspex under certain conditions will generate and hold static electricity, and this will attract fine particles of pigment away from the surface.

Backgrounds

Because of the closeness of the viewer to the exhibits care must be taken to see that the backgrounds are attractive without being distracting. If fabric is used, a fairly dense and even weave will be most suitable. With any fabric, tests should be carried out in advance to see to what extent it will show the pin marks of any fixing devices. Double-sided strip adhesive, used to mount labels, should be tested to see if it leaves marks on the backing fabric. Obviously a background colour should ideally be related to the collection itself, but where the cases are to house 'rotating' displays from the collection an oatmeal or other 'neutral' colour will be the most practical.

Labelling

An individual label to each print or drawing is usually the most satisfactory arrangement. The viewer will be in close proximity to the object and therefore the minimum legible type sizes can be used. As with paintings, but to a lesser extent, the label position must be related to the frame, the depth of its moulding and the shadow that it will cast.

Travelling. A small art exhibition, in a slim packing case, for touring schools, art clubs and factories. The works mounted on hinged leaves inside.
Bildlådan (The Picture Box),
Riksutställningar, Stockholm

Viewing position: glazed drawings are sloped under a lightbox with specular louvres. A leaning rail and visitors' choice of viewing distance permits lengthy study.
Christ Church Picture Gallery, Oxford

Furniture

Introduction

Furniture is principally made from wood, with small attachments of metal, leather, and decorative materials. Fabric coverings demand specific conservation conditions (see Textiles). Furniture surviving in museums will be either unique pieces which have been valued throughout their history, or simple pieces of very sturdy practical construction. Until recently pieces between these two categories were unlikely to survive.

Types of display

The main approaches to displaying furniture are:
As works of art, furnishing an art gallery, much as it would be set out in a stately home.
In room settings with appropriate backgrounds and props.
In bays and cubicles, enabling pieces to be considered on their own without distraction from other subjects.
In purpose-made cases for valuable and vulnerable items.
In technical displays, involving construction, materials and craftsmanship.

Security

Normal protection is needed as for all objects on display outside cases. (Cases may be required for exceptional pieces.) From a security point of view, most pieces will be large and not easily removed therefore without the help of more than one person. Chair exhibits may be sat upon in error by tired visitors! They should be isolated in unsupervised galleries, roped off to protect mistaken public use if exposed, or even labelled against use.

The designer has to know and judge his public. Slightly raised plinths will often be sufficient to isolate the exhibits from the circulation area. (Though whereas in one exhibition in one locale children may well climb upon the plinths with enthusiasm, in another the prohibition on climbing is likely to be respected.) Provision must be made for the examination of detailed ornament or unusual fittings. If hard to reconcile with security, photo enlargements of detail will help.

Conservation

Where total air conditioning is impractical, fluctuations in temperature and humidity will impose repeated strain on the timber grain and joints of furniture. Furniture should never be placed near sources of heating or ventilation. It may be necessary to provide portable humidifiers to maintain the humidification level at RH 55%±2%. Temperature should be 18–21°C.

Marquetry and painted work are very susceptible to light and must never be placed near direct sunlight nor high levels of reflected sunlight. The light source should be treated to eliminate ultra-violet radiation. Light levels should not exceed 150 lux. However, if fabrics are used as coverings, the whole object should be treated as if it was a textile and a 50 lux light level should be the maximum.

Inspection for infestation of timber or in textile covers should be routine, the designer allowing for easy access, for the conservator.

Stability
Furniture is basically stable and usually stands as it was made to stand. However care is needed if lids, doors, etc. are to be propped open for special points of display.

Lighting

This should try to simulate light appropriate to period and circumstances, ball room, farm kitchen, conservatory, etc. Point lighting should be limited to drawing attention to specific features of design, construction and ornament. As elsewhere, the designer should remember that light generates heat.

Backgrounds and props

These can be of partial room settings using genuine pieces, textiles, sections of panelling etc. Pseudo room settings can be created by carefully painted backgrounds. A single piece can often be effectively 'dated' by an adjacent small hanging or piece of carpet.

Bric-a-brac, plants, memorabilia, ephemera, all provide atmosphere and therefore understanding. Film and TV producers do not neglect this.

Identification

Furniture is often large, and the time taken to walk past it can be considerable, too. If many wardrobes, for instance, are to be compared, two or three grouped with photographs and drawings will secure better attention than a marathon through the gallery. A group of furniture can be identified from an adjacent label incorporating an outline drawing or miniature photograph of the group, with related text. When showing contemporary or recent pieces, labelling design can follow the style of the exhibit.

Information panels
An extended text may be needed in a gallery where object labels cannot carry full explanation, and also where backgrounds are unavailable. Texts can then incorporate photographs of rooms of the period, including comparable pieces.

Diagrams
These may be useful where the curator wishes to emphasise technical or historical points.

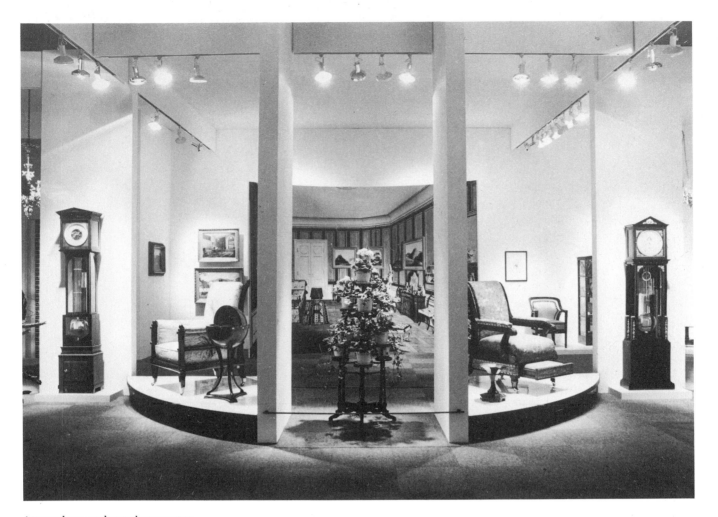

Atmosphere, order and symmetry.
Furniture is raised on plinths. Screens
permit and interrupt views through.
Exposed spotlights on track from
underside of fascia fins.
The Biedermeier Interior, Victoria and
Albert Museum, London
Designer: Paul Williams

Isolation: the screen slightly curved at
the corners separates this piece from
others. Raised on a plinth and lit from
ceiling spotlights
*Treasures from English Country Houses,
Europalia*, Brussels
Designer: Alan Irvine

Illusion: the owners have just left, with
lamps working and bric-a-brac in place.
Ropes and carpet steer the visitor
through a period room setting.
Cecil Higgins Art Gallery, Bedford

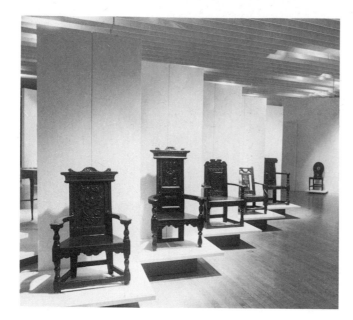

Comparison: a study arrangement with
no distractions. Each piece can be viewed
close up for detail. From further back all
can be compared.
Treasures in Trust, Royal Scottish
Museum, Edinburgh
Designer: Paul Williams

Photographs
These can be used to make comparisons, show contexts,
users, designers, details. Clear captioning is always
required.

Models
Though expensive, these can be useful in comparing a
number of pieces without excessive perambulation.

Replicas
Full-size pieces of replica furniture can be used to
create atmosphere in historical or biographical
exhibitions where it becomes part of the exhibition.

Maintenance

This, in a furniture exhibition, is simply housework.
The designer should consider floor finishes on which
the pieces are set. The legs of furniture may well need
protection against normal servicing by vacuum
cleaners or polishers.

Geological specimens

Introduction

Many collections of antiquities are, to all intents and purposes, finite. Barring a miracle, new exhibits are not likely to turn up, and the changes wrought by succeeding curators and therefore designers will simply be to re-arrange, display and re-interpret.

Geological specimens are, by definition, part of an open-ended collection. In theory, the curator of a geological museum could at any time go on an expedition, armed with a 'shopping list', change the balance of his collection as a result, and create a new exhibition. There are, it is true, certain collections of famous specimens of interesting provenance, unlikely to be redeployed, but most collections of geological specimens call for a fluid design strategy.

Man now has the means to increase his attack on the earth's crust, and extend it to the solar system. The scientist, with his curiosity about the origin of our material universe and the industrialist, with his need for more materials to exploit, are developing new and more powerful tools of transport, penetration and analysis.

One result has been that the cases of dusty rocks in geological museums are almost a thing of the past: such exhibitions have been completely transformed. With new techniques of collection come new methods of display, and the new possibilities for material technology make geology a subject for topical exhibitions as well as permanent displays, both in museums and in commercial situations.

It remains true, however, that the basic exhibits which the designer will be asked to display and explain are rocks, stones, minerals, precious and semi-precious stones, gems, and fossils, both developed and undeveloped.

Most of these objects are hard, and they range from minute precious gems to large heavy pieces of rock. (In many instances, it will be possible to obtain small samples: for once, possible uniquely in the world of the museum, the designer will be able to select, with the curator, exhibits to fit the space available!) The designer will probably find himself dealing with a very mixed bag. Some specimens will be bright, some highly polished; and some will appear to anyone but the subject specialist like very dull lumps indeed.

Types of display

Geological displays, as with many others, fall into three categories: specimens as art objects, specimens grouped by class, and specimens sequenced to develop a theme.

Aesthetic

Geological specimens lend themselves to aesthetic presentation. Many minerals and fossils are of exceptional beauty, and can be displayed as though they were the products of human art. Using rich settings and dramatic lighting it is easy to make them appear like objects from some treasure house.

Classification

A display based on classification may be more informative, but can easily become dull. The visitor will find the classification of little relevance unless it can be shown to bear on other facets of his experience, for example the landscape in which he lives, or the products from which he benefits. So a classified geological collection must be brought to life with 'sideways' developments, topics closer to the non-specialist experience. A classification that is stratigraphical (i.e. with the material grouped in the sequence in which it was originally deposited), can be quickly grasped by the layman.

Thematic

Thematic treatment depends upon material being available, with sufficient textual support, to tell a story. It is thus comparable with an article or lecture, and might be concerned with, for example, 'How old is the Earth?', 'Minerals and Farming', or 'The first fish'.

Security and cases

Minerals and fossils are highly 'collectable' items, and so any small specimens will need to be displayed in cases. They can also incorporate intricate detail, and provision should be made for them to be studied in much the same way as coins or jewellery. Cases subject to this sort of attention should have a leaning rail provided.

Large rock and fossil specimens can be exhibited in the open. Their surfaces are most tactile and attractive, and therefore they should be securely bolted down. In this situation, as in many others, the designer should not underestimate the strength of the members of school parties!

Conservation

In general and except for fossils and some specimens such as 'mud' stones, pyrites etc., the designer will have no problems of conservation when displaying geological specimens. They can be readily handled, brightly illuminated, and will not be affected by temperature or humidity.

Fossils are a different matter. Many may be brittle or friable, and their handling and mounting will best be done by experts in the subject, or with their close supervision.

Lighting

Unfettered by the usual problems of conservation the designer is able, in suitable situations, to achieve dramatic effects with both colour and intensity of lighting. High levels may be needed, for many minerals have very light-absorbent surfaces. General fluorescent lighting will always need to be supplemented by tungsten filament spot lights.

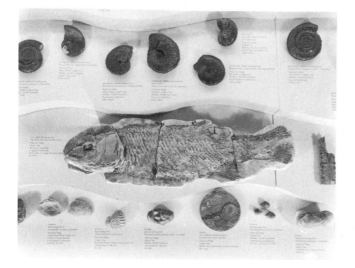

Displaying strata in sloped table cases.
Fossils mounted on stepped, painted
backboards. Each specimen labelled in
dry transfer lettering.
British Fossils, Geological Museum,
London

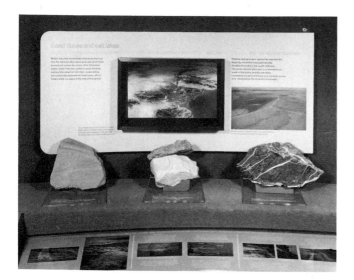

An open reference display. The rock
specimens, firmly bolted to the shelves,
are related directly to the text and views
of the landscape behind.
Britain before Man, Geological Museum,
London

Reflective surfaces

Some specimens will, however, be highly polished. In
the case of marble or granite, or where slabs contain
fossils, the reflective surfaces will present problems of
specular reflection. When displayed in vertical show
cases lamps can sometimes be concealed behind the
exhibit.

Ultra-violet lighting

Some specimens, contain natural fluorescence and this
can be demonstrated by the use of 'black ray', long-
wave ultra-violet lamps (these lamps are, however,
banned from almost all museum departments since
their light is highly damaging to organic material). The
'black ray' lamps will show the fluorescent properties
of the specimens, tungsten lighting being introduced
for short bursts, fading in and out every few seconds to
remind the audience of the specimen's normal
appearance.

Lighting fossils

When lighting fossils, the designer can turn for
solutions to the lighting techniques for fine art objects.
Undeveloped fossils are akin to sculptured reliefs, and
can be lit with a raking light to emphasise detail.
Developed fossils can be lit by general lighting, again
with spotlights added where some detail is significant.

Many small fossils are displayed in table cases and
here the problems of display are similar to those of
illuminating cases of coins or medals. The specimens
are likely to be somewhat thicker than the thickest
medal and cast substantial shadows and so, providing
the glare does not disturb the viewer, fluorescent
lighting will usually be the most suitable.

When displayed mounted on the wall, fossils present
the same problems as glazed paintings, and similar
geometric lighting arrangements will be applicable.

Translucent fossils

A few minerals which are transluscent can obviously be
lit from behind, in much the same way as glass.
Sometimes a transluscent object has to be grouped
with others which require frontal illumination. In this
event the individual object can be given its own
individual lighting from the rear, an appropriate
aperture being cut in the back of the display to control
the light scatter. The rest of the display can then be lit
as appropriate without any distortion of appearance.

To minimise the massive effect of some specimens
and to eliminate shadows, the floor of the case or the
top of the plinth should be light in colouring to reflect
light upwards on to the underside of the exhibit. An
attractive alternative is to provide discreet in-fill
lighting from the floor or the base of the case.

Detailed display requirements

These will be dictated partly by the type of
presentation selected, partly by the size and weight of
the specimens concerned. In cases, the specimens may
well rest upon the floor, or be supported on glass
shelves to give maximum exposure. A removable
adhesive, such as 'Blu-tack', will overcome any
problems of vibration. Sometimes expendable

specimens are available, giving the designer greater freedom. If they are not too heavy they can be mounted on vertical surfaces with epoxy resin contact adhesive. For more valuable, irreplaceable specimens a soluble adhesive should be used.

Soft minerals and rare fossils should be secured by shaped pins to a suitable backboard. The display considerations are much like those for jewellery. Pins could damage particularly susceptible specimens, and such pins should be covered with a polystyrene sleeve.

In general, fixings are always liable to compete with specimens, and preferably they should be coloured to tone in with the specimens, and ideally to become invisible.

There are several methods available for vertical displays. One is to set the specimens into panels of an easily carved material, such as polystyrene, attaching them with a suitable adhesive. Another is to fit the back of each specimen with a key plate or bolt, attached with 'Fibrenyl' dough, which will connect with a bolt or keyplate in a matching position in the backboard. A third method is to support the specimens on Perspex rods projecting from, and 'secretly' fixed to, the display backboard.

Large specimens on open display may be heavy enough to be completely stable, but if there is any doubt they must be secured. Soft specimens, such as sandstone, may have to be treated with a hardener before going on open display.

Information about geology

Object labels

Geological specimens displayed for their aesthetic appeal will require the same sort of discreet labelling as that employed for pieces of sculpture or jewellery. The information must be tied to the exhibit without causing distraction. The designer should try to imagine the visitor's sequence of perception. First, the object itself has an immediate appeal. The next stage involves a demand for explanation, and delivered close at hand. The designer should try to ensure that even the less curious are unable to escape uninformed! In a stratigraphic display the information needs to be tied very closely to each specimen. On open display a permanent form of labelling such as silk-screen printing is desirable.

Audio-visual

In thematic geological exhibitions all the current information techniques are applicable and often used: tape-slide, video, and films.

Charts and diagrams

A common element in thematic displays is the geological time chart, usually presented in the form of a stratigraphic column in which the various layers of rocks are arranged in vertical succession, running upwards to correspond to the natural deposits. These charts are a challenge for the designer, calling for clear graphic handling, and the need to avoid rehashing those already available in museums and textbooks.

Models and dioramas

Relief models are an attractive way of showing geological formations, permitting the display of familiar features, such as mountains and rivers and their inter-relationship, while adding technical information through cutaway sections. Where cost does not permit the creation of such complicated relief maps, diagrams representing the same material can be very effective, and some departments are now capable of generating these from computer sources.

Dioramas are also useful in this field but, like the relief maps, costly to produce. Models, dioramas and maps can only be justified in a thematic display if they have a long useful life in the museum.

Glass

Introduction

In early museum collections, objects were packed on shelves in solid show cases; stored rather than displayed. The qualities of glass would have been hard to appreciate in such a collection. The full beauty can only be seen by holding or displaying each piece against the light.

With the exception of elaborate table settings in historic houses open to the public, glass vessels cannot be seen in anything resembling their original setting. Engraved lines on drinking glasses in use would have been held a few inches from the eye, wine forming a coloured background to the decoration; the facets of a bowl or decanter would have caught the flickering light of candles. The very efficiency of modern light fittings can threaten the appearance of antique glass. The designer of the display has to reconcile two obligations; to re-create the ambience of the original setting and to give the student access to details of design and craftsmanship. All historical material has to be displayed with these two factors in mind, but glass in particular demands precise control of lighting.

Types of glass and their display

Each type of glass, classified by technique and appearance rather than chronology, demands a different method of display. Clear glass and coloured, transluscent and opaque, engraved, enamelled and gilded, each require their own treatment. It follows that a show case which included all these categories will not be easy to design or to light.

Early Egyptian opaque glass vessels and later eighteenth-century Venetian white opaque glass will probably best be displayed as ceramics. Plain, clear and coloured glass vessels and stained glass will be seen to best effect with soft light shining through. But with the addition of surface decoration: paint, gilding or enamel, the display has to balance the need to show the surface with that of presenting the silhouette. Engraved and cut glass poses similar problems, not all of which can be settled on the drawing board alone!

Security and cases

Because of their fragility it is advisable to display glass objects in cases. However, when constant invigilation is possible some heavy modern pieces might be candidates for an open display.

The cases for a glass display cannot be designed before the method of illumination has been determined. It may be difficult to convert existing cases to the exacting requirements of the special illumination which glass requires. In order to obtain uniform lighting from fluorescent tubes the depth of case will often have to be greater than that for other kinds of objects. Provision must be made for ventilating the light box. In addition, servicing of the lighting system must be quite independent of the display.

Vibration is a particular threat; the transfer of even slight vibration from the surrounding floor area is easily transmitted to the exhibits through the case. The floor area may have to be specially stabilised, and the cases designed to impart extra rigidity.

Conservation

Handling

Most museum objects should only be handled by experts but for obvious reasons this is particularly true of glass. The biggest safeguard for the designer is to see that the glass is handled by someone else! In general, glass is never lifted by its neck or its handles, both hands being used to take the weight at the lower part of the object. Vessels have often been repaired in the past with unsuitable glues, and can easily collapse if picked up carelessly, however sound they may appear.

Temperature and humidity

All showcases must be monitored for temperature and humidity. Glass is vulnerable to changes in temperature and should not be displayed where strong sunshine or hot lamps might cause it to crack. In a case containing glass the relative humidity is not usually critical provided it is not allowed to fluctuate dramatically: 50% to 55% is usually acceptable, provided that the glass is 'stable' in composition.

However, when glass is unstable, the material will have started to break down, either flaking or becoming iridescent. It is then essential that the glass be kept at a low relative humidity, say 40%, to avoid absorption of water from the atmosphere, which would produce a sticky surface, known as 'weeping' or 'sweating', leading to further deterioration. The designer must work to the instructions of the conservator, who will probably ask for conditioned silica gel, a soda-like substance, to be provided within the case. The designer can preserve the appearance of his display by putting the gel within a display block or under a perforated case baseboard.

'Crizzled' glass is another manifestation of chemical instability. The surface appears to be very finely crazed. Again, the advice of the conservator must be sought on what provision is required in the construction of the case.

Lighting

Natural illumination

Although the designer needs complete control over lighting, this is not to say that glass cannot be displayed effectively in natural daylight. An obvious and easy method of displaying clear and coloured glass is to show it against a window in simple cases on glass shelves. A view of a garden with pattern generated by the vegetation may be helpful as a background. If the view through the window is unsuitable (encompassing buildings out of scale with the objects, or moving people and traffic), the glass at the back of the showcase can be opaque. Fine net curtaining or white

Lighting techniques. Glass on the left is backlit. On the right the case floor is an illuminated panel. Perspex mounts. Text silkscreened on perspex panels.
Masterpieces of Glass, British Museum, London

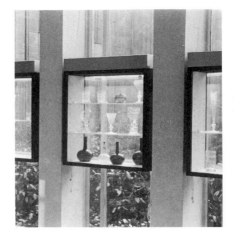

Natural background. The square display cases are set against the windows, daylight backlights the objects. Plants in the garden provide a textured background. Boymans and van Beunigen Museum, Rotterdam

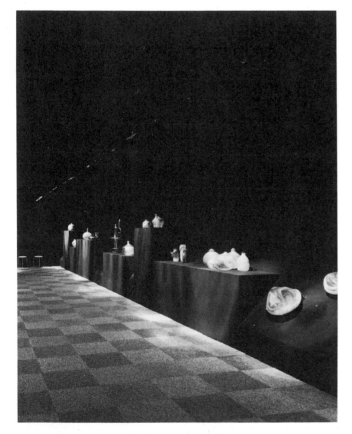

High contrasts: modern glass on stepped plinths covered in black felt set against black walls. Lit from high level, crown silvered spots.
Glass by Sam Herman, Victoria and Albert Museum, London
Designer: Alan Irvine

translucent blinds can also be used to diffuse the available daylight.

Often, however, the display will have to be viewed on winter days and in the evenings and artificial light will then be needed to simulate and supplement the missing daylight. For this purpose, fluorescent tubes (daylight matching) can be placed behind the display at approximately the same angle as the natural daylight.

Modern glass is frequently displayed, both in galleries and commercial showrooms, 'in the open'. With plentiful natural daylight, and making use of glass-topped tables, a number of interesting effects and reflections can be obtained, but security considerations should not be overlooked.

General overall illumination

Assuming elaborate lighting techniques are not possible, clear and coloured glass can be displayed effectively in a brightly lit room set against a plain white background. If the display is contained within a showcase the risk of reflections can be avoided by sloping the sides of the case.

Diffused light

The most dramatic effects in the display of clear and coloured glass are achieved by putting it in a room resembling a 'black box', blotting out daylight from windows and rooflights. Opal Perspex or frosted glass between the artificial light source and the object creates a light box and for clear and coloured glass without other embellishment this may be all that is needed. An even spread of lighting within the light box is very important, and this is best obtained by the use of fluorescent tubes, either concealed or set back some 50 cm from the diffusing material. It is advisable to experiment with tubes of different wattages and colours at different distances.

But the total effect in the room must also be considered. Too great or too bright an area of back illumination can be tiring to the eyes. Backlighting takes care of the silhouette form of vessels, but decorated glass (gilded, painted, enamelled) will, in

169

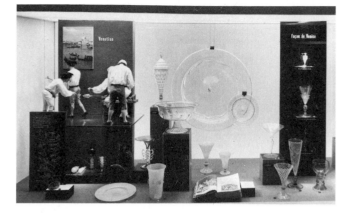

Display variety. Some glass is backlit, some is displayed against dark backgrounds to emphasise shape and decoration. The model glassblowers explain manufacture clearly, with minimum text.
Pilkington Glass Museum, St Helens
Designer: James Gardner

addition, require lighting of the surface; ideally, this should be from the normal viewing angle and can be achieved by top lighting from small spotlights.

Side illumination for engraved and etched glass
Decoration 'cut into' the surface of glass demands the reduction of light from the back to the minimum – or none at all – with the objects set against a dark background, and the provision of light from top, sides and even the bottom of the case. (As referred to on page 169 the light source would consist of fluorescent tubes set behind diffusing panels.) Surface decoration can be emphasised with small tungsten spotlights. With this type of display there are particular problems. If the balance of light between the showcases and the general room lighting is not correct, and if cases are not carefully positioned in relation to each other, the viewer will be subjected to distracting reflections. Care in arrangement of the cases on plan will reduce reflections, but if they are eliminated entirely the case glass becomes invisible and a danger to the public.

Local illumination
Glass may be part of a general display along with other materials. In such instances, glass or Perspex shelves in the showcase can be used to transmit the light to the engraved glass vessels being displayed. The light is 'sent' into the thickness of the shelf, from the edges, while the front and underside are painted to prevent it from spilling out where it is not wanted, and the top surface is roughened to cast the light up on to the objects. The amount of light transmitted by this technique is relatively small, and therefore the general room light will have to be low, and the background dark. Dustproofing of the cases is essential as dust on the shelves receives the full benefit of the illumination!

Spot lighting for cut glass
Facets of cut glass can be emphasised if the vessels are set against a dark background (as for engraved or etched glass) lit only by spotlights. Opaque or milky glass can be displayed and lit in the same fashion, but there is a danger of it taking on the appearance of ceramics, losing its translucent quality.

Display shelves and mounts

Shelves and exhibit mounts should be purely functional and seen as little as possible, especially when sited in front of illuminated panels. Glass and Perspex are the most suitable and unobtrusive materials to use for shelving and mounts. If the display has a solid coloured background the blocks and shelves are best covered in the same material. Contrasting materials and colours can be used, if there is some special point to be made, but this will always be at the price of lessening the impact of the objects themselves.

Labelling

Just as the character of glass dictates the style and technique of lighting the display, it can also suggest the method of labelling the exhibits. Information on paper or card will appear heavy, and if set against illuminated panels may well be unreadable. Individual labels, information panels and object numbers can be silk-screen printed on clear or opal perspex, or on to thin clear film. Positioned near the exhibit concerned, and lit by the same means, they can give a simple unity to the display. (For economy, transfer letters can be applied to clear film or to perspex by hand, but this is, naturally, time-consuming.)

Natural illumination. Panels of stained glass set between timber uprights. Daylight, with all its variations, and a view of the park beyond.
The Burrell Collection, Glasgow

Stained glass

Introduction

Although based upon the same material, the problems of exhibiting stained glass relate little to those of three-dimensional glass vessels. Both require light in abundance to create the display, but with this exception, the quality of stained glass is akin to that of paintings, or prints. The outlines are not ink or paint, but strips of lead, and the colours are in general incorporated, molten, into the medium, although some colours are painted on, but not fired into the glass. The resulting 'designs' are viewed within the same basic geometry as pictures in a gallery, but with the increased impact of an extended light scale, reading from a virtual black to a virtual white. Set in church windows, as an aid to devotion rather than pure pleasure, the designs were always seen under heightened, emotional conditions. The exhibition designer is faced with a challenge to compete with such circumstances.

Stained glass is a combined medium. The bold drawing of the subject, and the boundaries of coloured areas, are established by the bold lines of the leading which holds the glass together into a single light. The colours are mainly selected from plain coloured glass, the range of colours being quite narrow before the nineteenth century. One colour, yellow, was handled in a quite different way, being applied as a paint to completely clear glass, and fired in, which gives the colour greater texture.

The detailed drawing is achieved by a more refined technique. It is painted on to the glass (of all colours) and then fired into it when the drawing is complete. Such drawing can be very fine and detailed, scraffito being used (the scratching of white lines through a body of colour) for the most detailed textures and details.

The 'compound' quality of stained glass poses difficult display problems. The areas of colour, and the bold outlines of the leading, create drawings that can be 'read' across a cathedral. The painting and stippling and scraffito provide secondary, almost hidden, stories, to be read closely like a book.

Types of display

The display methods must relate to the two separate kinds of viewing which stained glass demands. The museum will contain a few complete windows, but they are likely to be small, and the designer can therefore engineer cathedral-like contrast within the normal scale of the galleries. There will, however, also be small fragments, and it may be appropriate to arrange close ('study') viewing in a different format. Individual pieces of glass, with detailed drawing, may well be best viewed from a distance of a few inches.

Larger fragments, or small complete windows or sections, can be suspended in front of or built into

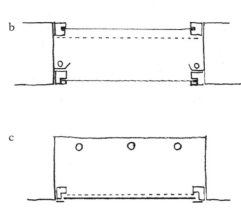

Illuminating stained glass:
a) By natural lighting which can be supplemented by flood lighting
b) A window reveal forming a light box for both natural and artificial illumination
c) The light box technique

existing windows in the museum gallery. If these do not exist or are unsuitable, window settings can be simulated either by setting the glass into screens, forming new windows in screen walls, or arranging the glass in its own case.

Special cases

Where a single item of stained glass is displayed in an exhibition with other material, requiring different lighting, the glass can be mounted in its own individual case with local back-lighting, to which the general case lighting will have to be adjusted.

Security

Stained glass is an unsuitable exhibit for a museum prone to vandalism. Where such risks are present, or where the leaded structure of the glass is unstable, or the exhibit very rare, or its position in the whole display puts it at risk, protection has to be built around the glass. The stained glass is then sandwiched between its Perspex diffusing panel and a protective layer of heavy laminated glass or Perspex, and the casing made incapable of interference.

Lighting

Natural illumination
The colours and overall design of stained glass can only be seen to effect if it is illuminated from behind. The point is obvious, but the designer has to be aware that the presence of a stained glass exhibit in an exhibition is going to determine the plan, because ideally the glass should be set within a window with an unobstructed view of clear sky.

The glass may also have to be viewed after dark. If the plan of the building permits, it may be possible to

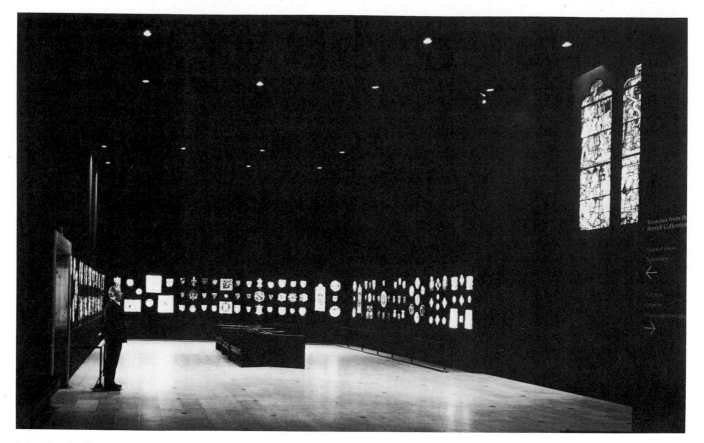

'Black box' technique. Backlit stained
glass and little else. Ceiling downlighters
give floor lighting sufficient for
circulation. Leaning rail barriers
throughout.
The Burrell Collection, Hayward Gallery,
London
Designer: Barry Gasson

organise external light fittings, even floodlighting,
which can be turned on after dark to simulate the
missing daylight. To carry out this simulation it will be
necessary to place a Perspex or ground glass panel
between the window and the external light source.
Alternatively the complete window opening can be
constructed as a light box, with Perspex diffusing
material behind the stained glass panel and the
window, illuminated by fluorescent tubes. Access to
service the lamps may be a problem, as this should be
possible without moving the exhibit.

Artificial illumination
The simplest method of display for an exhibition of
stained glass is probably where all daylight is
excluded. A completely free arrangement of the gallery
is then possible. The display would consist of the glass
exhibits set into one large light box, or a series of them,
provided with fluorescent tubes. The lighting must be
uniformly even, and sufficient depth of case must be
organised behind the exhibit, relating to its size, to
allow the tubes to be placed so as to ensure even
illumination, and provide access for servicing.
Ventilation holes must be provided to allow any heat to
escape from the light box. The inside of the light boxes
should be painted white to reflect the light which will
produce some degree of diffusion. If the depth of the
light box is limited by other factors, or there are
portions of completely clear glass in the display it may

be necessary to introduce panels of opal Perspex to aid
diffusion.

The optical properties of antique stained glass will
vary from one exhibit to another, and so the choice of
colour for the fluorescent tubes can only be made after
experiment. The level of room illumination should be
as low as the needs of circulation permit in order to
display the glass as powerfully as possible.

Labelling

Where the stained glass is contained within its own
small back-lit case the exhibit can be identified by
means of a label on the case or adjacent to it. Where
exhibits are all back-lit, with a minimum general
lighting for circulation, the viewing of labels becomes a
problem. Printed labels next to the exhibit will not then
be visible. If the frames of the 'imitation' windows are
slightly splayed, sufficient light may fall on to a
traditional printed label. The information should be
minimal and the typeface as large as possible. The eye
will need to adjust between illuminated panels and
printed text on opaque surfaces. If funds permit, the
label information should be printed on translucent
material, placed near the exhibit, and back-lit by the
same means.

Jewellery

Introduction

Jewellery is usually personal adornment, and sometimes incidentally a badge of rank. It can hardly be considered independently of costume. Although costume displays are usually completed with the appropriate pieces of jewellery, as accessories, most displays of jewels are shown as examples of the jeweller's art. Materials employed consist of gold and silver, some other metals including steel, precious stones and enamels. Jewellery will often have been made for people of rank and wealth, and have been handed down with care through many generations, some jewellery will be ethnographic, from other living cultures, and prehistoric material which has survived from burial sites. Where individual stones have to be given importance in the design, the exhibition designer should consider the mode of presentation of precious stones in geological collections. If objects are displayed to emphasise the wealth of the users, the effect can be intensified by close grouping of the pieces.

There will often be the need, too, to give an accurate picture of the designers and craftsmen as well as the users.

When a great deal of jewellery is concentrated in a small space in an exhibition, the 'reading time' of the individual pieces will be considerable, particularly if light has to be kept low for reasons of conservation or 'atmosphere'. As a result, people may linger for a long time in front of each case. If a case is at a critical point on the circulation route through an exhibition, the flow of the whole gallery may be impeded. It may be wise to create a jewellery 'bay' in an exhibition containing other material, permitting the specialist audience a considered view without restricting other visitors. It should also be borne in mind that a few pieces of jewellery, mounted one above the other in a case, may have an effective width of less than six inches; the viewer of these pieces, allowing for breathing space, will be between two and three feet wide!

Security and cases

Jewellery is always at risk, it is highly portable, and precious metals can be melted down and stones broken up. Case protection follows the same principle as that for coins and medals. Maximum provision is needed for alarm systems, as advised by security staff, and glazing (Perspex sheet or laminated glass) should be arranged to deter smash-and-grab raiders. In general, it is advisable that jewellery displays should never be mounted in the front hall of a museum, and cases should be placed away from the doors to individual galleries, but well within warders' sight lines.

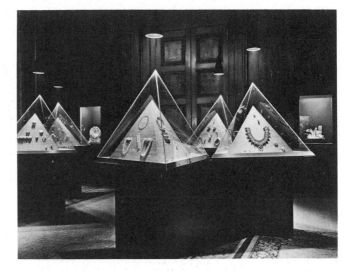

Modern. An elegant solution to jewellery display (designed in 1961). On silk-covered pyramids with pyramidal glass covers, each facet lit by fittings overhead.
Modern Jewellery, Goldsmiths' Hall, London
Designer: Alan Irvine

Ethnic jewellery and charms in wall cases, lit by 'cool spots'. Information panels between the cases, spot-lit externally, explain how objects are worn.
Nomad and City, Museum of Mankind, London

Conservation

Exhibits may be of many kinds, with differing conservation needs. Hence it is desirable to house exhibits of similar materials in small groups and cases. Gold, the noble metal, is chemically stable, but silver is highly tarnishable. Materials used in case construction and fabrics in the display must be tested. The mounting material used for sticking the stones within mounts can sometimes be softened by excessive heat.

Some pieces of jewellery incorporate 'tremblers' designed to increase the attention paid to the wearer. These will, of course tremble when visitors arrive on a sprung floor, and may need stabilising to avoid damage.

Lighting

Even, overall lighting is desirable, subject to advice from conservators. Warm fluorescent tubes for gold and brass, colder for silver and steel. To increase the sparkle of the pieces, particularly the cut facets of the

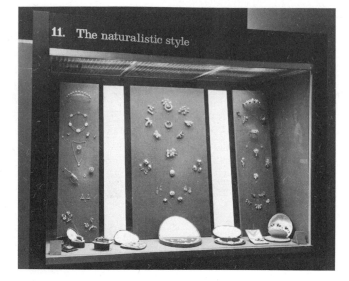

Many small pieces on silk-covered panels. Label panels divide the sections. Small plastic numerals identify the objects. Fluorescent lighting in standard showcase.
Hull Grundy Gift, British Museum, London

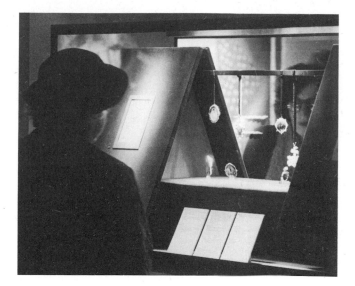

Concentration. Lit by low-voltage spots, the jewels stand unencumbered on Perspex mounts or hang free on velvet ribbons with sloped label histories down below.
Princely Magnificence, Victoria and Albert Museum, London

stones, a number of small point sources, simulating the effect of chandeliers, are advisable. Spotlighting individual pieces on a dark ground will convert the glass of the case into a mirror!

Overall lighting should be by fluorescent tubes, with small tungsten lamps for emphasis of particular features. These must be handled with care, to ensure that heat is not transmitted into the case. For 'fine-tuning', highlighting and lighting in individual cases the designer should, if possible, provide tracks and a number of adjustable lighting sources.

Display details and supports

The museum display of jewellery has little in common with that of the jeweller's shop. In museums displays need to make a clear 'point'.

Sometimes, particularly when technical points are being made, magnification will be required, either through a lens or the addition of photo enlargements. Often the backs of objects should be made visible by the discreet use of mirrors, for mirrors often reflect the normally hidden parts of a case.

Supports
Jewellery may be supported on pins onto a back panel, if the structure of the object permits. Pinned or threaded onto Perspex to provide support, it can then be suspended from the case top or shelving. If it is safe to do so, without putting undue strain on some pieces, jewellery can also be suspended; on nylon thread, enhanced by a ribbon, usually of velvet.

As to representations of parts of the body embellished by jewellery, a support taking the form of neck, arm or hand used as a mount can appear distracting and ghoulish. Rings can be mounted threaded on a wooden dowel or Perspex rod, giving scale without distraction. Free suspension of earrings could well simulate the original conditions of wear.

Props and backgrounds

An ideal setting for jewellery, other than displays involving technical explanation, is in place on a fully-costumed figure in a fully-furnished room of the period. Lack of space will probably preclude this as an accepted method of display. But in order to show the objects in their historical context, use can be made of contemporary portraits which will often feature jewellery. Where space, or difficulty of borrowing, precludes the use of original framed portraits, photographic enlargements of sections of the portraits showing the jewellery in detail can be included, and placed adjacent to the related jewellery exhibit. What is more, the historical context can be suggested by the use of appropriate fabrics as background to the jewellery, almost to suggest the very fabric of the costume that was worn by the original owner.

Another suitable background or prop is the original jewellery case, real or reconstructed.

Labels and the display of information

The labels will frequently be bigger than the pieces to which they refer. It will be less distracting to group the labels together, but within the case, keying them to the exhibits by small numbers or letters, perhaps on Perspex. Additional text material maty be better presented in optional catalogue or information panels, clear of the main flow of visitors. Diagrams might be useful for showing details of the faceting and cutting of stones, construction techniques and historical sequences. To increase the impact of small objects, large photographs can be very effective.

Facsimiles
Perfect facsimiles, which are expensive, could be used to fill gaps in the series in the display. Bad facsimiles on sale at the museum shop will unfortunately devalue the whole exhibition!

Manuscripts and documents

Introduction

Manuscripts consist of correspondence, literary manuscripts, maps, rolls, and papyrus. The material used will correspond closely with that in a department of prints and drawings and books in a library collection, but will occasionally include other substances: seals and cords, for instance.

Manuscripts are usually organised in museums separately from prints and drawings, since their importance lies in their historical or literary content rather than their appearance. They were essential tools of communication prior to the development and spread of printing, and in displaying manuscripts it is important to take into account their historical context. While many were legal and administrative documents – letters, deeds, minutes, reports, instructions, etc. – some were state documents, designed and illuminated by craftsmen to express the rank of the originator, as showpieces in effect. Manuscripts are the product of the literate. Since mass education is relatively recent, the bulk of manuscripts will be from the hand of the ruling classes, or more usually their literate servants, scribes, secretaries, and other officials.

Cases

Although existing cases may often have to be adapted, the designer should always attempt to secure the best viewing and reading position for visitors. Table cases will usually be most suitable; a slight angle is always best for reading, and the angle sometimes needs to be increased to give clear access to the longest objects.

There may be problems of size if manuscripts and scrolls bear seals below, especially if the designer is not forewarned of the additional space required.

Larger cases will be required if the manuscript material is displayed together with three-dimensional exhibits. This mixture will also raise problems of compatibility for the conservators.

Curtains may sometimes be required to reduce light damage.

It must be remembered that when reading a manuscript or a lengthy label the visitor may lean heavily on the case.

Security

Most manuscripts are in the nature of things unique, but often of no intrinsic value. Cranks are likely to pose as big a security threat as professional thieves, but no better for that. Illuminated materials, which possess added value as works of art, will need additional security and take up space.

Conservation

All manuscripts should be considered as fragile, although some, such as those on parchment, appear to be more robust. Those bearing seals are particularly vulnerable, the original document providing no protection for the pendant seal, suspended by a cord for centuries. Portable and valuable, they are also highly susceptible to the effects of light, heat, humidity, pollution and infestation. Manuscripts must always be cased, never near sunlight, heating or ventilation ducts. The level of light on a document written or printed in ink or decorated with illuminations should not exceed 50 lux. (The light level can be increased, but not to exceed 150 lux, if the document is written or printed in carbon ink.)

Conservation must control not only the documents but also seals and mounts. Fabric and photographic backgrounds must also be checked. Silver illuminations can easily tarnish if an untested fabric lines the case. Cases must include equipment to monitor temperature and humidity. In extremes, curtains may be fitted to cases to reduce the influx of casual light.

Some exhibits may require frequent monitoring by conservators. In such cases the designer must ensure ease of access.

Lighting

This must be even, with all ultra-violet light filtered out. The effect can be achieved by using fluorescent tubes (with uv filters fitted to them) controlled by dimming devices. Ordinary tungsten lights may be used if heat absorbent filters are attached, but these, unlike fluorescent tubes, can never be fitted within the structure of cases.

It is desirable to create within a case, an individual compartment for fluorescent lamps, completely separate, as far as heat and ventilation are concerned, from the display area itself; in effect, a case within a case. A thermometer/hygrometer should always be within the display area proper to monitor the effect of lighting; this is particularly important in exhibitions crowded with visitors who will cause the overall room temperature to rise.

Supports and mounts

Conservators advise that documents should be held firmly and supported throughout. Since handling and storage are also involved most documents will be mounted throughout their museum life. The designer may be able to influence the design of the mounts, which are of three basic types. The first is a window mount of acid-free card. The second is a sandwich between two pieces of glass, held together at the edges by a binding chemically acceptable to the conservators. The third type, only called for where images are very near to the edge of the sheet, is to rest the manuscript on a sheet of suitable card and to support it at each corner by 'retainers' in the form of acid-free translucent straps attached only to the base card.

Manuscript scrolls may be as long as sixty feet, and although rarely exposed from end to end at one time, case design and supports for them must be carefully planned. The ends of scrolls can be supported by small hooks, usually Perspex, on which the scrolls are 'hung'. The centre portion of the scroll must, of course, be supported, and is best laid against an easel board, forming part of the case, angled not far from the horizontal; movement of the scroll from the board is prevented by the provision of small hooks at the base of the board, in which the scroll lightly rests.

'Tier' display

Some manuscripts contain large blank or irrelevant areas. Moreover, sometimes a curator will wish to make a point by showing several items in close proximity. For conservation reasons, one manuscript can never rest directly on another. Therefore a tiered structure, rather like a cake stand, which enables one manuscript to be shown above and partially overlapping another, is called for. With fine adjustments it is possible to bring specific and important areas (such as signatures for comparison) close to one another by this means.

Backgrounds and props

Usually the manuscript will already be mounted; cream colours predominate although acid-free card is available in other colours: white, grey and buff. Sometimes, but rarely, the designer can influence the colour, or design the mounts for a specific exhibition.

Fine woven fabrics are particularly suitable for manuscript backgrounds, causing minimum interference with the text area. Legibility will dictate what is possible, but the background must never intrude for the sake of effect. A letter of William Morris might well be accompanied by a Morris wallpaper, but at a safe distance!

It is often desirable to show next to a manuscript, miniatures or portraits of the writer, subject, or recipient. The inclusion of these, or photographs of them, in a case will again give rise to the need for a conservation check.

Labels and information

These should be as near to exhibits as possible. Sometimes fading ink or a bad or strange hand may need a transcript provided nearby. This can be in typescript or typeset by a printer. Transcripts will be more effective if they are the size of the original concerned, and the transcription is line for line. Since there is a lot of reading matter in a manuscript exhibition anyway, any additional reading material should be sparingly provided.

Many documents are double sided, and may also be bound together in book fashion. Obviously mirrors will be of no help in this situation. Images to supplement the principal one can, however, be provided photographically, but this may increase conservation requirements.

Many exhibits will be hardly legible either as a result

Mounting techniques:
a) Window-mounted as a drawing or print
b) Sandwiched between glass
c) Fixed to a flat mounting board with melinex strips
d) Supporting scrolls with Perspex hooks and brackets
e) Layering

of unfamiliar calligraphy or fading of ink. Visitors must be able to read the material and case design must take this into account.

Optional biographical panels, outside the main flow of the exhibition, can cater for specialists without disrupting the flow of information to the general visitor. Audio-visual material may enliven a rather serious or complicated display.

Facsimiles

In order to reinforce the message of the display the designer may well wish to encourage the museum to provide 'take home' facsimiles for sale. In the case of manuscripts these can be relatively easy to produce and may be sold cheaply.

Models

Introduction

The use of the model as a source of information has been discussed elsewhere (see page 101) but the model is often an object to be exhibited in its own right. It then becomes an object in the display like any other, with problems of access, security, visibility, and conservation.

The information contained within a model may be very great indeed in relation to the space available in which to view it. As with other such 'dense' exhibits the designer must calculate the waiting time that must be allowed in front of it. Models of landscape, such as Stonehenge, and particularly where human figures are included as part of the story, will pack much information into a very small area. The same is true of enlargements such as an insect model half a metre long, where an extended period of study may be necessary. Even an object as familiar as a camera will have a lot to tell when modelled at three or four times natural size.

Concept models also involve subject expert and design team in working closely together. Even if the design of the model has been dictated by the work of a scientist, the designer must still cope with problems of positioning, height, and lighting, and these may be hard to reconcile with other material in the gallery.

Security and cases

Miniatures are always intriguing. Model houses, trees, animals could end up, however, as trophies for energetic schoolboys!

Intricate models may be housed in cases for reasons other than pilfering. Part of the construction may be liable to damage from vibration or dust, and must be isolated from visitors accordingly. When cased, all the problems of case displays will arise: the provision of enough light without generating troublesome reflections and heat, and the need to give access for monitoring by the staff. The designer should always list models as 'delicate' in his initial planning of an exhibition.

Access

A good model will often have information to impart from more than one angle. A landscape model can be viewed from surface level, affording the perception of a walker in the area. Alternatively, the quality of the model and the points that the curator wants to explain may make it essential to view it from above. The visitors can sometimes be given a viewing platform, or a view from more than one side can be provided by a hanging mirror. Guidance and barriers will often be needed, to see that the visitor obtains full advantage from all angles available for viewing the model, and is safe while doing so. Models are very exciting to children, and the design of barriers must always be checked with this in mind.

Information and labelling

As in the labelling of art objects the positioning of information text and diagrams is important. The model and its mounting may often provide an obvious solution. The barriers and the edges of the platforms used to control circulation will provide 'holders' for the text and graphics, and key diagrams can be provided from each available viewpoint, so that features such as landmarks can be identified.

If the volume of visitors permits, an audio-visual presentation near a model, or over it, may provide the

All round access to this model house, steps on three sides, three viewing levels altogether. In front, information on a sloped panel. Lighting from above.
Pompeii, Royal Academy of Arts, London
Designer: Alan Irvine

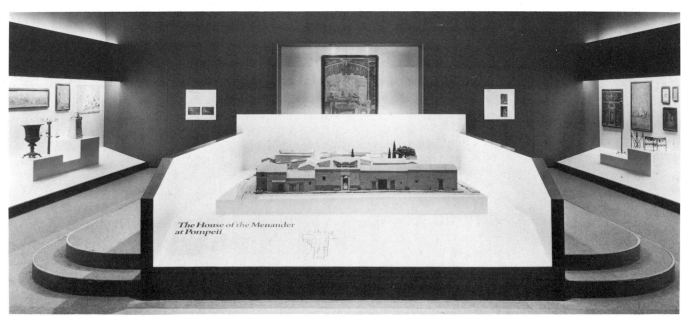

The chronological development of ships demonstrated by models set in wide, slim wall cases. The sea is rippled glass, and the back-panels carry information.
National Maritime Museum, Stockholm

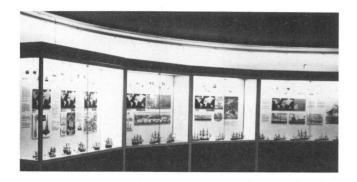

guidance required.

The scale of the model should be made clear. Those familiar with the subject will be able to assume it without reference to the text, but where the material is less familiar to a general audience, as in popular displays of science, the designer must make clear what the model is showing, to what scale, and also (if this is involved) what colour coding and other method of labelling is used within the model itself.

The best method of enabling the visitor to 'scale' the model instantly is to include a matching sample from the real world beside it. The enlarged insect, for instance, could have a matching actual size specimen incorporated into the label.

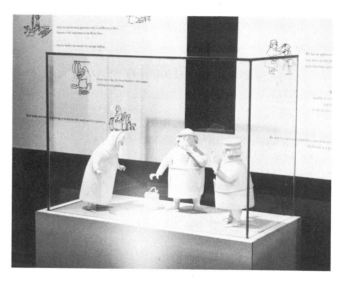

History encased. These detailed model people explain events in a city's development. The site is a converted church where many display techniques are employed.
The York Story, Heritage Centre, York

An historic site shown on a 4 metre square model. Barriers distance the visitors. Details are 'keyed' by drawings and text on sloped panels.
The Ancient Olympic Games, British Museum, London

Concept models. Geometry made of paper, on open display for a conference audience; solid versions cased or for handling are quite practical for museum exhibitions.
British Association for the Advancement of Science, York

Natural history specimens

Introduction

Many current exhibitions of science, and the natural sciences in particular, do not feature museum 'objects' in a major role. In the past the objects were often presented as icons, things to be marvelled at. They formed the centre of the display.

Museum galleries now transmit the message 'education', and there are many display devices which can be used for the purpose. The object now serves as illustration to the argument, or evidence for it.

This affects the density of the display. More space is often required to present an argument than to display a complete collection, and objects will be spaced out between graphics and audio-visual areas.

This does not mean that the designer is entitled to place the specimens in jeopardy. Many will be rare, and almost all will be expensive to collect and prepare. The designer must bear in mind their history as well as the present requirements and he must work closely with scientists, taxidermists and model-makers, both in planning and preparation.

An exhibition may draw on specimens already in the main study collection. These will need careful examination to decide how they are to be mounted in their new, explanatory, role. Some may be prepared, or borrowed, specifically for the exhibition. In the case of loans the designer will be well advised to inspect the specimen, and not trust to descriptions! In some subject areas, such as palaeontology, the exhibits will often be casts or replicas.

Model-makers will often be called in from outside by the exhibition team, particularly for exhibitions of art and history. But in scientific displays they are likely to be members of the central exhibition team, helping to arrive at decisions in the design process at all stages.

Types of display

Taxonometric

When scientists have arrived at a system of classification for specimens, the designer has to show the basis of the classification. The grouping may be according to a common habitat, or a common structure. Although a large number of specimens may be grouped together in this type of display their massing together will not be sufficient for the public to understand the theory behind the grouping unless it is made explicit by text and other means as well.

Naturalistic

The traditional diorama, when carefully executed, is a marvellous means of showing both living forms and habitats. It is a very expensive medium, and the designer is more likely to inherit examples than to be able to commission them. However, various styles of semi-diorama have been evolved. These use photographic backgrounds, sometimes in black and

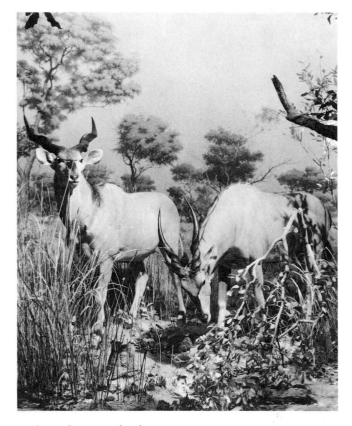

Realism: this giant eland group, complete with landscape, brings the habitat into the exhibition. Effective but expensive, long-lasting with proper conservation.
Akeley African Mammal Hall, American Museum of Natural History, New York

white only or derived from enlargements of engravings, supplemented by foreground dressing with rocks and grasses, etc. It is encouraging to find the extent to which these low-cost versions can be made acceptable.

Thematic

In an exhibition where an 'argument' predominates, and the specimens are providing three-dimensional illustrations, the designer has to find a format that will tie the exhibits to the graphics and audio-visual elements. It is essential that the display should not look as though the graphics were planned first, and the set then 'dressed' with specimens. And this means that the designer must become very familiar with the specimens, sizes, colours, and textures, right at the outset.

Aesthetic

It may sometimes be necessary to exhibit specimens in complete isolation from settings or substantial quantities of information. They then require the treatment given to paintings or sculpture, to be appreciated for their beauty alone, or to function as 'alerts' to attract the visitors to an exhibition or a section.

Live displays

Whereas a zoo can contain a museum section, it is harder for a museum gallery to incorporate a zoo.

Magnification: different insects (visible to the naked eye) displayed around circular units. Visitors select a specimen, slide the mobile microscope and choose the degree of magnification.
University Museum of Zoology, Zürich

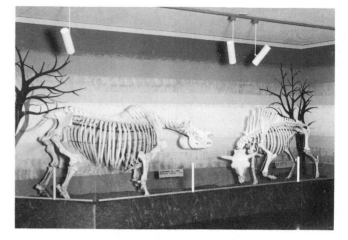

Skeleton information. These specimens permit a simpler presentation than a diorama. The painted background is stylised; spotlights, barriers and labels are clearly functional.
Natural History Museum, Geneva

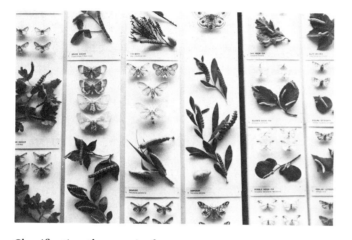

Classification: the grouping has a meaning as in a nineteenth-century engraving. Natural history for the informed, the specimens positioned in a strict order.
Natural History Museum, London

Exterior label for livestock. This must be weatherproof and robust. It is laminated plastic, engraved and mounted on a concrete block.
Cogges Farm Museum, Witney, Oxon

Perches, formed from a sheet of standard building reinforcing material which provides a display grid to support both specimens and labels.
University Museum of Zoology, Zürich

Groupings: cylindrical shapes provide both support and identification for individual specimens against a neutral background. Adjacent telephone receivers provide the bird's song.
Bird Gallery, Natural History Museum, London

However, if the designer can offer conditions acceptable to the conservator, living specimens – plants, insects and small mammals – will enliven the displays generally and attract younger visitors in particular. There will, of course, need to be extra provision for care and maintenance as a result.

Security and cases

Birds' eggs are a temptation to some collectors, ivories are valuable, and butterflies are fragile. They all must be in cases, and secured. Large mammals can sometimes be displayed in the open providing that the environment is controlled, and adequate barriers protect them from caresses! Palaeographic material is of such a variety that schoolchildren might be tempted to take home a souvenir. If duplicates or replicas are not available, then the display must be in cases.

Conservation and lighting

Where specimens are drawn from a storage collection or on loan from elsewhere, their condition must be established at the outset, and the conservation requirements specified. Such specimens are likely to have deteriorated to some extent, being of organic material. Sometimes the damage is visible; skins having lost their suppleness, split. The conservator may be able to limit the spread of the damage, and the designer can then carry out discreet camouflage!

The preparation of natural history specimens has improved greatly in the last few years. Recently mounted exhibits will not present the same problems as those from historic collections. However, the conditions of display will still have to be specified and monitored throughout the life of the exhibition; a temperature of 15–18° with an RH of 55%–60%, would be ideal. Dusts and pests can damage the specimens on display, and cases should be detailed to be as dustproof as possible, with the possible incorporation of pesticides.

Light levels are as important as in the display of works of art. Feathers, fur, scales, and skin will lose their colour and otherwise deteriorate if exposed to light, artificial or from the sun, if ultra-violet filters are not provided. Fluorescent fittings are no exception to this, uv filters also being required, and a limitation to 50 lux. The conservator must check what is proposed.

Heat can become a problem in natural history displays. Vegetation is often modelled in wax, and this will distort if subjected to heat from radiators and spotlights. Some testing is advisable.

Display details

When specimens are prepared for specific use in a display the designer, scientist and taxidermist can agree the exact posture to be achieved and the mounting required to display it. Using existing specimens, where the specimen is already mounted on a plaster or a glass fibre 'carcase', in turn mounted on a metal armature (similar to that used by the sculptors for clay models) the resulting exhibit can be quite heavy and the posture cannot be altered. Supports will

Magnified: this model, some 36 times life-size, informs a general public of form and detail more comprehensively and faster than text and diagrams.
Insect Gallery, Natural History Museum, London

usually extend through the feet, and must then be firmly secured to a timber display board, or straight on to the surface of the display itself. More recent specimens may have been built from polystyrene, and, as with the small mammals and birds which are now often freeze dried, will require less substantial fixings.

Information and labelling

As with any subject, the designer must prepare for visitors with many differing levels of knowledge. The well-informed will be able to enjoy a display, even on chance encounter. Others may not know the subject, nor have seen the exhibits before. So the exhibition team must provide identification and explanation on the spot, and this 'spot' information will have to be keyed into larger explanations of the subject nearby.

Shortcomings in the supply of information in an exhibition of art or history will usually leave the visitor with some pleasing direct visual experiences at the very least. Information failures in the sciences are more serious, producing not only frustration, but also reducing the visitors' general confidence. The curator, scientist and designer have to work particularly closely in planning information, agreeing the audience that they expect, its composition, previous knowledge, and the vocabulary acceptable.

Paintings

Introduction

This section is concerned both with the arrangement of exhibitions or displays of paintings in existing art galleries, and in temporary exhibitions in areas not specifically designed for paintings. Although the architectural design of art galleries is not discussed, the designer would be advised to study the method of lighting used in established art galleries and even more in those built from recent designs. For the display of paintings is principally concerned with the organisation of light upon them.

Although today we acccpt an art gallery as the natural place in which to see paintings it is in fact an artificial venue for the showing of things originally created as interior decorations for private patrons or as altar pieces in churches.

It must be remembered that artists practising today are the first generation to visualise the art gallery as the principal setting in which their work would be seen.

Most of the works with which the designer is concerned have already travelled far from their original context, and he is faced with the problem of lighting them in a way that neither their creators nor original owners could have envisaged.

The face that paintings present to the public is very much the product of the materials of which they are composed. (For this reason, watercolours, and their combination with pen and ink, pastels and gouaches are dealt with in the section Drawings and Prints. They are dealt with together there because of their size, and common conservation requirements, being paper-based.)

Paintings are made up of a number of elements, involving structure, medium, and finishing technique. Each of these can determine their conservation needs, their lighting, and to a considerable extent their manner of display.

Categories for display

Panel paintings

Early paintings on wooden panels are likely to consist of a number of planks, held together by keys, or by retaining strips running along the ends, or by braces on the back. Sometimes the braces incorporate some means whereby the structure can adjust to the movement of the timbers when subject to variations in temperature and humidity. On occasion the panel may be retained by the frame surrounding the picture, though this is not applied around the perimeter, as in later treatments, but forms part of the structure.

Canvases

When the support structure of a painting is of canvas, the system involved will consist of an adjustable frame (the 'stretcher') to which the canvas is tacked or held by cords. The tension of the canvas is adjusted by driving towards the corners of the stretcher small wedges which are slotted into it. On this support system will have been laid a ground, which can consist of combinations of size, chalk, and/or oil colour. Upon this the work will have been executed in paint consisting of body colour held together by a medium, either oils, or (in the case of tempera) white of egg. Most paintings will, when completed, have been protected by a layer of wax (rarely), or varnish. This finish to the work will decide, together with the impasto – the modelling created by the brush strokes – the total appearance and what lighting will be required.

Contemporary paintings may be on proprietary hardboards or blockboard, which can be regarded as being fairly stable.

Other materials

Some paintings do not have a separate structure of panel or stretcher, but are part of a wall. The designer may be called upon to illuminate and label a mural 'in situ' or display fragments of fresco.

In mounting a display of paintings, whatever the base on which they are made, the designer will have to consider the frame immediately around it and cope with the problems of reflection from varnish or glass.

Types of display

Art galleries

In galleries specially built for the display of paintings, the designer may either treat the gallery structure as the basis for a more or less permanent display, or may create a fresh installation to stand within it, providing a temporary setting for a specific period. Many galleries designed within the last decade or so incorporate elements of display systems, both in structure and in lighting, which make the division between the two styles of presentation less distinct.

With other material

Many exhibitions of paintings are simply a collection of individual works of art, and the designer is primarily concerned with mounting each piece in a way that maintains its integrity. An area of potential conflict arises in exhibitions where the works not only have their own aesthetic value, but are also interspersed with additional material, such as sculpture or examples of the decorative arts, to make a statement about a particular historic period or movement. Other difficulties can arise if works are accompanied by preparatory drawings used to establish provenance, etc., which may give rise to different considerations relating to both conservation and presentation.

Historic settings

Individual paintings are often displayed in historic houses, or in buildings with an historical connection with the painter or the subject. Although conservation considerations are the same as for art galleries, the problems of display relate to the furniture and decorations.

'Storage' displays

By contrast, paintings may also be presented at a very

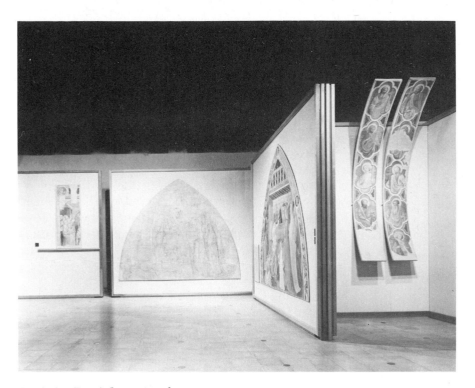

Left:
Large frescoes, divorced from their context, with minimal information, each set on a framed screen, displayed as individual paintings
Below:
Fragment set in angled metal frame displayed at floor level
Frescoes from Florence, Hayward Gallery, London
Designer: Carlo Scarpa

Proximity. Text information about paintings is usually on distant introductory panels, or the catalogue. Here it is integrated in the hanging near the subjects.
Manet at Work, National Gallery, London

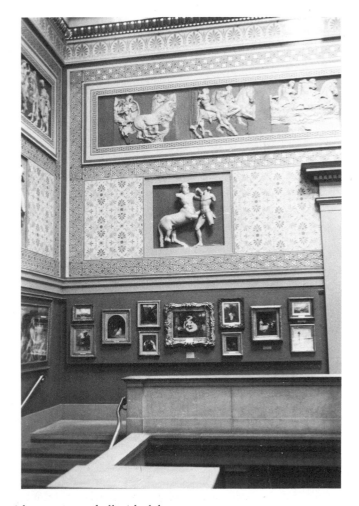

Secondary collections. Careful hanging of paintings in major galleries leaves many in store. Study collections on sliding panels facilitate public access and storage. Museum of Modern Art, Stockholm

A large entrance hall with elaborate architectural detail. The frieze unifies, and concentrates attention upon, a display of small paintings.
City Art Gallery, Manchester

183

high density, using a storage type of exhibition, perhaps for a secondary collection being provided as a back-up to the main display.

Conservation

Nature of materials and problems

Paintings on panels or canvas in either tempera or oils, are, for conservation purposes, stratified structures of great variety and complexity. Any element or layer can give rise to problems when on display.

Oil and tempera can both shrink over time, becoming brittle. The surface of the painting will then become covered in fine cracks, 'craquelure', as the film of paint cannot withstand even slight movement in its support, resulting from minor changes in the RH over a long period. Sudden and extreme changes in RH can result in more serious cracking and cleaving of the whole body of the picture. When adhesion is lost between the superimposed strata of the painting, blisters are formed which, if fractured, result in loss of the paint. The conservation of a painting depends on understanding how it will react to its environment, both as regards its support structure and the stratification of pigment that makes up the image.

Conditions for panel paintings

Control of temperature and humidity are the most important factors. Exposure to extremes of temperature causes dessication and extremes of humidity are most damaging to timber; the panels warp and crack, producing cleavage throughout the paint layers.

Paintings on canvas

Canvas behaves differently. In the raw unprimed state it will tighten when damp and expand when dry. The effect of the ground put on it by priming, and the layers of the painting itself will reduce such movement to a minimum. With age, however, the oil paint begins to lose elasticity, and changes in humidity make the canvas and the layers of paint move independently, the paint cracking as a result.

Dust and mould

Dust also creates problems for paintings. If the gallery is not 'conditioned' the dust in the air becomes contaminated by the sulphuric acid also present, and then lodges in the impasto of the painting, the 'craquelure' and the weave of the canvas. It then proceeds to attack all the materials with which it comes into contact.

Paintings should never be hung above or near to radiators, because not only will the fluctuations of temperature and humidity be extreme and destabilising, but the convection of the air currents will intensify the dust problem in relation to the painting surface.

Temperature and humidity

Because of the value and highly sensitive nature of most collections of paintings, designers should strive for ideal conditions. They are unlikely to achieve them without calling in specialist help. A constant humidity of 58% and a temperature of 17°C must be established, together with air conditioning and dust extraction. Then without the risk of damage by atmospheric pollution in most instances, it should, with approval from the conservator, be safe to remove the glass from glazed pictures so that they can be seen without specular reflections.

In many galleries and houses open to the public, some of the external walls are quite damp. If the paintings are fixed to them moulds will form on their backs, and in addition a bloom is likely to develop on the varnish. To prevent this, the wall can be panelled out on battens with air being allowed to flow freely behind it and with vents cut into the panel at top and bottom. The paintings can then be fixed to the face of the panels with some confidence. A cheaper temporary solution however may be acceptable to the conservator: by fixing small blocks to the wall and bringing the painting away from the wall surface, allowing circulation of air behind it. But there is a danger that any material connecting a painting to a damp wall could be a means of transferring moisture to it. A material providing a waterproof barrier should be used.

The effect of light

Oil and tempera paintings are affected by light and will be damaged by it in time. The conservators cannot tell us which colours will fade, nor when, but (with a few exceptions) colours can be regarded as reasonably fast for the duration of a temporary exhibition. For permanent display, a careful assessment at the outset and regular monitoring by conservators is essential.

In tempera painting, a few of the colours are 'fugitive', in particular a green 'copper resinate' which is liable to turn blue, and the red lakes, much subject to fading. Paintings containing these susceptible pigments should be sorted out by the conservator and set aside for special lighting treatment by the designer. Tempera paintings, in general, have a safe light level set by conservators at 150 lux. Northern daylight is acceptable for oil paintings, but sunlight and spotlights are not, since these cause premature ageing of the varnishes.

Pigments used in the creation of miniatures are much more susceptible. Like watercolours, they should be restricted to a very low light level of 50 lux.

Cases

Designers will be reluctant to put cases around paintings unless strictly necessary. However, if they are very small, very susceptible to the atmosphere and light, or to theft, cases will need to be fitted into the overall design. Sometimes it will be sufficient to glaze a frame from its outside edges, converting the painting into a self-cased exhibit, so to speak.

Cases for miniatures

Miniatures have to be cased for two reasons. First, because they are very small they have to be viewed at close quarters, and are therefore difficult for warders to supervise. Second, the pigments of which they are

made are very susceptible to light, which has to be closely controlled or even filtered for ultra violet. In extreme conditions, cases are covered in curtains when the miniature paintings are not being viewed. In other museums, a special darkened bay is set aside in the gallery for the purpose, or cases are lit only for short periods by push button.

Screens

Screens introduced into a gallery will act as additional walls to increase the display area, and to provide 'punctuation' within the exhibition. They can be of a modular type, which can be used to create rooms-within-rooms without constructional work, to create bays for special emphasis, and to enable works to be specially arranged in relation to the daylight source. Many proprietary screens are available, but these are usually portable for commercial display purposes, and they will need to be made more stable for use in a museum. Projecting feet or supports may be a problem; it is also important to be able to anchor them firmly to the gallery structure in some way.

Whether panels or screens are built specially, or a proprietary system is used, stability can be achieved. However, the eventual load of the pictures must be borne in mind, and supporting posts fixed to the floors, walls or ceiling structures are probably the best way of dealing with this.

Security

Security demands for an exhibition of paintings will be stringent. Some of the paintings, masterpieces, will be portable. Although the overall security of the museum or art gallery will be in the hands of a security adviser, the designer is always responsible for seeing that the sight lines in the layout of the gallery aid the invigilating warders.

As with other exhibits, fixings are important in securing paintings. The backs of the paintings will vary considerably in size and materials, and care will have to be taken to find the right forms of attachment, and secure 'beddings' for them in the gallery. In some instances it may be desirable for the designer to introduce barriers, either actual or psychological, into the gallery design. Such barriers now available, together with the sophisticated security devices, may make it possible to display some paintings without the distracting glass in which they have been traditionally housed.

Where paintings are to be screw-fixed to a false wall or screen panel, blockboard or dense chipboard should be used to provide a good housing for the screws. If rear access is possible, and the rear can be hidden, the plates or hooks for the paintings can be bolted through the panels, with washers and nuts securing them behind.

Lighting

It has to be said that the lighting of paintings cannot be devised on the drawing board! Time has to be set aside

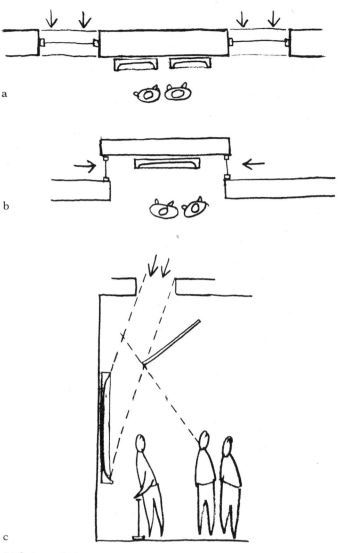

Lighting paintings;
a) Placing on wall between windows to avoid reflections
b) Side lighting
c) Top lighting (natural or artificial), viewing distance and glare protection

for trial and error, since, apart from the limitations imposed by conservation, the surface of each painting, its modelling by brush strokes and the type of varnish used, will demand 'fine tuning' if a coherent effect is to be achieved throughout the gallery. When a mixed display includes material other than paintings there is the added risk that the light necessary for other objects may spill upon the pictures.

All curators wish the colour in their paintings to be correctly rendered. We know that many of the paintings in our collections were originally viewed by candles and lamps, while others more recent were created in north-light studios. Today northern daylight provides us with a 'norm' by which one can consider the effect of artificial lighting of different types.

Some paintings are kept permanently under glass. The resulting reflections can be eliminated by careful attention to the geometry of the display, the windows of the gallery if any, and the sources of artificial light.

The frame of the picture, even if historically appropriate, can be a hazard. Some mouldings are so deep as to cast inconvenient and confusing shadows, and diffuse extra 'filling' light may have to be introduced to take care of such problems.

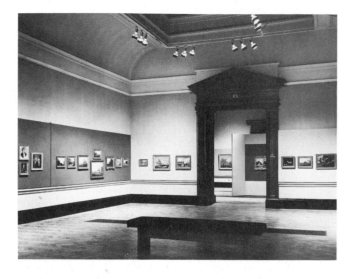

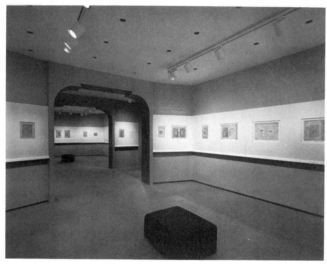

Top:
Focus on fabric-covered panels forming a band of display. In large galleries small paintings can lose impact unless grouped and related. *Painting in England 1780–1850: The Mellon Collection*, Royal Academy of Arts, London
Designer: Alan Irvine

Above:
Focus again: a glazed display bank with small paintings window-mounted.
Wonders of the Age: Safadid Paintings, National Gallery of Art, Washington

Frames

The designer will probably have to display a collection of paintings, each with its own frame. This will present both aesthetic and practical problems. Massed together the frames in different styles may become more powerful to look at than the actual pictures; moreover, the various methods of construction may make it hard to standardise the fixing procedure in the gallery.

Dimensions

At the briefing stage, the designer must make certain that the dimensions given for the works are all recorded in a clear and standardised format. Both the height and width of the canvas should be given, as well as the overall height, width *and* depth of the frame. Many a designer's headache has been attributable to the fact that the inner dimensions have been conveyed as the overall, and it is only when the objects are delivered that the total area required is seen to be much greater than estimated. Quite apart from dimensions, because the frame is such an indispensable part of a picture's impact, the designer must consider frames carefully in calculating the appearance of the whole exhibition.

Development of frames

Early pictures, which were part of an architectural structure, were kept in position with a moulding, like other timber panels. When paintings, with the arrival of portrait and ikon, became portable, the surrounding moulding served to keep together the planks of which the panel was constructed. This also protected the painting during its travels. With the introduction of canvas, pinned upon an adjustable wooden stretcher, the role of the frame became different. The whole item was lighter and more portable and could easily be raised or lowered to suit the other furnishings of the room. The frame now served to separate the picture from its surroundings. With domestic lighting, the picture and frame merged together.

Whatever the advantages of the lighting system in a modern gallery, one result is that the frame may often throw substantial and possibly distracting shadows, and generally assumes too much importance. The task of the designer in this context is to provide an overall setting which will ensure that the frames, however splendid in carving and colouring, remain subsidiary to the paintings. (Although not recommended, it is on record that, in the past, designers of exhibitions have been driven to dipping the frames presented to them in whitewash to achieve the desired unity!)

The frame acts as an indicator of the date of a work of art. While the designer will consider frame and picture together as a component in the gallery display, the frame will also function as a partial label to the individual exhibit.

Reframing

If the original frame is still around the painting, the designer has only a problem of display. If, however, a frame has been added from a period unacceptable to the curator, a replacement may be called for, and substantial costs may be involved. There are a few

specialist framemakers who can re-create facsimile frames of any period. The work is laborious and therefore expensive. The main profile of a frame is not itself expensive, but the creation of modelled detail and the provision of fine finishes and toned colouring, can be costly. In a low-budget display the designer has to seek some alternative, particularly if the exhibition has a short life. It is worth examining the possibility of creating a 'frame' which will provide the overall tone of the original setting, without attempting a total facsimile reconstruction. For example, a moulding in the past will have provided a series of shaded lines around the painting, similar to the line and wash rulings round a mount. Providing agreement is obtained from lender and curator, it may be possible to create comparable shadows and tones in a 'temporary' frame without the enormous expense of finished details.

Fixing frames
The most direct way of fixing small paintings to a vertical surface is by means of metal plates (known as mirror plates) fitted on two or more sides of the frame at the back, and then plugged to the wall with security screws. After the picture is in position the plates are still visible, and the projecting parts should then be made less conspicuous by touching them up with paint of the same colour as the gallery wall or screen. The main disadvantage of this method is that it damages the surface and it is likely that the area will have to be repaired and redecorated before the next show.

The weight on the frame and the state of the walls may preclude this method. An alternative is to fix lengths of chain to each side of the back of the frame, the chain being hung on hooks fixed to the wall, out of sight behind the picture. An advantage of this method is that the picture can then be tilted by the addition of small blocks, carefully positioned, to reduce reflection from the varnish or glass.

If the total weight of frame and painting together are excessive, it may be advisable to fit individual brackets or a continuous horizontal bracket to the wall to provide additional support under the base of the frame.

A more flexible method of picture-hanging (seen in many Victorian galleries) is achieved by providing a rail fixed to the wall at a high level or to the ceiling from which can be hooked pairs of chains attached to each picture. This method provides great flexibility in both directions, horizontal and vertical, but the chains are somewhat distracting. A contemporary version substitutes metal rods for chains. These are suspended from a rod-channel, fixed to the wall at a high level or over a 'picture rail' moulding.

An advantage of the rod system is that a number of pictures of approximately the same width can be mounted above one another on the same pair of rods.

As an alternative to the vertical rods another system uses continuous horizontal U-shaped channels set in to the walls. Brackets are then fixed to the back of the picture frames, which engage in the channel. This system is maintenance-free, but is only flexible horizontally. It has the advantage of providing the designer and those hanging the exhibition with useful datum lines for the pictures and the positioning of labels.

Any mechanical system for hanging paintings will provide some distraction, even if the components of the system are coloured to match the wall behind.

'Hanging' the exhibition

Sometimes the designer will be called upon to 'hang' an exhibition in an existing space, arranging the grouping and the spacing between, rather than to design a setting for the exhibition. He must take into account both the intellectual significance of the exhibition (its 'meaning') and the planning of the physical disposition of the elements.

The order of the works will usually be determined by the curator (known as the 'curatorial order'). This ideal order will be expressed in the catalogue, the timetable for the production of which will be set much in advance of the hanging stage of the exhibition. Indeed, decisions on spacing and 'eye level' will probably not be determined until all the works have been assembled together

In hanging paintings, the designer is using the pictures themselves to pace the visitor through the exhibition (its 'meaning') and the planning of the sections, and, ideally, these sections should be arranged to match the 'breaks' in the architecture of the gallery itself.

If the designer is able to divide the available space into various sections, corresponding to divisions in the material, he is able to exercise more editorial control over the viewer. Even stretches of corridor and staircase can be used to isolate certain aspects or individual paintings, though there are potential bottlenecks and dangers if visitors pause for too long on staircases and landings. A single piece, remarkable for its value or for the fact that it has been recently acquired, may even justify the allocation of a complete room, or a constructed bay, in which to display it.

One method of moving the visitor from one room or bay to the next is to site the most powerful painting of each section so that it is framed in the entrance to the room. Ideally, the designer will wish to scatter the major works throughout the exhibition, but his room for manoeuvre will depend on the 'curatorial order'. To emphasise the importance of a particular work (not necessarily the largest, incidentally) it may be desirable to devote some part of the wall space to it on its own, isolating it from other pictures more closely hung.

Another method of drawing visitors forward, particularly useful when they are to be attracted to information panels about a section of the exhibition, is to group together small pictures which by reason of their size will require close attention.

The subject matter of a painting, particularly if it involves strong handling, must always be borne in mind by the designer. Certain subjects, for example, a galloping horse, carry the eye in a definite direction.

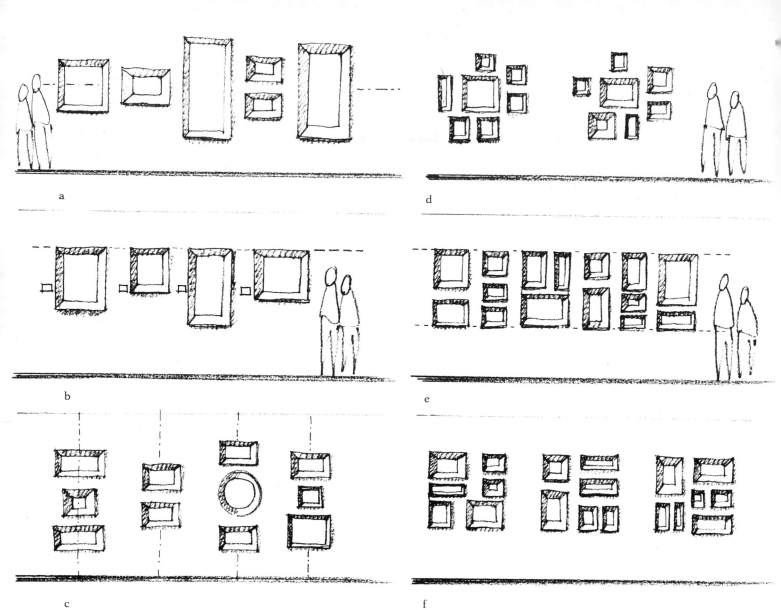

Styles of hanging for collections of small
pictures (also applicable to framed
drawings, prints and photographs):
a) 'Eyelining'
b) Top lining
c) Colonnading
d) Clustering
e) Banding
f) Panelling

Pointed towards a corner, such a picture can ruin a room's balanced arrangement.

Visitors can suffer fatigue in an exhibition of paintings as in any museum collection. The designer must organise some blank spaces for recovery purposes, such as a vista, real or contrived. A slit through a wall or screen, showing a view of another section of exhibition, may relieve both eye and brain.

Backgrounds

Walls are the most common surfaces on which paintings are fixed. Some have fixing systems built into them. Where the fixture is direct to the surface, it will be worth while considering a textured finish, either textured plaster or applied hessian which can be redecorated between exhibitions. Occasional repairs should not be too prominent.

When changes between exhibitions are frequent, walls can be faced with lift-off fabric-covered panels. These can be taken away from the gallery for servicing and recovering.

If exhibitions are being changed frequently, cost and other practical considerations will limit the choice of background materials. A neutral textured background will be bland and require little maintenance. For contemporary painting white backgrounds have become almost universal. Galleries with a rapid changeover use wood chip paper, on both structural walls and panels. This not only covers irregularities, but can be easily redecorated.

Labelling and information

The guide-lines for labelling an exhibition of paintings seems so obvious as not to be worth setting out. That this is not so can be seen by visiting almost any exhibition of paintings!

First, the labels should be designed to provide information effortlessly, even if it is only a catalogue number. To be visible they must not be in the shadow cast by the picture frame. The type face and therefore the label should be large enough to be easily read by visitors with less than perfect sight from the distance from which they would normally view the paintings themselves. A gallery full of visitors walking backwards and forwards between labels and exhibits is a design failure!

Finally, but very importantly, the designer must recognise that the hanging of the pictures and the planning and writing of the catalogue take place some time apart, and there is little chance that the pictures and their labels will be hung in numerical sequence. This being so, the visitors will often wish to search for a particular catalogue number among the labels, and this will be made easier not only if they are of a common type face, and of a large enough size, but also if they are placed at a consistent height from the floor, to ensure a smooth search. The considerate designer or organiser might also, at strategic points in a large exhibition, display an index giving the location of the paintings by their number or artist.

Whoever is responsible for the catalogue, the designer must understand its terms of reference, because the labels have to be designed and positioned to provide the key between the entries in the catalogue and the pictures on the gallery wall.

The traditional method of identifying paintings in permanent collections was by 'sign written' information centred on the bottom of each frame. This was then developed to include lettered labels attached to the frame. In temporary shows, with most of the works on loan, the designer must accept that these original labels will exist side by side with those which he is going to organise, tied to the catalogue. The lenders will not welcome his removing the original exhibition frame labels.

An exhibition of paintings lends itself to providing information in a number of tiers. Information panels can be used to provide an introduction to each section, audio-visual programmes are suitable for creating an introduction or background to the subject for the less informed visitors, and the catalogue can provide supplementary information and interpretation in greater depth, and for further study.

Photographs

Introduction

Photographs are familiar to the museum designer and curator as a method of recording a subject, copying the record, and enlarging it when required for display purposes. Such uses are considered in the section on the design of information (see page 91). This section is concerned with photographs as historical objects which illustrate processes and as archival material showing the contemporary recording of things and events.

Familiarity with photographs, as a tool of recording and display, may be a disadvantage. The archival photograph has to be seen as a unique and highly vulnerable object to be exposed to the public only when there is no risk of its destruction. The earlier a photograph the more unstable are its chemical components, and the less the likelihood of copies existing elsewhere. The conservator may well decide that the risk of exposure of such originals is too great, and in this case modern photographic skills can be called upon to produce facsimile copies or reconstructions by printing old negatives using the methods obtaining at the time they were first produced.

Identifying the technique

The designer should never handle or attempt to cater for a photographic exhibit which has not been clearly identified by a competent authority. There are advisers available to museums, large and small, who can take such responsibility.

Nevertheless, the designer must familiarise himself with the categories of photograph which he will have to display, and know the conditions governing their protection.

The first check is a simple one; is the image positive or negative? If there is a faint image which could be either, the exhibit needs special identification and display consideration.

A second check can be made by considering the history, if any, of the exhibit, and the dateable subject matter such as events, scenes and costumes which it contains. Any photograph containing an image before 1900 should be the subject of absolute identification by an expert.

A third check concerns the state of the exhibit. Can the photograph be exhibited or not? If there is any doubt, the exhibit should be copied forthwith and the original stored.

Types of display

Photographs are displayed as art objects of historical interest in their own right and therefore call for similar attention given to old master drawings or prints. In fact many of the display techniques are common.

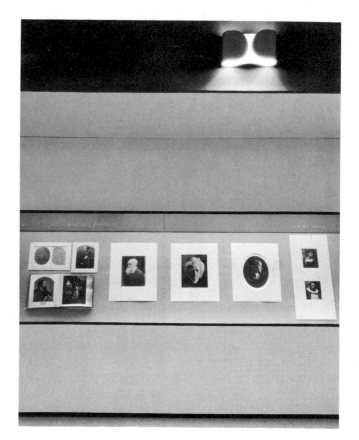

Window-mounted like drawings. Photographs displayed on a slope in a fluorescent-lit wall case. The gallery has special decorative lights on case fascias. *People in Camera*, National Portrait Gallery, London
Designer: Alan Irvine

Details for study. Contemporary photographers' contact sheets were centred in the gallery, glazed, on table-height black timber cubes. Enlarged photographs in frames on the walls. Historical Museum, Amsterdam

Original photographs can be included in displays of other contemporary material and, in particular, as illustrations to the history of photography, demonstrating the products of various cameras. Providing the curators and conservators will agree to the work being done, new prints from historic negatives can be made and displayed to give a telling emphasis to other contemporary material. Often the original print would be at too great a risk even if it still existed.

Early in the development of photography care was given to display. Daguerrotypes were produced in standard sizes, and handsome leather-bound cases were available to contain them.

The demands that photographs make on the person hanging the exhibition are quite different from those posed by paintings. In coloured prints and paintings every aspect of the exhibit can vary, image size, colour, technique, and texture. As a result the 'hanging' party have to make very fine adjustments to ensure that the strength of any one painting does not overwhelm its neighbours.

Photographs are more homogeneous. Technical limitations to some extent control their size, although their surface texture can vary from a high gloss to a velvety matt. However, this enables the designer to impose a much greater degree of standardisation of frame design, mount texture and colour, and as a result he can pack the photographic images much closer together than is possible with paintings.

Cases

When photographs are not individually framed, nor collectively in groups, larger cases, such as those used to display prints and drawings, will prove suitable for their display.

Security

Cases containing displays of photographs should be as secure as those for prints and drawings. When shown in individual frames, each frame should be hung on a screen and fixing arranged with the same care as for paintings. As a general rule, all original photographs must be displayed behind glass or Perspex.

Conservation

Photographs, especially early ones, are extremely sensitive to their environment and this must be considered in any display. Their very existence depends on conditions of display and storage, and this demands understanding of the chemical characteristics of each type of photograph and the specialised care with which they must be handled. Each type of photograph has a different reaction to the length of display to which it is subjected, to temperature, humidity, contamination, atmosphere, and light levels. They are made of relatively unstable materials that can tarnish, fade, stain, discolour, grow moulds, and are vulnerable to gases and insects. The dyes in colour photographs can fade, entirely altering their appearance. Where the mount is original, it can require different conservation techniques from those for the photograph that it contains.

Basically – there are two aspects to the problem: the conservation of the backing material on which the photograph is printed, and the 'photographic' layer, the emulsion, containing the chemicals that provide the image.

General atmospheric control
Air conditioning is advisable to provide a pollution-free atmosphere. When this is not feasible, provision should be made to include filters in the gallery. The display cases and/or frames should be sealed to make them dust-proof. The only exception to this being when nitrate films or negatives are shown, probably as part of a demonstration of historic processes. This type of film should be displayed separate from any other photographic material.

Temperature and humidity
These should be as stable as possible. At high relative humidity moulds can easily form on the paper on which the photograph has been printed, on the one hand, and excessive drying can make the paper-base and emulsion brittle. The temperature should be $19°C(\pm1°)$ and the relative humidity should be kept at less than 50% and above 40%. A higher level of humidity could result in the softening of emulsion and even in the growth of moulds on it. In colour photographs excess humidity could result in chemical reactions which would change the dyes.

Light
The conservator will impose rigid criteria for the display of original photographic prints. Daylight will be closely controlled or excluded, and the photographs will preferably be displayed in artificial light of 50 lux or less.

All light sources, whether natural or artificial, must be screened with ultra-violet filters. It is advisable for any case lighting to be fitted with dimmers to permit fine adjustment. Providing that the resultant heat can be dissipated, tungsten light may well be preferable to the conservator because ultra-violet light from the sun or from fluorescent light fittings produces detrimental chemical changes in the photographic emulsion and the base. It is not only the layers of albumen, collodion, and gelatin which carry the silver image, that are susceptible; the paper or film base can itself deteriorate as a result of excess illumination.

The conservator may also limit the length of time for which an original photograph can be displayed. This is especially the case where early photographs may not have been properly 'fixed' and early colour prints are particularly liable to fade. This may entail the designer including push-button or proximity switches in the local lighting circuits.

Original transparencies should never be projected although it might be considered acceptable to show them in front of a light box, providing that the fluorescent tubes are fitted with ultra-violet filters and that the front of the light box is of Perspex sheet of an ultra-violet excluding grade.

a

b

c

Mounting and framing photographs:
a) Mounted (as for a drawing or print) in a bevelled window mount
b) Traditional methods of mounting with photo corners or the corners fixed in slits in the mount
c) Grouping of smaller photographs (suitable for *carte de visite*) in a double mount system

Adjacent materials
Silver is the image-forming material in the majority of black and white photographs and this can be tarnished by volatile sulphur containing substances given off by certain materials. Such materials may already be present in the construction of the case and frame containing archival photographs. There is then a chemical conflict already present within the object itself.

The same risks are present in the proposed new display method. All the materials used must pass the conservator's silver tarnish test. These include the timber, proprietary boards, paint, fabric and adhesives. All must be tested and passed before being used for the making of a long-term display.

Painted areas within the show case could be the most dangerous, and oil-based paints and varnishes should be avoided in particular as they can contain oxidising or reducing substances. Painted areas should be allowed to 'cure' before the display is mounted, and a period of at least a couple of weeks should be allowed in the schedule for this purpose.

Old seasoned timber will be preferable to new. All bleached timber must be avoided, as there will be oxidising material present in the bleaching agent that has been used.

In fact few materials are likely to pass the conservator's most rigid tests, but this must not deter the designer from the need to arrive at a reasonable compromise. Glass, Perspex and acrylics are likely to be acceptable, while any material containing p.v.c. should be avoided.

The designer will wish to have tested all new materials that come on the market, to find what compromises are necessary for the creation of each display.

Original photographs must never be 'dry-mounted' on to card, but must instead be treated in the same way as a print or drawing. Acid-free card or acid-free paper must be used and the only adhesive used should be pure starch.

The methods and materials used in the mounting and presentation of photographs to secure good conservation may well affect the aesthetic appearance of the display. They will also demand the designer's consideration in relation to the overall budget.

Modern aluminium frames are generally approved by conservators. However, the designer will often wish to create new timber frames to suit the style of the photograph, and these can be made acceptable if treated with aluminium foil. This provides a sealed environment for the exhibit, isolating it from any pollutants in the timber of the frame.

Lighting

For uniform lighting effect in cases fluorescent tubes (i.e. Philips zero rated ultra-violet or other tubes covered with ultra-violet filters) are recommended.

Provided no heat is built up in the case, tungsten filament lamps may, however, be preferable, and dramatic touches and emphasis by highlighting can be achieved.

If original archival transparencies are to be put on display, with the agreement of the conservator, they should be sandwiched between sheets of ultra-violet filter with an even, back-projected fluorescent light behind. It is desirable that the light be fitted with a dimming device, and also that a push-button be added to reduce the amount of light to which the transparencies are subjected.

Mounts and frames

Window mounts
Photographs can be mounted in window mounts, with the bevelled edges to the photo, made from acid-free card. The photo is attached to the backing card with 'conservation' adhesive tape, or with the corners of the photograph secured by 'photo corners'.

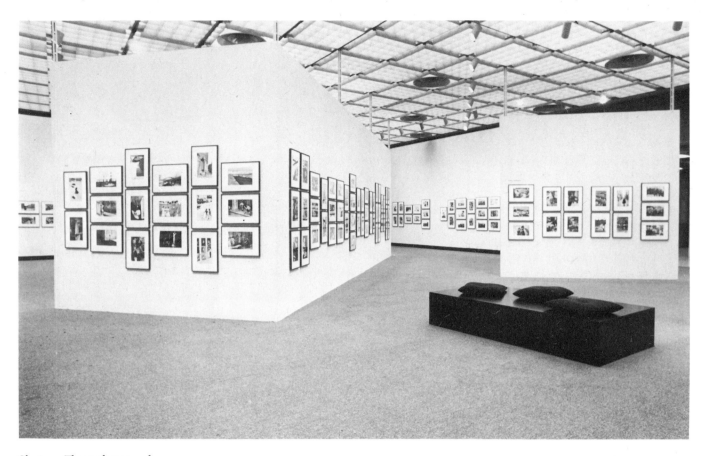

Clusters. These photographs are
individually framed, with mounts, then
grouped on centre lines, with several
patterns used.
Henri Cartier Bresson, Hayward Gallery,
London

Case display

Photographs can be displayed in a case, framed
individually, and fixed to suitable backing. A problem
arises when too many standard frames of the same size,
containing uniform photographic prints, are presented
together. The final appearance may correspond to a
picture book hung on the wall, with the pages lifeless
and repetitive.

Collective display

Photographs can be framed collectively; mounted
individually and then glazed together as a group. This
can be carried out in a picture frame or in the form of a
very slim wall case.

Backgrounds

These depend upon the type of display envisaged. For
an art exhibition, the colours and materials should be
chosen to create the atmosphere of an art gallery and to
evoke the period of the photographs being exhibited.

For an historical presentation, the backgrounds can
incorporate fabrics and wallpapers of the period,
accompanied by appropriate 'props' such as
contemporary newspapers.

Labelling

The problems of labelling photographs are similar to
those relating to drawings and prints. If individual
frames are used the label can be included within the
frame, overmounted upon the mount within the frame,
using acid-free paper or card, and appropriate
adhesive. Alternatively the label can be printed direct
on to the mount before framing begins.

When the label is placed on the wall panel
independently of the frame, this should be done after
'hanging' in order that the label will be clear of the
shadows cast by the frame. Labels can be made to
merge with the background by being produced on
material of a similar colour. Or it might be appropriate
to print labels photographically to match the technique
of the exhibit. Sepia toning or other tinting might be
appropriate.

Room settings and reconstructions

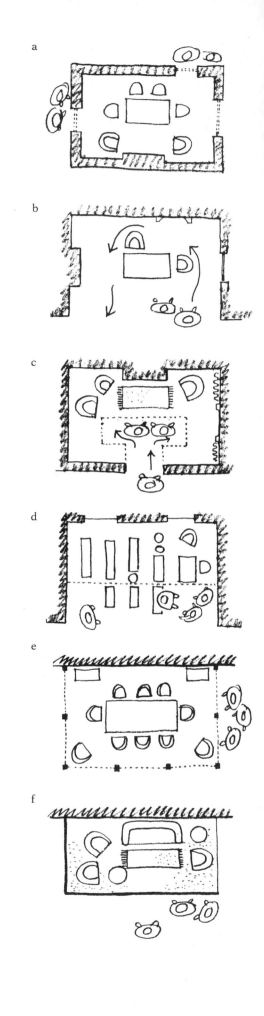

a

b

c

d

e

f

Introduction

A complete, furnished room set within an exhibition summons up atmosphere, epoch, and social history. It can be almost an exhibition within an exhibition, an element in explaining the design of interiors, furniture, perhaps an important 'chapter' in a biographical exhibition, or demonstrating the living conditions of an African tribe in an ethnographic exhibition.

The public have become used to visiting historic houses, where room, lighting and furniture are set in their original context. Museums may well find difficulty in competing with historic houses in this respect. Move the room to a gallery, with its relative lack of space, and the visitor is abruptly confronted by the room, in the midst of a 'museum-type' display. The thin 'walls' the designer is bound to introduce to save valuable space, make it difficult to smooth the transition across barriers of time, cultures, continents, and styles.

The introduction of a room setting into an exhibition brings an element of theatre. Many of the theatrical techniques are applicable, provided that the whole item can be incorporated smoothly into the style of the exhibition proper.

Presentation of information will be a problem if a complete setting has been attempted. A large number of practical and decorative items will be involved, and these must be keyed in some way to information about them.

Research

Curator and designer will have to decide early on how much of the room the public are to see. In a reconstructed room setting, the further that the visitor enters, the more complete the accessories have to be. A look into a window is one thing; to permit visitors to tiptoe over the threshold demands much more research and resourcefulness.

The successful creation of this kind of exhibit will involve much research. While the designer will rely heavily on the curator for guidance, it will be essential for him also to carry out his own research. Architectural details, the decorative arts of the period, furnishings, paintings, textiles, wallpapers, timber, finishes and lighting have to be 'right'. Time for this checking process must be set aside.

For an ethnographic exhibition, the designer will have to rely on the detailed fieldwork of the specialists, and will need photographic references of the interiors to be reconstructed, samples of materials, and even scrapings of colours.

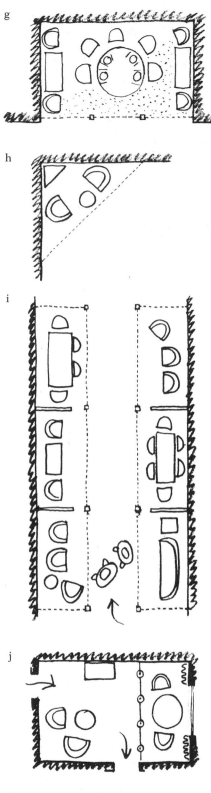

Plans of room-setting reconstructions with visitor access:
a) Looking inwards through windows
b) Walking through (with minimal furniture), posing no security problems
c) Viewing from a glass 'cage'
d) 'Half and half': glazed part of the reconstruction protects vulnerable objects with the other part available to visitors
e) Set against the gallery wall, glazed on three sides
f) The platform
g) Huge showcase, glazed on one side
h) The corner
i) The corridor of room settings, but with problems of reflections, if glazed
j) The 'walk through' with part roped off

Types of display

Types of room exhibits:

An original room taken from an historic house or palace and painstakingly reconstructed in a museum or exhibition, together with all its furnishings and furniture.
A 'simulated' room setting where the setting or original objects are copied from available reference and reconstructed in present-day materials to give a true impression of the original room.
A 'mixed media' setting where a background for original objects is merely suggested, by the introduction of present-day display techniques such as photographic enlargements, painted scenes or dioramas.

Security

Ideally, to recapture the original atmosphere of the room, the visitor should be able to walk through the setting, but the cost of warding such an exhibit may be prohibitive. Alternatively, at some sacrifice to the realism of the setting, part can be cased in. Some limitation of movement can be ensured by 'psychological' barriers, such as the raising of the level of the room-setting on a plinth, or alternatively raising the walk-way for the public. A rope, bar, or low wall may be sufficient if the character and behaviour of the visitors can be judged in advance.

Small items in the setting are important, and some may be treated as expendable. Otherwise they can be fastened down with adhesives, wire, or nylon thread, or even fitted to alarms. Pressure mats can usefully be combined with other methods of securing exhibits.

Lighting and conservation

Some of the items of original furniture or textiles in a room display will present conservation problems. In which case the normal conditions for the individual materials will apply. However, there must be consultation with a conservator, as almost certainly adjustments will have to be made based on individual items. In a display of mixed material there cannot be an overall compromise on conditions as the most vulnerable items could be damaged irreversibly. If the total area of the exhibition is not air-conditioned it should be possible to condition the immediate area of the setting. If this is done there will be a good chance of achieving acceptable levels of humidity (providing that the lighting installation does not dissipate too much heat). Portable humidifiers should be included in the scheme, either hidden from view behind pieces of furniture, or built into a wall.

Facsimile lighting

The lighting for the reconstruction will obviously be suggested by the method originally employed in the room (providing the level of lighting emitted is acceptable to the objects in the reconstruction), such as a naked light bulb in a simple Indian village house, or a chandelier in an eighteenth-century interior. Daylight, even sunlight, can be simulated by reflecting light from

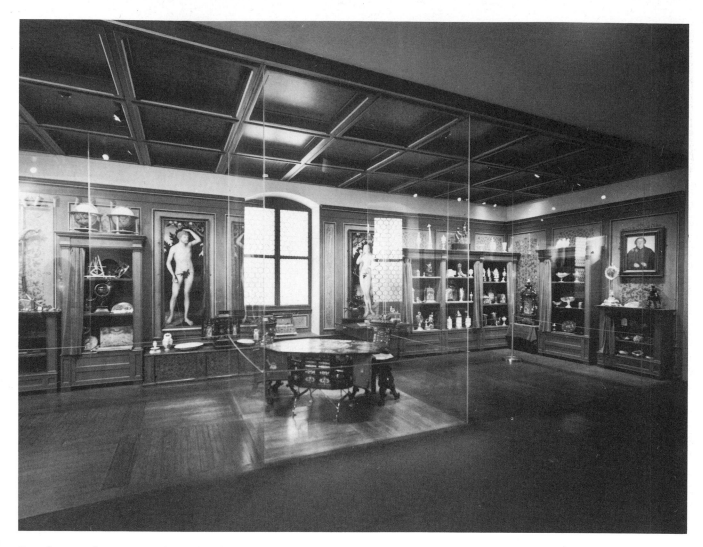

Kunstkammer: the visitor is admitted to the reconstructed room, but for security reasons relating to some of the objects, part is glazed, floor to ceiling.
The Splendors of Dresden, National Gallery of Art, Washington

floodlights mounted outside the room construction through the windows, or by converting the windows themselves into light boxes illuminated by fluorescent tubes.

However, if visitors are permitted to enter the reconstructed room there is a danger that any modern light source will destroy the illusion being attempted. Where the room is seen, as it were, through a proscenium arch, supplementary lighting can be directed into the room from fittings out of sight behind the fascia. A lighting track fixed there will give great flexibility in the choice of fittings, and their adjustment to the scene.

Practical sources of light should be used where possible – a simulated glow from the fire, or the skilful wiring up of original gas fittings and table lamps.

Display

In reconstructing a room setting the designer may need to employ a specialist scenic artist. Alternatively, the main contractor for the exhibition may subcontract this part of the work. An exhibition contractor will be able to find the skills within his own firm for building and decorating a traditional room interior, but the

building of a yeoman's house, a Viking's, or an African mud hut will call for additional skills and experience. These are the sort of skills that are normally called for in scene building for stage and television, where the right effect can often be achieved by skilful painting and modelling and tricks of light. The museum reconstruction receives closer scrutiny; the viewer may be only a few centimetres away and may even be able to touch some of the surfaces. A greater degree of 'realism' has to be achieved, the feeling and even smell must be convincing. One might call it 'the theatre of permanence'.

Some room settings consist of a mixture of media, some parts of the room construction being shown in graphic form, or by photographic enlargements, with authentic objects in front. Such a combined treatment is probably more effective when it forms part of the sequence of a 'story' exhibition, such as a biography.

Fireproofing
Another complication is that all the materials of the reconstruction, however true to the original construction methods, have to be fireproofed to the same standards as the rest of the exhibition. This demands great care, since, in ethnographical

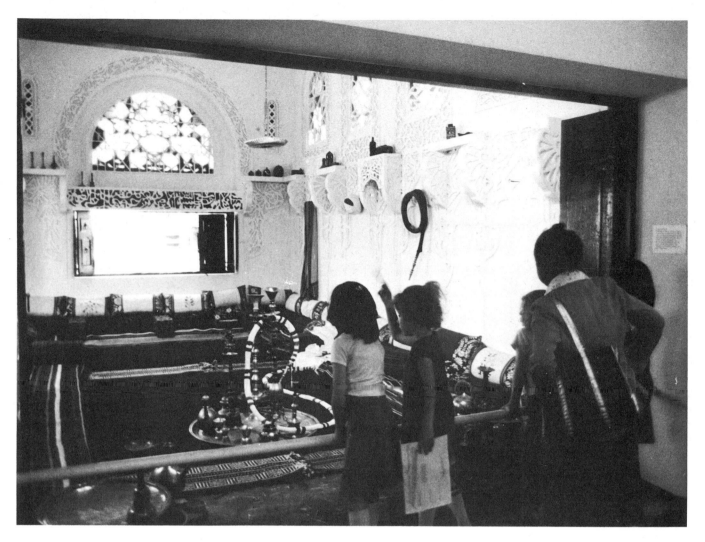

Proscenium treatment for this reconstructed *mafraj* from Sana, North Yemen. Lighting from external floods, reflecting 'bright sunlight' through the windows.
Nomad and City, Museum of Mankind, London

Half replica: the props are solid and original, the settle, fireplace, and mouldings painted in two-dimensional theatrical style. Lighting is by 'sunlight' through the window.
1776 exhibition, National Maritime Museum, London

exhibitions especially, grass and leaves and other vegetable material are there to create authentic touches. Fireproofing may well destroy their appearance.

Rooms with views

Rooms, European ones at least, may have more than one window and one door, and if a proscenium treatment is used for the reconstruction the visitor is likely to be faced with another opening at the rear of the display. Sometimes a door can be left ajar, with a partial reconstruction beyond. In the case of windows, the designer has to contemplate the manufacture of an artificial view beyond the window frame. For both door and window views, additional space must be allowed outside the room plan to give scope for manoeuvre when arranging the effects. If a room has been created with a complete 'dressing' of authentic furnishings and other props an obviously painted view outside the window will be discordant. To simulate the distance of landscape the visitor's eye lines have first to be accurately calculated, and there are many problems of colouring and perspective to be solved. It may, as a result, be as expensive to create the view as it was to construct the rest of the room.

Surprisingly, painting the view is not the only method that works. Although expensive, the use of large colour photographic enlargements, if carefully planned, may be more successful than a painted scene. Even a black and white photograph may be quite effective.

197

It may be possible to create the 'view' through the window solely with light. The window can be made as a light box, with fluorescent tubes behind a panel of opal glass. A surprising sense of distance can also be achieved by shining light on to a plain theatrical 'flat' behind a clear window, the flat being placed some distance behind. An amount of light that seems natural can then be reflected back into the room setting.

Figures

Designers and curators often debate the need for the introduction of figures into a reconstructed room setting. Unless the presentation of contemporary costumes is important there is a risk that immobile figures will do less for a simulation than an empty room which, in imagination, the occupants have just left and to which they could return at any moment.

Information

Historic houses usually have a guide in each room. The problems of warding, of imparting information, and of controlling the flow of visitors are solved in one fell swoop. The limits set to the time for answering questions can be used to empty a room before the arrival of the next wave of visitors. On top of this tight control, atmosphere can be added if the guides are in period costume, as in Colonial Williamsburg, Virginia.

Explaining the contents of an unattended room is rather more difficult. Curator and designer are likely to agree that labels and information texts within the reconstructed room would destroy the effect. It may, however, be acceptable to place panels of general information at the approaches to a room, or even at the 'forward' edge of the display area, in what might be termed a 'non-environmental' position.

Information panels

In a 'proscenium treatment' the room is closed to the public on three sides; on the fourth side, the viewing plane, the barrier can be adapted to incorporate sloping panels to take information, which can be read from the same viewing position. This is preferable to placing the information to one side of the viewing position, where it is hard to relate it to the objects. The information should, of course, be keyed to the exhibits to which they refer.

Portable information

In a 'walk through' reconstruction it is virtually impossible to key information panels or labels to exhibit items. Portable information will enable the visitor to pace himself, and to select the level of information that he needs. This can be in the form of a published guide, or a free printed handout sheet. Some museums adopt the paddle or 'ping-pong bat' form of portable label. Some supervision is needed with these to prevent them being removed from the gallery. Any tethering of the bats within the room, on the other hand, tends to destroy the atmosphere of the display.

Audio guides

If funds are available, individual portable commentary in the form of a sound guide is probably the best solution for 'walk through' rooms. The information can be substantial, drawing the visitor to consider objects that he would not otherwise view, and can include music and sound effects.

Recorded commentary from a loudspeaker is likely to be much less satisfactory than individual sound guides, even if it is only audible in the immediate vicinity and is controlled by push-buttons. The vehicle of information has to be seen as part of the reconstruction itself, anticipating estimates of visitor attendance, circulation patterns, and the bottlenecks and traffic jams that can occur.

Sound effects

There are problems in providing a number of sound effects by means of loudspeakers within a single gallery. Much of the sound finds itself into parts of the display where it has no business, irritating the staff through repetition and confusing the public by feeding them the wrong commentary.

If there is time and ingenuity, carefully phased sound effects and commentary points can be set off (and switched off) by proximity devices. These will require the most careful planning and 'scripting' but they make it possible for an imaginatively conceived reconstruction to evoke time and place without too much use of the printed word.

Maintenance of room settings

Reconstructed rooms need the same maintenance as real rooms in everyday use. Brushing down, sweeping and vacuum cleaning will have to be done regularly, and with great care, particularly in urban galleries. Floor cables put small furniture and bric-a-brac at risk, and therefore sufficient electrical socket outlets should be provided to reduce the length of run for cleaning equipment. The designer will have to devise camouflage for these.

Sculpture

Introduction

The first step in organising any display of sculpture will be to determine the size and weight of the pieces concerned.

Display problems can be classified by type of sculpture, whether the representations are carved or formed in the round or in two dimensions as reliefs. Much sculpture in museums and art galleries originally adorned buildings and this may be a factor to consider in its display.

Size, material, and subject matter can dictate the display method. Many galleries and museums will have been designed and built specifically to house a sculpture collection. Perhaps the display will be in a museum specially converted from a sculptor's studio. In general the permanent nature of the materials used for many sculptures – stone and modern bronze – may permit exhibits to be displayed in the open gallery, not enclosed in cases. Indeed, the sculptor will on many occasions have conceived the sculpture as part of a setting, and even if that setting is no longer relevant the designer would do well to study the artist's original intention. No exhibition of the works of a living sculptor should be conceived by anyone other than the sculptor, or at least the architect or designer working closely with the sculptor to understand the original intentions relating to siting, lighting, and adjacent materials.

Types of display

Open air

A landscape architect or gardener should be consultant in any team mounting a permanent sculpture exhibition. But a conservator should first advise on whether the individual pieces are suitable for display out of doors. For the temporary open-air show the task may well involve fitting the exhibits to existing vistas and settings. The screening of the exhibits from one another may stem from a collaboration between the organiser whose function will include the finding of sites and the designer whose brief will include barriers, signs, labels, catalogues and publicity material.

Specially built galleries and museums

The massive nature of some sculptures and their exacting requirements for natural lighting has resulted in many galleries specially designed by architects rather than by exhibition designers. The latter would do well to study the principles involved, which may well be applicable to temporary exhibitions too.

Mixed displays

In addition to being displayed in its own right, sculpture is often employed to enhance the architecture, exterior or interior, of museum galleries. Its positioning may be classical, e.g. pairs of figures or busts flanking doorways and staircases, to give the architectural features more prominence. Pieces of sculpture are sometimes incorporated into a 'story type' exhibition, into a biography, and mixed with displays of other material, paintings and cased exhibition displays. The decisions as to whether sculpture should be displayed in a gallery, in the open or enclosed in show cases, depends on size, material, and vulnerability. With the exception of reliefs, most sculpture should be seen in the round, both for full aesthetic appreciation and also for academic reasons.

Security and cases

The very weight of most pieces of sculpture fixed firmly to plinths ensures security. Smaller pieces in stone or metal can be securely fixed to their plinths and the main danger that the designer must cater for is wilful damage to the more vulnerable pieces. Prevention will be by good warding and therefore the layout of sculpture must be carefully designed to ensure that warding site lines are good and clear. The height of the exhibit plinth can raise the piece out of reach and a physical or psychological barrier around the base of the exhibit would serve to separate the public from the object itself. But this can present a design problem as the barrier can seriously detract from the sculpture. Small portable pieces of sculpture will usually be exhibited in cases.

While curators and designers will normally be at pains to prevent the public from touching sculpture, one of the groups of the most stable objects can, on occasion, be made available for the blind and partially sighted to touch. And the invitation to touch can provide the designer with as many problems as preventing them from touching!

Conservation

Sculptured objects are made from a number of materials, each with its own conservation display requirements: stone, wood, plaster, terracotta and metals such as bronze. Of these, stone will present some problems to the designer and conservator: the surface detail of marble and limestone will in time deteriorate owing to the action of sulphur dioxide in the atmosphere. This may determine whether exhibits are shown inside in air-conditioned or air-filtered museums or can be seen in an open-air display. Other types of stone can contain soluble salts which in fluctuating temperatures and conditions of humidity dissolve and later recrystallise at or near to the surface of the stone causing it to flake away, which in turn lead to a loss of detail in the original carving. Sculptures in this condition may well require environmental control within the gallery (an ambient temperature of 20°–23°C with the RH 39–45%) or will determine that individual items are shown in cases in their own controlled environment.

Danger from dust

Free standing sculptures will have to be dusted regularly as airborne dirt, if allowed to settle on stone objects, can discolour, obscure details and abrade the surface. Acidic dirt combining with moisture vapour in the air can chemically attack the surface of stone and bronze sculptures. The designer should ensure that the displays can be reached to be dusted.

Temperature and humidity

The intensity of heat from lighting is, in general, unlikely to present problems in the display of stone sculpture. However, the opposite is true in the case of wooden sculpture because of the inherent nature of the material. Warping and splitting can result if conditions for its display are not carefully controlled and monitored. The moisture content of different woods varies to some extent, and any change in the moisture content caused, for example, by heat from spot lighting can cause dimensional changes to the timber (more across the grain than along its length). A relative humidity level of 50% to 65% must be maintained constantly, and a constant temperature of 20°C should maintain wooden sculptures in a state acceptable to curator or conservator. In view of the problems of maintaining constant humidity levels, wooden sculpture is unlikely to be included in travelling or loan exhibitions.

Bronze cast sculptures will pose other problems for designer and conservator. All metal benefits from a dry atmosphere. Unfortunately the humidity level identified as the lower safe limit for moisture-absorbant materials such as timber sculptures (40–45% RH) is the upper limit for any bronze that is unstable.

Opposite page:
a) Contrapuntal setting. Figures freestanding on timber-topped plinths. Perspex covers encase smaller bronzes. Columns repeat the curve of the directional case plinth.
Giambologna: Sculptor to the Medicis, Victoria and Albert Museum, London
Designer: Ivor Heal

b) Neoclassical setting. Robert Smirke's gallery housing recent rearrangement. Tracked ceiling spotlights supplement daylight. Sculpture plinths are textured concrete each with sloped screen-printed labels.
Egyptian Sculpture Gallery, British Museum, London
Design: Robin Wade Design Associates

c) Sculpture spotlit, and isolated, with pose emphasised and modelling increased. The display is dramatic and heightens our attention.
English Romanesque Art, Hayward Gallery, London
Designer: Paul Williams

d) Dominating, set on a plinth and on a platform. As in Venice, visitors must move and climb to gain the various viewing angles.
Horses of San Marco, Royal Academy of Arts, London

e) Relationships: damaged sculpture, partially recreated by juxtaposing fragments on timber supports in edge-to-edge glass case. Bronze needing conservation, conditioned silica gel beneath the perforated base.
Horses of San Marco, Royal Academy of Arts, London
Designer: Alan Irvine

f) Rotation. The school party remains relatively still; the sculpture is revolved by the lecturer on its plinth (a device suitable only for warded galleries).
Centre Georges Pompidou, Paris

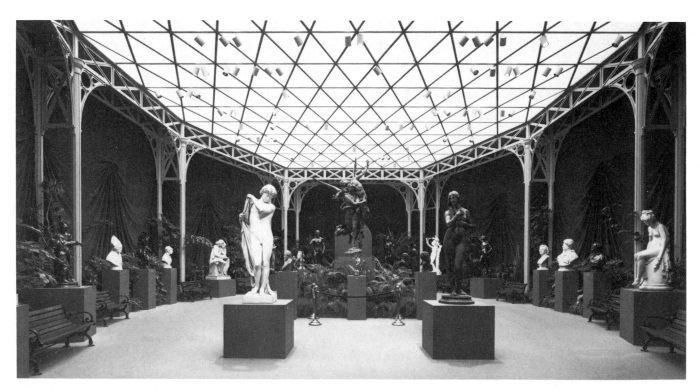

Replica 1870 'salon' built within a modern gallery. The ceiling is translucent and the triangular grid supports the spotlights to highlight the sculpture.
Rodin Rediscovered, National Gallery of Art, Washington

a

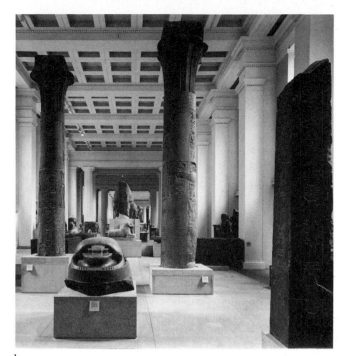

b

c

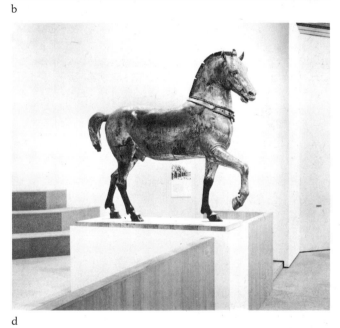

d

e

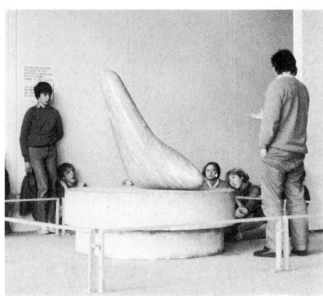

f

201

Accessible. Sculpture on textured concrete base on grassed terrace. Hirshorn Museum and Sculpture Garden, Washington

Distanced. Sculpture set in a square flower bed which acts as a barrier. Adjacent plants both compete and complement the exhibit. Picasso Museum, Château d'Antibes, France

Discreet description. The lion is a dominating image in a permanent gallery, while the label (an inset floor tile) has metal lettering set in a resin block. Nereid Room, British Museum, London

Ancient bronzes often have a heavy patina. Patina is formed by layers of corrosion, and this can still become active if the relative humidity is high, although bronzes with stable patinas can be safely displayed at 55% RH. So special cases may have to be constructed incorporating dehumidifying equipment for unstable bronzes within a display of mixed materials.

Air pollution generally and the effects on an exhibition within a mile of the sea can also cause problems for bronzes with unstable patina and so in areas where this might be a danger the bronzes should probably be displayed in cases.

Pests
Wooden sculpture will, like furniture, be prey to insects pests and fungi. Here the designer needs to be alert to the need for careful detailing of plinths and surrounding displays so that nooks and crannies can be easily cleaned and do not harbour foreign bodies.

The introduction of new timbers into a display must be checked to ensure that they have been properly treated. Old or reconditioned timber should be used with caution and should be fumigated under the supervision of the conservator before coming into contact with timber exhibits. Oak should never be used directly in conjunction with stone as it can cause staining.

Lighting

Except in the case of wood and painted pieces of sculpture, there is no conservation problem when lighting sculpture, so the designer can for once have a free hand.

Natural daylight
Daylight, with its changes in intensity and colour, is usually the preferred method of lighting sculpture, although summer light in Mediterranean countries will have a completely different effect to that of the light of grey northern winters. Many modern galleries provide for directional daylight to illuminate the exhibits and this directional emphasis is often backed up with additional spotlights even during daylight hours. The modelling of sculpture with light must be attended to most carefully.

Artificial light
Spotlighting is usually most effective when the light is coming onto only one side of the object, but the shadows effected should be studied to ensure that they do not detract from the modelling. Directional lighting is a problem when objects are seen in the round as the visitor will inevitably encounter direct glare.

Lighting reliefs
Reliefs, very shallow carved panels displayed on walls, are usually best lit with continuous fluorescent tubes, corresponding to the length of the relief and placed above the exhibit. In a low room this lighting can be incorporated in the ceiling, and if the ceiling is high, fluorescent lamps can be mounted behind a pelmet fixed close to the wall and above the exhibit.

Reflectors will probably be necessary to deflect the light on to the object alone and away from the surrounding wall. These should be custom-designed. One problem with relief sculpture on fairly deep pieces of stone is that the edge of the stone will cast a shadow on to the wall below. If this is likely to detract from the sculpture itself, the relief sculpture should be recessed into the wall or panel on which it is mounted. The higher the relief of the carving the less acute the angle of lighting need be. The optimum angle can probably

only be determined by experiment rather than on the drawing board. In a long length of relief carving, lit by fluorescent tubes, it may be desirable to introduce some additional lighting by tungsten lamps to emphasise particular areas and details of the work.

Detailed display considerations

Weight

The major consideration in any display of sculpture is whether the specially designed base or plinth will be strong enough to support the piece and whether the existing floor will be able to support the combined weight of plinth and exhibit in particular areas. It is also essential to check that the permitted floor loading is sufficient for the whole exhibition, and whether the floor loading permitted on the route, by which the exhibits are brought to the gallery, is adequate for the purpose (this is easy to overlook!). If there is any doubt, the designer must take the expert advice of the structural engineer responsible for the building, the stone conservator and masons. They will be in a position to make accurate calculations. If the floor loading is insufficient to take the immediate load of a piece and its plinth it may yet not be ruled out of the exhibition. The structural engineer may well be able to advise on a method of spreading the point load over a greater area of the gallery, or even to provide additional support from below the gallery floor. It is, of course, essential to remember that all floor loading calculations must take into acount the weight of the maximum number of visitors to the gallery!

Plinths and bases

Unless the original sculptor has arranged the base as an integral part of the sculpture, attention must be paid to the support for the exhibit. The base, plinth or bracket must be of material, size and proportion to enhance the exhibit rather than detract from it. It is worth while looking for any historical photographs or references that provide authority for an attempt to re-create the atmosphere of the period concerned. Although each piece has to be considered on its own, in designing the support, the variety of materials used in the gallery must be carefully restricted to provide a unity throughout the whole display and to avoid taking attention from the sculptures themselves.

There are problems when a number of pieces have been assembled from several different collections to form a temporary exhibition. The bases will be even harder to rationalise than a variety of picture frames. The cost of remounting the pieces will usually be prohibitive, even if the lenders would agree. However, it may be possible to mask the existing bases in a uniform way, by bedding them in loose marble chippings, for example, or dry, salt free sand or by facing each plinth in timber.

Missing pieces

Ancient pieces of sculpture are often in fragments, and some of them may be missing. It can be necessary to display these, both as archaeological evidence and for aesthetic reasons, in their (assumed) positions.

Blending: mounted in a shallow pool, with sunlight reflected onto the sculpture, which is partially reflected in return. The effect perhaps requires Mediterranean light.
Maeght Foundation, Saint Paul de Vence, France

One method is to place the pieces upon an outline or shaded shape of the assumed whole, with a conjectural indication of what has been lost. The reconstruction can be carried out three-dimensionally, by suspending or supporting the pieces in relation to each other, with the supports being reduced to a functional minimum, or by designing an overt support system of a material entirely different in character from that of the exhibit.

Labels

As most sculpture is displayed outside cases in an open gallery, or in the open air, labels will have to be in keeping with some element of the display, the exhibit itself, its base, or the surrounding floor area.

The label may have to be angled to facilitate viewing and unless it is made from a non-reflective material it may be difficult to read, for in dramatically spot lighting the object the label will also be brightly lit.

Stamps and banknotes

Introduction and types of display

As far as conservation and lighting are concerned, the display of stamps and banknotes has much in common with that of prints and drawings. In effect, stamps are miniature prints; banknotes are also like prints but, like many original drawings, are worked on both sides of the paper. Stamps, which come in many shapes and sizes, are frequently displayed unused in large numbers on sheets, as printed; many stamps are shown on the envelope on which they were used and franked; with the stamps are often displayed the sketches and artwork of the philatelic artist who prepared the designs for printing.

Displays of stamps and banknotes appeal to the experts and the amateur collector, and are not usually geared to the casual museum visitor. Those well informed will want to be able to refer to vast numbers of stamps, and therefore most stamp displays are basically storage collections. Much of the collection will be stored in albums, and the displays will have to cater for the presentation of album leaves.

Cases

Any case for stamps and banknotes must offer access to the visitor who wants to view the specimens at very close quarters. Many of the specialist visitors will be using their own magnifying glasses. While fitting in the maximum number of exhibits maximum security has to be maintained, and many display fittings include secure storage, built below the viewing area.

In theory both banknotes and stamps can be viewed in conventional table cases. For banknotes this is completely practical, but for stamps, the sheer numbers involved make vertical storage and display a better solution.

There are two commonly used forms of casing for stamp collections. In one, the exhibition cabinets house glazed pull-out frames providing double-sided display, each leaf being capable of being pivoted to give a full frontal view. The other method is the wall-mounted 'book leaf'. Several double-sided panels are hinged at a single point, effective, but wasteful of space. However, this is the best method of viewing both sides of banknotes if duplicates do not exist. Another method of display brings the stamps to the viewer. The visitor sits at a display console, from which point he can call up the items he wishes to view.

The sizes of all display areas and modules, and those for storage also, are determined by the stamp album sizes. The designer should check that everything he is called on to house uses the same standards. The manufacture of the cabinets is, of course, precision engineering. The sliding and pivoting mechanisms must accommodate the weight of the display leaves. It must also allow for a considerable load from an enthusiastic young visitor! Timber is prone to warping, and high grade steel should be used in case construction.

Security

Stamps and banknotes are small, portable and valuable. Security has to be rigidly maintained. Cases and frames containing stamps and notes on display have to incorporate laminated glass, or a sandwich of glass and perspex in front of the exhibits. Glass alone is not adequate; it has been known for an individual stamp to be removed from a display with a glass cutter. Stringent warding of such collections is essential and the designer must make certain that all sides of the cases or screens involved are easily visible.

Conservation

The ideal condition for the display of stamps will be with light levels limited to 50 lux, all the fluorescent light sources being screened to exclude ultra-violet light. Temperature should be kept within the range 15°C–18°C and the RH 50%–55%. Any drop in the humidity may make stamps curl slightly, for the backs of unused stamps are coated with adhesive which reacts to changes in the atmosphere. Stamps from tropical countries are coated with gum arabic, which with dry room conditions can crack, involving possible damage to the paper of the stamp. To avoid such problems the conservator usually removes all the gum from the backs of stamps so that the printed paper alone is displayed.

All mounts and backing sheets for stamps and banknotes must be 100% acid-free.

Mounting individual specimens:
a) Each miniature polyester (melinex) wallet which is stuck to
b) a backing sheet or album leaf, which in turn can be fixed to the display board by means of 'strip' corners

Convertible: storage to display. Glazed metal frames precisely engineered, each panel lit, in use, from light box overhead. Security and conservation are ensured in storage mode. National Postal Museum, London

Access: the collection is indexed on vertical panels, mounted between the frames. Each sliding frame is numbered. National Postal Museum, London

Lighting

A good even light is essential for the viewing of stamps and banknotes. Most collections are of a study nature, the whole room area being involved, and therefore the room light has to be evenly distributed. Diffused fluorescent lighting directly over vertical display cabinets will provide this, provided that the tubes have been treated to prevent the emission of ultra-violet light and that the level can be kept down to 50 lux. Attention to colour rendering is essential and therefore care must be taken when selecting the type of fluorescent lamp to be employed. It is advisable to fit dimming devices in the circuit so that the correct level can always be maintained.

Many stamp designers now work with original transparencies and overlays, rather than with artwork illustrations. When these are displayed together with printed stamps two sorts of lighting are involved within the case, the transparency being back lit without generating any heat and the stamps being surface lit. On occasions this can be achieved by the introduction of fibre optics.

Detailed points of display

The obvious and well tried method of attaching stamps to their backing sheets is by the use of stamp hinges. With the development of conservation materials other more sophisticated methods are now employed. Each individual stamp can now be in its own transparent polyester wallet, which bears an adhesive strip for fastening the wallet to the album leaf. In turn, the whole leaf can be placed in its own polyester protective wallet, which is then fixed by its cover or by an adhesive strip to the backing board of the display frame. Envelopes can be treated in the same fashion, or

fixed to the backing board by means of corners made from 'Melinex' strips. Original artwork in the display brings many problems. The boards used by individual artists can be heavy and vary in size, destroying the uniformity of the album leaf display. Fixings can vary, but corner fixings are common, as with mounted manuscripts.

Labelling

Stamp display is very traditional, each stamp bearing its legend underneath and centred. The heading to each album sheet calls for the skill of a book designer, so dense are the exhibits and so detailed the patterns on them. The designer has to give thought to the clear labelling of the displays in the cabinet, and the problem of siting the related index nearby. It must be remembered that a few users studying such detailed material and checking related entries in an index can easily clog the gallery unless attention is paid to the positioning of both exhibits and indexes, and other sectional information.

Approved mounting. Each glazed metal frame contains an acid-free paper backing sheet. Stamped envelopes in the collection are attached to it by 'melinex' corners. National Postal Museum, London

Flat textiles

Introduction

'Textiles' covers a wide range of objects found in museums, in many sizes and shapes. 'Flat textiles' range from huge tapestries to small pieces of lace and include what we call today 'soft furnishings': curtains, quilts, carpets and rugs, together with flags, banners and church furnishings. The term 'shaped textiles' covers costumes, uniforms, and many costume accessories.

Both flat and shaped textiles are found in a variety of different fabrics: wool, silk, linen and cotton, for which the conservation and mounting requirements will vary considerably. Fragments of embroideries and lace will require special treatment, sometimes being mounted and displayed flat, and sometimes specially supported as three-dimensional textiles.

Types of display

Flat textiles can be shown either in context in an actual period room setting or simulation, or treated as an object in isolation, but displayed on the same plane and at the same height as in its original usage, i.e. horizontally for floor coverings, vertically for tapestries.

However, rugs and tapestries are often treated as works of art, away from their original context in order that their pattern and quality can be emphasised by isolation.

Depending on their size, textile fragments are often mounted and treated as though they were framed paintings or prints. For 'lengths' of fabric the conservation requirements may dictate the display method. Draping cloth for a lengthy period may not be possible as it subjects the material to tension and other strains. Often the area of pattern or texture to be displayed will occur within a small area of the textile, and the balance of the fabric will therefore have to be masked or hidden in some way.

Large collections of flat textiles will take up excessive wall space and the storage type of display may well be the solution, giving the public access by means of standard stacked screens on runners or hinged.

Where material is replaceable it is possible to use it to create an exciting display of contemporary fabrics, showing a complete range of colours, weaves and patterns. Shop window displays have accustomed the public to such bold, draped, almost sculptured forms. Perhaps the museum on occasions will feel able to treat the lengths of fabric as 'sacrificial' objects, enabling the visitor to enjoy them more intimately and intensely.

When a textile fragment is displayed in a show case with objects of other material it may be necessary to isolate it for reasons of conservation.

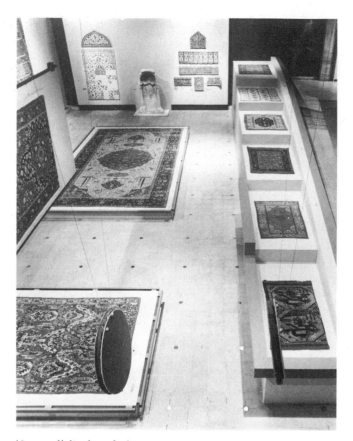

'Stepped' display of Islamic carpets, seen here from a balcony, height enabling comparisons. A strong timber edging to the plinths provides a psychological barrier.
Arts of Islam, Hayward Gallery, London
Design: Michael Brawne & Associates

Security

When rugs or lengths of textiles are displayed in the open their method of mounting must itself provide the physical security; they must be so attached that they cannot be removed or even disturbed. Further, a psychological barrier can be created by mounting carpets and rugs on plinths or on shallow easels.

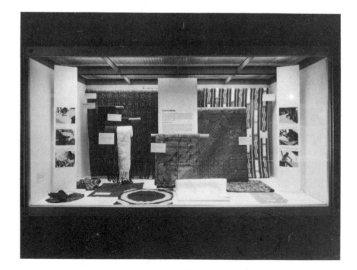

Suspended: lengths of textile rolled on p.v.c. rain-water pipes, bamboo rods projecting at ends, hung from underside of case tops by nylon wire.
African Textiles, Museum of Mankind, London

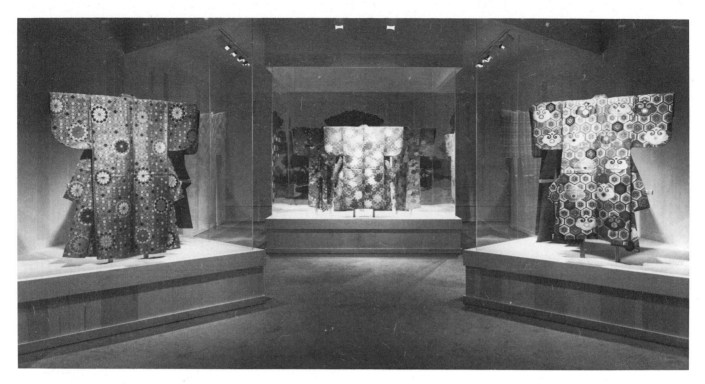

Form and formality: Japanese kimonos supported on traditional timber stands. Each one is given plenty of space in generous full-height cases.
The Tokugawa Collection, National Gallery of Art, Washington

'Wigwam' arrangement. Against a wall hung with textiles, more are draped on open display, from bamboo structures lashed together with rope.
Indian Master Weavers, Royal College of Art, London
Designer: Ivan Chermayeff

Bays: these quilts are hung against panels, forming alcoves in the exhibition. Sloped 'barriers' in front carry information panels (lettering is large, the visitors need not bend).
Irish Patchwork, Somerset House, London

Identity tag: the label knotted to the structure identifying each length of cloth.
Indian Master Weavers, Royal College of Art, London

Conservation

Textiles in any shape or form provide the designer and conservator with many problems because they are among the most vulnerable exhibits in a museum. Dangers are posed by light, humidity, dust and pests.

Light

Textiles are extremely vulnerable to ultra-violet radiation in light and the natural fibres of wool, silk, cotton and linen will all be weakened. When, as in most instances they are, dyed with natural dyes they will fade if exposed to daylight or strong artificial lighting. Exposure to light results in the weakening even of man-made fibres.

Natural daylight presents the greatest conservation hazard. The variation of illumination levels in daylight is particularly difficult to control and artificial light is usually chosen for textile displays, for although some lamps emit ultra-violet radiation it can be more easily controlled because the level of illumination will be constant. Illumination of not more than 50 lux is recommended. Ultra-violet radiation must be eliminated from all light sources. Some artificial light sources – most tungsten lamps (but not tungsten halogen) and a few fluorescent lamps such as Phillips 37 – emit so little ultra violet that screening is not necessary. The conservator will wish to meter and monitor the ultra-violet emission from any other lamps, which must be kept below 75 microwatts per lumen. Anything above this level will require filtering. Although most tungsten lamps have a low ultra-violet emission they do have a light–heat output which must be dissipated. The designer may have to accept the inclusion of electric fans in the gallery to increase the movement of the air.

In areas unavoidably illuminated with natural light the levels must be reduced by the use of curtains or blinds and the treatment of external windows with ultra-violet absorbing varnish or additionally fitting screens of ultra-violet absorbing perspex.

Temperature and humidity

The display should be mounted in a well-ventilated atmosphere where the relative humidity is maintained at a level of 55% ± 5% with a recommended temperature of 19°C ± 2°C. Unless these conditions are achieved there is a danger of the textiles being vulnerable to moulds or fungus attack if the RH rises above 65%. Below 40% the textile fibres may become brittle.

Dust

Dust is a particular problem with large areas of textiles on open display and if the exhibition gallery is not air-conditioned or fitted with an air-cleaning system the designer will have to take precautions to prevent or minimise airborne dust from settling on the carpet. All air intakes, ventilators or windows will have to be fitted with dust filters.

If the exhibition is on a direct route from the street, visitors will bring in dirt and traffic fumes. A double set of doors to the room containing the display, forming a lobby, can be fitted with a 'dust-trap mat' which should reduce the number of dust-particles entering the room.

Use of Perspex over a textile is not ideal as the electrostatic quality will attract dust in the atmosphere and this will transfer to the exhibit. But antistatic polish can be used to reduce the electrostatic quality and the conservator may prefer the use of Perspex coverings rather than leaving the textile on open display.

Pests

The conservator will be alert to the possibility of attack by pests, such as moth and carpet beetle. The designer can assist in this vigilance by ensuring that the display is designed with ease of maintenance in mind so that there are no nooks and crannies to harbour pests, the objects are isolated in frames or cases and doors and windows are kept closed.

Lighting

For both flat and shaped textiles a low level of lighting is required for conservation reasons. Fluorescent tubes used in showcases in the museum or in overall illumination should be checked for ultra-violet radiation emission and be controlled by dimming devices to reduce the lighting level to that advocated, 50 lux. Low-level tungsten lighting can be used as the ultra-violet rays it emits are low enough to be acceptable. Provided also that light levels are carefully checked, and heat dissipated some spotlights may be possible in a textile display. Where textiles are displayed with other material requiring more light, the textiles will have to be isolated, either by screening them from the main exhibition lighting, by judicious placing in the gallery or by providing curtains or push-button switches to the case, limiting the light to the periods when the case is being 'used'.

Some embroidered fabrics, filigree or lace, are difficult to appreciate using front or top lighting and the intricacies of the patterns and techniques may be seen to greater advantage if back lighting is adopted. The overall spread of light is best achieved with fluorescent tubes spaced evenly, and sufficiently far behind a sheet of opal Perspex to prevent the shape of the tube being visible from the front of the display. The textile should be mounted either on this sheet of Perspex, or on to a sheet of clear Perspex in front of the light box and behind normal glazing. This would be advisable anyway because of dust attractions by Perspex. It is advisable to fit dimmers to the tubes to ensure achieving the 50 lux level or even lower levels that may be required by conservators.

Mounts and supports

Carpets and rugs displayed flat in the open gallery are too vulnerable to be walked upon. However, if the exhibits are raised slightly they are separated from the 'walking area' and their pattern can be featured displayed more clearly. The degree of angle of the mounting board surface will depend upon the strain that each individual exhibit can tolerate.

If exhibits are hung they must never be fixed with nails or pins, but should be suspended by means of a

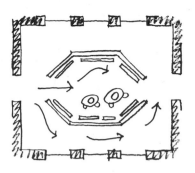

Plan of a textile display in a daylit gallery, a 'room within a room'. Textiles displayed on the inner faces of screens, in a lower illumination level

Above and right:
Framing textiles. The textile fragment is sewn to a fabric backing which is then fixed to a backing board. The glass is kept away from the exhibit. Plan view, above right, of frame corner and, below, section through

Below:
Hanging textiles and labelling methods:
a) Textile suspended from pole with label attachment and labelling device for a wall-hung textile (plan view and section)
b) Textile with attached fabric loops, and attached to batten, with Perspex cover to protect fringe

strip or looped tabs sewn on to the textile, or even better, forming a complete lining to it. Through this sleeve fixing rods can be threaded with care. Such an arrangement can be a positive feature in the display.

If a visible fixing method is undesirable, fixing can be by strips of contact fastener, such as 'Velcro'. One strip can be sewn to the back of the textile exhibit, and the other fixed to a batten on the wall or display panel.

Small fragments of textile – lace, embroideries, etc., can be displayed framed. The textile should be sewn on to a fabric backing, such as linen. The exhibit should not touch the glass, a narrow fillet of wood being fitted inside the frame as a spacer.

Lengths of fabric, if too long for inclusion in the case, can be partially rolled onto a wooden dowell, plastic drain pipe, or bamboo rod and then suspended. The support will need to be approved by the conservator.

Labelling

Labels can never be pinned or stapled to textiles. The conservator may allow a strip of 'Velcro' fastening to be sewn to the edge of the fabric. The graphic designer can then provide a printed or lettered card label with 'Velcro' strips attached to its back, which can in turn be connected to the strip on the exhibit.

Sometimes a number of textiles have to be grouped together, butted closely, and leaving no part of the supporting panel visible. However a slender metal bracket can be attached to the wall panel or behind the textile, and brought out discreetly between the two adjacent selvedges, at the point where the two exhibits are butted together. The bracket can then be turned a few inches out from the textile to provide the support for the labels, which will then appear to float freely in space.

Some labels can be mounted, where space permits, on the floor of the case or the gallery floor itself, independently of the supports used for the exhibits.

The labelling of framed textiles will present similar problems to those arising with the identification of framed drawings or prints. Care should be taken to see that shadows cast by the frame itself do not interfere with legibility.

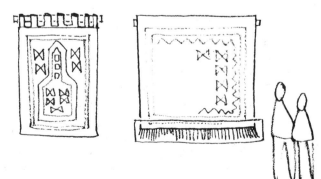

Toys

Introduction

Most toy museums form a record or recall of childhood, but others, museums for children, are designed to increase and extend the range of play experience of the child visitors. There is one such in Brooklyn, USA, and one is being created in Britain.

Since toys are designed to reflect a whole world in miniature, every conceivable material will be involved, a true test of design and conservation skills. The main task for the designer is to adapt his ideas to a miniature world of exhibits and a range of miniature visitors.

Some toys are intended to entertain only, some inform in passing, and some are overtly educational. Such emphasis may provide the curator and designer with natural groupings. The primary users of a toy display will be the users of toys, children through the whole school age range. A second audience will be nostalgic parents, and a third audience, social and educational historians. The main audience dictates the scale of the display, to which the adult audience must adapt.

A toy collection may sometimes provide a touching part of a biographical or historical exhibition. For example, the toys of the children of Queen Victoria at Osborne.

Generally speaking, adults look for a rationale in a museum, whereas children are familiar with jumble!

Cases and security

Many toys will be completely unique, some having been produced in very small numbers. Such must be completely cased and secured.

Children will seek complete access, but if touching the exhibits is denied them, small cases with access all round, or the provision of plinths and steps to adult-sized cases, will all help.

The eye line of the cases must be low for the age of children catered for. Perhaps the designer can devise dual-height cases, bearing in mind, however, that steps, ledges and plinths provided for the children can often be lethal for adults.

Conservation

A few of the exhibits will be from manufacturers collections, in pristine condition, but most will be well worn. Some unique specimens may be the subject of partial restoration and extra support.

Rare pieces cannot be handled, and yet a toy museum where nothing can be touched is unthinkable. If the rare exhibits are protected thoroughly, a secondary collection of 'spare' toys, known by the Americans as a 'sacrificial' collection, will maintain healthy interaction with the prime audience.

The conservation needs of toys are as important as for any type of material, but are often very complex due

Double vision: row of low-height cases with sloped glazed sides, enabling both children and adults to view the display of historic toys.
Nordic Museum, Stockholm

Multiple access: these circular cases are fitted with a step on which the children can view the displays (adults remaining on the gallery floor).
Toy Museum, Stockholm

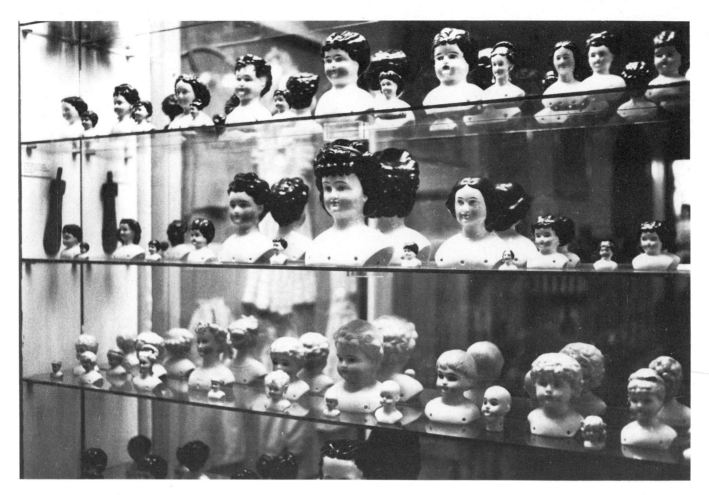

Plethora: a collection of dolls' heads set
on glass shelves, against a mirror
background. This multiplies the bulk of
the display (and visitors' interest).
Toy Museum, Stockholm

to the many different types of material in any one toy. Many toy museums will be lightly funded, but advice must be sought from area conservation services before displaying such vulnerable material.

With a number of small objects, maintenance will be time-consuming. But it is necessary to avoid infestation and dust, and the designer should organise the best possible access to all cases.

Lighting

Ideally the rare examples should be isolated for low lighting, since many of the materials used are vulnerable, dolls' clothes in particular. Otherwise, good light is required for clear visibility, including detail.

Backgrounds

If space and props permit the designer may consider placing the toys in reconstructed or facsimile nurseries of the period. A study of room settings of all kinds will suggest possibilities.

Photographic backgrounds of the period will increase the pleasure of adults, though it is doubtful if children will 'read' them together with the toys in an adult fashion.

Contemporary toys are sometimes displayed to adults to induce them to buy better made and more instructive toys for their children. This demands a completely different treatment.

Information and labelling

Dating and some history will be needed for the nostalgic adult, or one answering the children's questions. Information for more specialised visitors might be better separated from the labelling system into optional information panels or catalogues.

211

Subject exhibitions

The designer working on an exhibition of a collection of objects that are substantially alike will evolve his own method of display or will elect to use one generally accepted. Whether large or small, dull or shiny, the uniformity of the objects can provide a certain degree of uniformity in the display.

To design an exhibition displaying a *subject* is quite another matter. There will be a different factor in the arrangement of the exhibition. Primarily the scheme will be based on editorial rather than aesthetic considerations. Here a number of objects which may be quite unrelated in shape, size or material, will have to be welded together to illustrate a coherent story. For example: a manuscript letter, a bronze cannon, a uniform and a stuffed bird may all have to be juxtaposed to make a single and precise point. Often this juxtaposition will produce problems of design and conservation over and above those of displaying the individual objects concerned.

Alternatively the subject to be displayed in an exhibition may have few original objects in it, or none. The academics concerned are trying to put over processes, or even concepts; this sort of approach will often be appropriate in areas of technology and science.

The steps by which a designer organises the research, design and construction of an exhibition are much the same, whatever the subject. One must assume, however, that there is a 'best' way of tackling art, history, or science and technology. To find out the design approach that is most appropriate one must have a clear idea of each subject, of course, but also an understanding of how it relates to the other subjects to which the visitor may try and relate it.

Analysing the subject area

One method is to group the related topics and their subsidiary topics and interconnections into some form of diagram. This may be best as a topology in some instances, a network diagram in others.

Regardless of the final merit of the particular representation that is used, its construction and commitment to paper will help to clarify the assumptions of the presenters. The curator and designer will have seen and agreed the location and connections of the subject areas, and also considered how they relate to the departmental functions within a museum.

Identifying the audience

This charting of ideas will not only secure agreement between the members of the exhibition team, it will also enable them to agree their assumptions about the visitors for whom they are catering.

Such a diagram would become a 'map' on which two areas have to be identified. The first area will contain the answer to the question, 'where is our proposed exhibition on this chart?' and the second will indicate where, on the chart, is located the knowledge about the subject of the exhibition topic (and related subjects) which the average visitor is likely to possess.

An essential separation

One could see science and technology as separate entities. This separation is not usually made in 'science' museums, where often the artefacts left behind by technology and medicine are displayed together with the scientific theories which made them possible. Whether to make this separation in an exhibition is obviously a critical one, and determines the whole approach from the earliest stage.

Science, in the dictionary sense, is knowledge. This knowledge will range from the most neutral collection of data to the theories to which they give rise, some proven, some still speculative.

Technology tells of the application of the theories to the way we change the world, through the products of industry; and ourselves, through the techniques of medicine.

Whether science and technology are grouped together will vary from one exhibition to another. If and how are very early decisions in the strategic planning of the exhibition team, and essential in the designer's brief.

There follow examples of the problems of combining objects of differing kinds, showing how the type of story-telling required by the curator may affect the strategy that the designer employs.

The sorting out of such 'stories' and the grouping of the units of information are considered on pages 45–49.

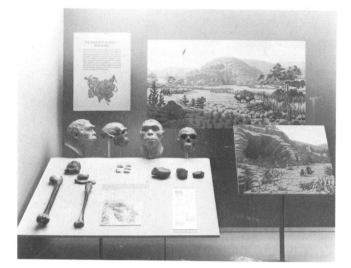

Mix: display in wall case devoted to
Peking Man. An assembly of objects,
reconstructions, of both landscape and
inhabitants.
Hall of Asian Peoples, American Museum
of Natural History, New York

Overview. An archaeological site as
exhibition, with a walk-way over the
excavated mosaics; its barriers support
information panels over the floors
concerned.
Roman Palace and Museum, Fishbourne,
Chichester

Slice: an effective explanation of strata.
A photographic reconstruction of the
different layers excavated with adjacent
miniature portraits of the emperors of
corresponding periods.
Roman Palace and Museum, Fishbourne
Design: Robin Wade Design Associates

Evidence: the archaeologist's drawing of
the excavated ship burial.
Photographically enlarged, it forms the
background to the objects found on the
site.
Sutton Hoo exhibition, Statens Historiska
Museet, Stockholm

Archaeological exhibitions

Introduction

Many museums contain archaeological displays, and often there are archaeologists on the staff, yet the displays are usually neither exciting nor clear, and have helped to confirm the stuffy impressions of museums. Such failings, not the result of lack of thought or concern, arise from the wide range of material to be displayed, and the necessary explanation to be incorporated. The more recent the age of the objects excavated the more documentation exists as to origin and function, and the more familiar the material will be to the visitors. But the material from prehistoric sites may be slight, fragmented, and only meaningful to the specialist or well-informed visitor and this poses acute problems of presentation for the general public.

Another major problem concerns the provision of information; in archaeological exhibitions often the material when assembled appears encyclopaedic, giving the visitors acute problems of selection as they try to extract the story and allocate their attention between the displays. They will be reliant upon the exhibition organiser and designer to provide a clear and accurate 'menu' from which they can make a quick and satisfactory choice.

Organisation by chronology

It is useful to consider how archaeological material may be grouped by the curators in a museum. The earliest section will be *pre-history* (sometimes referred to as 'text-free archaeology') where, in the absence of documentation, the only evidence of 'early' man is from material remains alone. The next section, known as *proto-history* (or first history) starts where some corroborative documentation exists, as well as human traces and artefacts. This is the area and period of classical archaeology—that of Greece and Rome—and is usually taken as ending in the year AD 476. The third chronological section is *mediaeval*, and in this section the archaeological material may be accompanied by contemporary pictures and written information.

Even more material is available to aid the explanation in the period of *modern history* (from the fourteenth century to the present day), because much of the material, the technology, customs and processes, will be related to the experience of the visitors to the museum.

A further section, much developed in recent years, is that of *industrial archaeology*. Although substantially concerned with the machinery and processes of the Industrial Revolution, displays will often incorporate material from the medieval and even earlier periods.

Display problems

Museum exhibitions are not now an automatic choice for presenting archaeology. In the last twenty years archaeology has been explained more and more through the medium of film and television, and while asking whether a museum exhibition is always the best means of putting forward the story, one should take another look at what a museum exhibition is, in particular how it serves this subject area.

A museum exhibition (as opposed to a purely 'study' collection) uses objects to explain ideas. There is usually a comfortable ratio between the number of objects displayed and the amount of accompanying argument in text and diagram form.

Where objects are intrinsically attractive the curiosity of the non-specialist visitor can be easily aroused, the amount of explanation offered can be correspondingly less, and more easily accepted. Such an exhibition can be thought of as 'object based', with material and explanation evenly balanced.

In the display of the earliest archaeology, the material is usually minimal. Often there are no artefacts, merely traces, and the ratio of objects to explanation has been considerably reduced. The visitor is being asked to turn detective, without the sensitivity or training of the professional. It is in this area that television has served archaeology so well, the viewer being faced only with fragments, traces, minimal clues, but accompanied by a guide, philosopher, and friend!

Strategies for archaeological exhibitions

Archaeology has been defined as the study of mankind through material remains. A definition so all embracing does not help the designer faced with a specific exhibition in mind. How does one find a way in to such a subject area; are any paths worth pursuing?

Taxonomy

The most basic approach is taxonometric, the grouping of exhibits into classes, arrangement of corresponding groups, and the provision of descriptions and explanation. Such simplicity is not to be sneezed at. Most of us have learnt from displays of this sort on school visits to the local museum, and provided the text or commentary are appropriate to the visitors expected a satisfactory exhibition can be created, and one that is also interesting to look at.

By personality

Another method is to make less of the objects themselves, and more of the story of their discovery: the men who worked on the site, the difficulties of excavation, and the detective work of piecing the evidence together are a good introduction to the subject. Photographs of working sites are always attractive, since one observes detective work about our past being carried out with shovels and in Wellingtons!

In many instances the people who initiated or carried out excavations were politically or socially important. However dramatic the opening of the tomb of Tutankhamun, it was made no less newsworthy by being done under the leadership of an English lord. For

many visitors the characters of the investigators will be of great interest, even when the objects found are not exciting in themselves.

By chronology

Sometimes the chronology of a site and a project will be the best way of assembling the material. Maps of our cities are fascinating showing the growth of the perimeter on the one hand, and also the demolition of buildings and the development of railway lines on the other. This sequential method can be applied in either direction, starting with the site when identified and as yet unopened, showing the progress of excavation and discovery: or beginning with the earliest state of the site, and bringing it forward by stages to the present day, a climax being provided when it takes on something of the world as visitors know it today.

Thematic

Another 'facet' of the material may be that aspect of human development on which the material has cast particular light, such as 'beliefs and burials', 'food gathering and diet', 'settlement and defence.' The visitor, trying to compare his own experience with that of his early ancestors under study, can be offered information which will give some insight into the societies concerned, their organisation, and the changes that took place in them.

Simulation

This approach can be developed into a form which is probably the most appreciated by the non-specialist visitor, a full-size reconstruction. Even in model form it is possible to show the visitors the environment, shelter and life of their earliest ancestors.

With ethnographical subjects this method is well practised, since all or most of the references required to make things in facsimile will exist and have been agreed between the experts. With archaeological subjects many items will be based more on speculation than hard fact. The designer might be prepared to include facsimiles that cannot be fully authenticated, but the archaeologist, historian and scientist will be more wary.

Whichever of the strategies or combination of strategies is chosen the grouping of the material and the displays that result must be subject to firm editorial control, and controlled by clear visual emphasis. In other words a good story line must be evident. However the designer must remember that there are two levels of understanding. The archaeologist concerned is familiar with many aspects or facets of the culture which he is studying, and can switch consideration from one to another with ease. Not so the visitor. If the 'point' of a given section of display is, say, 'Diet' or 'Shelter' the whole display and text must connect with this subject heading, and all other references to site, techniques, etc., must be subordinate. If the 'point' of a display is the work of the archaeologist and the supporting sciences, this must be emphasised, and the clues used and the discoveries made from them made subordinate to this.

Presentation of information

Even given such determined 'polarisation' of the material, the problems of visitor-access posed for the designer may still be formidable. If the ratio of objects to explanation (as mentioned before) is very low it will be hard to produce an exhibition that seems to fit into the traditional museum pattern. If the argument has to be put forward through a great deal of text, pictures, and diagrams, the result will be unsatisfactory as an exhibition, and would best be left to the medium of the book. However ambitious a designer may be, the book must be recognised as a remarkably efficient vehicle even in the twentieth century!

It is true that a complex of audio-visual techniques can be developed, combining lighting effects, all sorts of projection, and computer-controlled displays, but in this situation the designer walks a tightrope. The result can be informative and exciting if properly balanced and the appropriate medium is chosen for the message, but the essence of the message can easily be lost, with the gallery becoming a sort of fairground.

Displaying text and diagrams

Text is usually of prime importance in an archaeological exhibition. The graphic designer will play a decisive role in aiding the visitor's understanding. An exhibition is not a learned journal, and diagrams, maps, and plans of excavations will have to be in a bolder and simpler style than in a publication.

Uniformity is most important. Maps and plans should be drawn to the same scale and to the same orientation unless there are good academic reasons for not doing so. If size, scales and orientation have to change, such changes must be made clear to the viewer.

The archaeologist will usually have excellent plans already, excellent, that is, for their specialist purpose. Time and funds must always be allowed so that they can be redrawn to the new style, size and convention of the exhibition display.

The design and planning of traditional graphic charts and maps will of course overlap and sometimes be duplicated by other means of communications. There will be elements of graphic design in all the following:

Audio-visual displays of archaeology

Interactive devices, derived from the research that took place in the teaching machine era, now incorporated into computer displays. Here the visitor can vary the material with which he is dealing, and also pace the rate at which it is delivered to him.

Interactive response devices, which only become activated by the presence of a viewer, operated by floor pressure pads, the interruption of beams. Such trigger devices can start a series of lighting changes within a display, calling attention to a number of items in sequence.

Participation areas, in which the visitor can taste and imitate some of the crafts and processes demonstrated in the exhibition area. Pottery and modelling skills are often made clear in this way.

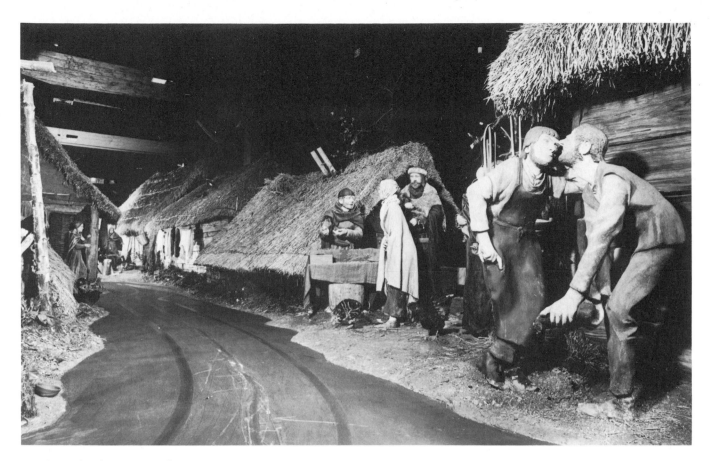

Time capsule: electric cars take visitors
back in time through this reconstructed
Viking street, complete with sounds and
smells. The figures are life-like, lighting
dramatic.
Jorvik Viking Centre, York

Models of concepts (as opposed to the enlargements of
physical entities, such as insects or cells). These are
also of great value in chemistry, physics, and
microbiology.
Video displays, particularly with very small monitors
that can be incorporated within the display. These can
be activated by the response devices already
mentioned.
Phased superimposition, where images can be
sequentially projected on an area, object, or model,
linking the object with analysis of it. A good
application being the showing of stratification in
archæology.

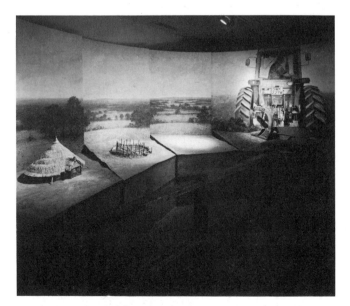

Revelation. The archaeological sequence
shown dramatically. A building, first
abandoned and obliterated, then
rediscovered by modern farming. Three
models mounted in a diorama of
changing landscape.
Dorset County Museum, Dorchester
Design: Robin Wade Design Associates

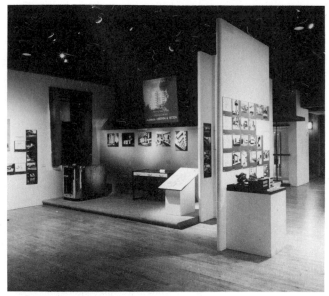

Open trough. Study collection of architectural photographs. In a rack with Perspex fronts. Square-mounted (accessible like records) related to the city plan displayed above.
Museum of Architecture, Helsinki

Mixed media. A fluid use of gallery space, describing an architectural period. Panels of photographic collages, models, and an audio-visual presentation.
The Thirties, Hayward Gallery, London

Incorporation. This archway is an historical exhibit and now becomes a functioning part of the museum building.
The Burrell Collection, Glasgow
Designer: Barry Gasson

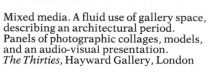

Hallmark. Specially constructed archway for the exhibition, as part of the structure, evokes the style of the architect and the atmosphere of the epoch.
Sir Edwin Landseer Lutyens, Hayward Gallery, London
Designer: Piers Gough

Architecture

Introduction

How can architecture be covered in an exhibition? Of all the arts subjects it is possibly one of the most difficult to tackle. To understand and appreciate architecture the public should see a building, on its site, in context with other buildings that it was designed to complement or to compete with. They should be able to walk into it and to judge the success of the choice of materials and the functioning of its plan.

Within a building of architectural interest there is a unique opportunity for designers to bring object and explanation together; the building can contain the history of its conception, the life of its architect, his plans and drawings for the building, his other work, and the recent conservation work done on the building. Sir John Soane's early nineteenth-century collection in Lincoln's Inn Fields is an exhibit in itself and contains all aspects of architecture and the other arts applied to architecture. It is a study collection for the enlightened and does not attempt to explain or display for the general public, to whom it may be a 'curiosity'. It is the product of one man's interest.

But how can the art and science of architecture be presented within the confines of a museum or art gallery?

Organisation of the material

Reconstruction of a building

This can make use of original and or substitute components. The restrictions are naturally those of size. The building to be erected within a gallery must by definition be small or the museum must be built around the building. The public should be afforded similar views to those obtaining on the original site, and should, of course, be able to enter the building itself. Here, to make sense of the building for the general public, its history and the social history of the time will have to be linked to the building and its form.

Fragments

Of course it is far more likely that fragments of buildings, or casts made from details of buildings of merit, will have been collected. These pose an acute display problem: that of making clear the overall style of the original building, how it functioned, and even more difficult, of giving the feel of the whole. If there are sufficient fragments they can be treated as a whole, but isolated pieces will have to be treated as sculpture, the 'story' being completed by plans, drawings, and models to which the fragments can be keyed by the text.

Plans, drawings, photographs and models

The most compact and intensive way of displaying architecture is by the method that architects themselves use to convey information and their intentions before the building is undertaken. Few of the public, however, can read plans and elevations, and a model gives a far better idea of a building. Models used within an exhibition should, if possible, all be made in the same style, with the same materials, to the same scale, and to the same level of 'finish' so that the lay public can easily compare one with the other.

Presentation by drawings and models leave out an important element of architecture, that of the pedestrian's view of the building. Photographs and contemporary paintings are essential to convey the atmosphere of the building and its setting. However, when all the elements have been brought together the designer should consider how a specific element can be introduced to make the whole display more than an enlarged book.

Audio-visual

Projected slides, films and video-recordings have increasingly been used to enhance ethnographic and theatrical exhibitions. They are also being applied to architectural exhibitions, with the effect of transporting the visitor in the gallery to the site and to the interior of the buildings. With careful planning these experiences can be tied closely to the more didactic material in the exhibition.

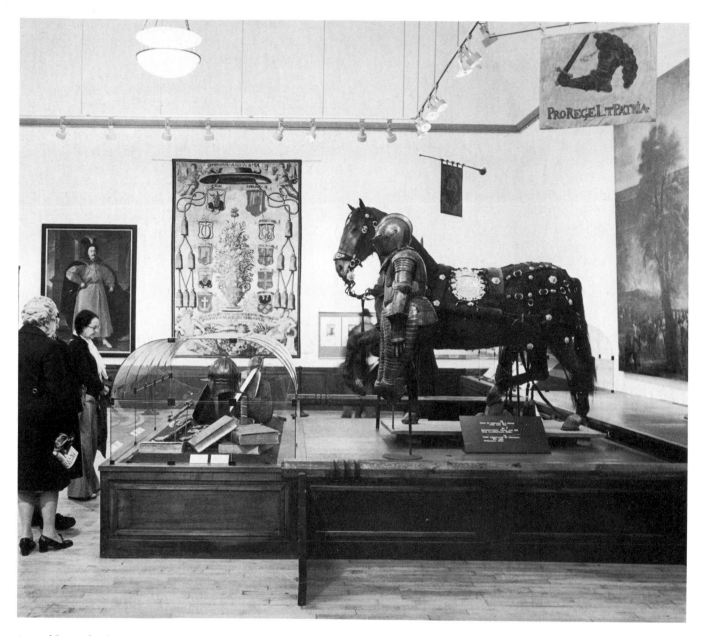

Assemblage. The display is an aesthetic
one, information minimal, the objects
related to the man. (Design assumes the
visitors are fairly familiar with the
subject.)
Sigismund Vasa, Stockholm
Design: Clason & Sörling

Biographical exhibitions and displays

Introduction

Many exhibitions have as their subject matter the achievements of a particular man or woman, in history, politics, the arts, sciences, or humanities. Other exhibitions, displaying the works of a particular artist, will have as an introduction a section devoted to his life.

Sometimes a single aspect of the subject is developed significantly, such as the collection of works of art by Charles the First or the images of the Emperor Augustus. The exhibition team may assume that the visitors to this type of exhibition either possess enough information to relate this aspect to a complete portrait of the subject, or will be encouraged to seek such information after seeing the display. There is a place in such an exhibition for a simple bibliography.

But a biography presents quite specific problems to the exhibition designer. These are, of course, no different from those posed by the literary biography which attempts the same subject. There are a number of keys with which the person can be brought to life, and these include exact moments in their life and work, historically in time and geographically in space.

Structuring a biographical exhibition

Time

Most people have a very hazy idea of time. It is marked by major events and characters rather than by dates. To be told that a subject lived between the death of Queen Victoria and the rise of Hitler provides an instant location in time. Equally, to have the beginning and end of a career tied to colourful popular images can help to bring a character to life. A subject could have witnessed, say, the funeral of the Duke of Wellington, and also the crash of the last of the airships. These are the sort of markers with which we plot items of history.

When one is dealing with subjects for a biographical treatment, these are the sort of points which can be plotted on a chart of their times. The forebears and progeny of the subjects will also be relevant, providing clues to the sort of cultural matrix in which they developed their ideas.

Place

The other biographical 'plane' of equal importance is that of space, the area in the world which they moved. Many of the famous hardly left their country, sometimes not even the town of their birth. Others travelled, worked, and extended their influence throughout the world. Detailed plotting of this kind can be very revealing, suggesting references for illustration providing background to an exhibition. How important, for instance, to show that while Wordsworth was writing a poem in one village, Constable was painting some miles away.

In many ways the writer of a biography has a much easier task than the designer. Existing illustrations can be reproduced, information and stories from the writings of others can be collated and retold to give colour to the subject.

Objects

The designer of an exhibition, however, has to work principally with concrete objects, provided by a curator, and frequently reflecting one aspect alone of the achievements of the subject. Supplementary evidence, possibly of a two-dimensional form, may have to be introduced to produce a balanced portrait. There is a danger that such two-dimensional material may result in a 'flat' exhibition.

The designer will often, however, be faced with a collection of objects or memorabilia which has been assembled at random, or by historical accident, and then be called upon to suggest a treatment for the exhibition that will not only display that collection but also 'round out' and develop the story.

If the objects available for display are 'plotted' on the twin planes of time and space (and the plotting can be quite literal, a drawn chart) any gaps can be seen, and additional objects sought on loan to fill them. On a larger scale one can plot the movements across seas and continents. Exploration, trade, emigration and war all produce patterns of information and provide the designer with clues for the tracing of illustrative material. This investigation is not only for the benefit of the designer and planner of the exhibition; some aspects of it will be needed as graphic illustration in the exhibition itself.

Contemporaries

The two planes so far considered have been concerned with 'when' and 'where'. Another aspect of importance is 'who' and 'with whom'. The effect on the subject of contemporaries and their actions is very important, and the portraits of those who influenced the subject or even existed at the same time in the same place will enrich the exhibition treatment. Many of these illustrative objects will be attractive exhibits in themselves. However, it is important that they are also firmly plotted in a framework of time and place.

The role of memorabilia is considerable. The achievements of the great tend to separate them from the present-day public, and their personal possessions on display can help to reconnect them to the onlooker. When it comes to wearing clothes, using furniture, collecting keepsakes, writing and reading diaries, paying bills, the visitor becomes one with the great.

Final chapter

The literary biographer has one great advantage over the designer, his capacity to sum up. The design team will find that the summary exhibit is one of the hardest to create.

The cast. 'Illustrated book' treatment: vignetted portraits and biographical details of those on Cook's second voyage, against a photo mural – the ship provisioning.
Captain Cook in the South Seas, Museum of Mankind, London

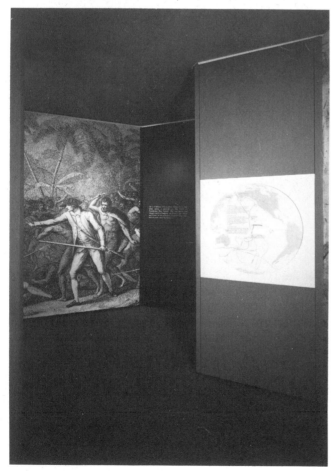

Finale. Theatrical climaxes strain exhibition format. The final voyage mapped, Captain Cook's murder ends the story (a contemporary print, much enlarged and dramatically lit).
Captain Cook in the South Seas, Museum of Mankind, London

Expressing the subject in time and place

To set the subject in his time and place the designer may well resort to a number of idiomatic devices, which are not exclusive to biographical exhibitions. The style of detailing of the entrance and orientation area of the exhibition can immediately suggest the period and location of the subject of the exhibition. It may be practical to reconstruct part of a building or a room setting where the subject was born, worked or died. Graphic elements can be used, such as the family tree or a chronological chart of major world events in the lifetime of the subject. Reproduction of a contemporary illustration of a major event or location can establish a character in a few moments. Reference systems of this sort, widely used in popular illustrated books, are equally important and valid for the exhibition designer.

The designer must remember that the visitor has entered from one time-system (now) and one place (the street) and is being asked to adopt to another time and place within the exhibition. Many designs fail to provide an area and the right material to make this orientation possible. If space and facilities permit, this may best be done through a short video or slide-show with taped commentary. Such an orientation is a familiar experience through television, and is particularly useful to the designer if objects from certain aspects of the subject's life are unavailable.

Displaying memorabilia

No biographical exhibition should be without some memorabilia of the subject. Here the exhibition has an enormous advantage over the written biography, or even over television, for the visitors can examine the actual objects used and treasured by the subject. What is more, they can take their own time in doing so.

The message of these personal mementoes is a very personal one, and the designer should ensure that, subject to security considerations, the visitors can get as close as possible to the display. The object should be placed as naturally as possible, just as one's own belongings are scattered on dressing tables and desk tops. The visitor should be allowed 'to come on them'.

Displaying achievement

The display of major achievements is another matter. If major works of art have to be shown they will themselves dictate position and style. Here the designer has to establish ties between them and the story without reducing their impact in their own right.

It is in the conveying of ideas that an exhibition designer meets his principal challenge. Literary achievements can be brought alive by displaying the stories and characters, and through these showing the mind of the exhibition's subject. Philosophic and advanced scientific notions are harder to transmit through an exhibition. Perhaps one has to recognise that for certain tasks the exhibition is not the best medium.

'Showcase room' where time has stopped. The atmosphere is private, possessions apparently left recently, the visitor privileged. (The doorway is glazed, labels on the reveal identify exhibits.)
Mountbatten of Burma, Broadlands, Romsey
Design: Robin Wade Design Associates

Showing conclusions

It is debatable whether a life's work can be summed up or appraised in an exhibition.

The exhibition has to work in a more diffuse fashion. However, before the designer attempts to find a stylistic treatment or an attractive object to complete the show, he should perhaps find out from the curator whether a summing up is needed, and if so what. For instance the total achievement of explorers or conquerors can be shown graphically in the form of areas on maps and perhaps through trophies. In the arts and sciences the whole exhibition is perhaps the summing up, with no attempt to send the audience away with a simple conclusion.

Fitting. Bland contemporary gallery,
proprietary louvred ceiling, a travelling
exhibition, grid-planned graphic panels,
product shelves on stainless steel
uprights.
Dieter Rams – Design, Boilerhouse
Project, Victoria and Albert Museum,
London
Designer: Dieter Rams

Exhibiting 'Design'

Introduction

Museums and art galleries move into the twentieth century not only by collecting contemporary works of art but also by purchasing and exhibiting everyday objects, the products of industrial design. To the painters in Victorian England it would have been inconceivable that someone would exhibit a flat iron in a similar way that they exhibited his paintings. Today, the painter might not be pleased, but he would not be surprised. Collections of ceramics, glass and furniture are kept up to date by the addition of contemporary pieces, and complete exhibitions are devoted to 'designed' artefacts.

Inherent problems are posed by the objects themselves. The dilemma facing the designer of a museum exhibition of everyday objects, however fine in themselves, is that many of the visitors do not expect them to be there. The less sophisticated visitors will be reluctant to accept that objects from their everyday lives are being included in a museum; it has to be broken to them that these objects have been 'designed', and also that they have become, through being in the museum, 'history'.

Exhibition organisers are not yet entirely familiar with this sort of explanation and interpretation, and until they are, contemporary industrial products will not sit happily on museum shelves.

Sites and settings

For these visitors a bridge has to be built, a rapid explanation of what the objects are on display for. The proprietary display equipment, screens, panels and cases, that are easily available to the gallery are very similar to those in use in shops and commercial exhibitions, and if they are used for the museum display their familiarity may well obscure the point that the familiar objects are there in order to be viewed in a new light.

If time and funds permit the most successful setting will be one specially designed. This can be used to promote the leap of imagination required of the visitors, to make them look at these objects afresh.

Supporting the objects with information

Art is familiar as an idea to the average museum visitor, and they are familiar with the element of 'design' that craftsmen practise when producing handmade objects. When seeing the industrially produced objects they must be able to understand how their usage was first analysed, and materials and processes deployed for a solution and set the object in its 'user' context. Even more, they have to learn about the designers behind the process, a stage away from the actual makers themselves.

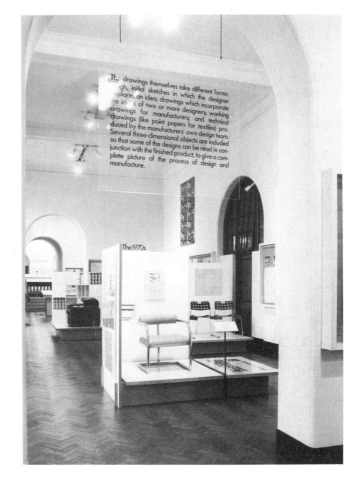

Sources. Sketches and designs on screens surround furnishings on plinths. The archway panel explains the concept of the exhibition.
The Way we Live Now, Victoria and Albert Museum, London
Designer: Paul Williams

Ethnographic exhibitions

Introduction

The range of objects provided for display in an ethnographical exhibition is a challenge to the designer. One can say, literally, 'all life is there'! Explaining different races through their material culture will involve the display of a vast range of objects from complete houses, and wooden canoes, down to very small pieces of personal adornment such as beads or a feathered comb. The exhibition may contain domestic utensils, complete costumes, weapons, and religious idols and fetishes. Compared with other collections, ethnography can present a somewhat untidy display task.

Much of the material will be unwieldy, organic and fragile. It will be very hard to provide the correct conditions for conservation if the gallery is not air-conditioned. The list of objects must be checked with the conservators at the start.

Many of the objects will be too large to fit cases of standard dimensions and will be best housed within a modular system of case construction which can be extended to the shape and size required. If very large objects can be exhibited in the open gallery the designer will have to provide protection by the use of plinths and barriers.

Display problems; orientation

The visitors will seldom be familiar with the races and tribes shown in the exhibitions. They have to be 'orientated' before they can take in the detailed information, they have to be certain about the place, and know whether the material is from the past, or the present day. Simple introductory explanations should not be left out by the designer. The experts will skip them, but the lay visitor be grateful.

The location of the subject is usually by the provision of two maps at the start of the gallery, the first showing the area concerned 'high lighted' on the continent, and a second showing the specific territory under discussion upon a map of the general area.

This sort of specific geographical information is strengthened, of course, by clues provided by the atmosphere created at the opening, often provided by giant photographic enlargements, climate suggested by the general use of colours, and a sample display of indigenous materials. The designer may, however, decide to propel the visitor immediately into a complete simulated scene of the territory.

Tape-slide, video or film shows are often used to strengthen ethnographic exhibitions, and they can often be used at the outset as a compact method of 'orientating' the visitor.

Strategies of display

The curator and designer first have to decide if the objects available are best presented as a traditional museum exhibition, using showcases supplemented by informative texts. Often they will wish to try a more evocative treatment. Conservation may well dictate whether an open, free arrangement, simulating the environment of the ethnic group is possible. If some of the objects are in a delicate condition (or of high value) some part of the display at least will have to be enclosed, and a mixture of two treatments will be called for. The designer will then have to find a way of placing a suite of cases near a simulated forest, or a wigwam, and yet maintain the illusion of reality for the visitor.

The two treatments in use have to be screened from one another. If there is sufficient space they can be separated by a neutral area, or by a gradual change of colour. If the width of the gallery permits, the material in cases can be arranged in small study booths, to one side of the simulated area.

Use of figures

Sometimes the curator will press for the inclusion of figures in the reconstructed scene. They will not only be needed to show domestic life, but also to act out the work done by craftsmen and farmers, etc. The designer should be cautious. In a display of costume the dummies used may be finished with a stylised head only, and yet be quite satisfactory since the emphasis will be on the costume details. Where the figures have to demonstrate the carrying out of actual tasks in a realistic setting with authentic 'props', much more realistic figures will be needed to match. Naturally this degree of detail and finish will be expensive, and may take up a substantial part of the budget. To be convincing the facial features will have to be specially sculpted to give the right expression and ethnic characteristics.

Unconvincing figures can destroy the atmosphere of an exhibition faster than any other factor in the display. If the designer cannot buy the quality that he needs it will be better to keep figures out of the reconstruction, and their role in the story can be told by adjacent life-size photographs of the population concerned.

Special effects

Sound

If silent, the simulated scene may still be unconvincing however much care has been taken with it. The playing of recordings from field work or a reliable sound library will add enormously to the impact. The sound effects, however, must be carefully controlled, and localised to the display to which they refer, with little or no 'spillage' outside the area. If there are different soundtracks playing in different sections of the exhibition their timing should be coordinated so that if they are discordant only one is playing at any given time.

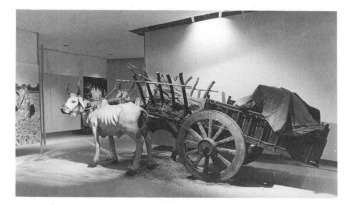

Trompe l'oeil. Neither space nor budget permitted full realistic settings. Intense (electric) sunlight on stretched calico, the cart authentic, the bullocks specially modelled.
Vasna – Inside an Indian village, Museum of Mankind, London

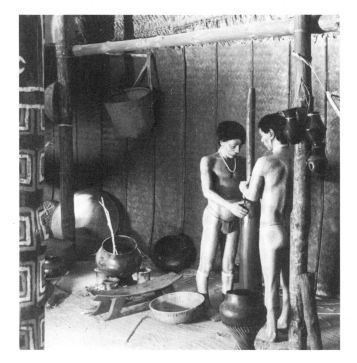

Admission within a *maloca*, minimal barriers, visitors immersed in the household's way of life. Sunshine (external floodlights) flickers through walls and ceilings.
Hidden Peoples of the Amazon, Museum of Mankind, London

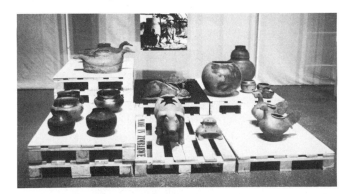

Market style. Pottery displayed on pallets. Low plinths of rough timber at ground level to give the feel of an open African market.
Zimbabwe, Ethnographical Museum, Stockholm

The visitors are not the only people to hear the sound effects. They will only be ten or twenty minutes, say, in the zone, but the warders will be stationed there somewhat longer! If the exhibition is not overcrowded, the looped tapes can be activated by beam devices or pressure mats as the visitor approaches the area concerned.

Smell

Many exhibitions smell unintentionally; the rubber from the backing of the carpet, the paints and adhesives will be evident long after the exhibition is opened. So the smells of spices in the market, or bread in a bakers, or scents in domestic scenes will not only be evocative, but also help to mask the odours left behind by construction. As with sound effects, smell effects should be made as local as possible. Where herbs or spices are available in the exhibition area the budget should allow for renewing these 'props' at regular intervals; they will be a cheap way of helping to create an illusion. If something more elaborate is needed it may be necessary to fit ducts at various points, the scent being delivered by fans.

Finishes

The effect of the reconstruction will be greatest if the visitors are allowed to proceed through it, without barriers. The designer will have to satisfy security and conservation points before organising such an open access treatments. However, a price has to be paid in the construction stage, because the finishes may have to stand up to direct wear in places, and will also be subject to close scrutiny.

In many instances the finish can be improved by the available craftsmen simply spending more time on details of texture and colouring. In certain areas, however, the designer is up against the problem of the illusion being shattered, because it will become obvious that real sand is not being used in the desert; the warding staff would suffer from the rising dust, and there would be maintenance problems not only within the particular gallery, but also through the whole building in which the exhibition is housed!

Compromises will have to be worked out. Where the original material cannot safely be imported into the gallery, something with the same properties can be substituted or the original loose material can be 'fixed' in some way. The illusion of a forest will probably still be maintained if the visitors walk on a soft carpet of a suitable colour, but would be shattered by a hard floor surface. The designer should remember that most visitors are really on the same side as the designer and curator: they really want to believe in the simulation.

Movement

The original scene, which the designer is trying to reconstruct in the gallery, will have been full of movement, fabrics blowing in the wind, moving foliage breaking up the sunlight, a ship or boat moving slightly on the water. If the scene is reconstructed without any movement the designer is creating a sort of giant waxwork, which though impressive technically will not convey the right atmosphere to visitors. Putting

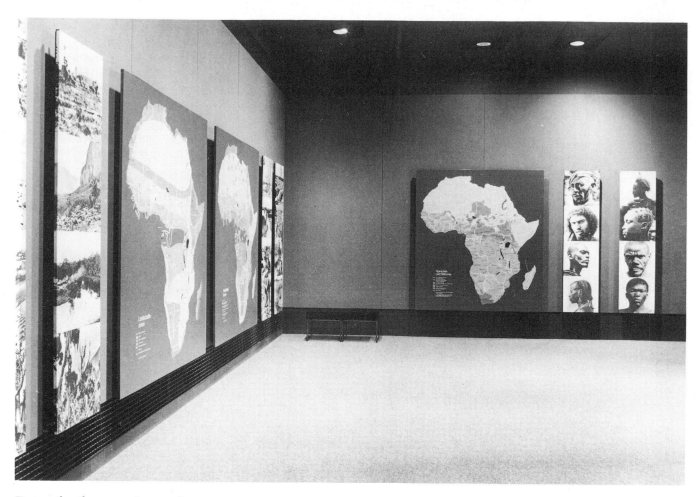

Facts rather than general atmosphere.
Maps, texts and photographs, individually
at work. Ceiling-recessed 'wall-washers'
light the silk-screened graphic
information panels.
The Races of Africa, Museum of
Ethnology, Dahlem, Berlin

Sensation. Reconstructed village house,
partly original, transports the visitor to
India. Information restricted to panels
displayed at the exhibition's end.
Vasna – Inside an Indian Village, Museum
of Mankind, London

movements of this kind into a reconstructed scene need
not be expensive in money terms, but a lot of thought
can be applied to get the most from very simple
equipment. Simple time switches, if their action is
properly scripted, the draught from small fans,
miniature motors rocking some of the smaller props
will together, in the right combinations, produce
effects that would not shame the best film studios!

Lighting
Conservation will always win over illumination. The
designer may wish to re-create African sunlight in the
gallery, but floodlights and spots in the relatively
confined space will build heat up to a level that will
damage, if not destroy, the objects.

The designers can help the conservators in two ways.
A realistic scene, complete with authentic objects, can
be constructed, but lit as though at dusk. As an
alternative, the landscape or longer exterior view of the
reconstruction can be brightly lit, with the vulnerable
objects arranged and viewed within a reconstructed
interior, which will naturally be at a much lower light
level.

Historical exhibitions

Introduction

There is not one history but many: ancient, mediaeval, contemporary, ecclesiastical, local; each has developed its own tradition and handles a different type of material to make its points.

The exhibition designer is following a tradition of presenting history in the form of written texts. The designer will have to marshal a number of objects to do the same job, and to make certain of doing so the work will have to be based on a well-constructed script. Discussions with the academic staff at this stage will be much less damaging than when the final gallery arrangement is being dressed with exhibits.

The script has to start from the recognition that many visitors who would enjoy the exhibition are quite unfamiliar with the period or background, and a technique must be incorporated at the opening stages of an exhibition to enable those who have no previous knowledge to become involved before they reach the first complicated display. Magazines publishing serial stories recognised this years ago by including a small insert 'New readers start here'!

As with other exhibitions of mixed collections, there will be a wide range of objects and materials grouped together, raising problems of conservation. Many of the materials will demand special treatment, making the display of others extremely difficult; manuscripts and documents, for example, require very low levels of illumination.

Another problem is to find methods of bringing the subject alive, when fairly modest exhibits: belts and buckles, a book, a small portrait, for example, have to conjure up vast battles, the movement of whole populations, the fall of kings. Here the designer has to function as an illustrator, using atmospherics and colour in the gallery to enliven the case displays.

Budgets will also be a problem, particularly in the display of local history. Here the material is often very touching, and the stories to be told are easily grasped, but the premises may well be unsuitable for display, with inadequate space for circulation, and funds inadequate for building an exhibition that will unify a wide diversity of objects, and give the display enough light. Such exhibitions call for great patience and ingenuity, and should perhaps be the training ground for tyro exhibition designers.

Display problems

Orientation

An historical exhibition is a form of time capsule. Visitors come in from the street already tuned to one time band, today, and the designer's job is to switch them as rapidly as possible back into another. The smaller the resources available, the longer the transition will take. An archaeological display showing stratifications will slowly enable the visitor to make the adjustment, but the Jorvik Viking Centre in York, for example, uses a more radical (and, of course, expensive) method by transporting the visitor physically at the same time as doing so psychologically. The visitors are 'taken back' through the centuries to the starting point of the exhibition.

The budget available will tell the designer how much of this kind of activity he can deploy.

Most historical exhibitions are mounted in chronological order, the earliest material nearest the entrance. This sequence is familiar from schooldays, and any visitor will be able to connect with it, provided the right clues are provided at the start.

By colour

Even a large area of appropriate colour may do the job. How many successful exhibitions have got off to a good start with an entrance lobby with a royal, ecclesiastical, or horticultural colour predominating. A lot can be learnt, perhaps, from packaging designers, who have to transmit instantly to the supermarket shopper impressions of freshness, or solid construction, or novelty, as need be.

By style

The public can read architectural features almost as quickly. Stonehenge, Gothic tracery, half-timbering, and Georgian fanlights have all entered into the visual shorthand of the general public, and enlarged photographs or contemporary prints at the entrance will be read very easily. It is worth remembering that most people have only a limited time to spend in an exhibition, and if the introduction and the visitors adjustment can be carried out quickly, the visitors will have more time, unhurried, to examine the individual exhibits with care.

With props

If characteristic of the era, even a single piece of furniture or a portion of a costume will establish the date. A painting may do so also, but will, if studied by the visitors, produce a bottleneck in the entrance area.

By room settings

If space and the collection permit, the time change may be best effected by leading the visitors right away through a complete room-setting of the period concerned. This is a shock treatment, and will be most effective if the setting and the props are sufficient to create a quite overwhelming impression on the audience. Large museums will have collections big enough to draw on for this purpose, others will have to borrow.

By texts

An introductory panel, edited ruthlessly to make only the key points, will provide a simple opener. Anyone planning an information panel should bear in mind, (many have not!) that reading takes time, and the visitors have to stand somewhere while reading.

By audio-visual programme

Where space, cost, planning and production time permit, a complete audio-visual programme may provide the best introduction to an exhibition. The

time available to the visitor has to be correctly calculated as well. Will the visitor have time to see both programme and exhibition at the same visit? If not, it may be best to duplicate some of the information inside the exhibition itself, so that the visitor is not handicapped by shortage of time.

Imparting information

Once the scene has been set for the exhibition and the visitors have been nudged into the appropriate mood, the exhibition will have to start to deliver hard facts to identify the objects and put them in historic context. Although each case and object can be described in detail, many visitors need to see a whole 'pattern' of the time under consideration, and it will often be worthwhile to create substantial chronological and genealogical charts with the space to study them carefully. Again, the initiated will skip them, and the less informed be grateful.

The designer will find it easy to translate into a static exhibition display some static entity from outside. A landscape model can be made very convincing with care. It is harder, however, to give the flavour of the battle that took place on it. Diagrams can serve to show groupings and movements of forces, but the actual dynamics of the events will demand something stronger in the way of treatment. And, for instance, Nelson's uniform, with its telling blood stains, is not usually available.

If the money is there a combination of waxworks and 'Son et Lumière' can be deployed, but the final effect may be much too lurid for a serious subject. There are many more modest techniques available to give partial movement to displays and diagrams, fibre optics can be used to pinpoint items on a diagram, and a few time-switches control the lights on a model. Experimental time must be allowed if such effects are to be tasteful and relevant; such devices cannot be tamed in advance on the drawing board. In the end, the objects may tell the story a lot better.

Conclusions

Many exhibitions appear to end at the point where the designer ran out of space! A conclusion is needed, even to putting over quite a modest story, and the designer is probably best advised to plan with the curators the start and the finish first, and later fill in the area left over.

In an historical exhibition the conclusion is of particular importance. If the exhibition has worked well the visitors will want to take the subject further, either by additional visits or reading. They will be helped in this aim if the designer has arranged that they take their leave with a clear summary in their heads.

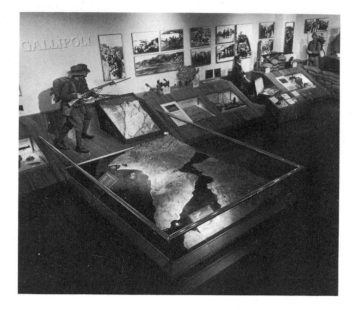

Evidence for emotive subject, for visitors to judge. In uniform, the men who fought, the actions photographed, weapons, memorabilia, kit. Foreground: cased relief map of terrain.
Gallipoli, Australian War Memorial, Canberra

Sea battle. Shown plain and simple,
while visitors do the work. Ships,
cannons, men who fired them.
Seamanlike, clutter eliminated. Labels
are small, seats consist of coiled rope.
1776, National Maritime Museum, London
Design: Robin Wade Design Associates

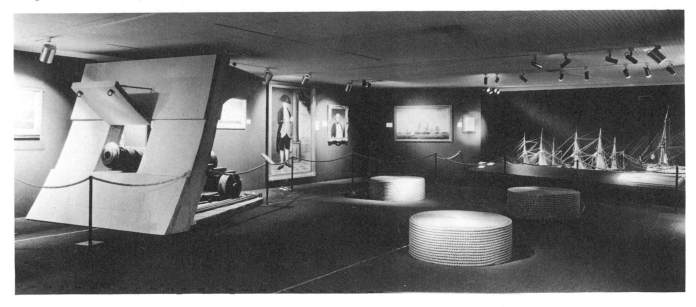

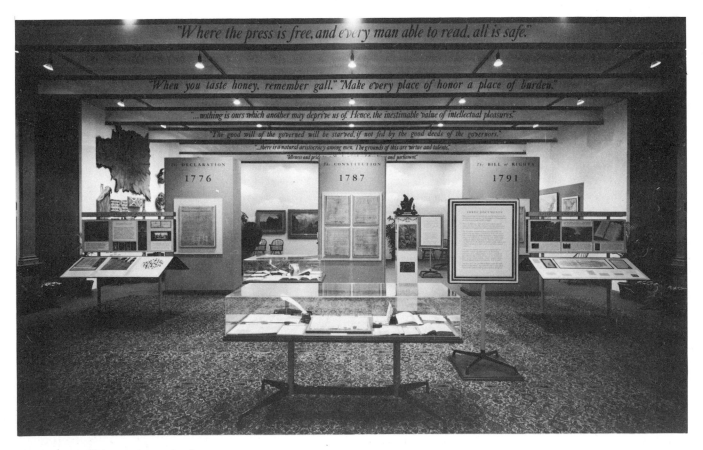

Components of history. A mosaic of
documents, information, photographs,
text, in self-sufficient units. Visitors route
themselves and compile the story.
The World of Franklin and Jefferson,
British Museum, London
Design: Charles and Ray Eames

Science and technology

Introduction

Although science is frequently studied separately from technology, in museums they are usually presented together. Most museums of science in Britain were created in the nineteenth century when the general public was usually more concerned with the products that would advance their wellbeing than with the knowledge that had made it possible.

The result of this bracketing of science and technology is that today's collections contain an even wider range of subject matter and objects and call for more varied methods of display than those in a museum of art or history. Sometimes all the branches of science may be 'displayed' in the same building – chemistry, physics, biology, even medicine – although natural history is often the subject of separate displays in separate institutions.

However slight an acquaintance one has with the sciences it will usually have been made at school, with a mediating teacher helping fit the parts of the story together. Even with the aid of textbooks and visual aids the transaction does not always take place! When the exhibition organiser sets out to carry out the same sort of transmission of a scientific subject, specific strategies have to be developed as a substitute for the missing teacher. To see how this can be done demands a study of what the teacher does, and for what the exhibition is to be the substitute.

Types of transaction

There are at least three types of transaction between teacher and student. The first depends on encouraging the student to observe, to take in the maximum of information. The second is to provide a means for the student to intervene in the process that has been observed, and, if possible to experiment by modifying parts of the process to see what effect this will have on the other parts. The third stage is to impart to students a theory which will explain what has been observed and experimented with, or to encourage students themselves to develop a theory or explanation.

The science exhibition has to attempt substitution for the teacher, and therefore will have to embody something corresponding to each of the three phases discussed above. A capable designer will find a way of carrying out the first stage, that of showing a phenomenon clearly to a visitor not familiar with it. Good lighting, clear colours and texts, and a checking of sight lines will effect this.

Enabling visitors to 'experiment' will demand the organisation of 'interactive' devices, by which they can manipulate the material in the displays. (This has reached a very sophisticated level with the creation of Science Centres and 'Exploratorium' in the USA.)

The third phase, the consideration of theories, entails the creation of visible analogues of the ideas concerned, both two- and three-dimensional diagrams, through which visitors can consider pure ideas, or material not visible to the naked eye. The planning of these diagramatic items is intellectually taxing; the visitor may not be used to deciphering such things, and the diagrams and models may not fit visually into the rest of the displays in the gallery. But ideas have to be expressed in this way, nevertheless.

Expressing ideas

It is from this need to express ideas that the science exhibition differs most from the display of art and history. Even where scientific objects play a substantial part in the whole exposition, many of the items exhibited will themselves have been created by the design team.

This has certain advantages. Such creations need not be unique, and therefore they do not have to be protected in the same way as traditional museum collections. For instance there are unlikely to be problems of conservation. The designer is not out to encourage vandalism, of course, but laboratory equipment and machines can be replaced, and charts and schematic models duplicated, and the designer may therefore attempt a much freer design. This freedom from some of the traditional constraints of the art museum is usually immediately apparent in scientific exhibitions. They appear busier, less reverent, and are not afraid to juxtapose exhibits that differ widely in scale, material, and style.

In displays of science and technology the role of the designer can be very demanding. In handling material from the arts a good deal can be achieved through fine and sensitive arrangements, but with science the designer has to master, and then express, ideas.

The designer's task

On occasion the designer may be providing the complete presentation. Where there are no traditional museum objects the designer will be responsible for stimulation, for the communication of ideas, for providing a complete entertainment. The style of the exhibition will derive from his work alone, unaffected by other aesthetic considerations.

He will also be responsible for the creation, with the scientists, of completely new objects. The structure of a cell, a star, or an electrical field can only be appreciated after the creation or application of devices. The star has to be brought nearer, the cell enlarged, and the designer has to find a convincing form for both.

To many, science and technology are not part of their daily lives, and appear vast and forbidding. Only rarely will the designer be working for an informed specialist audience, and the material will have to be translated into a language that the lay visitor can understand, and served up in chunks that the visitor can take in. The best bridge between such subject matter and an uninitiated audience is maximum participation in the exhibition and the processes, by making as many of the displays 'interactive' as possible. Touching exhibits or controlling them through levers and buttons will give the visitor a sense of having entered the subject themselves. For the designer, of course, there is not

Notions. Design welds together objects and abstractions. Here the familiar telephone, when lifted, talks about 'communications' (but only the tightest commentaries keep visitors listening!).
Challenge of the Chip, Science Museum, London
Design: Gordon Bowyer and Partners

Experience. Often the visitors and their families had worked here with such machinery. Given such understanding, design must concentrate on sequence rather than 'display'.
Blist Hill, Ironbridge Gorge Museum

only the task of designing installations to be attractive and hold attention, but also of arranging for maintenance and operational concerns.

However, the designer tackling a science or technology subject may also be asked to display many traditional museum objects: pieces of equipment and machinery may need to be displayed in their physical and social settings, just as with paintings, costumes or pieces of furniture. Like these, they may have to be emphasised and treated as aesthetic objects, or

Scientific reconstructions: the moon built in a science museum. Visitors walk round men and machines seen before only on television.
Exploration, Science Museum, London

possibly dealt with as part of a 'study' collection.

An aesthetic treatment of individual pieces will not necessarily provide an overall, satisfactory aesthetic treatment for the whole exhibition. When the designer is handling works of art, these will have been created and used and seen in one aesthetic framework. Their originators who made and used them will have shared ideas on colour, texture, size, in fact on style in general. The designer can then connect with this style consensus, and develop it for his exhibition purposes. In a science exhibition the exhibits (particularly those that the designer has created) will not share such an aesthetic consensus, and if he wishes to create such a unity the designer may have, as it were, to start from scratch.

Such a unity in appearance may not even be desirable. The very nature of the material, the display of phenomena and related ideas may not best be done by harmonising them with other similar items, but by allowing them to compete vigorously with them. Indeed, many of the ideas being expressed and displayed may be in conflict with each other and such conflict has to be made clear. This makes the role of the designer all the more important. No longer is he playing 'second fiddle' to the collection, but directly organising a statement.

What techniques does this suggest? Pioneering work in the USA within the last twenty-five years provides evidence that it is the involvement of the visitor with the exhibit that holds their attention and enables information to be transmitted.

Display techniques

Attention devices

The designer will be seeking 'alert' design idioms; the use of a 'sock opening', a symbolic object, possibly greatly magnified, very bright colours, movement, detailed lighting effects, even humour where appropriate. Until the visitors pay attention, nothing can take place.

Operating devices

Pushing buttons, winding handles, and lifting levers to make something happen within the display are fairly simple and popular devices which were the first interactive displays associated with science exhibitions. They still work. Such devices can activate a variety of displays, from simple mechanical movements of machinery to complicated demonstrations of chemical experiments. They also enable the visitor to call up his own sound commentaries and audio-visual presentations.

Physical involvement

Visitors can be strongly involved by making them guinea pigs in an experiment or demonstration. Reflecting in mirrors, or their images glimpsed through closed circuit TV, can be used to teach many points: on space, perception, and distortion.

There are also more active forms of participation, such as measuring energy and breathing after pedalling on a fixed 'bicycle'. Such devices enable the visitor to match theoretical explanations, to which he may not be used, to direct personal experience.

Even fixed microscopes and binoculars are very attractive; for reasons which are not quite clear, few of us can resist looking through a proffered lens. The designer has to bear in mind that all these devices for direct physical involvement must be very robust; once the fairground spirit has been invoked in a display (and it may often be the best method of exciting interest) the equipment will be heavily tested.

Computers

A few years ago a computer was miraculous, and the chance to operate one extremely exciting. Now it is part of the domestic furniture, amusing but no longer awe-inspiring. Computers have a role in science exhibitions as devices which can be programmed to involve the visitor in the learning or discovery process. They are also programmed to explain their operation, even their history. A generation now exists to whom the computer terminal is a natural partner in a conversation, and the designer can allow for them in the role of substitute guides to the display.

Computers can be used to provide encyclopaedic memories, but it may not be appropriate to search an encyclopaedia in a crowded gallery. The time that the visitor, particularly the very young, may allot to any terminal will be short, but it may permit question and answer strategies, even extended into quiz games.

Such games can be very simple or sophisticated, text questions, sound cues, coloured images, a whole range of stimuli, but the designer of the whole scheme may

Active learning. Scientific principles and experience. Throughout the exhibition, standardised, horizontal information panels, fluorescent lit. Visitors study eddy currents and build a catenary arch. *Experilearn*, Museum of Victoria, Melbourne

Intermediary. Computer displays generate dense information, and need human answers to questions. High staffing levels are entailed (the identifying 'T' shirts – silk-screened). *IBM Exhibit*, Natural History Museum, London

Copying. The chip is changing everything, audiences as well. The showcases hold terminals, which become teachers. The students take notes. *Challenge of the Chip*, Science Museum, London

well find such an exhibit interrupting the general design, and it is well to remember that one terminal can only service one (or possibly two) visitors at a time, and the gallery can easily become a pin-table arcade, with all its limited charm.

As in the running of tape-slide programmes, the need is always there to get the programme back to the start and this must be incorporated into the first stage of planning. Does the screen zero when the first 'player' quits? What of his friend, looking over his shoulder? What of parties who circulate and operate in groups? The programme will have to find a way of knowing who it is playing to and with.

The designer must realise that though the equipment is getting cheaper by the day, the time required to exploit it is still great, high level, and expensive. Premature incorporation of computer displays in a gallery may easily cripple the budget before anything else is built.

Demonstrations

An exhibition in a science or technological museum may include a 'live' demonstration of an experiment or the application of a technique. If the numbers permit, visitors can participate to some extent. Such demonstrations require a good deal of space, and often additional services, as well as staff time to prepare and carry them out. Unless the personal atmosphere that they generate is essential to the exhibition they may be better shown as films, video, or tape-slide programmes.

Animated displays

Movement in any display will attract attention, but it should have a meaning if the visitor is not to be frustrated. There are many biological processes that can be demonstrated by simple animated models, or by liquid animated diagrams. There are many ways of animating such diagrams with the simplest of electric motors and switches. An animated model in continuous action becomes boring, and it may be preferable to secure the participation of the visitors by making them push-button it into life, a time-switch turning it off after a reasonable demonstration.

Animated models and diagrams are better used sparingly, as part of a larger grouping of specimens and information panels. Too many, lined up together, will have the frivolous appearance of a shooting gallery!

Multi-media: film, slide sequences, animation, back projection, sound effects and specially modelled revolving globes all play a part in telling
The Story of the Earth, Geological Museum, London
Designer: James Gardner

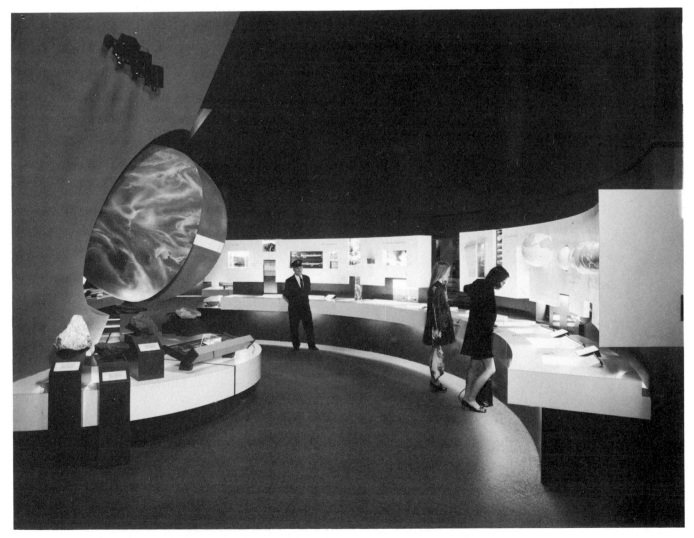

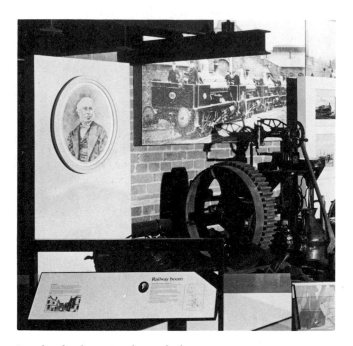

Local technology. Beer brewed where visitors now stand. The equipment, the product, its transportation, the men involved – all are explained on floor-standing, illuminated information panels.
History of Brewing, The Bass Museum, Burton-upon-Trent
Design: Colin Milnes Associates

Models

There are many occasions when space does not permit the inclusion of an essential exhibit, and a scale model is called for. The change of scale will often give emphasis to the item, both enlargement, such as models of cells, and small-scale renderings of engineering; the change of scale from that of everyday life is in itself an attention-getter. The visitor is being taken into a new world, inside a molecule, a micro chip, or even the mechanism of a camera; a two-dimensional diagram would have no comparable effect.

The scale model used to render landscape is also very attractive. From one display item the whole nature of a piece of countryside can be made clear, or the implications of complex technical industrial processes, such as an oil refinery.

Again, cost will make the designer think twice. Model making to a high standard will take a great deal of money. On many occasions, however, the organisers may find that models exist, made for other projects, which may be borrowed and mounted to make them fit into the general design of the gallery.

Reconstructions, full-size replicas and simulations

Where the original machine is unavailable, or too fragile to transport, a full-size replica may be created. In transport displays, replicas have often been built by teams of engineering apprentices. Such technical back-up is rarely available to the designer, but in a project with adequate time for advance planning it may be possible to get assistance of this kind.

Often the designer will wish to incorporate a complete simulated interior, or part of a natural wild scene. Exhibitions of art and history use these to great effect, and in the field of science and technology they add immensely to establishing atmosphere, transferring a large amount of information in a single display. No photograph or diagram can convey, as a reconstruction can, the nature and detail of a ship's interior, a laboratory, an operating theatre, or a coal mine.

Such reconstructions do not necessarily involve great expense, if the furnishings and minor props are already available. The figures representing the scientist, the surgeon or the miner will be expensive. The designer should always calculate on considerable time being spent on 'dressing' the set, the fine arrangement of small props, such as instruments and personal effects. These small items may well be decisive in making the whole reconstruction believable.

Audio-visual techniques

Audio-visual techniques, from the simple taped message to the complex multimedia presentation, are widely used in science exhibitions and are an obvious medium for conveying technical information instead of a mass of text.

The commentary is the most common device in science and technology exhibitions, used to describe the workings of a display, a model, a reconstruction, or a simulation. When coupled to slides or a film, commentary can be used to explain complex or unfamiliar images.

The commentary play-back can be localised in an area around a given display, enabling more than one visitor to benefit from it at a time, or it can be restricted to a few visitors or a single individual by the use of 'listening wands' or through the use of 'pick-up' handset telephones.

It is easy to overload the listener with information. The length and style have to be carefully calculated to keep the attention of the visitor throughout.

The projection of slides, either on to the front or on to the rear of the screen will create more interest within a display, than a static display of photographs on panels. The same is true, of course, of video recordings played through built-in monitors.

The effect of displays on the rest of the gallery must be foreseen by the designer. If there is an accompanying commentary or sound effects this may distract other visitors, and the same information appearing on the screen as text may cause the visitors to stay too long to watch the display and disrupt the general flow within the gallery.

Talking heads

If a film close up is shot, full face, of a speaker giving a commentary, and projected on a matching dummy head with careful registration and the avoidance of vibration, the complete effect is achieved of a 'talking sculpture'. The effect is so startling that it might easily be dismissed as a gimmick, but properly placed by the designer in the gallery display it provides a most telling way of attention getting and the delivery of information.

Projected dioramas

In the past, painted dioramas were often used in natural history galleries. In a suitably darkened gallery transparencies projected on to a shaped background will be cheaper, and often equally authentic.

Pepper's ghost

A nineteenth-century showman, anxious to be able to change a solid display into another similar, without any apparent mechanism, invented 'Pepper's Ghost', an arrangement of lights and mirrors.

The viewers had to be stationed in front of the display, barriers and a proscenium preventing them from straying too far on either side. Through the proscenium they could view a normal model, of a village, or waxworks, or machinery, lit in a traditional way. The arrangement, to all intents and purposes, was that of a shop window. The lighting appeared perfectly normal.

What the viewers could not tell was that they were viewing the scene through a half-silvered mirror, set at forty-five degrees to their line of sight. Out of the direct line of sight through the proscenium a second model was stationed, angled at ninety degrees to the first one, differing from it only in certain significant features. This model was lit independently of the first, the angles of the light matching exactly, and when the set of lights of the first model were faded out, and those of the second faded in, the image of the second model took over from that of the first (by now in darkness), a spectacular change taking place as a result.

In the 1920s this technique was often used by machinery manufacturers to show, in cut away, the internal workings and structures of their products. Careful design will yield a number of science exhibition applications.

Left:
Rapport. The designer communicates to the child. Playground pattern demonstrated on photographs and immediately copied.
Hall of Human Biology, Natural History Museum, London

Muscles. Theory and practice brought together. An effective interactive display which is most successful in conveying its message.
Hall of Human Biology, Natural History Museum, London

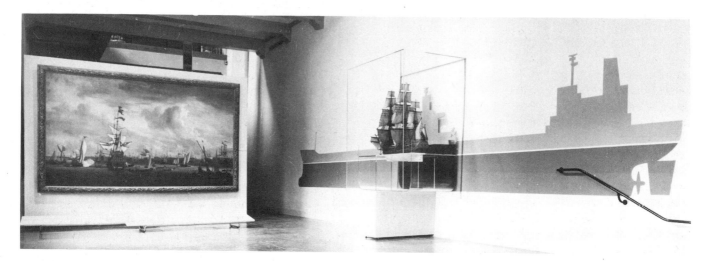

Scale. Technology and time have
increased the size of ships. The painted
silhouette instantly compares the ship in
the painting and model with one of today.
Historical Museum, Amsterdam

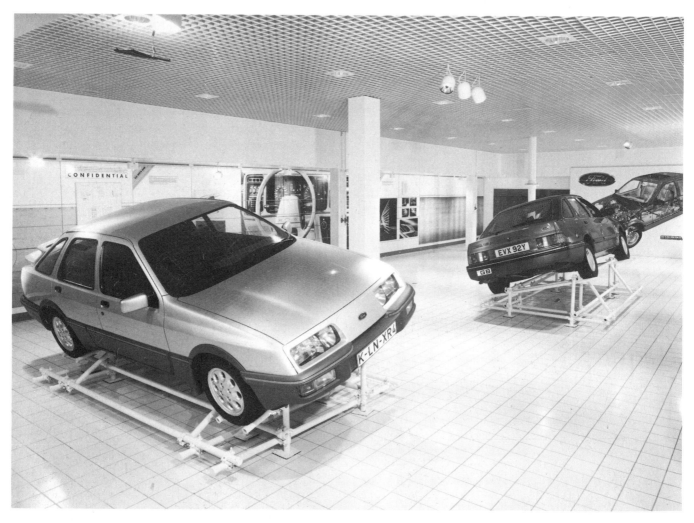

Viewing angle changed. On the road these
are merely cars, but raised and tilted they
become 'exhibits', visitors seeing both
body interior and underside
The Car Programme, Boilerhouse Project,
Victoria and Albert Museum, London

Transport

Apart from buildings, the largest objects the museum team will ever have to organise will be vehicles and vessels. While cars and cycles, both pedal and motor, can be treated as a cross between machinery and furniture, public vehicles will have many of the characteristics of houses, with the added complication of engineering elements to be explained to the visitors.

The designer will find that an exhibit through which the public has to move becomes a maze. It may be convenient to bring visitors in at a certain level for purposes of general management of circulation, but it may not be the point at which the exhibit makes most sense. The giant rib of a ship which has been raised from the sea bed provides little information at first sight. And aircraft viewed from the ground, the mechanics' view, can be overwhelming for people who are used to being fed into them up a staircase and through a passenger door!

The designer should be prepared to put a pin down at random, in all parts of these large interiors, and be able to satisfy himself that the visitor will be able to know where he is, and what it is that he is facing. Vehicles are designed for use by people who are either highly trained in their operation, or who have staff to guide them through the structure. If visitors are now to be let loose within these structures without such personal support, the information system that the designer builds in must be complete enough to take the place of the guide.

When dealing with large objects of this sort the designer will not be principally involved in how they are placed. Technical considerations will predominate. The designer's skill will be concentrated on interpretation and explanation. Subsidiary but nonetheless essential displays may include anything from technical drawings to fashions.

Access. Complex machinery cannot be put at risk by allowing the visitor complete access, so walk-ways, steps and barriers enable enthusiasts to view without damaging the exhibits. National Railway Museum, York

Exhibit patterns. Set against a wall these early bicycles are seen not only as a means of transport, but as decorative elements. Swiss Museum of Transport, Lucerne

Role reversed. The barrier is not to protect objects, but to safeguard visitors. A static label for moving objects, vehicles in use in a working brewery. Bass Museum of Brewing, Burton-upon-Trent

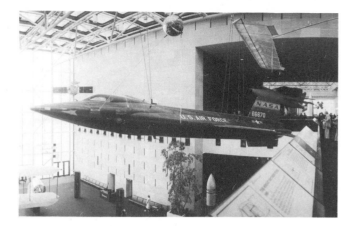

Immobile. These silent, suspended planes can be viewed both from a mezzanine gallery and from below. For detailed study, information is grouped and mounted on the balustrade.
National Air and Space Museum, Washington

Problems of scale. A giant object is on display, but how should it be labelled? The visitor must be attracted, steered to information. Weatherproofed panel on sturdy industrial barriers.
Imperial War Museum, Duxford

'Labelling' will have to be larger, and, since often exposed, much more robust than usual. The designer used to the fine finishes of the gallery must now think in terms of hoardings.

In planning circulation in transport exhibitions the designer will be dealing with three dimensions, rather than the usual two of the gallery floor. Visitors will need access to an aircraft, for example, and airline passenger steps may not be available in a museum. The rail enthusiast will want to view the footplate, and also will wish to climb underneath the engine if

encouraged. Access will not be needed for visitors alone. The maintenance of large transport exhibits cannot be carried out in the hour before opening alone. The staff will need access throughout the day to keep displays in good order.

Barriers, where needed, will have to be robust. If possible the barriers used in the working life of the exhibit should be obtained and adapted. If not available, the design of the original barrier may suggest the style of barrier to be built in the exhibition.

Out of reach, raised up on plinths with information on angled units. Daylight is augmented by floods and spotlights.
National Motor Museum, Beaulieu
Design: Brennan and Whalley

Appendix 1
Designing exhibitions for the disabled

Introduction

Museums have begun to adapt to the needs of the handicapped visitor. It is hard to realise that before the United Nations International Year of the Disabled, 1981, a significant section of the public had been virtually excluded from many exhibitions.

Legislation and clear specifications now govern the provision of access to public buildings for the physically disabled. In museums and art galleries, however, many of the exhibits and information panels are still badly placed for visitors in wheelchairs. (Designers should check the eyelines of visitors thus seated as well as those on foot).

Other visitors might be visually handicapped; it is difficult to display objects and information for those with limited sight or none, but in the last few years several exhibitions have set out to do just this. Wheelchair access to galleries has been followed by guidance systems to steer the partially or unsighted visitor round the displays, and close surface contact with the exhibits (usually forbidden) has been positively encouraged.

Information systems have been strengthened by the use of a number of alternatives, such as notices in enlarged typefaces, and braille panels. In such specially organised exhibitions the sound guide takes on a new importance.

Of course, making these extra provisions poses new problems for curators, designers, and particularly, conservators. Can the objects stand up to such additional handling, can a sufficient number of visitors be got round the exhibition to make it worth while? And can those who are not disabled enjoy the exhibition as well?

We have now reached a point where provision for disabled visitors to museums should be a matter of routine. Consideration of the necessary provisions should be included automatically in the design brief.

Although these notes are intended to cover the requirements of those who have difficulty in walking, most will be equally appreciated by the able bodied.

Access

Information on facilities available announced in advance in publicity material. Accepted symbols displayed outside the building.

Car parking needed for disabled with attendants and space to transfer from car to wheelchair.

Entrance doors, internal doors, passageways between displays to be wide enough for wheelchairs (*see*: British Standard 5810) or revolving doors should be provided with adjacent access for wheelchairs.

Feeling for sculpture. Raised arrows, sound guides take sightless visitors round this one-way exhibition (all plinth edges softened). For partially sighted the leaflet type is enlarged.
Please Touch, British Museum, London

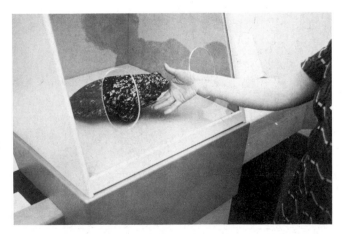

Tactile exhibit in a 'feeling box'. Set on a plinth it could not be secured and sightless visitors could have knocked it. Here it is secure, confined and also visible.
Please Touch, British Museum, London

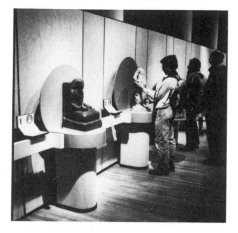

Dual system. Information designed for several kinds of visitor: blind, partially sighted and sighted. The labels carry braille, raised drawings of the building and enlarged type.
Please Touch, British Museum, London

Touch encouraged when usually forbidden. Linear arrangement. Guide rail between individual stands. Brightly coloured shaped panels behind each object to focus attention of the partially sighted.
Human Touch, British Museum, London

Ramps should be installed wherever steps are provided; alternatively a stair-climber, chair or platform lift.

Steps need handrails; wide steps need centre rails.

Wall- and free-standing cases should ideally be designed so that a wheelchair visitor can get right up to the case and look inside.

Services

Adequate seating is required by all, not only the disabled.

A lavatory accessible to wheelchair users should be near the exhibition.

A phone with open hood at the correct height for a wheelchair occupant to use should be nearby.

Dispenser for hand wipes and waste-bin for collection of used wipes in a 'touch' exhibition.

Visibility

Sales counter should be at a reasonable height to enable wheelchair visitors to see goods displayed on the counter top.

Routes for wheelchairs should be marked with accepted symbols.

Differences in floor levels should be easily discernible.

Obstructions and projections from walls on the circulation route should be easily discernible, or should be emphasised by changes in floor texture.

Dramatic changes in light level should be avoided and bright spotlights should not shine in people's eyes.

Information

Not all blind visitors will be able to use braille, but about 11% do in fact use it. So braille labels or maps, although useful, may not be helpful to the majority of blind visitors. Cassette recordings would probably be more widely appreciated especially if these are available in advance of a visit. Handling sessions for the blind within the exhibition might be possible if the material is robust and there is assistance. Handling tables for sighted children could easily be designed to double for the partially sighted, but, for conservation reasons, clean hands are essential and a wash basin should be within reach of the exhibition.

Multi-purpose label. Top tier: number and shape key to adjacent object and enlarged-type catalogue. Centre: large-type information. Bottom: braille text.
Human Touch, British Museum, London

Appendix 2
Exhibition budget checklist

A budget showing estimated expenditure must be drawn up by the exhibition organisers during the early planning stage of the project. At this stage, before the exhibition is planned in detail, the overall estimate is likely to be a 'guesstimate' based on previous experience in relation to known areas, updated to allow for current inflation and taxes.

The number of items requiring expenditure will vary according to size of project and size of organisation but the following checklist may be useful:

Travel

Travel and expenses to cover the selection, collection and return of objects borrowed from other museums, private lenders, etc.
Local travel for project team if necessary.
Visits to contractors (not necessarily local).

Exhibition construction and installation budget

To cover all construction materials, finishes, cases, special effects, electrical work, display lighting, ironmongery, with labour provided by a specialist exhibition contractor.

This budget should also cover the production of exhibition graphics: typesetting for information on panels and labels; silkscreen printing, photographic enlargements, colour prints, applied lettering, signs.

Staff costs

Staff salaries/fees and expenses:
Many organisations will have full-time staff already on the pay roll, but help from one or more specialist or additional members of staff as listed below might be necessary to cope with a major exhibition project. Sponsored projects appointing staff for a 'one-off' event will probably need and have to pay for services from among the following:

List of specialists:
Exhibition organiser
Academic adviser
Guest lecturers
Researcher/translator
Architect (working to RIBA scale of fees)
Designer/s
Lighting consultant/audio-visual consultant

Security advisor/publicity consultant/copy writer
Conservation advisor
Surveyor/structural engineer
Quantity surveyor
Illustrator
Accountant
Production manager
Object-mounting technicians (preparators)
Exhibition manager
Secretary/typist
Maintenance staff (if not part of main installation contract)
Cleaners
Warders
Ticket sales staff
Shop sales staff

Site costs

Hire of exhibition gallery
Gallery maintenance after previous exhibitions
Redecoration, reflooring
Servicing of existing installations: air conditioning, radiators, ventilators, electrical mains, etc.
Re-instating site

Insurance

Cover for objects in transit in UK and abroad
Insurance for staff, travelling
Complete third party risks to cover all eventualities
Cover for objects on display
(Cover for contractor's workmen on site is usually arranged by the firm of contractors but this should be confirmed prior to a contract being placed)

Transport

Cost of collection and return of borrowed items by specialist removal firms
Packing and packing cases
Specialist removal of heavy sculpture, etc.

Running costs

Cost of electrical consumption
Telephone rental and calls
Daily cleaning service
Warding/sales staff (*see* staff costs)

Merchandise

Catalogue:
 author's fee
 typesetting, printing and binding
 photography
 illustrator's fee
 designer's fee
Postcards:
 photography
 printing
Souvenirs/replicas:
 cost of production and packaging
Carrier bags:
 cost of origination
 design fee
 production costs

Publicity

Printing:
Poster:
 origination costs
 printing; overprinting for travelling exhibitions
 special posters (e.g. sides of bus)
 distribution/postage
Press and private view invitation cards:
 origination costs
 printing
 postage
Leaflets:
 origination costs
 printing
 distribution
Banners:
 origination costs
 production, erection and dismantling

Advertising:
Classified advertisements
Paid advertising, newspapers, periodicals, local radio, TV
Hire of poster sites
Printed stationery/press notice
Postage
Free issue catalogues for press
Press photographs
Press cuttings service

Office materials

Drawing office materials, dyeline or xerox prints
Purchase of samples
Cost of prototypes, models of design proposals
Cost of photographic records of project
Subject reference books
Stationery
Postage

Security

Cost of alarms, installation and dismantling
Warding costs, if extra warders are needed
Warding staff overtime for late openings of exhibition

Hospitality

Press view:
 drinks
 caterer's costs
Private view/reception
 drinks and food
 caterer's costs/waiters
Hire of PA equipment for opening speeches
Hire or purchase of furniture, plants, etc

Conservation requirements

Cost of special equipment, humidifiers, hygrometers, etc
Materials for the conservation of objects

Installations to be hired or purchased

Telephones
Fire extinguishers
Ticket-dispensing machines
Turnstiles
Safe
Office equipment

Maintenance and dismantling

Electrical maintenance costs
 (Contractor on hourly rate)
Replacement lamps
Contingency sum for general repairs, alterations, corrections etc.
Cost of specialist contractor removing and disposing of installation. (This may form part of the main contract for the original construction).
Cost of storage of components

Special effects/Exhibit mounting

Models, reconstructions, simulations, dummies, probably carried out by specialist firms, display mounts and fixings for objects.

Sound, audio-visual equipment and photos

Production costs of audio-visual and sound programme
Reproduction rights for tapes, films and photos used in exhibition

Contingency

The above list, in spite of its length, is unlikely to be comprehensive and so it is advisable to allow a sum for contingencies. This could be a percentage of the total estimate or of parts of the estimate, such as the construction and installation costs.

Appendix 3
Checklist of site details

Obtain any existing drawings of exhibition area, check on site, carry out or commission a survey.

Obtain information on floor loadings in relation to specific exhibits, numbers of visitors expected, including private view.

Check access to and from gallery for large exhibits, display furniture, contractors' equipment, etc.

Floor plans of the site should show the following:
Existing boundaries of the area
Main overall dimensions and diagonal figures
Outline of adjacent galleries
Services access through the area

Sections through the gallery taken along full length of the section line of the key drawing to the same scale will be required.

Elevations and ceiling plan to same scale will also be necessary.

Note specific details on the drawings as follows:
Existing finishes on floor, walls and ceiling
Services such as telephone positions, heating ducts, etc.
Fixed fire alarms and hoses, etc.
Electrical installations, i.e. existing electrical fittings, light switch positions and outlet sockets, junction boxes
Emergency light points
Fixtures and fittings, i.e. wall cases
Other equipment, i.e. free-standing furniture, fire hoses and extinguishers.

List any structural or decorative defects (to be agreed later with the successful exhibition contractor).

Obtain electrical loading available to the gallery.

Check the means of gallery ventilation, access to window- and roof-light openers, and access to radiators and controls.

Check type of air-conditioning and obtain operational manual; take advice on positioning additional partitions, etc.

Check path of sunlight.

Check whether local authority planning permission is likely to be needed for any external signs or temporary external structures.

Appendix 4
Checklist of security/fire/safety precautions

Security

Are the existing doors of the gallery free from obstructions and can they be closed and locked quickly and easily?

Has the Security Officer and those responsible for the objects approved the method of alarming or protecting the cases/exhibits?

Has the period required for wiring circuits been allowed for in the overall schedule? Has the additional electrical loading been calculated?

How many warders are available or will be available or required for the exhibition?

Where are the warders' chairs located? Can all areas of the gallery be seen from these positions? If not, consider the use of mirrors.

Is there anywhere for the warders to keep their torches in case of power failure?

Are there any voids likely to be created by the exhibition layout or case construction? If so, arrange for these to be covered in; alternatively provide easy access to these voids for quick inspection.

Calculate whether any areas are likely to be in deep shadow or darkness. If so, increase the level of illumination.

Are any of the free-standing exhibits vulnerable? If so, consider barriers.

Fire Prevention

Have the materials been passed by the Fire Officer?

Are all backs of panels, etc. specified to be fire-proofed or painted with emulsion?

Is there any plastic foam specified? If so, this will have to be replaced by alternative material, except where it is used as for example in upholstery and is covered with fire-proof material.

How many portable water-gas fire extinguishers and CO_2 gas-gun extinguishers are required for the exhibition? Where are these located? Are positions acceptable to the Fire Officer?

Are the fire-alarm points clearly visible and easily accessible?

Safety Precautions

Where are the emergency lights? Are they positioned so that in case of failure of display lights the public can see their way out of all parts of the gallery/exhibition?

Where is the fire-exit?

Is it marked and lit according to regulations? (i.e. 125 mm high capital letters in green).

If there is an escape corridor is it the same width as the door it leads to and from, and is it quite free of obstructions?

Are light switches readily accessible for supervising staff?

If there is a sales counter, is this positioned so that any crowding around it will not impede circulation and the entrance and exit to the exhibition? Is the cash register protected against a 'quick grab' attempt?

Are the 'star' exhibits placed in such a position that any crowding around them will not impede circulation or escape routes?

Bibliography

Designers and curators will assemble their own libraries on the subject of museum design and its related subjects. The following personal list is of books and articles which the author has found interesting and useful. Several have been quoted in this book.

The grouping of the lists corresponds roughly to the chapters of the book. In addition some of the titles listed under the general heading will be found to include detailed sections on conservation, lighting, etc.

Bibliographies and information on further reading will often be found in many of the listed works.

A list of the principal journals cited appears at the head of the bibliography.

JOURNALS

Curator
American Museum of Natural History, New York
(Quarterly)

International Journal of Museum Management and Curatorship
Butterworth, London
(Quarterly)

Museum
UNESCO, Paris
(Quarterly)

Museum News
American Association of Museums, Washington DC, USA
(Six times a year)

Museums Bulletin
Museums Association, London
(Monthly)

Museums Journal
Museums Association, London
(Quarterly)

Visible Language
The research journal concerned with all that is involved in our being literate
Box 1972, CMA, Cleveland, Ohio, USA
(Quarterly)

General

Aloi, Roberto
Musei: Architettura-Technica
Hoepli, Milan 1962

Arnell, Ulla; Hammer and Nylof
Going to Exhibitions
Riksutställningar, Stockholm 1976

Auger, Hugh A
Trade Fairs and Exhibitions
Business Publications, London 1967

Beazley, E
Design for Recreation: a practical handbook for all concerned with providing leisure facilities in the countryside
Faber & Faber, London 1969

Belcher, M G
'A Decade of Museum Design and Interpretation: a Personal View'
Museums Journal, vol.83, No.1, 1983

Belcher, M G
'A Survey of Design Practice and Resources in Museums in the British Isles (1980): a summary'
Museums Journal, Vol.84, No.2, 1984

Bergmann, E
'Design Tour of some European Museums'
Curator Vol.18, No.2 1975

Brawne, Michael
'Object on View'
Architectural Review, 126, 1959

Brawne, Michael
The New Museum: Architecture and Display
Architectural Press, London 1965

Brawne, Michael
'Public View: Housing the Arts'
Journal of Royal Society of Arts, January 1978

Brawne, Michael
The Museum Interior - temporary and permanent display techniques
Thames and Hudson, London 1982

Carpenter, Edward K
The Best in Exhibition Design
Print Casebooks 3,5
R C Publications, Washington DC 1978, 1982

Casson, Hugh
'Beyond Pedant and Fusspot'
Sunday Times, London, 15 June 1980

Coates, G
'Museum Architecture'
Museum, Vol.26, No.3/4, 1974

Cossons, Neil
'When is a Museum not a Museum?'
The Listener, London, 2 August 1984

Gardner, James and Caroline Heller
Exhibition and Display
Batsford, London 1960

Gatacre, E
'The Limits of Professional Design'
Museums Journal, Vol.76, No.3, 1976

Gillies, Pam and Antony Wilson
'Participation Exhibits: Is Fun Educational?'
Museums Journal, Vol.82, No.3, 1982

Gleadowe, Teresa
Organising Exhibitions
Arts Council of Great Britain, London 1975

Gretton, R
'Museum Architecture: a Primer'
Museum News, Vol.44, No.6, 1966

Hall, Pauline
Display: the Vehicle for the Museum's Message
Canadian Museums Association, Ottawa 1971 second edition

Hanson, Neil and Susan Jones
Directory of Exhibition Spaces
Arctic Publishing, Sunderland 1983

Hudson, Kenneth and Ann Nicholls
The Directory of Museums
Macmillan, London 1975

Hudson, Kenneth
Museums for the 80s: a survey of world trends
UNESCO and Macmillan, Paris and London 1977

Lehmbruck, M
'Museum Architecture'
Museum, Vol.26, No.3/4 1974

Miles R S et al.
The Design of Educational Exhibits
British Museum (Natural History) Allen and Unwin, London 1982

Rovetti, P F
'Supermarketing your exhibit'
Museum News, Vol.51, No.4

Communicating with the Museum Visitor: Guidelines for Planning
Royal Ontario Museum, Toronto 1976

Mankind Discovering
Vol I: *A Plan for New Galleries at the Royal Ontario Museum*
Vol II: *Evaluations: the Basis for Planning*
Royal Ontario Museum, Toronto 1978, 1979

Neustupny, Jiri
'What is Museology?'
Museums Journal, Vol.71, No.2, 1970

Neal, Arminta
Exhibits for the Small Museum
American Association for State and Local History, Nashville 1976

Miles, Roger S
'Museum Audiences'
International Journal of Museum Management and Curatorship, Vol.5, No.1, 1986

Porter, Julia
'Mobile Exhibition Services in Great Britain: a Survey of their Practice and Potential'
Museums Journal, Vol.82, No.3, 1982

Thompson, John (ed)
Manual of Curatorship: a guide to museum practice
The Museums Association/Butterworth, London 1984

Wetmore, R
'Museums and how to make the most of them'
Design, London, February 1972

Wheeler, Alan
Display: An Aid to Selling
Heinemann, London 1975

Winstanley, Barbara R
Children and Museums
Blackwell, Oxford 1967

Witteborg, Lothar P
'Museum Design'
Museum News, Vol.43, No.5,

3e Biennale des Arts Graphiques
Revue Internationale de la Création Artistique dans le Domaine de la Presentation des Expositions
Brno, Czechoslovakia 1968

Institute of Conservation and Methodology of Museums
International Museological Seminary: The problems and contents, didactics and aesthetics of modern museum exhibitions
Istvan Eri, Budapest 1978

Organisation of Museums - Practical Advice
UNESCO, Paris 1978 (fourth edition)

Kelly, F S
'Setting the Stage for Exhibits'
Museum News, Vol.52, No.1

Pope-Hennessy, John
'Specimens or People? - Some Problems for Art Museums'
Museums Journal, Vol.69, No.3, 1969

Pope-Hennessy, John
'Design in Museums'
Journal of the Royal Society of Arts, Vol.123, No.5231, October 1975

Rattenbury, Arnold
Exhibition Design: Theory and Practice
Studio Vista, London 1971

Ripley, Dillon
The Sacred Grove
Simon & Schuster, New York 1969

Shettel, H H,
'Exhibits: Art Form or Educational Medium?'
Museum News, Vol.52, September 1973

Sobol, Marion G
'Do "blockbusters" change the audience?'
Museums Journal, Vol.80, No.1, 1980

Background

Alexander, Edward P
Museums in Motion: An Introduction to the History and Functions of Museums
American Association for State and Local History, Nashville 1979

Alexander, Edward P
'William Bullock: Little-Remembered Museologist and Showman'
Curator, Vol.XXVIII, No.2, 1985

Allwood, John
The Great Exhibitions
Studio Vista, London 1977

Attick, Richard D
The Shows of London: A Panoramic History of Exhibitions 1600-1862
Harvard University Press, Cambridge, Massachusetts and London 1978

Bayer, Herbert; Walter and Ise Gropius (eds)
Bauhaus 1919-1928
Charles T Branford, Boston 1959

Bayer, Herbert
Herbert Bayer: Painter, Designer, Architect
Praeger, New York 1965

Bayer, Herbert
'Aspects of Design of Exhibitions and Museums'
Curator, Vol. IV, No.3, 1961

Bazin, Germain
The Museum Age
Desoer, Brussels 1967

Black, Misha
Exhibition Design
Architectural Press, London 1951

Benedict, Burton
The Anthropology of World's Fairs: San Francisco's Panama Pacific International Exposition of 1915
Lowie Museum of Anthropology and Scolar Press, London 1983

Clasen, Wolfgang
Exhibitions, Exhibits, Industrial and Trade Fairs
Architectural Press, London 1968

Caygill, Marjorie
The Story of the British Museum
Trustees of the British Museum, London 1981

Dorner, Alexander
The Way beyond 'Art': the Work of Herbert Bayer
Wittenborn Schultz, New York 1947

Expo - le Livre des Expositions Universelles 1851-1989
Union Centrales des Arts Décoratifs, Paris 1983

Franck, Klaus
Exhibitions - a Survey of International Designs
Praeger, New York 1961

Girouard, Mark
Alfred Waterhouse and the Natural History Museum
Yale University Press, New Haven and London, in association with the British Museum (Natural History) 1981

Gutmann, Robert and Alexander Koch
Ausstellungsstande
Alexander Koch, Stuttgart 1954

Hudson, Kenneth
A Social History of Museums
Macmillan, London 1975

Hillier, Bevis and Mary Banham (eds)
A Tonic to the Nation: the Festival of Britain 1951
Thames and Hudson, London 1976

Lissitzky-Küppers, S
El Lissitzky
Thames and Hudson, London 1968 (reprinted 1980)

Lohse, Richard P
New Design in Exhibitions
Verlag für Architektur-Erlenbach, Zürich 1953

Luckhurst, Kenneth W
The Story of Exhibitions
Studio Publications, London 1951

Marciano, Francesca Ada (ed)
Carlo Scarpa
Zanichelli Editore, Bologna 1984

Miller, Edward J
That Noble Cabinet: a history of the British Museum
Andre Deutsch, London 1973

Mordaunt Crook, J
The British Museum
Penguin, Harmondsworth 1972

Pira, Antonio
La Fabbrica di Cultura - la questione dei musei in Italia dal 1945 a oggi
Edizioni il Formichiere, Milan 1974

Royal Institute of British Architects
Carlo Scarpa: Architetto Poeta
Exhibition catalogue, Heinz Gallery, London 1974

Stearn, William T
The Natural History Museum at South Kensington: a history of the British Museum (Natural History) 1753-1980
Heinemann, London 1981

The exhibition makers and the design brief

Belcher, M
'The role of the designer in the museum'
Museums Journal, Vol.70, No.2, 1970

Bergmann, Eugene
'Exhibits: a Proposal for Guidelines'
Curator, Vol.XIX, No.2, 1976

Floyd, Candace
'Exhibit Designers talk about their Work'
Museum News, March 1981

Ciulla, Vincent and Charles F Montgomery
'Creative Compromise: the Curator and the Designer'
Museum News, March/April 1977

Hebditch, M
'Briefing the Designer'
Museums Journal, Vol.70, No.2, 1970

Wetmore, R
'Curator and designer'
Museums Journal, Vol.65, No.1, 1965

Wetmore, R
'Designers in the museum'
Designer, January 1972

Classifying exhibitions

Harrison, Richard F
'Swedish Travelling Exhibitions, Riksutställningar'
Museums Journal Vol.78. No.1, 1978

Lewis, Brian N
'The Museum as an Educational Facility'
Museums Journal Vol.80, No.3, 1980

Olofsson, Ulla Keding
'Temporary and travelling exhibitions'
Museums, Imagination and Education
UNESCO, Paris 1973

Morley, Grave L McCann
'Museums and circulating exhibitions'
Museum, Vol.3, No.4

Museums and Galleries Commission
Report by Working Party on Museum Travelling Exhibitions 1983
HMSO, London 1983

Shaping the communication

Baddeley, Alan
'Reading and Working Memory'
Visible Language, Vol.XVIII, No.4, 1984

Chambers, Marlene
'Is Anyone out There? Audience and Communication'
Museum News, June 1984

Evans, Harold
Editing and Design: Newsman's English
Heinemann, London 1972

Evans, Harold
Editing and Design: News Headlines
Heinemann, London 1974

Evans, Hilary and Murray
Sources of Illustration 1500-1900
Adams and Dart, London 1971

Evans, I M
'Specimens or People: a Question of Communication'
Museums Journal, Vol.69, No.3, 1969

Flint, Michael F
A User's Guide to Copyright
Butterworth, London 1979

Gardner, James
'Communicating Ideas'
Museums Journal, Vol.65, No.2, 1965

Gibbs-Smith, C H
Copyright law concerning works of art, photographs and the written and spoken word
Information Sheet No.7, Museums Association, London 1974

Hall, Nigel (ed)
Writing and Designing Interpretative Materials for Children
Design for Learning and the Centre for Environmental Interpretation 1984

An interview with Dr Hellenkemper
'Communication and the Museum'
Museum, 141, 1984

Jewett, Don L
'Multi-level Writing in Theory and Practice'
Visible Language, Vol.XV, No.1

Keenan, Stacey A
'Effects of Chunking and Line Length on Reading Efficiency'
Visible Language, Vol.XVIII, No.1, 1984

Morrison, Robert E and Albrecht-Werner Inhoff
'Visual Factors and Eye Movements in Reading'
Visible Language, Vol.XV, No.2, 1981

McLuhan, Marshall, et al
Exploration of the Ways, Means and Values of Museum Communication with the Visiting Public: A Seminar
New York 1969

Rees, Herbert
Rules of Printed English
Darton, Longman & Todd, London 1970

Sorsby, B D and Horne, S D
'The Readability of Museum Labels'
Museums Journal, Vol.80, No.3, 1980

Treib, Marc
'Rethinking Exhibitions'
Print Magazine, USA, Sept/Oct 1980

Wall, John (compiler)
Directory of British Photographic Collections
Royal Photographic Society, Heinemann, London 1977

Williamson, M
'Communications and the small museum'
Museums Journal, Vol.67, No.1, 1967

Security

Building Research Establishment Report
Results of Fire Propagation Tests on Building Products
HMSO, London 1976

British Standard 476
Fire Tests on Building Materials and Structures
Part 7, Surface spread of flame tests for materials
British Standards Institution
London 1971

Fennelly, Lawrence J
Museum, Archive and Library Security
Butterworth, London 1983

Gibbs-Smith, C H
The Art of Observation: a Booklet for Museum Wardens
Victoria and Albert Museum, London 1971

Greater London Council
Code of practice: means of escape in case of fire
GLC, London 1984 (No longer available)

Greater London Council
Exhibitions and Similar Displays: Standard Conditions
London Building Acts (Amendment), Act 1939, Sections 20, 34 and 35
GLC, London (No longer available)

Keller, Steven R
'Taking Steps toward Better Museum Security'
Curator, Vol.XXVIII, No.1, 1965

Loader, Kathryn
Flammability of Textiles
Fire Protection Association, London

Mannings, J
'Security of Museums and Art Galleries'
Museums Journal, Vol.70, No.1, 1970

Mason, D L
Fine Art of Security: protecting private collections against theft, fire and vandalism
Van Nostrand Reinhold, Wokingham 1979

Museum Security
Information Sheet, No.25, Museums Association, London 1981

Tillotson, R G
Museum Security
ICOM 1973

Conservation

Blackshaw, S M and V D Daniels
'The testing of materials for use in storage and display in museums'
The Conservator, 3, 1979

Blythe, A R
'Antistatic treatment of Perspex for use in picture frames'
Studies in Conservation, 19,
Journal of the Institute for Conservation of Historic and Artistic Works 1974

Conservation Source Book
Crafts Advisory Committee, London 1979

Diamond, Michael
'A Micro-Micro Climate'
Museums Journal, Vol.73, No.4

Control of the Museum Environment: a Basic Summary
International Institute for Conservation of Historic and Artistic Works 1967

Keck, Caroline
Safeguarding your Collection in Travel
American Association for State and Local History 1970

Leene, Jentina E
Textile Conservation
Butterworth, London 1972

Oddy, Andrew
'An Unsuspected Danger in Display'
Museums Journal, Vol.73, No.1, 1973

Per, E Guldbeck
The Care of Historical Collections: A conservation handbook for the non-specialist
American Association for State and Local History, Nashville 1972

Plenderleith, H J
'Climatology and Conservation in Museums'
Museum, Vol.13, No.4, 1960

Plenderleith, H J and A E Werner
Conservation of Antiquities and Works of Art
Oxford University Press, Oxford 1974

Stolow, Nathan
Controlled Environment for Works of Art in Transit
Butterworth, London 1966

Stolow, Nathan
'The technical organization of an international art exhibition'
Museum, Vol.XXI, No.3, 1968

Stolow, Nathan
Recent developments in exhibition conservation
Museum, Vol.29, No.4, 1977

Thompson, Garry
Conservation and Museum Lighting
Information Sheet, No.6
Museums Association, London 1985 (fourth edition)

Thompson, Garry
The Museum Environment
Butterworth, London 1981 (second edition)

Werner, A E A
'Second Design Conference. Conservation and display: environmental control'
Museums Journal, Vol.72, No.2, 1972

Simple Control of Humidity in Museums
Information Sheet No.24,
Museums Association, London 1985

Sight and Light

Allen, W A
'The museum in Lisbon for the Gulbenkian collection - a new approach to illumination'
Museums Journal, Vol.71, No.2 1971

Chartered Institution of Building Services
Lighting Guide - Museums and Art Galleries
London 1980

Bloomer, Carolyn M
Principles of Visual Perception
Van Nostrand Reinhold, Wokingham 1979

Durrant, D W (ed)
Interior Lighting Design
Lighting Industry Federation/Electricity Council
London 1973 (fourth edition)

Flynn, John E and S M Mill
Architectural Lighting Graphics
Reinhold, New York 1963

Harvey, J
'Air Conditioning for Museums'
Museums Journal, Vol.73, No.1, 1973

Gregory, R L
Eye and Brain: the psychology of seeing
World University Library, Weidenfeld and Nicolson, London 1966

Harris, J B
'Some Dos and Don'ts on Museum Lighting'
Light and Lighting, September/October 1974

Holmes, J G
Essays on Lighting
Adam Hilger, London 1975

Hopkinson, R G and J D Kay
The Lighting of Buildings
Faber and Faber, London 1969

Issue devoted to museum lighting
International Lighting Review
vol.XV, No.5/6

Loe, D L, E Rowlands, and N F Watson
'Preferred lighting conditions for the display of oil and watercolour paintings'
Lighting Research and Technology, Vol.14, No.4, 1982

Lighting of Art Galleries and Museums
IES technical report No.14, December 1970

Miller, Naomi and David; Peter Ngai
'Computer graphics in lighting design'
International Lighting Review, No.4, 1984

Nuckles, James L
Interior Lighting for Environmental Designers
Wiley, Chichester, New York 1976

Philips
Lighting: Comprehensive Handbook
London, (current edition)

Tate, R L C (ed)
Technical Handbook
Thorn, London (current edition)

Thompson, Colin
'Daylight in art galleries'
Museums Journal, Vol.71, No.2

Tibbs, Hardwin
The Future of Light
Watkins Publishing, London/Dulverton 1981

Turner, Janet (ed)
Light in Museums and Galleries
Concord Lighting, London 1985

Werner, A E A
'Heating and ventilation'
Museums Journal. Vol.57, No.6, 1957

Museums and Galleries, Update 7: 'Display Lighting'
Architects Journal, London, 14 August 1985

Show Cases

Rivière, Georges Henri and Herman Visser
'Museum Showcases'
Museum, Vol.12, No.1, 1960

Neal, Arminta
'Gallery and Case Exhibit Design'
Curator, Vol.VI, No.1, 1963

Stolow, Nathan
'Fundamental Case Design for Humidity Sensitive Museum Collections'
Museum News, No.11, 1966

Turner I K
Museum Showcases: A Design Brief
British Museum Occasional Paper, No.29,
London 1980

'Showcase Design'
Architectural Review, London, May 1974

Whole issue devoted to Showcases
Museum, No.146, 1985

Information Design

Bartram, Alan
'Exhibition graphics and the British Museum'
The Penrose Graphic Arts Internatinal Annual
Northwood Publications, London 1974

Bruce, Margaret and Jeremy J Foster
'The visibility of coloured characters on coloured backgrounds in viewdata displays'
Visible Language, Vol.XVI, No.4, 1982

A special on museum promotion
Communication Arts, California, No.133
September/October 1978

'Computer Graphics: A special issue'
Visible Language, vol.XIX, No.2, 1985

Crosby, T; A Fletcher, C Forbes
A Sign Systems Manual
Studio Vista, London 1970

Deken, Joseph
Computer Images: State of the Art
Thames and Hudson, London 1983

Easterby, Roland and Harm Zwaga (eds)
Information Design - the design and evaluation of signs and printed material
Wiley, Chichester, New York, 1984

Follis, John and Dave Hammer
Architectural Signing and Graphics
Architectural Press, London 1979

Herdeg, W
Graphis Diagrams
Graphis Press, Zürich 1974

Hurlburt, Allen
The Grid
Barrie and Jenkins, London 1979

Kner, Carol Stevens
The Best in Covers and Posters
Print Casebooks 5
R C Publications, Bethseda 1982

Kinneir, Jock
Words and Buildings: the Art and Practice of Public Lettering
Architectural Press, London 1980

Lockwood, Arthur
Diagrams: a Visual Survey of Graphs, Maps, Charts and Diagrams for the Graphic Designer
Studio Vista, London 1969

McLendon, Charles B and Mick Blackstone
Signage: Graphic Communications in the Built World
McGraw-Hill, New York 1982

Pettitt, C
'Label material for wet-preserved biological specimens'
Museums Journal, Vol.75, No.4, 1976

Pilditch, J
Communication by Design
McGraw-Hill, New York 1970

The Best in Environmental Graphics
Print Casebooks 4
R C Publications, Washington DC 1980/81

Ryder, John
The Case for Legibility
Bodley Head, London 1979

Sorsby, B D and S D Horne
'The Readability of Museum Labels'
Museums Journal, Vol.80, No.3, 1980

Spencer, Herbert
The Visible Word
Lund Humphries, London 1969

Spencer, Herbert; Linda Reynolds and Brian Coe
A Report on the Relative Legibility of Alternative Letter Shapes
Readability of Print Research Unit, RCA, London 1973

Spencer H and S L Reynolds
Directional signing and labelling in libraries and museums: a review of current theory and practice
Readability of Print Research Unit, RCA, London 1977

Spencer, H; L Reynolds and G Glaze
The Legibility and Readability of Viewdata Displays: a survey of relevant research
Readability of Print Research Unit, Royal College of Art, London 1978

Weiner, George
'Why Johnny can't read Labels'
Curator, Vol.VI, No.2, 1963

Williams, L A
'Labels: writing, design and preparation'
Curator, Vol.III, No.1, 1960

Audio visual

Alt, M B
'Improving Audio-Visual Presentations'
Curator, Vol.22, No.2, 1979

Beaumont-Craggs, Ray
Slide Tape and Dual Projection
Focal Press, London 1975

Benes, Josef
'Audio-Visual Media in Museums'
Museum, Vol.28, No.2, 1976

Collison, David
Stage Sound
Studio Vista, London 1976

Eden, Philip
'The Listening Post (a new audio-guide device)'
Museums Journal, Vol.78, No.3, 1978

Dawes, Colin V
'Audio-visual Displays for small Museums'
Museums Journal, Vol.78, No.2, 1978

Kissiloff, William
'How to use mixed Media in Exhibits'
Curator, Vol.XII, No.2, 1969

Long, C W and M K Kidd
Projecting Slides
Focal Press, London 1963

Norgate, Martin
'Tape and slide scripting'
Museums Journal, Vol.74, No.4, 1974

Owen, David and Mark Dunton
The Complete Handbook of Video
Penguin Press, Harmondsworth 1982

Quinion, Michael B
'Slide-tape presentations'
Museums Journal, Vol.76, No.1, 1976

The designer communicates

Alexander, Christopher; Sara Ishikawa and Murray Silverstein
A Pattern Language: towns, buildings, construction
New York University Press, New York 1977

AJ Metric Handbook
Architectural Press, London (latest edition)

Carter, David
The Psychology of Place
Architectural Press, London 1977

Design Council
Designing Against Vandalism
Design Council, London 1979

Eastwick-Field, John and John Williams
The Design and Practice of Joinery
Architectural Press, London 1958

Goslett, D
The Professional Practice of Design
Batsford, London 1971

Howell, D B
'A network system for the planning, designing, construction and installation of exhibits'
Curator, Vol.XIV, No.2, 1971

Lang, Douglas W
Critical Path Analysis
Hodder and Stoughton, London 1977

Lawson, Bryan
How Designers Think
Architectural Press, London 1980

Neufert, E
Architects Data
Crosby Lockwood Staples, London 1970

Potter, Norman
What is a Designer?
Hyphen Press, London 1969

Shulman, Julius
The Photography of Architecture and Design: Photographing Buildings, Interiors and the Visual Arts
Architectural Press, London 1977

Specification
Architectural Press, London (annual: latest edition)

Titus, William H
Photographing Works of Art
Watson-Guptill, New York 1981

Topalian, Alan
The Management of Design Projects
Associated Business Press, London 1980

The Final Score

There is a wealth of material on exhibition evaluation and visitor surveys. The following will afford a brief introduction.

Alt M B
'Evaluating Didactic Exhibits: a critical look at Shettel's work'
Curator, Vol.XX, No.3, 1977

Borhegyi, S F de
The Museum Visitor
(Publication in Museology 3)
Milwaukee Public Museum 1968

Borhegyi, S F de
'Museum exhibits: how to plan & evaluate them'
Midwest Museums Quarterly, Vol.23, No.2, 1963

Borhegyi, S F de
'Testing of Audience Reaction to Museum Exhibits'
Curator, Vol.VIII, No.1, 1965

Cameron D F
'Effective exhibits - a search for new guidelines. The evaluations view point.'
Museum News, Vol.46, No.5

Cameron D F
'How do we know what our visitors think?'
Museum News, Vol.45, No.7

Cameron D F
'The Evaluator's View Point'
Museum News, January 1968

Digby, Peter Wingfield
Visitors to three London Museums
HMSO, London 1974

Kimmel P S and M J Mares
'Public reaction to museum interiors'
Museum News, Vol.51, No.1

Borun, Minda
Measuring the Immeasurable - a pilot study of museum effectiveness
Franklin Institute Science Museum and Planetarium, Philadelphia 1977

Leambruck, Manfred
Museum Architecture: Physiology: factors affecting the visitor: Physiology: perception and behavior.
Museum, Vol.26, No.3/4, 1974

McLuhan, Marshall
Exploration of the Ways, Means and Value of Museum Communication with the Viewing Public
Museum of the City of New York, New York 1969

Morris R C M and M B Alt
'An experiment to help design a map for a large museum'
Museums Journal, Vol.77, No.4, 1978

The Metropolitan Museum and its public: highlights of the Yankelovich survey
The Metropolitan Museum of Art Report, New York 1973

'Museums and interpretative techniques: an interim report'
Museums Journal, Vol.75, No.2, 1975

'An evaluation of the Museum's Visitor's programme'
N.Y. State Museum 1968

Parsons, L A
'Systematic testing of display techniques for an anthropological exhibit'
Curator, Vol.8, No.2, 1965

Robinson, E S
'Experimental education in the Museum - a perspective'
Museum News, Vol.10, No.6, 1933

Screven, C G
Measurement and facilitation in the museum environment: an experimental analysis
Smithsonian Institute Press, Washington DC, 1974

Screven, C G
'The Museum as a responsive learning environment'
Museum News, Vol.47, No.10, 1969

Screven, C G
'Exhibit evaluation - a goal-referenced approach'
Curator, Vol.XIX, No.4, 1976

Shettel, H H
'An evaluation of existing criteria for judging the quality of science exhibits'
Curator, Vol.XI, No.2, 1968

Weiss, R S
'The communication value of exhibits'
Museum News, Vol.42, No.3, 1963

Witlin, A
'Exhibits: interpretative, under-interpretative, mis-interpretative'
Museums & Education, Smithsonian Institute, Washington 1968

Futures

Cash, Joan
'Spinning toward the Future: The Museum on Laser Videodisc'
Museum News, August 1985

Coates, Joseph F
'The Future and Museums'
Museum News, August 1984

Gardner, George S
'The Shape of Things to Come'
Curator, Vol.XXII, No.1, 1979

Stowens, Doris
'Co-operative use and storage of exhibition materials'
Curator, Vol.XVIII, No.1, 1975

Designer's notebook objects and subjects

Area Museums Service for South-East England
Moving Pictures:
I Framing for Loan
II Packing for Transport
III Packing: a range of alternatives
3 papers from a Seminar, June 1984
International Journal of Museum Management and Curatorship, No.4, 1985

British Standard 5454
Recommendations for the Storage and Exhibition of Archives
British Standards Institute, London 1977

Conybeare, C and D Viner
'New Archaeology Galleries at the Salisbury and South Wiltshire Museum: a Review of the King's House Development'
Museums Journal, Vol.84, No.4, 1985

Clarke, G C S
'Evolving an Exhibition on Evolution'
Museums Journal, Vol.84, No.3, 1984

Cranstone, B A L
Ethnography
In the series *Handbooks for Museum Curators*
Museums Association, London 1958

Cross, Susan and Andrew Millward
'The New Bird Gallery at the Manchester Museum'
Museums Journal, Vol.83, No.2/3, 1983

Danilov, Victor J
'America's Contemporary Science Museums'
Museums Journal, Vol.75, No.4, 1976

Danilov, Victor J
Science and Technology Centres
MIT Press, Cambridge, Massachusetts 1982

Davies, Stuart and David Symons
'Birmingham's Coin Gallery'
Museums Journal, Vol.82, No.4, 1983

Duncan, Tony
'The Shapes of things to come? Reflections on a visit to the Hall of Human Biology, South Kensington'
Museums Journal, Vol.78, No.1, 1978

Finch, Karen and Greta Putnam,
Caring for Textiles
Carrie & Jenkins, London 1977

Harris, Jean Karyn
Costume Display Techniques
American Association for State and Local History, Nashville 1977

Ginsburg, M
'The mounting and display of fashion and dress'
Museums Journal, Vol.73, No.2, 1973

Glaister, Jane and Alison Wyman
'Parade' - an exhibition designed to communicate (an exhibition of Diaghilev costumes)'
Museums Journal, Vol.80, No.1, 1980

Glover, J M
Textiles and their Care and Protection in Museums
Information Sheet No. 18, Museums Association, London 1973

Greenwood, B D; D K Moore and E F Greenwood
'A plantroom for museum displays of living plants
Museums Journal, Vol.78, No.2, 1978

Harding, Eric
Mounting of Prints and Drawings
Information Sheet No.12, Museums Association, London 1980

Howie, Francis M P
'Conserving and Mounting Fossils: a Historical Review'
Curator, Vol.XXIX, No.1, 1986

Keek, Caroline K
A Handbook on the Care of Paintings
American Association for State and Local History, Nashville 1965

MacDarell, David W
Coin collections and their preservation, classification and presentation
UNESCO, Paris 1978

Howell, Alan C
'Yesterday's World: the New Geology Gallery at the Hancock Museum'
Museums Journal, Vol.80, No.1, 1980

Picture Frames (Whole issue devoted to)
International Journal of Museum Management and Curatorship, Vol.4, No.2, 1985

Photographic Processes, Glossary and Chart
Information Sheet No.21, Museums Association, London 1978

'Mineral displays: a new method'
Museums Journal, Vol.74, No.4, 1975

Seale, William
Re-creating the Historic House Inteior
American Association for State and Local History, Nashville 1979

Stansfield, Geoffrey
'Three New Natural History Galleries'
Museums Journal, Vol.81, No.2, 1981

Stansfield, Geoffrey
'The Bird Room at the Hancock Museum, Newcastle-upon-Tyne'
Museums Journal, Vol.80, No.4, 1981

Stansfield, Geoffrey
'Three New Natural History Exhibits - Manchester, Liverpool and Kendall'
Museums Journal, Vol.83, No.2/3, 1983

Stobbs, William
Motor Museums of Europe
Arthur Barker, London 1983

Thackray, J C and G Velarde
'British Fossils: a New Exhibition at the Geological Museum'
Museums Journal, Vol.80, No.2, 1980

'Models in museums of science and technology'
Museum, Vol.23, No.4, Paris 1970-1

Weinstein, Robert A and Larry Booth
Collection, Use and Care of Historical Photographs
American Association for State and Local History, Nashville, Tennesse 1978

Wetzel, J
'Three steps to exhibit success: a guide to art installations'
Museum News, Vol.50, No.6, 1972

Whybrow, Peter J
'A History of Fossil Collecting and Preparation Techniques'
Curator, Vol.XXVIII, No.1, 1985

Ucko, David A
'Science Literary and Science Museum Exhibits'
Curator, Vol.XXVIII, No.4, 1985

Exhibitions for the disabled

British Standard 5810
Code of practice for Access for the Disabled to Buildings
British Standards Institution, London 1979

Callow, Kathy B
'Museums and the Disabled'
Museums Journal, Vol.74, No.2, 1974

Coles, Peter
Please Touch: an Evaluation of the British Museum Exhibition of Animal Sculpture
Public Committee of Enquiry into the Arts and Disabled People, HMSO London 1984

Harkness, Sarah P and James N Groom, Jnr
Building without Barriers, for the Disabled
Watson-Guptill, New York 1976

Heath, Alison
'The same only more so: museums and the handicapped visitor'
Museums Journal, Vol.76, No.2, 1976

Kelly, Elizabeth
'New Services for the Disabled in American Museums'
Museums Journal, Vol.82, No.3, 1982

Pearson, Anne
Arts for Everyone - Guidance on Provision for Disabled People
Centre for Environment for the Handicapped, London 1985

Pearson, Fiona
'Sculpture for the Blind, National Museum of Wales'
Museums Journal, Vol.81, No.1, 1981

Hands On - setting up a discovery room in your museum or school
Royal Ontario Museum, Toronto, Canada 1979

Indexes

References throughout are to page folios; text references are in roman, references to pages on which illustrations appear are in italic.